The Camera of My Family

Alfred A. Knopf New York 1976

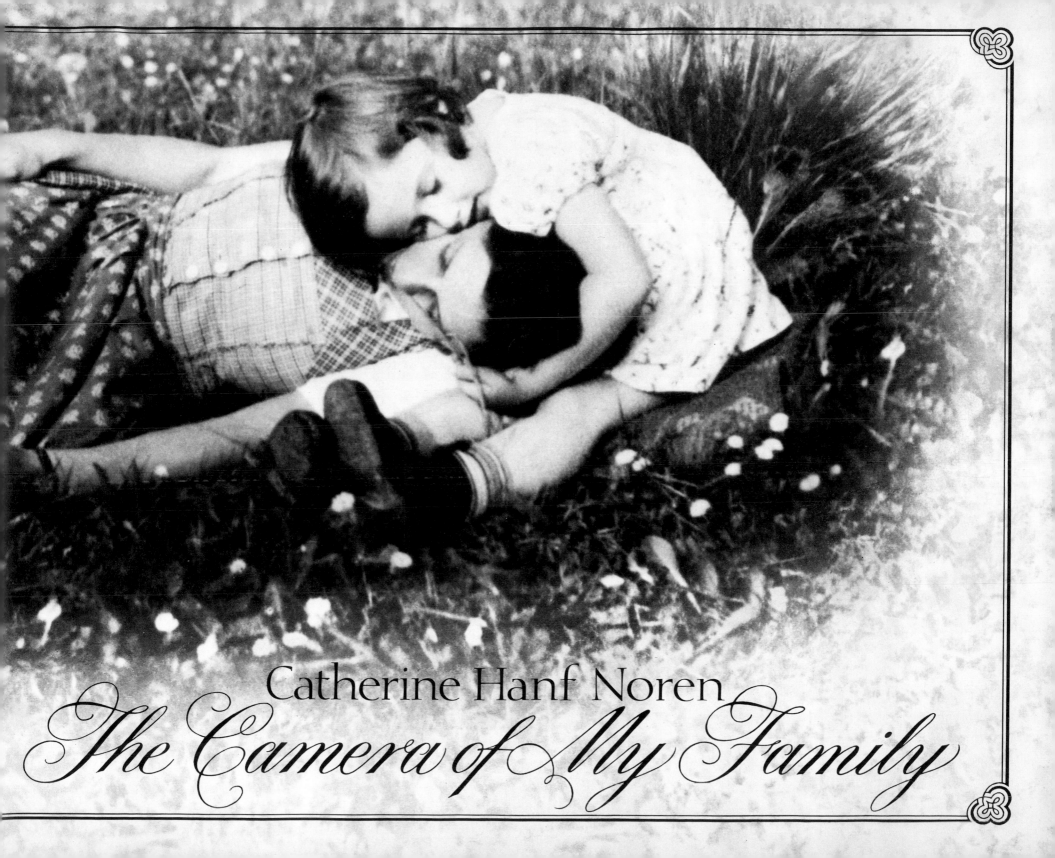

Catherine Hanf Noren

The Camera of My Family

This book is my gift to my family and their gift to me.

It is dedicated with love and admiration to Mutti.

Acknowledgments

My thanks and gratitude to each and every member of my family who participated in helping me to put this book together. Although there are many of them whom I have never met, they have been without exception willing and cooperative in their response to my written requests for photographs, documents, and information.

As to the genealogical material, I should like to acknowledge the research done by the late Dr. Hermann Wallach of Duisberg, my grandfather's cousin, the late Julius Wallach, my grandfather's brother, and the late Siegfried Porta, a great-uncle of my father's. I should also like to acknowledge the work of Dr. Alfred Laurence of Surrey, England, and to thank him for permission to reproduce the portrait of Süsskind Stern on page 29. For more recent dates and relationships, I have relied heavily on the material gathered by Binyamin Banai (formerly Werner Strauss), a cousin of my mother's now living in Israel. Eric Schaal, family friend and photographer, has been extraordinarily generous in allowing me the use of his photographs, and I thank him.

The photographs, documents, and information supplied by my grandmother, Meta Strauss Wallach, and her sister, Grete Strauss Loeb, were indispensable to this project. My grandmother and my great aunt are the link between the past and the present, and without them *The Camera of My Family* could not have been created. Of the other members of my family, I should particularly like to thank my mother's cousin Liesel Rothstein for supplying me with documents of a personal and often painful nature. Another of my mother's cousins, Ilse Wallach de Sternau of Buenos Aires, sent me literally hundreds of photographs, which she went to great pains to caption and date. My parents, Eric Hanf and Lotte Wallach Hanf, patiently endured dozens of hours of questioning and probing, as did aunts, uncles, and family friends. My mother gave tirelessly and enthusiastically of her perceptiveness and fluency in helping me to translate historical and business documents.

Jim Hughes, formerly of *Camera 35*, and Cornell Capa were the first to recognize the validity of this project in terms of its publishability. My sincerest thanks to them for their support and encouragement, as well as the assistance of the International Fund for Concerned Photography.

The Camera of My Family started life in 1973 as an exhibit at the Jewish Museum, New York City. To Mrs. Joy Ungerleider, director, Mrs. Susan Goodman, curator, Avram Kampf, consultant, and the staff of the museum, my gratitude and appreciation.

Dr. Fred Grubel and the staff of the Leo Baeck Institute helped me to make sense of the genealogical material. I thank them for their patience, and for permission to use valuable material from the Institute's extraordinary archives.

Two editors have helped me to fashion this book. My very warmest thanks to Regina Ryan, formerly of Alfred A. Knopf, for her guidance, enthusiasm, and understanding of what I was trying to piece together. Ann Close, who had the task of picking up the pieces after Regina left Knopf, did so with humor and grace. Betty Anderson, who designed the book, has intuitively and exactly caught the visual spirit and style of the family, and in doing so has given the book its final, indispensable integrity.

Finally, there are two people whom I hardly know how to thank. Sid Kaplan gave endlessly of his photographic expertise, his facilities, and his personal generosity. Dr. Jonas Cohler gave me the heart to undertake this investigation and the courage to persevere.

Foreword

My family are the people I live with in time; the people whose lives prepare for mine, whose lives parallel mine, for whose lives mine prepares.

This book is a document of my family's passage through time; their deeply rooted life in Germany, their devastation by Hitler, and their subsequent resifting and resettling.

Although I did not know it at the outset, I created this book in order to know my family. Because I am the last member to be born in Germany—I was a few months old when we left—I have, of course, no personal memories of that time.

People have various ways of dealing with loss. The way my family dealt with their enormous loss—of homeland, life style, root-room, comfort—was, I believe, to deny that what they had lost had ever existed, or had validity; to create determinedly a new set for themselves. But the emotional vibrations and reverberations, the anachronisms and the myth remained, and these were the source of a certain kind of secrecy that accompanies the suppression of feelings. The aura of myth was always there, but its content was always arcane.

The facts which were made available to me were bare: I knew that I had been born in Germany; we left and went to Australia in January 1939. During that war time in Australia, much of which I remember well, our one prevailing wish was that the war be over and that we might come to the United States, where my mother's family had emigrated.

We came here in 1946, and I did most of my growing up in Cornwall, Connecticut, a small town in the New England Berkshires. I knew almost nothing about the holocaust, I did not know that Hitler had murdered the Jews; I did not know that I was Jewish.

My grandfather's work in Germany had been the documentation and preservation of indigenous folk art and design. The family regained this business after the war, and therefore we have retained close ties with Germany and the continuing fact of our German-ness. But the emotional substance of that tie, because of the conflict surrounding it, was made even more deeply mysterious and unavailable.

During my teen years and into my twenties, none of what was past had much interest for me. What was of interest to me was learning to live where I was, of assimilating myself into the life of a small New England town. I heard bits and pieces from the past, particularly from my grandmother, but they had no relationship to me. I was intensely interested in the present. But there was always a split; I felt there was something my family knew that I didn't, and I believe that sense of secrecy caused an unidentified resentment in me, as well as a sense of alienation.

I came to this project via the photographs. One afternoon during the summer of 1972, I was visiting my maternal grandmother at her home in Lime Rock, Connecticut. We were drinking coffee and talking, and she mentioned another of those names which were so familiar to me and bored me so much. Saying that she had a photograph of the person she was talking about, she directed me to a chest of drawers, and in it were hundreds of photographs, some in albums, some in old wooden boxes, some loose. I admired them, appreciated their beauty as any photographer would. But more, I was awed by the strange and alien time, flavor, place they evoked. I had no sense of identification with the photographs, but I knew almost at once that I wanted to make a book. How or in what fashion I had no idea; it was like falling in love at first sight, with a complete stranger.

The initial identification came when I started to make

copy prints of the photographs. As the images emerged in the developer, I saw signs of myself: throughout my mother's family, for instance, the same hands, again and again, and they are my hands. My great aunt Else (see photograph on p. 58), whom I had not only never met but never consciously heard of, was in physiognomy a sister to me. When I first saw her image I was stunned. Looking again and again at a set of prints, I felt myself to be in an enchanted place. Perhaps that is why this book has so much more to do with Germany and the past than with the here and the now—because it is an investigation, an unfolding of secrets.

It was only after circling the photographs for some time and with purposeful detachment that I allowed myself to become involved with them. To do so seemed to me to be trespassing on someone else's property, or reading someone else's mail. But when I finally confronted that unspoken taboo, the silence that had for so long surrounded my family's life in Germany, and started working on the manuscript, I found that almost all the information I asked for was readily available and accessible to me.

My mother's family is more prominent in this book than is my father's. My father's family was clearly not as interested in documenting themselves visually, and thus there is not a fraction of the material available. Further, on my father's side, his parents and their siblings have all died, and what my father and his siblings have been able to tell me is relatively little. However, there is extensive genealogical material on both sides. I found, only after I was well into the project, that I am by no means the first member of my family to take an active interest in our collective history, although what was done before me is of a considerably more scholarly and less personal nature. To those members of the family (many of whom are now dead) who have done this genealogical research I am grateful, because while this book does not intend to be a scholarly work, having the benefit of this additional material has enabled me to place the more immediate past, that which is the focus of my interest, in the context of larger time.

I feel a much stronger sense of continuity now. This is not a psychological narrative, nor is that its intention. It is an assemblage of reminiscences, of feelings, of images. It is also a personal history of the fate of the German Jews under Hitler.

The book falls roughly into six sequences. The first section, the Strausses, is about my maternal grandmother, Meta Strauss, and her family, her life as a child and a teenager, and the milieu in which she grew up. The second section, the Wallachs, is about my maternal grandfather, Moritz Wallach, and his family. The next section is about Moritz and Meta's life together in Munich, and their children: my uncle Rolf, my mother Lotte, my uncle Fritz, and my aunt Annelise. This section is the fullest and most happy, as Moritz's work is recognized and his family enjoys the benefits of what they believe is their birthright, as indeed it is. Next is an introduction to my father's family, the Hanfs, and their parallel flowering in the Rhineland. In the midst of this happiness and content, the shadow of Hitler begins to stretch itself across their sunlight.

The bewilderment and horror of the approaching holocaust almost obliterates the family psyche; the only focus is on escape, survival. The Auschwitz diary is the culmination of all that was terror and malice beyond conception.

Finally the people of my family relocate themselves and each other after their terrified flight; they try to reestablish old ties which might have been forever, but which have been shredded and decimated past comprehension.

At last, *The Camera of My Family* is about heart and healing.

New York City
September 1975

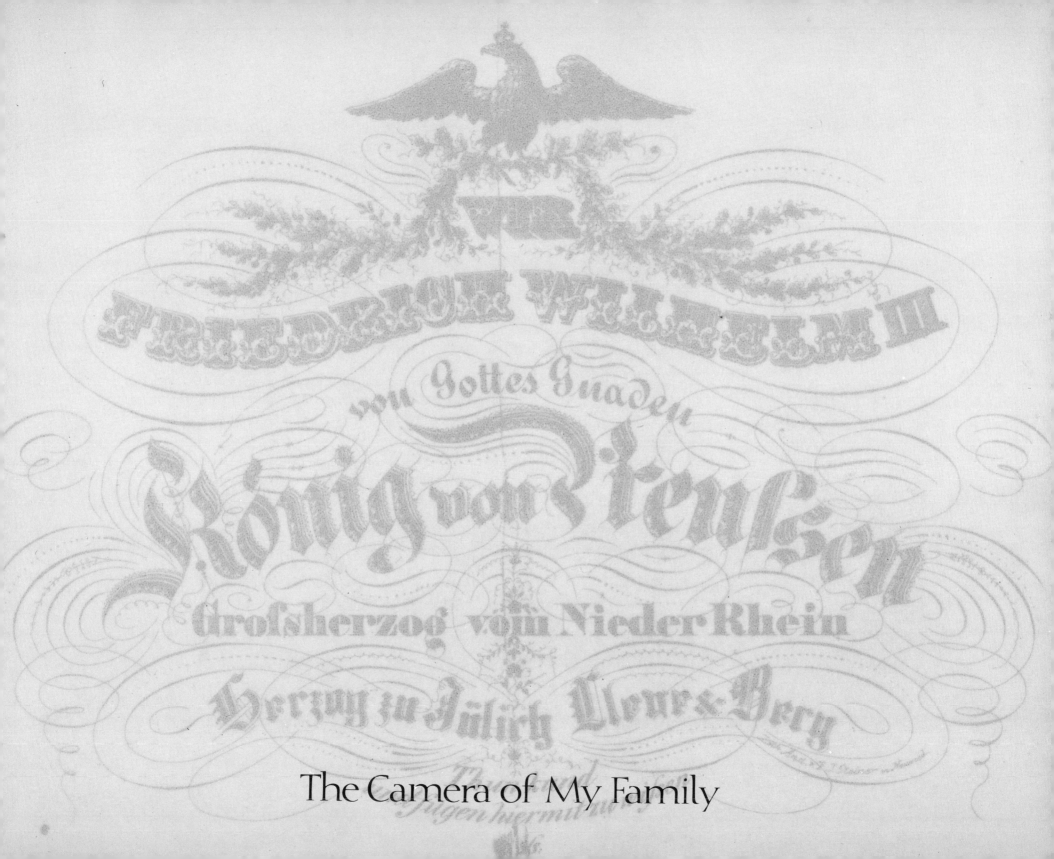

The Camera of My Family

WE

FRIEDRICH WILHELM III

by God's Grace

KING OF PRUSSIA

Grand Duke of the Lower Rhine

Duke of Jülich, Cleve and Berg

No. 129

HEREWITH by this document do declare and announce, that

This day, the fifteenth of June, in the year one-thousand eight hundred and forty-two, at eight o'clock in the morning, in the presence of Anton Alois Queckenberg, Royal Prussian Notary of the Grand Duchy of the Lower Rhine, County Court, District of Coblenz, Township of Remagen on Rhine, appeared, well known to him by name, position and dwelling, Mr. SALOMON CAHN, as bridegroom, merchant living in Remagen, in his majority, son of the also present, assisting and also well-known to the Notary, Mr. Gottfried Cahn, merchant, living here, on the one hand; and Miss SIBILLA GOTTSCHALK, without profession, in her majority, daughter of Salomon Gottschalk, both residing in Thur, in the District of Mayern, appearing as bride, on the other hand, acting in the presence and with the agreement of her above-named father.

WHICH parties have arranged the following agreement among themselves, NAMELY:

Article One

The above-mentioned Salomon Cahn and Sibilla Gottschalk repeat herewith the marriage promise which has taken place between them, and which they are about to have ratified by the Civil Servant.

Article Two

The engaged parties do herewith marry each other according to the lawful rules of joint ownership of property.

Article Three

To make their union and their establishment more secure for the couple, the bridegroom will bring into this marriage a house situated in Remagen, on the main street, under the number of One hundred fifty, between Adam Drossner and Johann Christian Klemens, together with all the outbuildings, which are given to him by his here-present father as a gift for his wedding, free of debts and mortgages, and therefore as his property.

Article Four

The bride brings from her side the sum of seven hundred fifty thaler, which her father has promised to give to the bridegroom upon the accomplishment of the marriage ceremony. [It's difficult to estimate how much my great-great-grandmother's dowry was worth, because this was during a time of bad inflation. For instance, a 4-pound loaf of bread cost 3.34 silver thaler; on the other hand, one could rent a four- to five-room lodging for a year at a cost of only about 10 thaler.]

Article Five

To assure the bride, for any eventuality, that her marriage gift is secure and kept for her, the bridegroom and his father are giving the aforementioned house and outbuildings as special security, that mortgages may be taken upon it.

Article Six

Further, the engaged parties have agreed that upon the dissolution of their marriage, whether or not there are children of the union, the surviving partner will have personal use of the dower and property brought by the other into the marriage, but that he cannot assign it to anyone else without providing security for it.

Article Seven

For the purpose of maintaining the settlement of property agreed upon in the preceding Article, each of the engaged parties will bequeath his settlement to the surviving partner.

CONCERNING WHICH this document has been read to the witnesses, and to it has been affixed a seal worth two thaler.

As done and recorded in the office of the Notary at Remagen on the above-recorded day, in the presence of Bartholomeus ADAM, forest warden, and Ferdinand BREUER, bookbinder, for this purpose chosen and known to the Notary, who, after the proper reading with the witnesses and the Notary, have thereunto affixed their signatures. The original was signed by:

_____ *Salomon Cahn* _____

_____ *Billa Gottschalk* _____

_____ *Gottfried Cahn* _____

_____ *Salomon Gottschalk* _____

_____ *Adam* _____

_____ *Breuer,* and _____

_____ *A. A. Queckenberg, Notary* _____

We

order and command all bailiffs [?] who were previously retained to execute the present instrument; we also ask our representatives and our main counsel to take care of our rights in the state courts. We also ask the officers and commanding generals of the armed services, or their representatives to assist when such assistance is required.

To legalize this request it was signed and sealed by the below-named notary public for identical execution.

The cover and final two pages (over) of the marriage contract of my maternal grandmother's maternal grandparents. Sibilla Gottschalk and Salomon Cahn.

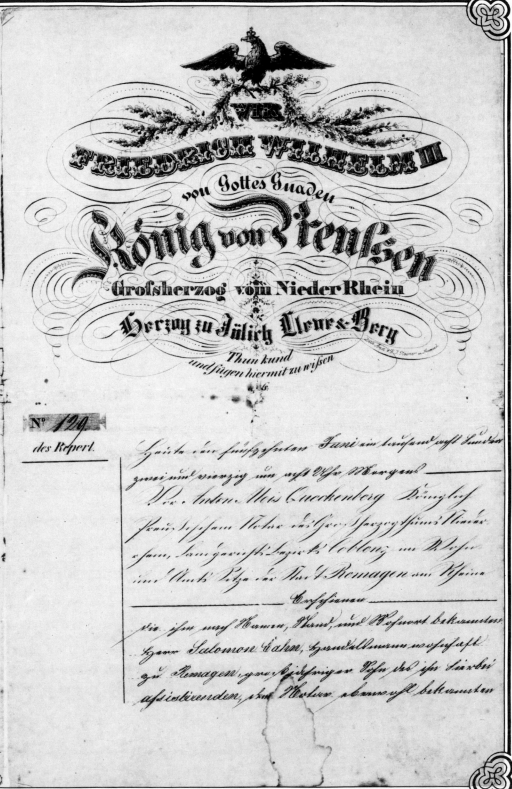

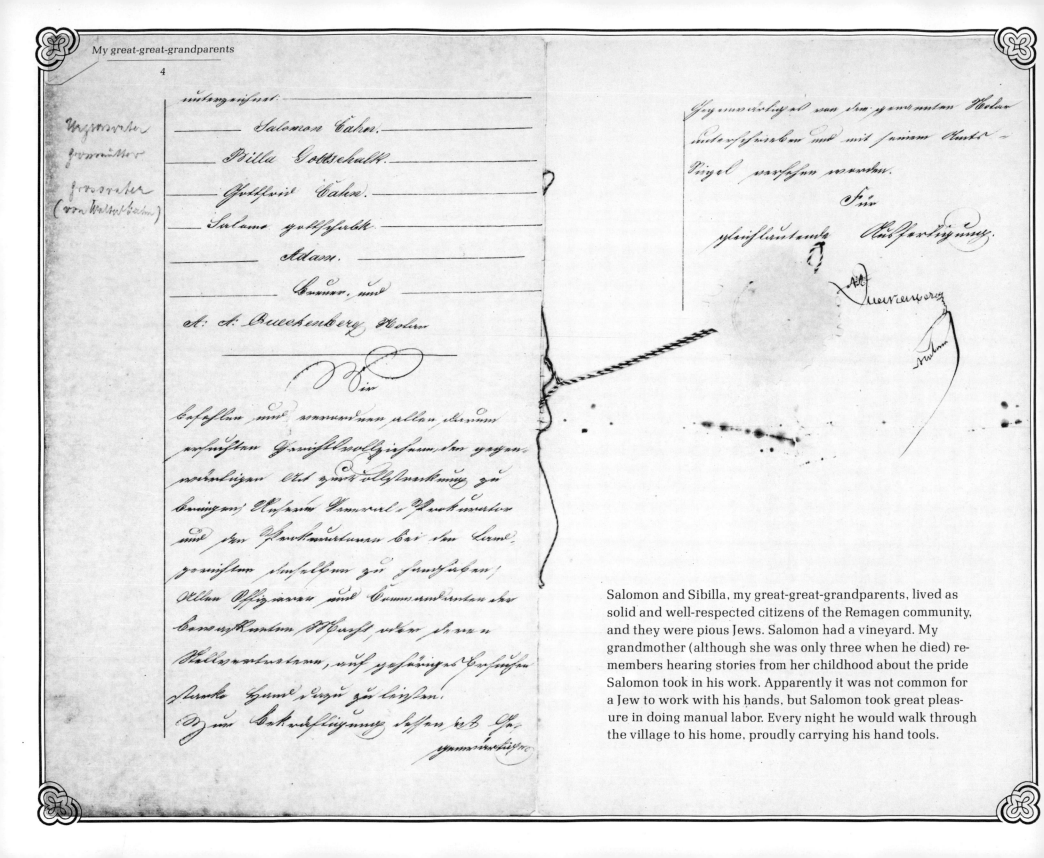

[handwritten German document in old script]

Salomon Cahen.

Billa Gottschalk.

Gottfried Cahen.

Salomo Gottschalk.

Adam.

Cremer, und

A. A. Buchenberg, Holur.

[left margin:] Urgrossvater — Grossmutter — Grossvater (von Walter Cahen)

Salomon and Sibilla, my great-great-grandparents, lived as solid and well-respected citizens of the Remagen community, and they were pious Jews. Salomon had a vineyard. My grandmother (although she was only three when he died) remembers hearing stories from her childhood about the pride Salomon took in his work. Apparently it was not common for a Jew to work with his hands, but Salomon took great pleasure in doing manual labor. Every night he would walk through the village to his home, proudly carrying his hand tools.

The Strausses

Emilie Cahn

My great-grandmother Emilie Cahn
was the fifth of Sibilla and Salomon's nine children.
Born in 1851, she spent her childhood in Remagen.
Although it was unusual for a woman in her time to leave
home before she was married, her father was ambitious
for her to better herself, and so, as a young woman,
she left the small village and went to work as a salesgirl
in a larger, neighboring town, where she met
her husband-to-be, Samuel Strauss.
This photograph was taken about a year before
she and Samuel were married.

Emilie Cahn, ca. 1873

Samuel Strauss

My great-grandfather Samuel Strauss
was also the fifth of nine children. He was born in 1847
in the Prussian town of Solingen. After the Franco-Prussian
War, in which he served as second lieutenant, he worked
first as a traveler (traveling salesman), during which time
he met Emilie, who was working in one of the stores
that he visited. After their marriage they settled in
Bochum, a flourishing coal-mining town, where Samuel
opened a store for millinery and men's wear.
He is photographed here in his field uniform:
eighth company, fifty-seventh regiment.

Samuel Strauss, 1871

My great-grandparents

Generation

 I

MARX CAHN
b. ?, Bavaria
d. 1813, Remagen
m.
Sibilla Abraham
b. ?, Breibach
d. 1848

 II

GOTTFRIED CAHN
b. 1786
d. 1856, Remagen
m. 1812
Rosetta Callman
b. 1781, Altenkirchen
d. 1869

 III

SALOMON CAHN
b. 1813
d. 1886, Remagen
m. 1842
Sibilla Gottschalk
b. 1816, Thüringen
d. 1904

V

ALFRED STRAUSS
b. 1875, Bochum
d. 1891, Bochum

HEDE STRAUSS
b. 1876, Bochum
d. 1953, Israel
m.
Arthur Gotthelf
b. 1872, Solingen
d. 1926, Remscheid

ELSE STRAUSS
b. 187?, Bochum
d. 187?, Bochum

OSKAR STRAUSS
b. 1880, Bochum
d. 1942*
m.
Agnes Zunsheim
b. 1892, Duisberg
d. 1942*

RICHARD STRAUSS
b. 1885, Bochum
d. 1942*

VI

TRUDE GOTTHELF
b. 1899, Remscheid
d. 1942*
m.
Jack Cohen
b. ?, Deventer (Holland)
d. 1942*

FRANZ GOTTHELF
b. 1903, Remscheid
d. 1973, Leominster, Mass.
m.
Ruth Wolff
b. 1916, Hamburg
— Leominster, Mass.

ULLA GOTTHELF
b. 1916, Remscheid
d. 1961, Israel
m.
Zeev Jahalom
b. ?
— Israel

WERNER STRAUSS
(Binyamin Banai)
b. 1924, Remscheid
— Israel
m.
Rosa Klejn
b. 1930, Sarain (Belgium)
— Israel

VII

Two children (One child*)

Four children

Three children

*Died in concentration camps

The Strauss Family Tree

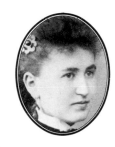

EMILIE CAHN m. 1874 SAMUEL STRAUSS
b. 1851, Remagen b. 1847, Gräfrath
d. 1935, Frankfurt d. 1922, Düsseldorf

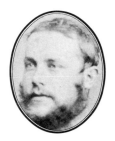

MORITZ WALLACH m. 1908 META STRAUSS
b. 1879, Geseke b. 1883, Bochum
d. 1963, Lime Rock, Conn. — Lime Rock, Conn.

FRITZ STRAUSS
b. 1890, Bochum
d. 1926, Bavaria
m.
Erna Steinhart
b. 18?
d. 19?

GRETE STRAUSS
b. 1892, Bochum
— New York City
m. 1918
Theo Loeb
b. 1888, Frankfurt
d. 1952, New York City

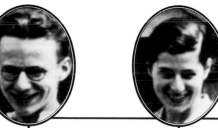

ROLF WALLACH
b. 1909, Munich
— Sherman, Conn.
m. 1933
Violet Hirschfeld
b. 1908, New York City
— Sherman, Conn.

LOTTE WALLACH
b. 1911, Munich
— Cornwall, Conn.
m. 1933
Eric Hanf
b. 1907, Mönchen-Gladbach
— Cornwall, Conn.

FRITZ WALLACH
b. 1914, Munich
— Sarasota, Fla.
m. 1943
Lucille Carey
b. 1919, Salem, Mass.
— Sarasota, Fla.

ANNELISE WALLACH
b. 1919, Munich
— Roslyn, N.Y.
m. 1943
Howard Rosenberg
b. 1912, Hamburg
— Roslyn, N.Y.

HEINZ STRAUSS
b. 1925
— New York City ?
m. ?

HAROLD LOEB
b. 1919, Frankfurt
— New York City
m. 1946
Laura Gerstle
b. ?, Munich
— New York City

KURT LOEB
b. 1922, Frankfurt
— Toronto
m. 1946
Zelda Alter
b. ?, Toronto
— Toronto

BRIGITTE HANF CATHERINE HANF Two children Two children Two children Three children

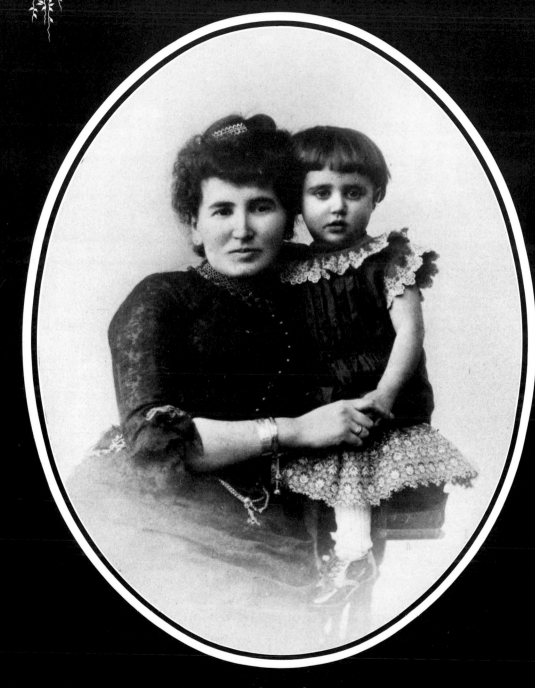

Emilie and Meta

Of Emilie and Samuel's eight children, my grandmother, Meta, was the third of four daughters; she was born on April 12, 1883. Samuel was apparently very proud of his new daughter, since he placed birth announcements in two local newspapers. In the *Märkischer Sprecher (Mark District Speaker)*, April 12, 1883 (left, top section): BIRTH ANNOUNCEMENT, "Samuel Strauss and his wife happily announce the birth of an infant daughter. Bochum, April 12, 1883." From the *Bochumer Zeitung (Bochum Times)*, Saturday, April 14, 1883 (right, top section): "The birth of a fine infant daughter is happily celebrated by Samuel Strauss and his wife. Bochum, April 12, 1883."

Meta Strauss, with her mother, Emilie, 1885

My grandmother as a two-year-old, surrounded by three of her siblings: Alfred (he died of diphtheria at fourteen), Hede, Meta, and Oskar Strauss; December 9, 1885. Meta's plump hands are to appear again and again in this book. She has "bequeathed" them to all four of her children, and they in turn to their children.

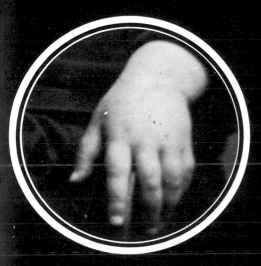

Alfred, Hede, Meta, and Oskar

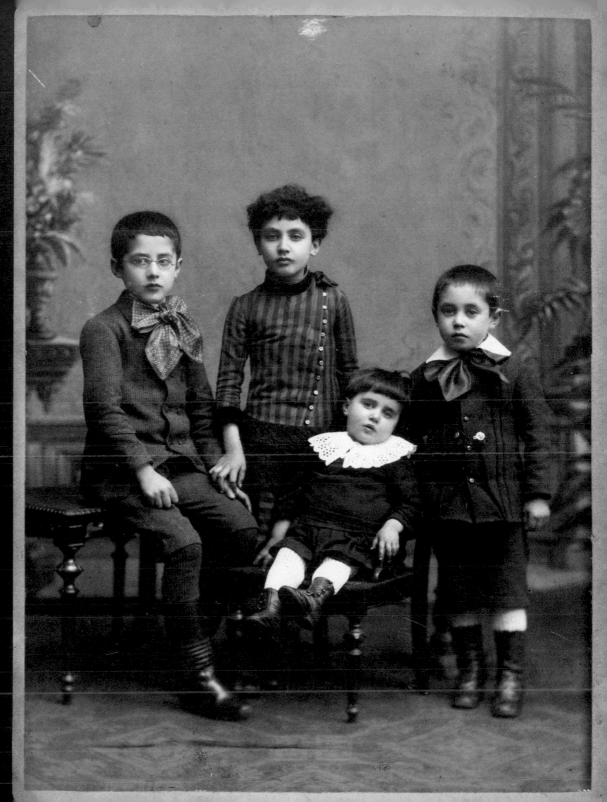

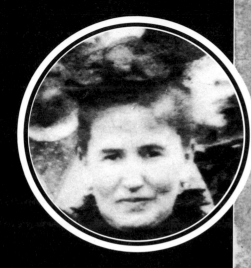

A Memento of Norderney

At Norderney, an island in the
North Sea where Emilie sometimes took
her children for a month's holiday
in the summertime.

*Front row, fourth from right: Meta as an eleven-
year-old with Emilie directly behind her;
August 26, 1894*

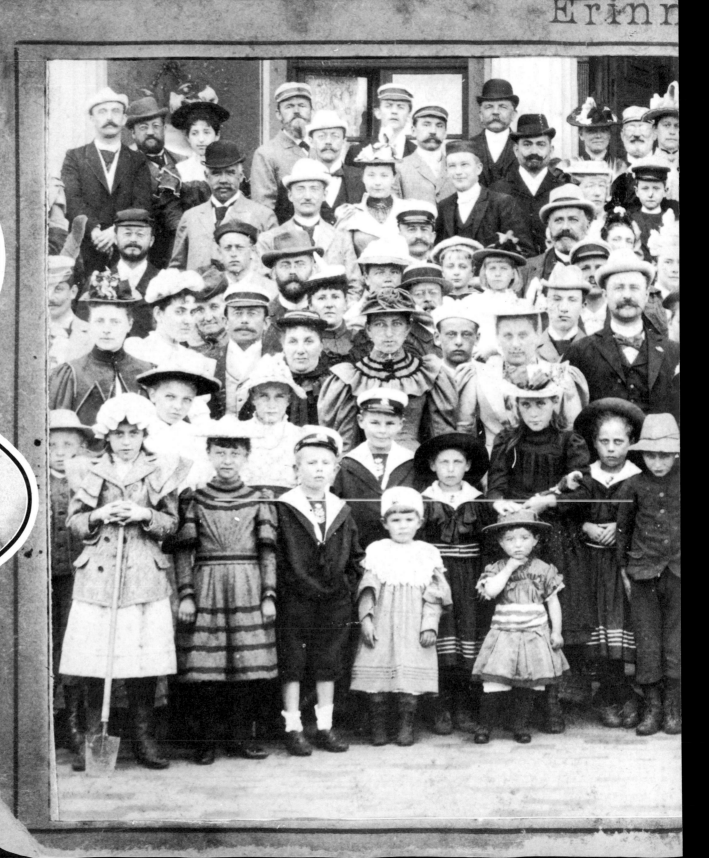

Hotovo u. Norderney

Fritz Gaertner

— 10 —

5. Rotkäppchens Reue.

Weiß nicht, mir ist ums Herz so schwer,
Als hätt' ich große Sünd' begangen;
Ich finde keine Lieder mehr,
Und mich beschleicht ein heimlich Bangen.
Gewiß, ich kann die Nacht nicht ruh'n,
Weil ich dem Spielen nachgegangen,
Ich will es auch nicht wieder thun.

Sie lockten mich auch gar so sehr,
Und ach, sie locken immer wieder;
Viel tausend Blumen ringsumher,
Dazu die lieben, süßen Lieder.
O rufet, winkt immer zu!
Gott sendet seine Engel nieder,
Daß ich es doch nicht wieder thu'.

Deklamation.

Dem Wolfe wird die Zeit gar lang,
Er dreht sich auf die and're Seite;
Zuweilen guckt er in die Weite
Und lauschet auf Rotkäppchens Gang.
Sehn wieder ist's ihm schwach im Magen,
Ach ja, ein Wolf kann viel vertragen.

Die Kleine aber ängstlich irrt
Im tiefsten Walde ganz verwirrt,
Sie findet weder Weg, noch Bahn;
Kein Himmel lacht in diese Räume.
Es schau'n sie finster drohend an
Die ries'gen, unbekannten Bäume.
Doch wie die Angst zum ärgsten steigt
Und will ihr fast das Herz erdrücken,
Da hat sich ihr der Weg gezeigt,
Sie allen Nöten zu entrücken,
Da sinkt sie betend auf die Kniee,
O treuer Gott, erhöre sie!

6. Chor der Engel.

Fürchte ich nicht, der Herr wird dich hören;
Ließest du auch in verbotenen Spiel
Dich von den lockenden Stimmen bethören,
Reuigen Kindern verzeihet er viel.
Gehet dein Weg auch durch Nacht erst zum Licht:
Rein ist dein Herz, drum fürchte dich nicht!

Fürchte dich nicht, der Herr will dich wahren,
Will dich erretten aus Dunkel und Graus,

— 11 —

Sendet die mächtigen, himmlischen Scharen,
Treu dich zu leiten zum himmlischen Haus.
Sieh' dort den Glanz, der das Dunkel durchbricht:
Gott ist dir nah', drum fürchte dich nicht!

Deklamation.

Rotkäppchen steht nach bangen Stunden
Mit Kuch'n, Wein und prächt'gem Strauß
Nun endlich vor Großmutters Haus:
„Hab' offen doch nie die Thür' gefunden! —
Schön' guten Morgen!" — Alles still.
„Weiß nicht, was das bedeuten will."
Sie geht zum Bette zagend hin,
Großmütterchen liegt still darin,
Die Haube tief in dem Gesicht,
So wunderlich und regt sich nicht.

„Großmutter, wie sind deine Ohren so groß!"
„Daß ich dich besser hören kann."
„Großmutter, wie sind deine Hände so groß!"
„Daß ich dich besser packen kann."
„Großmutter, dein Maul so entsetzlich groß."

Die Aufführung dieses Werkes ist nur gestattet, wenn die dazu erforderlichen Stimmen von der unterzeichneten Verlagshandlung erworben wurden.

Rotkäppchen.

Ein Cyklus
von neun durch Deklamation verbundenen Gesängen.

Dichtung
nach dem bekannten Märchen
von
Hermann Franke.

Für zwei Soprane und Alt
(Soli und Chöre)
mit Begleitung des Pianoforte
in Musik gesetzt
von
Franz Abt.
Op. 526.

Verlagseigentum von Johann André in Offenbach a. M.

Siehe Seite 10

LITTLE RED RIDING HOOD

*A cycle of nine songs
after the famous fairy tale
connected by speaking voice
Poetry
by
Hermann Franke
For two sopranos and Alto
(solo and choir)
with piano accompaniment
Set to music
by
Franz Abt
Opus 526*

One of my grandmother's few performances was in "Little Red Riding Hood." Samuel proudly wrote in the margins of Meta's part (the verse describes Red Riding Hood's walk through the woods): On the left-hand side, "Well and loudly delivered by our dearest Meta at the school festival, March 22, 1893, at Harmonia Hall." And on the right, "Dearest Meta wore a little ivory cashmere dress which we had bought for her in Brussels. It was tied at the wrists with red velvet ribbon; her hair was loose and held back with a red velvet ribbon. She wore black stockings and new patent leather slippers. She looked very pretty."

Postkarte.
An Fräulein
Meta
Bochum

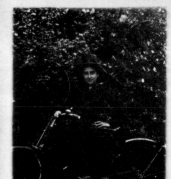

Gruss aus Bochum
sendet dir ein
stiller Verehrer.

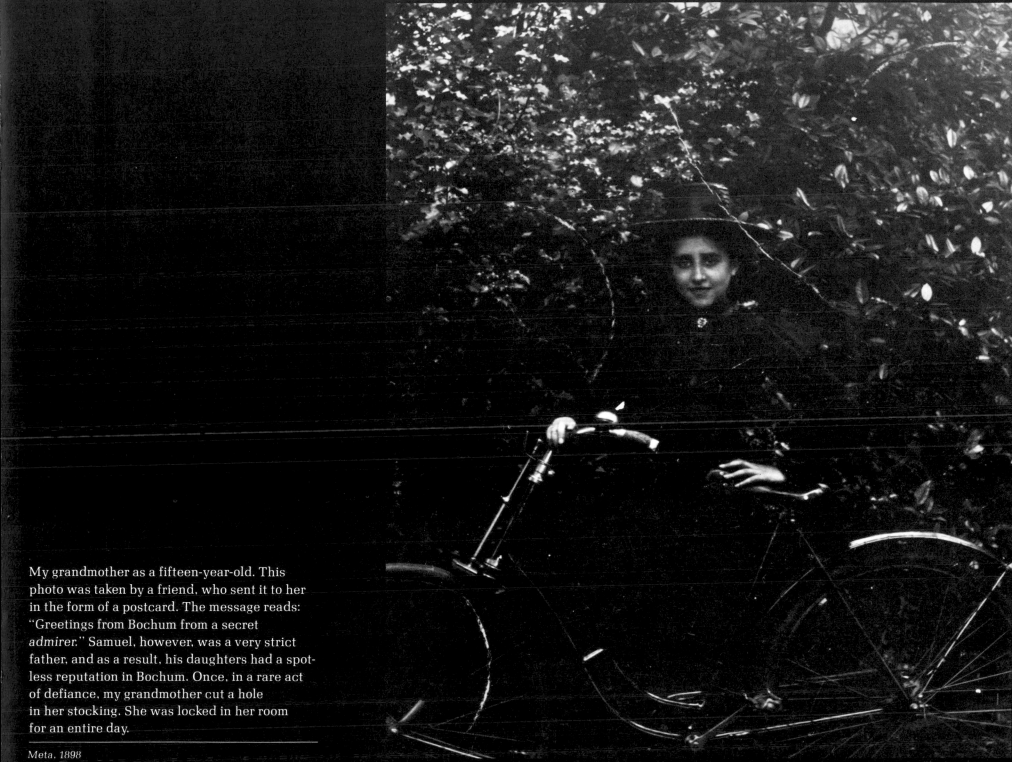

My grandmother as a fifteen-year-old. This
photo was taken by a friend, who sent it to her
in the form of a postcard. The message reads:
"Greetings from Bochum from a secret
admirer." Samuel, however, was a very strict
father, and as a result, his daughters had a spot-
less reputation in Bochum. Once, in a rare act
of defiance, my grandmother cut a hole
in her stocking. She was locked in her room
for an entire day.

Meta, 1898

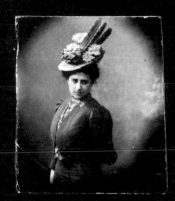

At Lausanne
and at Home

In 1899, when she was seventeen, my grand-
mother was sent to finishing school in Lausanne
because the doctors thought a change of air
would be good for her health. It was: her sister
(my great-aunt Grete) remembers her as being
very "finished" indeed when she returned. In
the picture opposite, she is on the right side of
the bench, between the two trees.

I recently asked her how she celebrated the
turn of the century (she was in Lausanne at the
time). She said she remembers wearing red,
white, and black—the colors of the German flag
—and writing a letter home to her father say-
ing: "Wir sind stolz auf unser Vaterland" (We
are proud of our fatherland).

The photos on the right are from a page in
the Strauss family album. The Strausses here,
clockwise from the top, are: Meta, ca. 1912;
Meta and a friend, ca. 1902; Grete and Fritz,
1904; Fritz, Grete, Meta, Richard, Hede, Oskar,
1904; Richard, Oskar, Fritz, 1900.

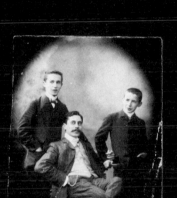

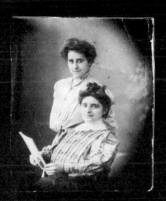

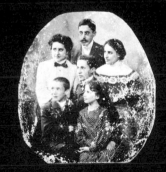

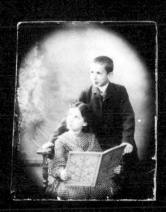

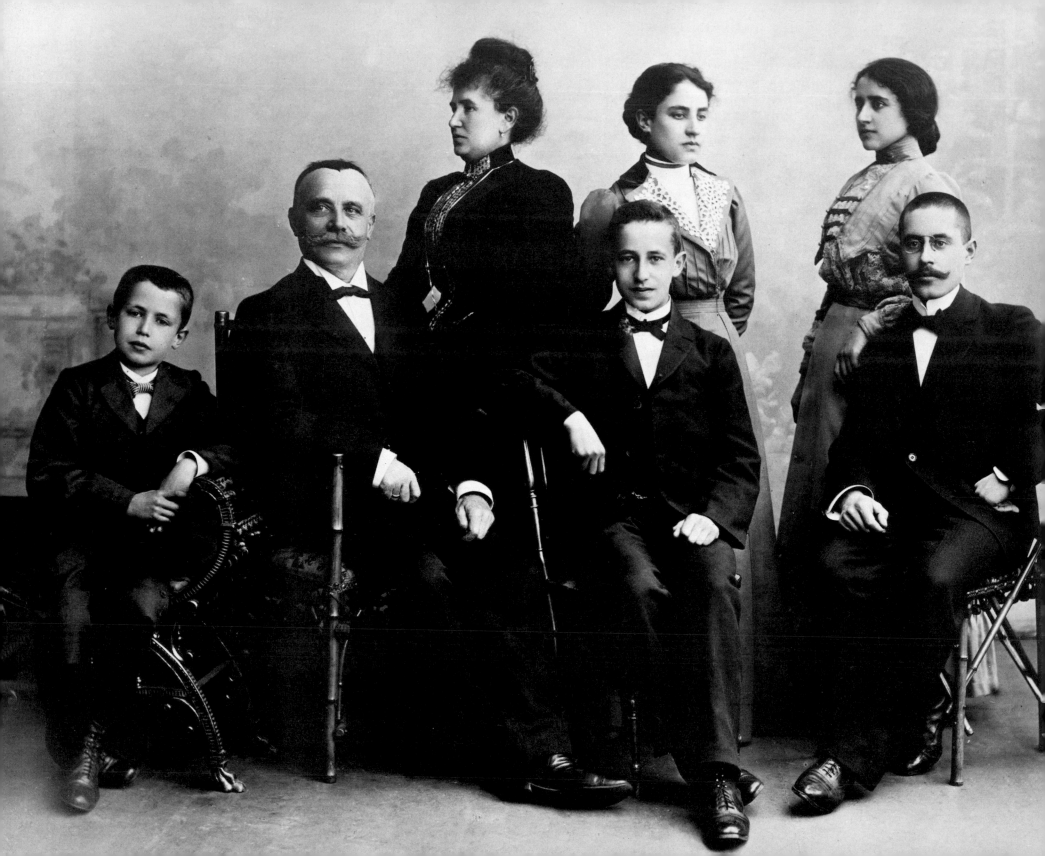

Samuel did well with his millinery store, and shortly after this photograph was taken, he retired (he was fifty-six) and moved his family from Bochum, an industrial town, to Düsseldorf, a "garden city."

Although my great-grandparents had eight children, only the six shown in this photograph lived to maturity. Alfred, born in 1875, died when he was fourteen, and a daughter, Else, died shortly after birth, sometime in the early 1870's.

Opposite, from left to right: Fritz, Samuel, Emilie, Richard, Hede, Meta, Oskar, and Grete. 1903

The same, seventeen years later, in Düsseldorf

Samuel, Emilie,
and Their Children

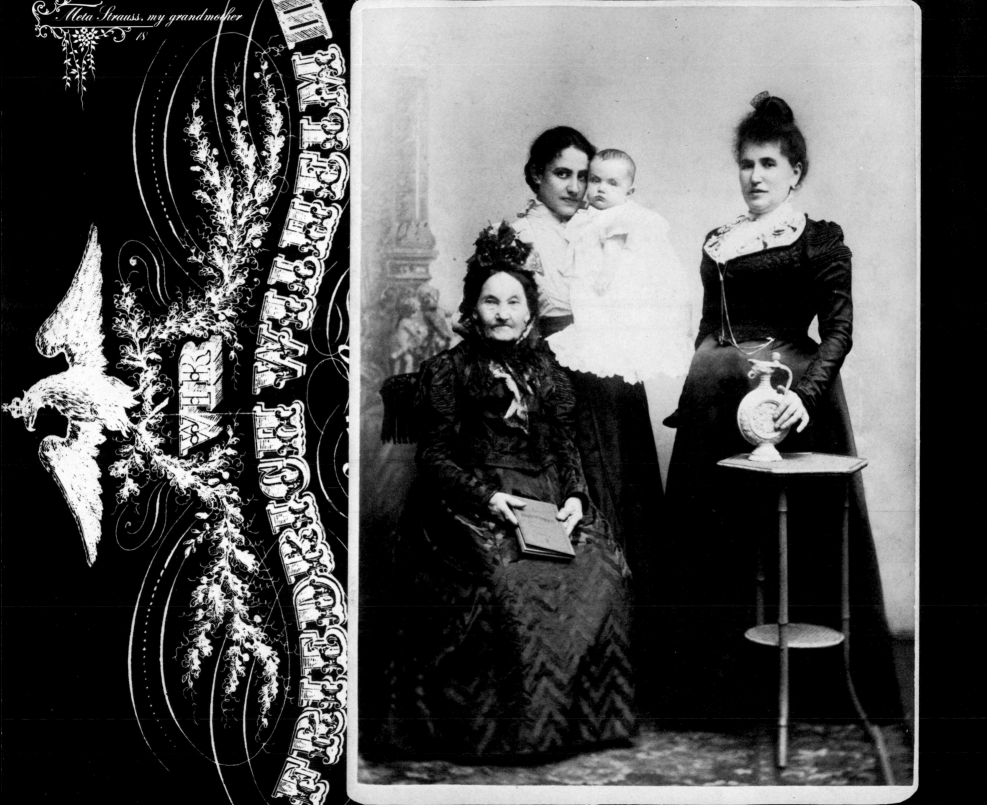

My grandmother was miserable and lonely in Düsseldorf until one night, as she sat alone at a dance, Marta Grünfeld, a gregarious twenty-year-old, took her in hand and introduced her to Düsseldorf society. Years later, Meta's daughter Lotte married Marta's son Eric—they are my parents. Here is Meta, at right, with one of her new friends.

Four Generations, 1900

My great-great-grandmother Sibilla Gottschalk Cahn, my great-grandmother Emilie Cahn Strauss, my great-aunt Hede Strauss Gotthelf, and Hede's first baby, Trude. My grandmother remembers her grandmother chiefly as a pious old lady who sat all day by the tiled oven and mumbled her prayers.

Hede, the oldest of the Strauss daughters, was also the most original, perhaps eccentric. She ran a sort of literary salon and was amazingly "liberated." She permitted her three children—Trude, Franz, and Ulla—to entertain their lovers at home, where they were sometimes served breakfast in bed by Hede herself.

Below: Hede's younger daughter, Ulla, ca. 1917

Meta and a Friend

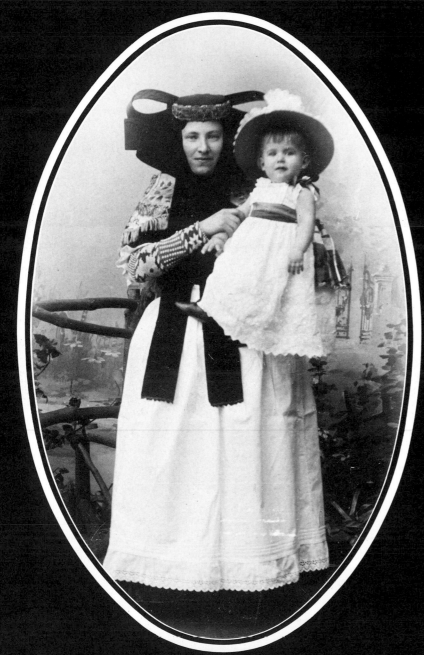

Grete and Her Wet Nurse

Grete, the youngest of the Strauss children, was born on September 20, 1892. Her wet nurse is wearing the native costume of the Bückeburg area. My grandmother still remembers with some indignation that this woman, whom they called Angel, was forced by poverty to leave her own child to nurse somebody else's. Grete is pictured with her here, around 1893.

At the fifth reunion of her class in 1915, Grete (at right, front row center) and her Rhine-maiden friends picked flowers in the fields near Düsseldorf, then took a dayboat excursion up the river.

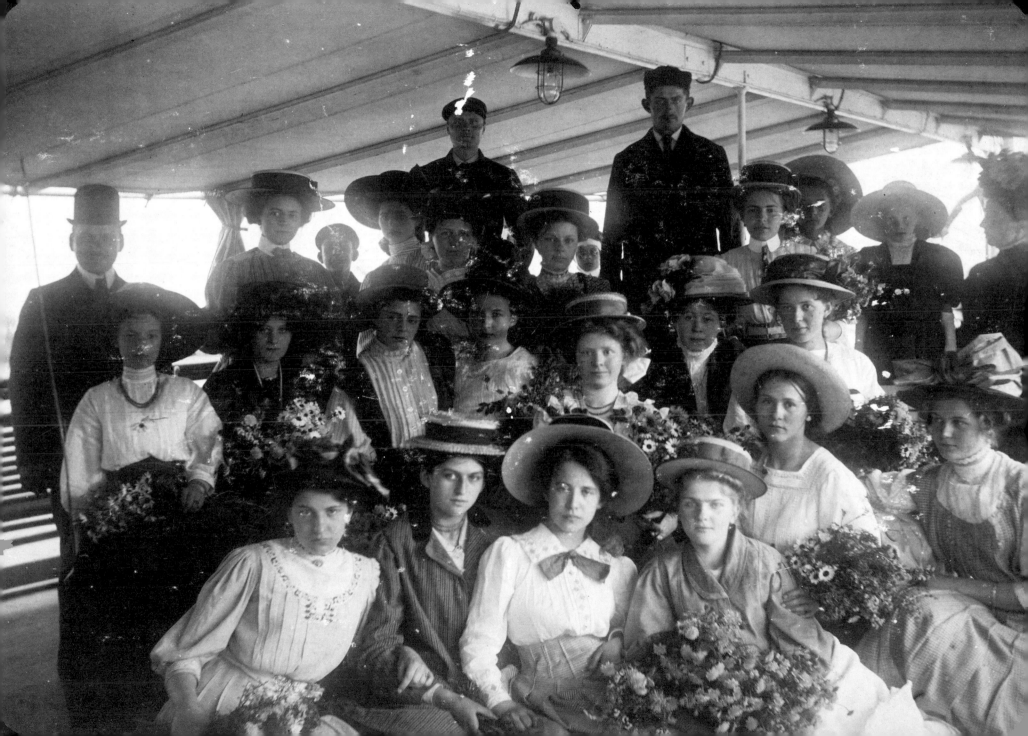

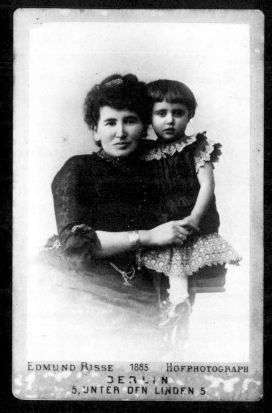

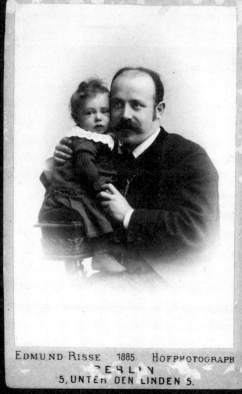

Emilie and Meta

Richard and Samuel

The four small photographs above are of a type called *cartes-de-visite*, because they were the same size as a visiting card, 4 by 2½ inches. The *carte-de-visite* was a paper print pasted on a cardboard mount (see back of mount with photographer's credentials, above). The negative-making technique that made these portraits possible was patented in France in 1854 and virtually dealt a death blow to the daguerreotype. The cards were the same size all over the world, and elaborately bound albums with cut-out openings made to hold them were introduced around 1860. The family album thus became a fixture in Victorian homes.

Grete

Above, from left to right: Emilie and Meta, 1885; Richard and Samuel, 1885; Grete with her wet nurse, ca. 1893; Fritz, ca. 1893.
Opposite: Grete, ca. 1915-18.

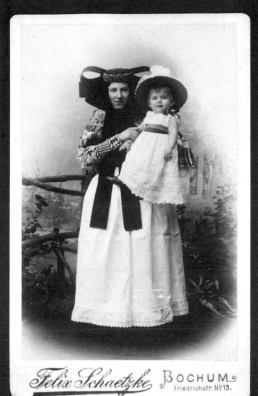

Grete and Her Wet Nurse

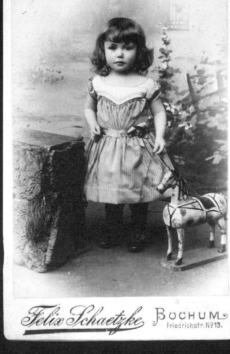

Fritz

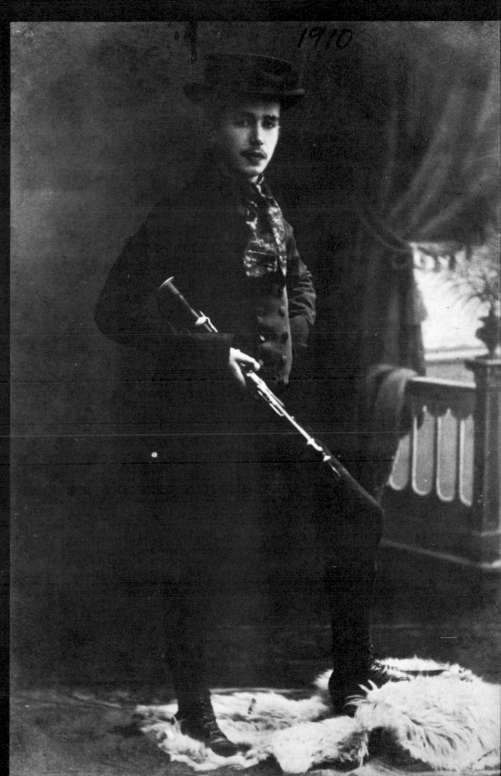

1910

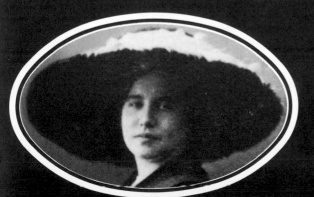

Fritz, 1910

The youngest of my great-uncles, Fritz, was born on November 5, 1890. He and Richard were both musical; between them they played the clarinet, piccolo, violin, flute, and oboe. But Samuel adamantly refused to buy them a piano. "No piano, and no chaise longue,"

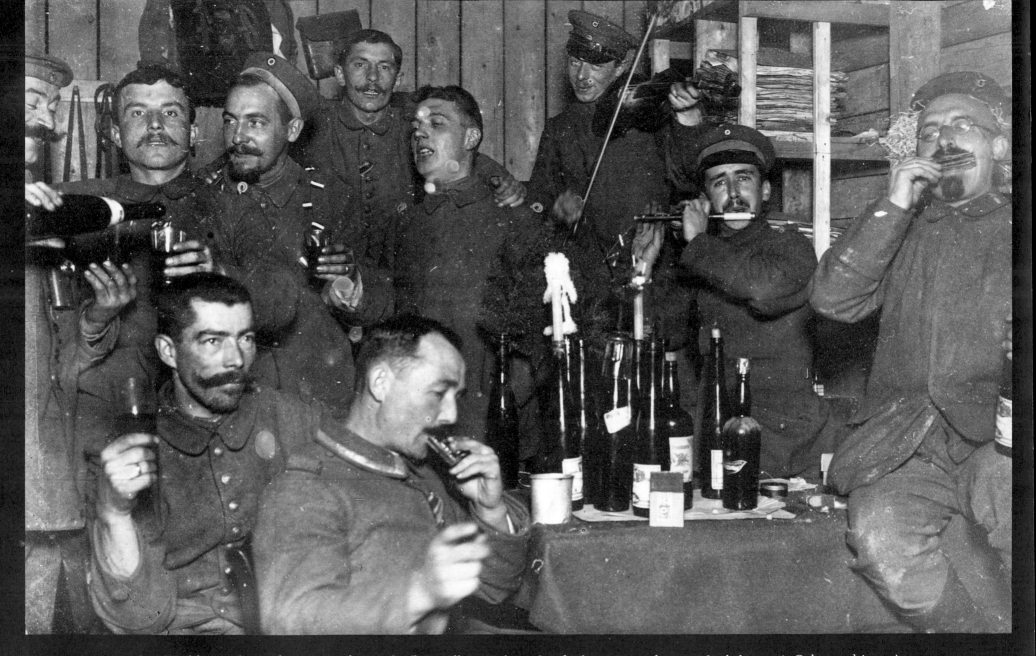

In a World War I barracks, Fritz is playing the flute. All Samuel and Emilie's sons and sons-in-law (except my grandfather, who had a kidney ailment) were in the army.

After the war, Oskar and Richard went into business, operating a hardware store in Remscheid. There Oskar met and married Agnes Zunsheim, a Wallach cousin (it was through this family that my grandparents had also met). Oskar and Agnes's only son, Werner, emigrated to Palestine in the early thirties. Richard, I'm told, was extremely timid and never married. It was perhaps because Samuel had such a dominating personality that all three of his sons were so passive. Fritz, who married Erna Steinhart and had one son, Heinz, disappeared in 1926.

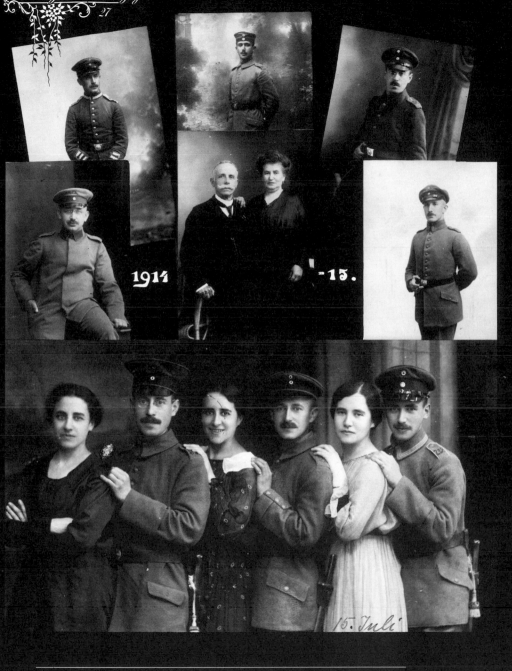

1914 -15.

15. Juli

*Top, from left to right surrounding Emilie and Samuel: Hede's husband,
Arthur Gotthelf; Richard Strauss; Fritz Strauss; Oskar Strauss; and Grete's
husband, Theo Loeb. Below: Hede, Oskar, Meta, Richard, Grete (she was to
marry Theo Loeb the following year), and Fritz.
Top right: Fritz with his mother, Emilie, September 1926,*

Alpine Zeitung

❋ **In den Bergen vermißt.** Die Landesstelle
Bayern für das alpine Rettungswesen teilt mit:
Der Kaufmann Fritz Strauß aus München,
37 Jahre alt, schlank, schmales Gesicht, brünett,
wird seit Mittwoch voriger Woche vermißt. Es
ist nicht ausgeschlossen, daß Strauß einen Aus-
flug in das Gebirge — Wetterstein, Gegend Ehr-
wald — unternommen hat und sich in jener
Gegend aufhält. Auch ein alpiner Unfall scheint
nach Lage der Dinge nicht unmöglich. Per-
sonen, die allenfalls einem Herrn, auf dem die
Beschreibung paßt, begegnet sind, werden ge-
beten, zweckdienliche Mitteilungen an die Ge-
schäftsstelle der Bergwacht Fernsprecher 58886, in
den Abendstunden 40936 gelangen zu lassen.

ALPINE NEWS

Missing in the mountains: The administrative seat of the Alpine
rescue operations announces that merchant Fritz Strauss from
Munich—37 years old, slender, thin face, brown hair—has
been missing since Wednesday of last week. The possibility has
not been excluded that Strauss has undertaken an excursion in
the mountains—on the Wetterstein, in the area of Ehrwald—
and that he is now in this area. Under the circumstances, it is
probable that he may have had an accident in the mountains.
Anyone who has seen a man fitting the above description is
requested to report to the district office of the Alpine rescue
operations; telephone number 58886; or, in the evening, tele-
phone number 40936.

For two years there was no word of him, and finally the
family, desperate, hired a clairvoyant to help find him. This
woman received a vision of bones in the snow. Not long
afterward a climbing party found the bones, which were
identified by the dental work. Fritz had climbed up into the Alps

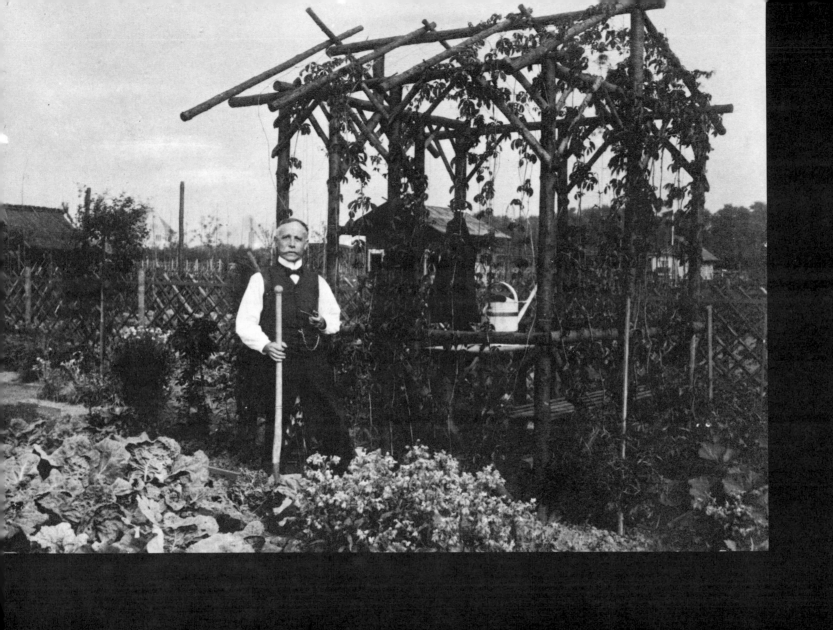

Retired and relaxed in Düsseldorf, Samuel works in his Schreber garden. (These gardens were plots of land that could be rented for a relatively low fee.) Samuel had a considerable amount of money and owned two houses; when his daughters married, each received a dowry of 25,000 marks. In 1908, when Meta married, this was worth about $100,000 in buying power. But in 1918, when Grete married, the inflation following World War I had reduced its value to almost nothing (a fact which Grete tells me her husband, Theo, never quite forgot).

Süsskind Stern is the great-great-great-great-great grandfather of my maternal grandfather, Moritz Wallach. Although much more is known about the ancestors of the Wallachs than of the Strausses, Süsskind has descendants in both families. A lot is known about him, since he was a prominent figure in seventeenth-century Frankfurt. This portrait is interesting because it is probably the oldest fully authenticated portrait in oil of a German Jew. It is marked 1671, a time when family portraits were considered sacrilegious by religious Jews. Dr. Alfred E. Laurence, an English descendant of the Stern family, writes in his *Sosatia Judaica Revisited* (Leo Baeck Institute Yearbook, Vol. XVIII, 1973): "It is extremely unlikely that Süsskind was ever known at Frankfurt to have had his portrait painted, while he was a highly respected member of the religious congregation and of a *Chewra Kadisha* [holy brotherhood]. Jews, even rabbis, were, of course, frequently painted during his lifetime in the Netherlands, where the less observant Marano Iberian immigrants were frequent sitters to the great master painters. Although the Stern portrait was obviously not painted by a recognized professional, it may have originated there during one of the sitter's business trips."

1671

The Wallachs

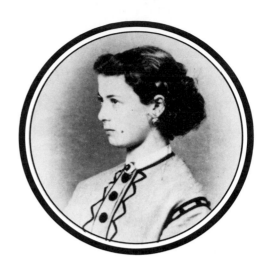

Julia Zunsheim, 1867

My great-grandparents

Julia Zunsheim, the fourth great-granddaughter of Süsskind Stern, and my grandfather's mother, was born in 1850. Here she is as a seventeen-year-old, three years before her marriage to my great-grandfather, Heinemann Wallach. She was known throughout her married life as "Mutter Julchen."

I don't know much about my great-grandfather Wallach, since he died at the age of fifty-seven, and nobody in the family today remembers him. He had a farm in Geseke, and later a wholesale grain business in Bielefeld.

My grandfather Moritz and his brothers and sisters were young children during the farm years at Geseke, and they were always warned to leave the hens alone. But once Max and Julius teased a hen that was setting, and the hen left the egg the day before it was scheduled to hatch. Max and Julius, frightened, decided that they would sit on the nest. That afternoon, their teacher came to the house to find out what had happened to the boys. As he walked by the chicken coop, he heard someone say, "I just can't do it any more, it's your turn!"

Opposite, from left to right: Ernst, Karl, Mutter Julchen with Grete on her lap, Vater Heinemann, Hugo, Else, Adolf, Betty, Julius, Moritz (my grandfather), and Max. Ca. 1890.

Julius

Max

Moritz

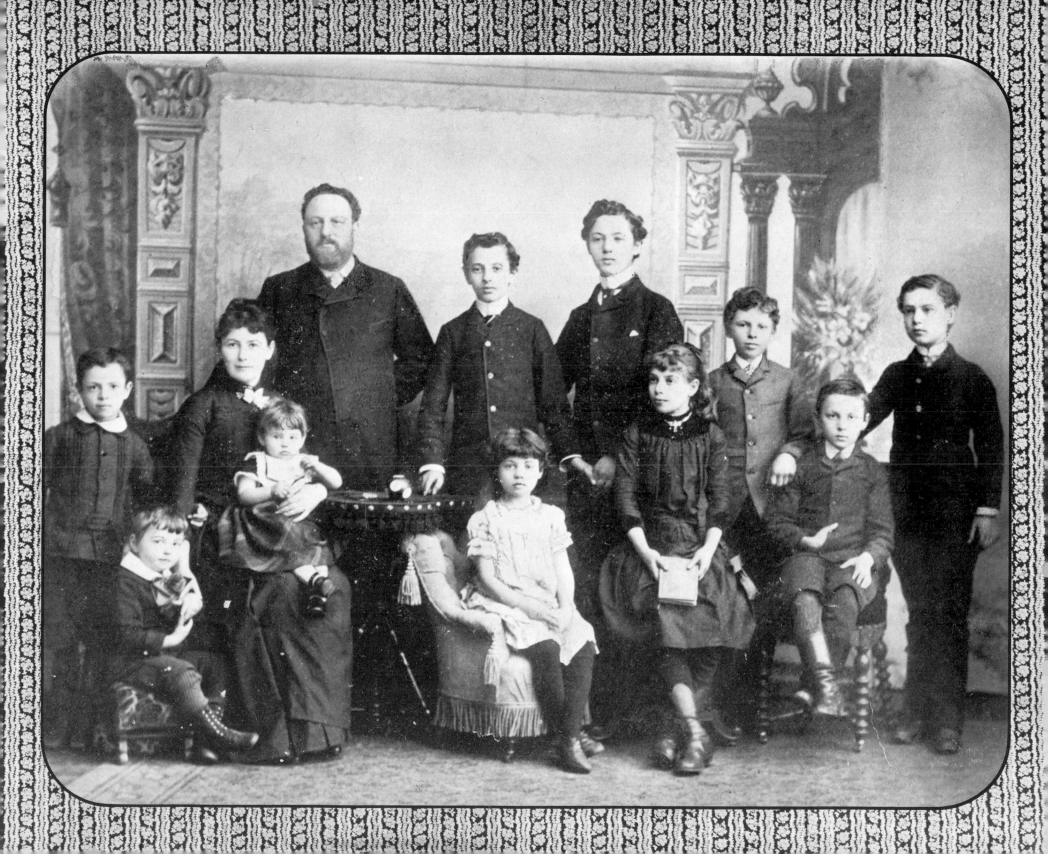

Dr. Laurence's article on Süsskind Stern continues: "His funeral inscription calls Süsskind 'Ha-Kadosch, [holy] . . . and states that 'his eyes were daily at prayer before dawn' and that his public charity was doubled by his secret alms-giving. Yet the existence of his surviving portrait proves that he must have been rather liberal-minded; it may also indicate that he belonged to the individualistic Jewish civic leaders of late feudalism of whom one is reported to have replied to a non-Jewish questioner: 'We are no princes — we control them!'

"In the Soest family's tradition Süsskind Stern was only remembered as having lived at Frankfurt between 1610 and 1687 as a 'money-changer and dealer in pearls,' and as having been the father of Jacob Stern (1650–1746), ancestor of the Soest Stern family who lived in Soest at his house Thomae-strasse 22 from the turn of the century [Jacob acquired this house around 1700, and his descendants remained its owners until a few years ago]. He [Jacob] is remembered as bearer of the title of a 'morenu' [teacher] and 'a very learned Hebraist.'

"Much more information about both men is available to-day; their burial records survive, also the words of praise on their star-decorated Frankfurt gravestones. . . . Their descent can be traced back with definite dates to the death of Meier Bingen in 1559, who was Süsskind's grandfather's grand-father and himself the son of Moses, who is recorded to have come to Mainz from Bingen in 1517. From that year, available records may lead back as far as 1349, the year of the 'Black Death' persecutions. The family's worldly success can be judged from the extant taxation records: Meier Bingen's son Salomon Haas was taxed at Frankfurt on the remarkable fortune of 10,000 Gulden; only a few years before then Ann of Cleve's impoverished brother William 'The Rich,' Duke of Cleve, had agreed to relinquish the city of Soest from most of his territorial rights in order to obtain a contribution of a mere 1,000 Gulden to his sister's dowry. Meier's grandson Samuel, Frankfurt's richest Jew, was taxed on 15,000 Gulden, and Süsskind himself was *Höchstbesteuerter* [most highly taxed] in 1660. . . .

"Contemporary Frankfurt records mention Süsskind as the ghetto's baker; the altogether thirteen men dying be-tween 1349 and 1768 listed as bakers were obviously the holders of considerable public responsibility. . . . Süsskind's main business activities were undoubtedly connected with banking and financing: the family fortunes included at his time also extensive mineral rights, for instance the revenues from the saltmines at Bad Orb. . . . Süsskind's religious activi-ty is confirmed by his membership of the *Gomle Chassidim*, one of Frankfurt's two burial fraternities — his interest in traditional learning also by the rabbinical studies and 'morenu' title of his eldest son Jacob. . . .

"Süsskind's lifespan encompassed . . . the whole Thirty Years' War, the French invasions, the Turkish wars and the siege of Vienna preceded by the expulsion of the Jews from that city. . . . His son Jacob, too, lived through very troubled times, and . . . preferring to move away from Frankfurt, he elected to take up residence in Soest . . . where his father's portrait was to remain for approximately three centuries, in a city without ghetto restrictions and feuds. . . ."

Dr. Laurence goes on to describe the activities and des-tinies of Süsskind's descendants. In Soest, Jacob managed to obtain one of the two official *Schutzjude* privileges for him-self and his family. His descendants later on succeeded also to the second. Both were held by the Sterns until the whole system was abolished at the beginning of the nineteenth century. (These *Schutzjude* privileges, contained in letters of protection — *Schutzbrief* — included articles on commercial privileges, religious rights, freedom of movement and taxa-tion; they had to be renewed regularly.)

Jacob and some of his children settled in Soest to a small-town life of cattle-dealing, money-lending, even butchering, and finally hat-making (they were the first to manufacture bowler hats in Germany). His elder son, also named Süsskind, remained at Frankfurt. This Süsskind had eight grandsons, including the Portuguese Barons de Stern. Their descendants, in turn, included various English notables, among them a Lt.

Col. Sir Albert Stern, who, as Temp. Lt. RNVR during World War I, began to develop the first tanks for Winston Churchill.

Dr. Laurence goes on to say: "When Albert Stern's tanks smashed Emperor Wilhelm's German army, no less than fifty-seven Jewish soldiers from Soest were fighting in it, among them nineteen volunteers and twenty-eight recipients of the 'Iron Cross.' This may perhaps explain why the present author, a Soest descendant, tried in vain to interest Süsskind's English descendants in the fate of the ancient family portrait before it was finally carted off in [a] junk dealer's vehicle. In April 1970, Anna Stern, spinster, a refugee in England who had returned to the old house in Soest in the early fifties, was the last to be buried there in the officially closed Jewish burial-ground . . . her mother and two of her sisters . . . had been deported to the extermination camps [near Lublin] thirty years before."

Shortly before his death in 1965, my grandfather's brother Julius Wallach wrote a privately printed chronicle of the Wallach family. Julius and his cousin, Dr. Hermann Wallach of Duisberg, had long been interested in our collective history, and collaborated in their genealogical research. Onkel Julius, as he was known to some of us, was given to both romanticism and versifying, and much of the material he and Dr. Hermann unearthed, he subsequently rewrote into poetry. This is his version of the early history of the Wallach family. (I should explain that the immediate Wallach ancestors all came from Westphalia, and it is this branch that he and Dr. Hermann attempted to trace. As Onkel Julius says, there is a gap in this lineage between 1720 and 1750, which neither he nor Dr. Hermann were able to bridge.)

"I beg to be spared the burden of proof about the antecedents of the Wallach family before 1650. For almost all my information, I am indebted to my cousin Dr. Hermann Wallach, Kings Counsel and notary at Duisberg on the Rhine. We have both searched for years, . . . and finally found some reference points from Worms, Alsfeld, Rinteln, Paderborn, and Rheda. Around 1730, at Heidelberg, one finds a Wallach studying medicine. As the now-oldest of the line, I feel it my duty to dedicate this book to the descendants of the family.

"One finds traces of the Wallisch family—later probably simplified to the name Wallach—only in the Rhineland and that area. One finds the name in Mühlhausen, Elsass, Koblenz, Köln, but despite all our endeavors, the link with Westphalia is missing.

"Around 1750, a Wallach ancestor lived at Gaukenbrink [a house] near Rheda in Westphalia, and this old gentleman is certainly of our branch.

"In the 'tradition room' of Dr. Hermann Wallach in Duisberg, the dearest of my relatives, what was left by way of furniture, pictures, writings, and drawings of our ancestors was carefully preserved. It was a sort of family-museum. None of this exists anymore, but often, in more tranquil times, the two of us sat together there with a glass of Rhine or Moselle, among the mementos of older times.

"The Zunsheims most probably came from Zons on the Rhine. Unfortunately, there was no trace of them in the records of this old town. The center of town was completely burned out in turbulent times, and only the old town walls are still standing. My grandfather Enoch Zunsheim lived in Störmede, Westphalia, a blue-dye master and merchant. I have only the faintest memory of this artist of life, he was full of humor. Of the old Wallach generation who were born between 1810 and 1820, I knew . . . my grandmother Caroline Zunsheim. She died in 1886, in the middle of her busy work. I remember her very well.

"This is the result of [Hermann Wallach's] research into the roots of the family Wallisch, Walch, Wallach, written on August 1, 1930:

"The name means stemming from Italy. The first Wallisches came after the end of the Thirty Years' War, prob-

Generation

I

SÜSSKIND SCHNEUR STERN
b. 1610
d. 1687, Frankfurt
m. ?

II

JACOB STERN-KANN
b. 1650
d. 1746, Frankfurt
m.
Jachet Loeb-Kann
b. ?
d. ?, Frankfurt

III

GUTHEL STERN-KANN
b. ?, Frankfurt
d. ?, Soest
m.
Abraham Cosman Levy
b. ?, Essen
d. ?, Soest

IV

EVA (ABRAHAM) LEVY
b. 1735
d. 1801, Soest
m.
Elias Simon Bacharach
b. 1729, Zons
d. 1798, Soest

V

GUTHEL (JULIE) MARCUS-BACHARACH
b. 1770, Soest
moved to Geseke
d. 1850, Störmede
m.
Herz Zunsheim
b. ?
d. 1818 (1823?), Störmede

VI

HENOCH (HONIG) ZUNSHEIM
b. 1815, Störmede
d. 1879, Geseke
m.
Caroline Guthrath Jacobs-Mansbacher
b. 1816, Hohenlimburg
d. 1886, Geseke

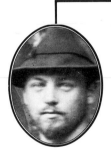

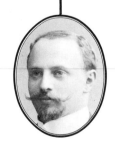

VII

ADOLF WALLACH
b. 1871, Geseke
d. 1942*
m. 1904
Greta Ruhstadt
b. ?, Alme
d. 1936, Amsterdam

HUGO WALLACH
b. 1872, Bielefeld
d. 1942, Buenos Aires
m. 1902
Martha Weinberg
b. ?, Herne
d. ?, Buenos Aires

JULIUS WALLACH
b. 1874, Bielefeld
d. 1965, Neubeuern (Germany)
m.
1 Emma Koschland (1903, div. 1926)
b. ?, Ichenhausen
d. 1942*
2 Johanna Einstein
b. ?
d. 1954, Lancaster, Pa.

MAX WALLACH
b. 1875, Geseke
d. 1942*
m. 1914
Melanie Hollander
b. ?, Darmstadt
d. 1942*

BETTY WALLACH
b. 1877, Geseke
d. 1942*
m.
1 Bernhard Rothstein (1905)
b. ?, Hungary
d. 1918, Munich
2 Hugo Epstein (1920)
b. ?, Breslau
d. 1942, Munich

The Wallach Family Tree

JULIA ZUNSHEIM
b. 1850, Geseke
d. 1938, Bielefeld

m. 1870

HEINEMANN WALLACH
b. 1842, Weidenbruck
d. 1899, Bielefeld

MORITZ WALLACH
b. 1879, Geseke
d. 1963, Lime Rock, Conn.
m. 1908
Meta Strauss
b. 1883, Bochum
— Lime Rock, Conn.

ERNST WALLACH
b. 1881, Geseke
d. 1960, Johannesburg
m.
Clara Breitbart
b. 18??
d. 1939, Johannesburg

ELSE WALLACH
b. 1883, Geseke
d. 1937, Amsterdam
m. 1906
Willy Mannheimer
b. 1878, Worms
d. 1930, Worms

KARL WALLACH
b. 1884, Geseke
d. 1970, New York City
m.
Leni Stein
b. 1894, Paderborn
d. 1975, New York City

GRETE WALLACH
b. 1888, Geseke
— Wiesbaden
m. 1913
Hermann Ohletz
b. 1888, Duisberg
d. 1956, Bielefeld

*Died in concentration camps

(continued)

ably from the University at Padua, from where they were summoned by suffering towns on the Rhine. [They were doctors, and Germany was afflicted with the Plague.]

"For some centuries this branch of the family lived in the 'house of the flowers' in Worms on the Rhine. Most probably also in other cities down to the lower Rhine. There are documents in existence confirming this; they are in the Bodleian Library at Oxford. . . .

"At the end of the eighteenth century, one branch of the Worms family moved to Paderborn. There are also traces of them in Minden, in Westphalia. Around 1750 one finds a Wallach family at Gaukenbrink, in Rheda, Westphalia. The then Duke of Bentheim, Tecklenburg, and Rheda gave permission for the construction of this house, Gaukenbrink, as a special favor to the family. My great-grandparents and grandparents were born there. Until around 1720, there were Wallachs in Minden on the Weser. The only gap in the family line occurs between the years 1720 and 1750.

"The more than thousand-year-old Jewish cemetery in Worms would be the best source for more information about the Wallachs, but the names on the stones are eroded and no longer legible. . . .

"What I know about the doctor of medicine Feibusch, called Fabian Walch, of Worms, is as follows [this was the doctor who was summoned from Padua]:

> "Perhaps it's the truth, perhaps only story,
> The tale of this man was one of glory
> A doctor, a poet, a writer full of drink
> He wrote these lines at the end of his book
> 'Finis—may it go down with ease'
> The wine of Worms was his disease
> His chronicle likewise, yellow and mildewed
> The text sometimes lively, in parts full of ire
> In part full of scarcely contained youthful fire
> So he wrote of things that surprise in the telling
> But in vain I looked for a sign of his dwelling."

Onkel Julius goes on to say (in verse) how he looked for evidence of Dr. Feibusch's house, called the "flower house," where he was supposed to have settled in Worms, but found neither the house nor any other artifacts of this man's life.

He had come to Germany from the University of Padua around 1650, traveling first by covered wagon, then by boat down the Rhine to Basel, where for months the Black Death had been taking the lives of the people. Upon his arrival, the town council greeted Dr. Feibusch with a special beaker of wine, apparently to show their gratitude (how much of this is fact, how much Julius's fantasy, there's no way of knowing).

The doctor set about his task, ordering the infected houses to be contained by rings of fire, burning the contaminated garments of both the poor and the rich, determining that the streets be cleaned and the river water boiled before drinking. As all this was done and the Plague conquered, the town showed its relief and respect by appointing Dr. Feibusch to be city health officer, a position which was to be inheritable by his children. Now, where once the winds of home had blown from the University of Padua, they now came from the University of Heidelberg.

Four generations of Wallischs became doctors until, as Julius says, "the last proud flame was snuffed, had burned itself out." The old man, the original Feibusch, was shaky, sick (apparently from drunkenness), and alone, as his children slunk nervously away. Two of them went to Oberhessen and one to Westphalia. This last was apparently our ancestor, as he settled in Paderborn. But his son did not pursue the study of medicine; he became instead a simple peasant, and his son, in turn, drove the local post horse.

Here Julius's poem ends, but he continues, in prose, to give somewhat more specific information about these, my more recent eighteenth- and nineteenth-century ancestors.

My great-great-great grandfather was Abraham Wallach. He lived in the house called Gaukenbrink (still standing as of 1965) in Rheda, Westphalia. His birth and death dates are not

known. His son, my great-great grandfather Moses Wallach, was born on June 6, 1806, in Rheda. He moved to Wiedenbrück, where he drove the post horse. In 1829 he married Bonette Weinberg from Bösingfeld, also born in 1806. She died on November 20, 1872; he on March 18, 1878. They are both buried in the cemetery in Rheda, where their stones are still standing.

My great-great-great grandmother Julie Marcus married Herz Zunsheim in 1788 (see Stern-Zunsheim family tree on p. 34). She died on May 2, 1850, at the age of eighty. (Her husband had died in 1818.) Their son, my great-great grandfather Enoch Zunsheim, was born on May 15, 1815, in Störmede. He was married on May 18, 1843, in Limburg on the Lenne to Caroline Jacob, born October 29, 1816. She died on December 14, 1886, having outlived her husband by seven years; Enoch died on July 11, 1879.

Of my great-grandparents Heinemann Wallach and Julia Zunsheim Wallach, Julius has this to say:

"My father was born in Wiedenbrück in 1842, attended primary and middle school, and when he was eighteen joined a wholesale grain business in Dortmund. At a relatively young age he was married to his beloved Julie, and they had an extraordinarily happy marriage, as one can clearly see from his quiverful of children. However, earning a livelihood was proportionately strenuous. In the small city of Geseke, he and his brothers-in-law Hermann and Moritz Zunsheim ran the produce firm of Zunsheim and Wallach. Father sang and played the piano well, and in that way bridged various worries. The two brothers-in-law took their ambitions farther afield, and father was left to run the business alone. In the year 1888 the family moved to Bielefeld. In the beginning it must have been difficult to get a foothold there, but they managed by dint of their industriousness; also by that time the children were grown and some already on their own feet. So father could finally enjoy a little peace. He enjoyed his evenings playing skat [a card game] with friends at a neighbor's house. He was never sick but unfortunately he was too

round, and that was not good for him. He was barely fifty-seven years old when he died of a heart attack.

"Our good mother was left alone with three not-yet-grown offspring. It gave us older sons great pleasure to support our marvelous mother. She came to Munich almost every year [Julius, my grandfather Moritz, and their sister Betty lived there]; she visited the Bavarian Oberland, the Konigsee, the Achensee, and even climbed to the Herzogstand with us. Our brother Karl moved to a house on the Goldstrasse in Bielefeld, where our Julchen spent her later years, rejoicing in her garden, her children and grandchildren. She remained alert and cheerful in her old age, respected, honored, and beloved. I visited her three weeks before her death. Her table was bedecked as ever and always before. For what I knew to be the last time, we sat together with a glass of Moselle, and, distressed, I journeyed back to Munich. On a sunny spring day, an April 24, we accompanied this extraordinary woman and best of mothers to her grave, in the year of evil 1938."

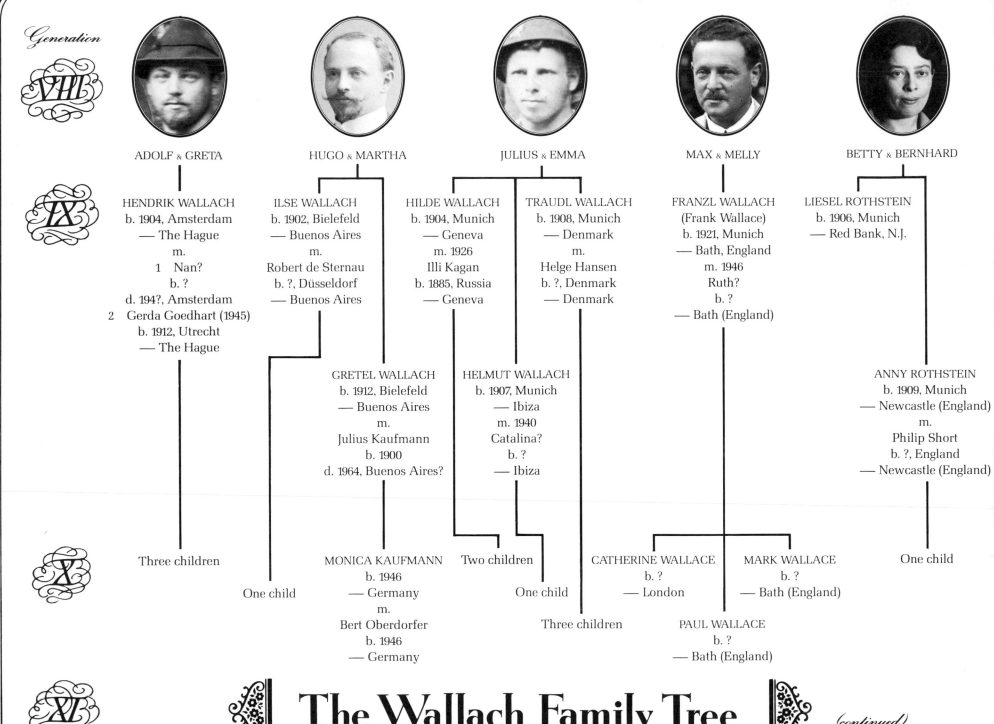

 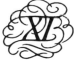

VIII

ADOLF & GRETA

HUGO & MARTHA

JULIUS & EMMA

MAX & MELLY

BETTY & BERNHARD

IX

HENDRIK WALLACH
b. 1904, Amsterdam
— The Hague
m.
1 Nan?
b. ?
d. 194?, Amsterdam
2 Gerda Goedhart (1945)
b. 1912, Utrecht
— The Hague

ILSE WALLACH
b. 1902, Bielefeld
— Buenos Aires
m.
Robert de Sternau
b. ?, Düsseldorf
— Buenos Aires

HILDE WALLACH
b. 1904, Munich
— Geneva
m. 1926
Illi Kagan
b. 1885, Russia
— Geneva

TRAUDL WALLACH
b. 1908, Munich
— Denmark
m.
Helge Hansen
b. ?, Denmark
— Denmark

FRANZL WALLACH
(Frank Wallace)
b. 1921, Munich
— Bath, England
m. 1946
Ruth?
b. ?
— Bath (England)

LIESEL ROTHSTEIN
b. 1906, Munich
— Red Bank, N.J.

GRETEL WALLACH
b. 1912, Bielefeld
— Buenos Aires
m.
Julius Kaufmann
b. 1900
d. 1964, Buenos Aires?

HELMUT WALLACH
b. 1907, Munich
— Ibiza
m. 1940
Catalina?
b. ?
— Ibiza

ANNY ROTHSTEIN
b. 1909, Munich
— Newcastle (England)
m.
Philip Short
b. ?, England
— Newcastle (England)

X

Three children

One child

MONICA KAUFMANN
b. 1946
— Germany
m.
Bert Oberdorfer
b. 1946
— Germany

Two children

One child

CATHERINE WALLACE
b. ?
— London

PAUL WALLACE
b. ?
— Bath (England)

MARK WALLACE
b. ?
— Bath (England)

Three children

One child

XI

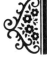 # The Wallach Family Tree *(continued)*

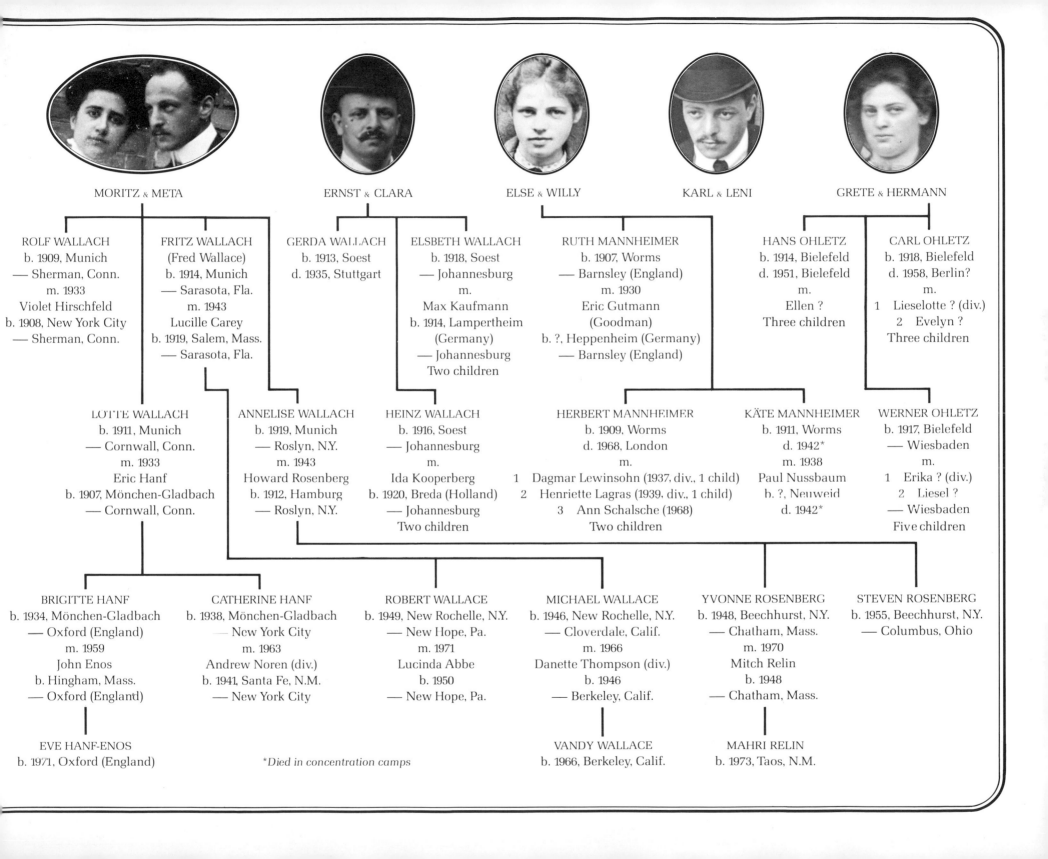

MORITZ & META ERNST & CLARA ELSE & WILLY KARL & LENI GRETE & HERMANN

ROLF WALLACH
b. 1909, Munich
— Sherman, Conn.
m. 1933
Violet Hirschfeld
b. 1908, New York City
— Sherman, Conn.

FRITZ WALLACH
(Fred Wallace)
b. 1914, Munich
— Sarasota, Fla.
m. 1943
Lucille Carey
b. 1919, Salem, Mass.
— Sarasota, Fla.

GERDA WALLACH
b. 1913, Soest
d. 1935, Stuttgart

ELSBETH WALLACH
b. 1918, Soest
— Johannesburg
m.
Max Kaufmann
b. 1914, Lampertheim
(Germany)
— Johannesburg
Two children

RUTH MANNHEIMER
b. 1907, Worms
— Barnsley (England)
m. 1930
Eric Gutmann
(Goodman)
b. ?, Heppenheim (Germany)
— Barnsley (England)

HANS OHLETZ
b. 1914, Bielefeld
d. 1951, Bielefeld
m.
Ellen ?
Three children

CARL OHLETZ
b. 1918, Bielefeld
d. 1958, Berlin?
m.
1 Lieselotte ? (div.)
2 Evelyn ?
Three children

LOTTE WALLACH
b. 1911, Munich
— Cornwall, Conn.
m. 1933
Eric Hanf
b. 1907, Mönchen-Gladbach
— Cornwall, Conn.

ANNELISE WALLACH
b. 1919, Munich
— Roslyn, N.Y.
m. 1943
Howard Rosenberg
b. 1912, Hamburg
— Roslyn, N.Y.

HEINZ WALLACH
b. 1916, Soest
— Johannesburg
m.
Ida Kooperberg
b. 1920, Breda (Holland)
— Johannesburg
Two children

HERBERT MANNHEIMER
b. 1909, Worms
d. 1968, London
m.
1 Dagmar Lewinsohn (1937, div., 1 child)
2 Henriette Lagras (1939, div., 1 child)
3 Ann Schalsche (1968)
Two children

KÄTE MANNHEIMER
b. 1911, Worms
d. 1942*
m. 1938
Paul Nussbaum
b. ?, Neuweid
d. 1942*

WERNER OHLETZ
b. 1917, Bielefeld
— Wiesbaden
m.
1 Erika ? (div.)
2 Liesel ?
— Wiesbaden
Five children

BRIGITTE HANF
b. 1934, Mönchen-Gladbach
— Oxford (England)
m. 1959
John Enos
b. Hingham, Mass.
— Oxford (England)

CATHERINE HANF
b. 1938, Mönchen-Gladbach
— New York City
m. 1963
Andrew Noren (div.)
b. 1941, Santa Fe, N.M.
— New York City

ROBERT WALLACE
b. 1949, New Rochelle, N.Y.
— New Hope, Pa.
m. 1971
Lucinda Abbe
b. 1950
— New Hope, Pa.

MICHAEL WALLACE
b. 1946, New Rochelle, N.Y.
— Cloverdale, Calif.
m. 1966
Danette Thompson (div.)
b. 1946
— Berkeley, Calif.

YVONNE ROSENBERG
b. 1948, Beechhurst, N.Y.
— Chatham, Mass.
m. 1970
Mitch Relin
b. 1948
— Chatham, Mass.

STEVEN ROSENBERG
b. 1955, Beechhurst, N.Y.
— Columbus, Ohio

EVE HANF-ENOS
b. 1971, Oxford (England)

*Died in concentration camps

VANDY WALLACE
b. 1966, Berkeley, Calif.

MAHRI RELIN
b. 1973, Taos, N.M.

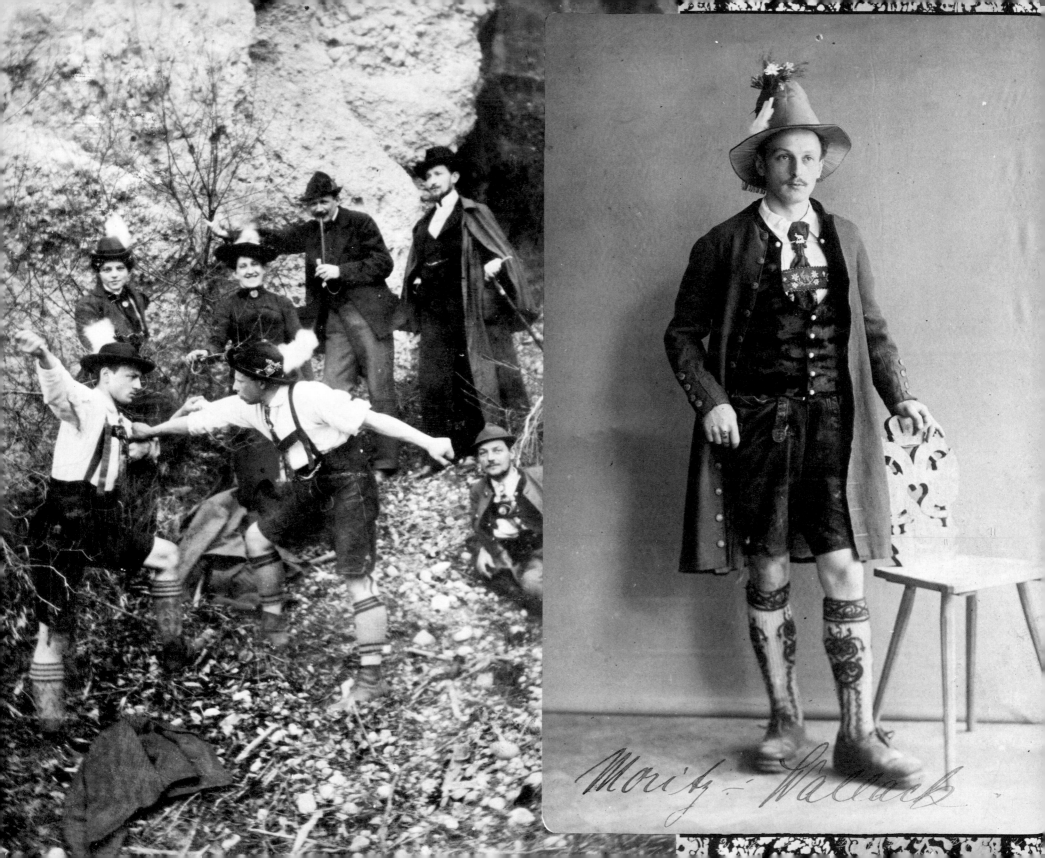

Moritz Wallach

Moritz Wallach

My grandfather, whom we called Vati, was born in 1879 and died in 1963. The thing I remember most clearly about him was his single-minded preoccupation with his work, a quality for which he was both admired and maligned. Like most of his brothers and sisters he had a large ego and a singular determination, and that combination brought him into the best of times and through the worst of times. In his earlier years, he had a sense of practical fun, always an incredible energy, and a strong affection, if short-lived attention-span, for his family. He was so impatient that it was all but impossible to have a conversation with him; those "conversations" were most often monologues about his work or about what he had planted in the garden (he was crazy about gardening). He never really learned English; he both spoke and wrote in a combination of English and German, which may have been confusing to some of the people he dealt with, but was entirely clear to him.

Vati had an unbendable and sometimes foolhardy sense of justice (see his appeal to the Reichs Board of Art, p. 149, concerning the Aryanization of his business, and the terms under which he would not consent to it, even when threatened with death). My uncle Rolf tells me a touching story concerning his sense of fairness. When he started in business at the beginning of the century, his first employee was a woman by the name of Frau Nuissl, who continued to work with him until 1938, when his business was confiscated. Frau Nuissl stayed on to work for the Nazis. Rolf believes this was one of the deepest hurts of Vati's life. After the war, when his

business was returned to my grandfather, Frau Nuissl, by then destitute and desperate, asked to see Vati, hoping that she might once again work for him. He refused ever to see her or speak to her again, but he gave her a pension for the rest of her life.

He was immodestly proud of his accomplishments, and of his enormous energy and stamina. One day during the winter of 1959, which I spent in Germany with him and Mutti, my grandmother, Vati and I were driving down the autobahn toward Kufstein, in Austria. He indicated the Alpine horizon before us, singled out every peak by name (they all looked alike to me), and told me the year or years in which he had climbed each. During that same winter (he was seventy at the time, I was twenty), he one day decided to show me Munich from above. Munich has many churches with many steeples; the one he chose to take me up was the steeple in the Peterskirche, at that time, I think, the only church tower left in the city which still did not have an elevator. We climbed hundreds of steps to the belfry, and with each step I became progressively more worried, and he progressively prouder of himself.

When he was eighty-two he had a stroke while shoveling snow. He woke up in the hospital in an oxygen tent, liberated himself from the tent, and immediately got up to call Mr. Ulrich, his assistant, to come and take him home. He subsequently had to be literally tied to his bed. After a later, second stroke, he was expelled from the hospital—I think "kicked out" is a more fitting term—because he was such an impossible patient.

On April 12, 1963, the family was gathered at my parents' home in Cornwall to celebrate Mutti's eightieth birthday. At about nine thirty that evening Vati complained of a headache, and shortly afterward he and Mutti went home to Lime Rock. Sometime during the night he lapsed into unconsciousness. The next morning, a Saturday, he was taken to the Sharon Hospital, where he died the following Tuesday without having regained consciousness.

Far left: My grandfather and Julius (right) fencing in the Alps (their sister Else is directly behind Moritz). This photo is a fair summary of their relationship: business partners for almost thirty years, they had an improbable and difficult alliance. Julius was the dreamer, the idealist, Moritz the more practical one.
Near left: My grandfather models the tracht (native costume) of the Tyrol. This photograph was probably taken around 1910, during the early days of the Volkskunsthaus Wallach.

Shortly before his death in 1963, my grandfather wrote a fifty-page memoir, the history of the Volkskunsthaus Wallach (Wallach House for Folk Art), the enterprise that occupied his entire adult life. Here, somewhat abridged, is the first installment:

THE VOLKSKUNSTHAUS WALLACH
by Moritz Wallach

Around the turn of the century, our native Westphalia was still a fruitful field for the study of folk art. The gables of many of the houses were artistically carved, heavy oak furniture mirrored the character of the population. In the market place, one saw peasant women in the attractive costume of the Bückeburg area. Around Bielefeld and Herford there were still a number of handweavers; in Wuppertal they were still making handwoven brocade and ribbons, and handtooled objects round the home spoke of the flowering of handcrafts.

At the same time, industry had destroyed much of what was traditional. Young men from the villages joined the military or went to the factories; the girls worked in the towns. Those who came back were ashamed of the traditional costumes. The demand for costume material and ribbons decreased, and it was no longer profitable to manufacture them.

Coming from a family that had been settled here for centuries, my brother Julius and I were interested in the beauty of our area. We saw a possibility to keep these irreplaceable traditions and to revitalize them. My brother had gone to Munich in 1895, and I followed him in March of 1899. We became members of a club for the maintenance of folk tradition and costume.

With a few pieces of native apparel, I went to see the heads of the German-Austrian Alpine clubs in Stuttgart, Karlsruhe, Cologne and Hannover. From them I received the addresses of firms that catered to festivals. We arranged exhibitions in the market places of various towns in Upper Bavaria. Besides the spectators, we also met artisans who were of great importance for the future of the enterprise we were planning. There were pantsmakers in Tolz and Holzkirchen, women who could make the bodices of the native costumes of the Inntal, handweavers and embroiderers. By late 1900, my brother Julius had started a small store for native costumes in the suburb of Sendlinger in Munich. I continued in my métier as window decorator, and helped my brother build up his enterprise, until, in 1905, its continued existence seemed assured. Then we moved our business to the Petersberg, opposite the Peterskirche. From the upper-storey windows the passers-by were greeted by hand-carved lifesize figures wearing the native costumes of Upper Bavaria, Lower Bavaria, and the Tyrol. We started to research the various

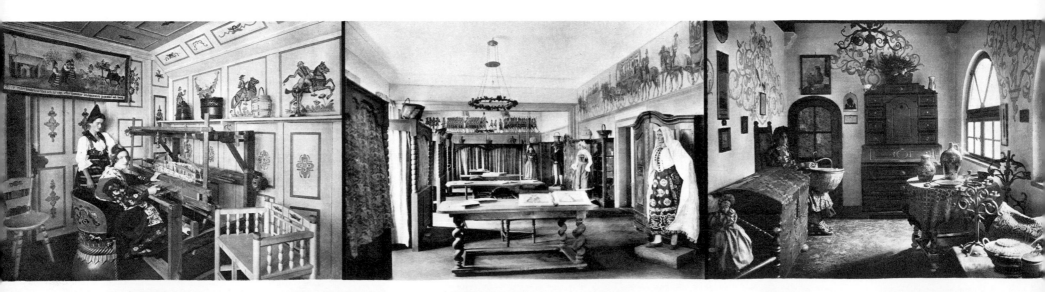

areas of Germany and Austria thoroughly, bought original costumes, and ordered material from artisans in the Bavarian forest and Franconia so we could make copies. Although people generally were pleased by our work, it was not financially profitable; therefore we had to look for ways to use these costumes.

The proprietors of most of the firms we approached were not interested in what we had to show, and we were almost desperate over the lack of interest, when suddenly, in the square around Freiburg Cathedral, we saw a woman showing pottery. We spoke with her; she was Frau Maria Lang, and we suggested that she make a typical Black Forest store out of her little shop. We offered to help her furnish it, and she accepted. Her enterprise was soon widely known. It still exists today, run by her daughter. Other firms in Freiburg, when they saw how her shop had succeeded, asked us to work with them, too. Julius went to Sweden and Norway, and brought back original costumes from there, while I went to Galicia and Poland for the same purpose.

In 1908, we moved our outfit to the Dienerstrasse, on the corner of the Landschaftsstrasse. In this long, narrow store we built small cubicles the better to show our work. We started working with the theaters. Soon we had orders for costumes for operas, operettas, and plays, which had to look as authentic as possible. We outfitted the chorus for the spinning-room scene of *The Flying Dutchman*; also *Zar and*

Zimmermann, Carmen, Grafin Maritza, Gypsy Baron, and many others.

In 1906, Julius brought back a native costume from Brixental in the Tyrol, and it occurred to me that one could fashion a becoming, modernized version that could be worn in town. So the first dirndl dress was created, and it soon became popular. Princess Joachim of Prussia ordered the first dirndl made of silk, to wear at a festival in Paris; the dress caused such a stir that Parisian fashion designers became aware of our existence. Our first visitor from Paris was Paul Poiret. He gave us an order for handwoven brocades, and a large order for handprinted materials for which he had made the designs. Later we worked with Madame Lanvin, Rodier, and when I went to Paris I established connections with several other houses.

In 1911, the centennial of the Oktoberfest was to be a great celebration. We were commissioned to do part of the parade in period costumes circa 1811. In 1912, I was voted president of a major Bavarian exhibit of arts and crafts, and at this show we ourselves exhibited and were also represented by many of our customers who were also exhibitors.

In 1913, on my spring business trip, I arrived at Leipzig in the middle of the trade fair, and as I walked through the streets, I realized that this fair would be a good place for us to exhibit. I rented space for the following fall in a shop in the Peterstrasse.

The Volkskunsthaus Wallach, 1920

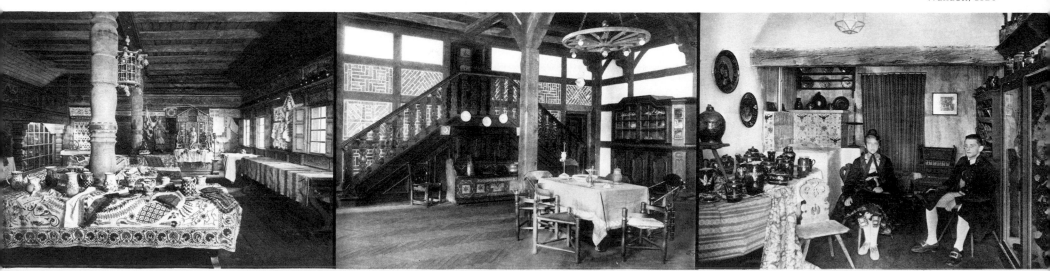

The first time was a failure. Nobody interested in textiles came to the Leipzig Fair. Its main exhibits were household gadgets, office machines, ceramics, and so on. In spite of my brother's objections, I made samples, and engaged crafts-women who used our fabrics to dress dolls, line baskets, and make bags and pocketbooks. At the second try in Leipzig we met our expenses; and later, when I was able to rent space in a better location, we finally enjoyed real success there. I was instrumental in getting other firms interested in the fair, among them the Arts and Crafts Organization in Munich. At any rate, I can claim that, together with Madame Dangotte of Brussels, I started the textile department of the Leipzig Fair.

In December 1913, the Royal Theater in Munich arranged a benefit costume show with national dances. We displayed the native costumes of Upper and Lower Bavaria, Dachau, Swabia, the Black Forest, Mecklenburg, Mähren, Hungary, the Beskiden-and-Tatrag area, Rumania, Croatia, Galicia and Poland, Montenegro, Italy, Sardinia, Sicily, and Spain; also three different regions of France—Brittany, Normandy, and Arles—as well as Sweden and Norway.

The national dances were performed by the Ballet of the National Theater. The affair was an enormous success; the court asked to have it repeated. Soon afterward, the court of Saxony gave us a commission for curtains and tablecloths for their hunting lodges in Eulen- and Riesengebirge. Hostels in Münster, Soest, Düsseldorf and Cologne ordered too, as did hotels, for instance, the hotel Vierjahreszeiten in Hamburg and the Louisenhof in Hannover. Breweries were also among our customers—Schultheiss in Berlin, Dinkelacker in Stutt-gart, Weihenstephan, the Hofbräuhaus in Munich, as well as Thomasbräu, Löwenbräu and several others. Our enterprise flourished until 1914.

Prince Ludwig, later King Ludwig, was one of our visitors. I remember a funny incident: When Ludwig was planning to visit the Pfalz area after he became king, the mayor's wife of the town of Germersheim came to rent costumes in which to receive him. The young ladies of the town, who were to give him flowers, would wear the costumes. As far as we knew, this part of the country had never had any native costumes. But we assumed that the king was not as well informed as we were, so we gave the mayor's wife jackets and scarves belong-ing to the only native costumes ever worn in the region. But the king knew better; he told her that as far as he knew those costumes had never been worn in that particular neighbor-hood, and asked where she had found them. She had to admit blushingly that she had rented them from Wallach's. "That's my neighbor," the king said, "and you can give us these things and I'll take them back to him." So the rented pieces of clothing were returned to us with a polite letter from the court.

A performance of *Carmen* was planned for the Rhenish festival in Cologne. We were commissioned to make the cos-tumes as authentic as possible. Julius traveled to Spain with references from the Bavarian court to the court in Madrid, to buy the costumes in the right place. This reference from the Bavarian court opened up all sorts of opportunities to him, and he came back with magnificent results. [In Madrid, Julius went to a bullfight—then later bought the costumes directly off the bullfighters' backs.] The Cologne newspaper wrote: "The costumes made by the firm of Wallach in Munich were most effective in their colorful harmony, the warm and south-erly tones full of color and authenticity. The choice of mate-rials was made after thorough research in the original locale."

I was asked by the Chamber of Commerce of Nürnberg to undertake a trip through the Bavarian forest and Thüringen to find out whether one could not help the weavers in these districts. Some of them worked for Saxonian industries at wages equivalent to those paid for mechanical manufacturing, and that amounted to less than 7 pfennigs an hour. I saw to it that from then on those people used heavier yarn and designs that were more suitable for handmade materials. I arranged for a special exhibit at Peter's in Cologne, at Wertheim in Berlin, and various other places. Thanks to this effort the weavers were actually able to earn up to 55 pfennigs an hour.

Adolf
and Greta

Hugo
and Martha

Adolf, the oldest of the ten Wallach siblings, with his wife, born Greta Ruhstatt. He was the only one of the ten to leave Germany voluntarily; Julius, in his biography, implies that Adolf left because of the anti-Semitism he encountered in the military. He moved to Amsterdam in 1891, where he manufactured handkerchiefs. He and Greta had one son, Hendrik, who, now in his seventies, still lives in The Hague.

It was sort of a family joke that the Wallachs "owned" the cities in which they lived. For instance, whenever anyone went to visit Adolf, they visited "Adolf's" Amsterdam. The visitor would be blindfolded, taken to the Rijksmuseum, and led to Rembrandt's *Night Watch*. Lo! the blindfold would be removed, the visitor confronted with "Adolf's" *Night Watch*! This, my mother remembers with amusement, was not such an uplifting experience, since the painting, not yet restored, was "more or less a blob of black."

On the right, Hugo, the second of the Wallach brothers, appears with his bride, Martha, on their wedding day, September 14, 1902.

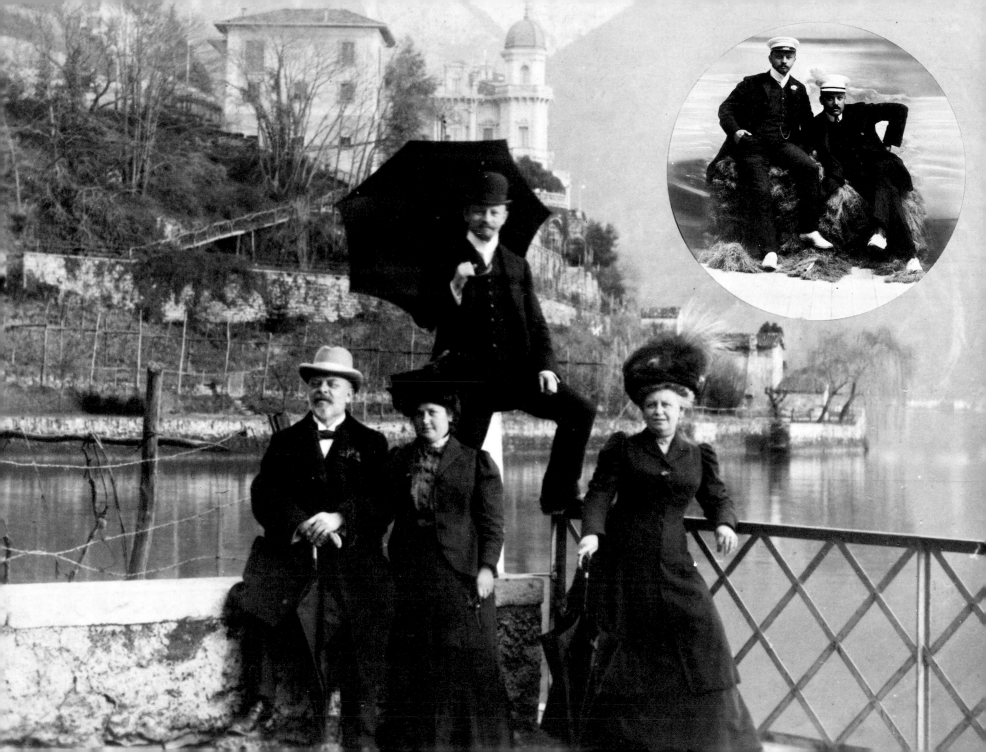

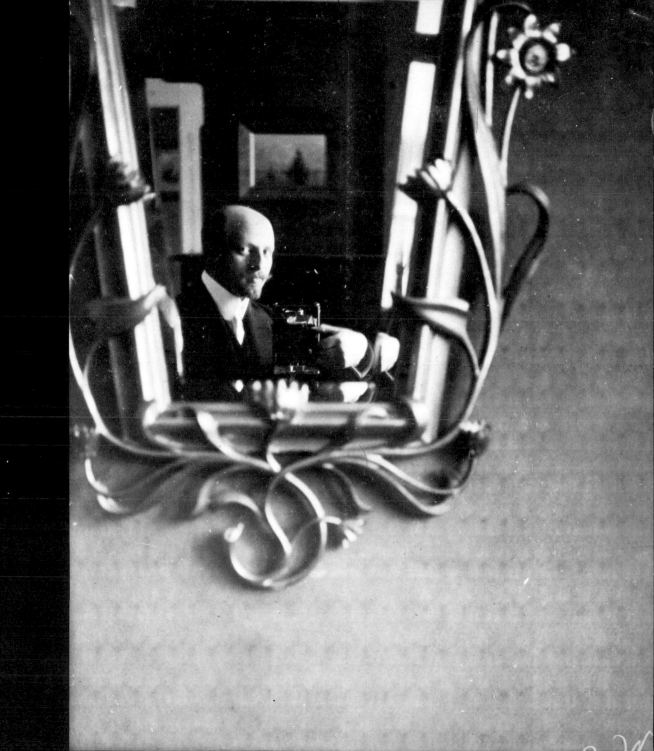

When Heinemann died in 1899, Hugo took over his father's wholesale grain business, in partnership with his youngest brother Karl and his brother-in-law Hermann Ohletz. Here he is, in the circle, with his brother Ernst in 1908. And on a rainy day in Lugano he holds the umbrella for Martha (center) and two unidentified friends.

Hugo shared the family passion for photography, as can be seen from his self-portrait on the right, carefully dated "August 21, 1910."

Ilse

Gretel

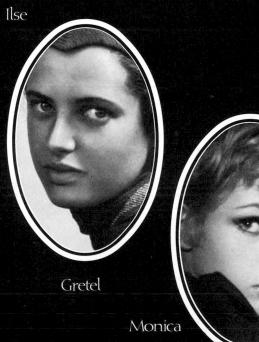

Monica

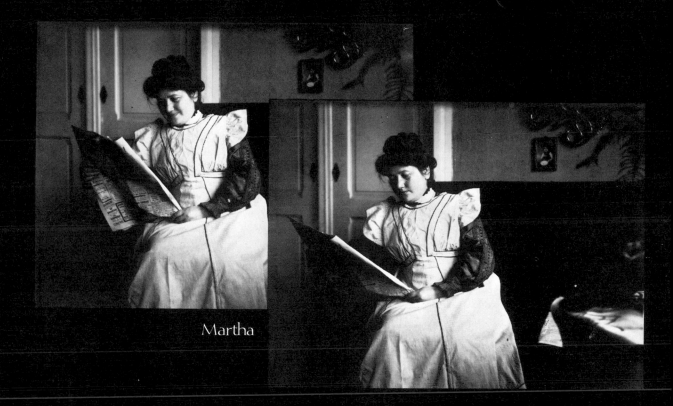

Martha

Hugo and Martha had two daughters, Ilse and Gretel. Hugo, inordinately proud of them, had their portrait painted. It was a life-sized portrait, and he hung it in the place of honor over the couch. One day his brother Max came to visit. Hugo opened the door and proudly showed him the portrait. Max looked at it in silence for a while, then finally said, "With turpentine, you could take it off." From that time on, relations between the two brothers were slightly strained.

Ilse studied dance at the Mary Wigman School (Mary Wigman was Germany's answer to Isadora Duncan), and Gretel became a writer. Driven from Germany by Hitler, the family scattered to Ibiza, where they were caught in the crossfire of the Spanish Civil War. They finally reached Argentina, where Hugo died in 1942. Ilse and Gretel still live in Buenos Aires; Gretel's daughter Monica Kaufmann went back to Germany, where she works today as an actress in films.

Far left: Ilse, 1909. Ovals: Gretel, 1930, and Gretel's daughter, Monica, 1970. Top right: Hugo's wife, Martha, 1909. Bottom right: Ilse and her cousin Liesel, Betty's daughter, and Liesel, November 30, 1909.

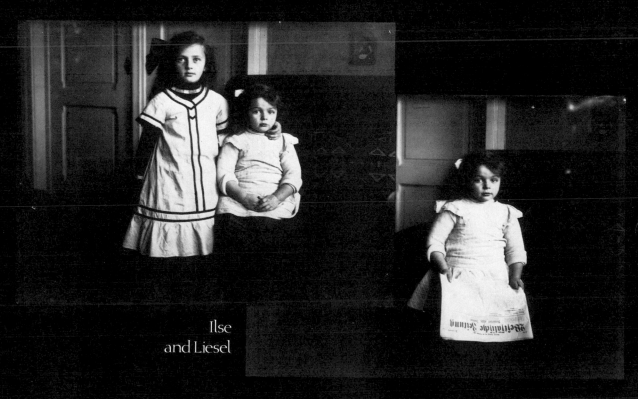

Ilse
and Liesel

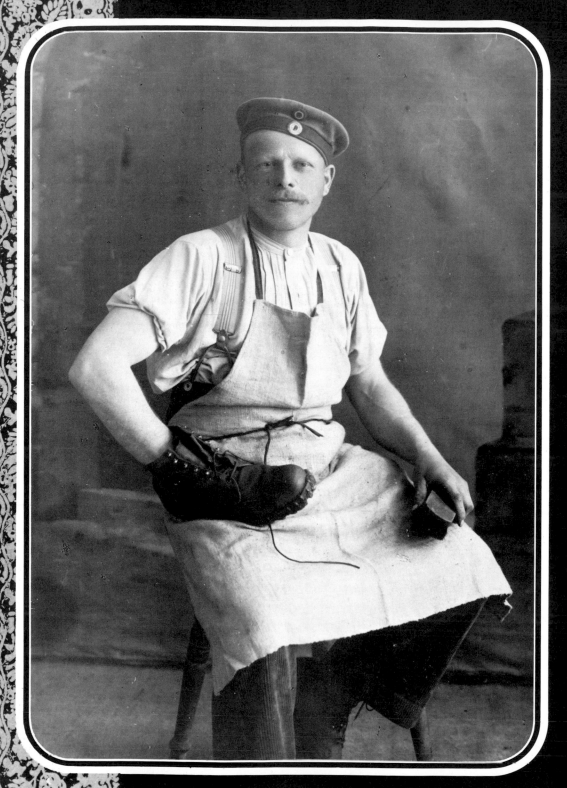

Julius

There is some dispute about this photograph of Julius.
Although he is wearing military fatigues, my grandmother
insists that it's not a military photograph. She recalls that
Julius put on this costume to recite a poem at her wedding to
Moritz in 1908. The poem is lost, but her memory of it
includes some tomfoolery with a pair of drumsticks landing
in the whipped cream—a source of great hilarity to the
earthy Wallachs, and of great embarrassment to the genteel
Strausses.

Julius and my grandfather were in business together until
1926 (see the story of the Volkskunsthaus Wallach, p. 103). In
1926, Julius "retired," that is, he started another business of
his own. He was the only one of the Wallachs to return to
Germany permanently after the war, where he settled in the
small Bavarian town of Neubeurn. At the age of ninety, he
wrote a biography of the Wallach family, which he had pri-
vately printed, and which has been a source of much of my
own information.

During the late 1950's, Julius's daughter Hilde and her
husband had a summer house in Woodstock, New York.
Julius, then in his eighties, had been spending the summer
with them. The house was built on a slope, and halfway
down was a sort of landing—and here Julius declared that
there should be a rock garden. Hilde said, "No, we don't want
a rock garden." Julius insisted. So one night, when everybody
was asleep, Julius went out, found a rock, and built a rock
garden around it. The rock was so huge that it took six men to
remove it after he left.

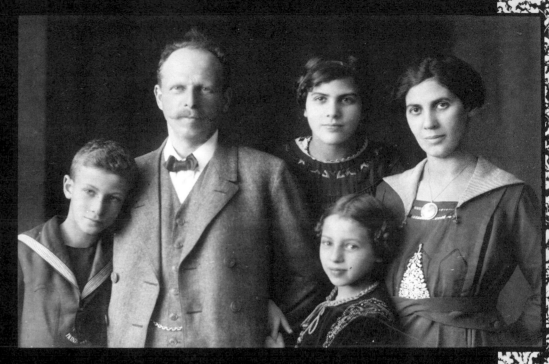

Julius, his wife, Emma Koschland, and their three children. Julius and Emma were subsequently divorced, and much later Julius was remarried— to his childhood sweetheart, Johanna Einstein.

From left to right: Helmut, Julius, Hilde, Traudl, and Emma, 1919.

Julius died in 1965, at the age of ninety-one. He always swore that the secret of longevity was woolen socks. Hilde describes his last performance: "We notified Traudl who came with Helge [Traudl's husband], and luckily Julius still recognized them and myself....He wished us luck for the future and talked very solemnly, we were all very touched. Then suddenly he yodeled like a very young chap, thanked us for everything we had done for him, and fell back into sleep."

Left: Julius. ca. 1960

Max was a turbine engineer in the Merchant Marine who
helped lay the transoceanic cable to Shanghai. He then lived
in China for ten years, working for a Danish firm in Hankow.
There he had a trotting horse and a houseboat, which he had
towed up the Yangtze Kiang to its source. Returning to
Europe on home leave, he traveled across Russia on the
trans-Siberian railroad. For ten more years he worked as an
engineer in Uruguay and Paraguay, until Mutter Julchen
begged him to return to Europe. Upon his return, around
1919, he helped my grandfather and Julius set up their new
printing factory in Dachau. Max married Melanie Hollander
(hereafter known as Melly), and they had one son, Franzl.

My uncle Rolf (my mother's brother) remembers his uncle
Max: "Max was very careful not to be caught short about
anything. He had an automobile with a self-starter—self-
starters were new at the time; people were still using cranks.
One time Max got all excited; he couldn't find his crank. And
I looked under the seat of the car and I said, 'There it is,' and
he said, 'No, that's the reserve crank.' "

When Max became technical director of the new factory
at Dachau, they first got a makeshift water wheel going. Max

Opposite. top right: Max and his wife. Melly. Lower right: Max in China.

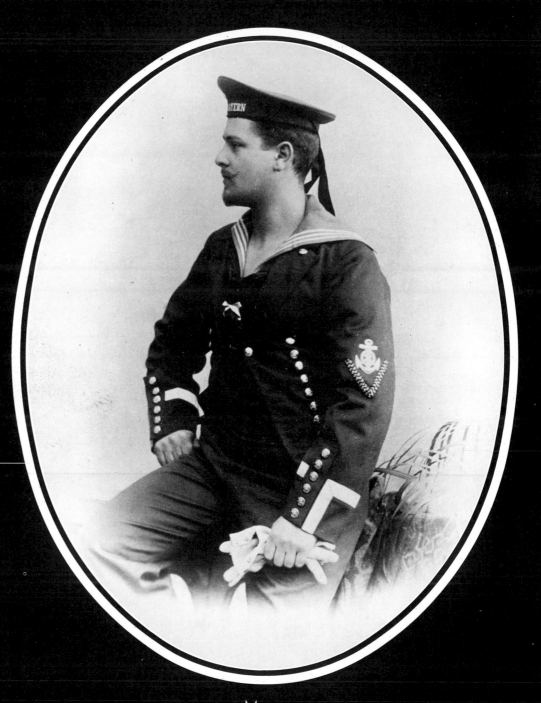

Max

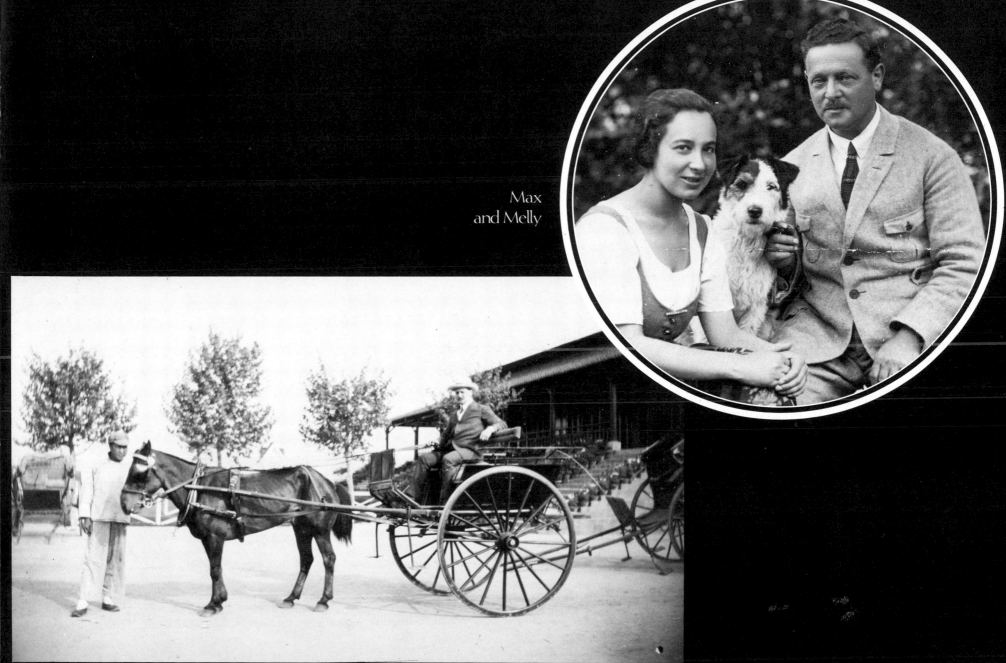

Max
and Melly

then decided to exchange the water wheel for an old turbine he had acquired somewhere. When everything was functioning fairly well, he decided that the turbine was really no good, and that if it broke down, the factory would be without power. So he went to Hamburg and bought a ship's steam engine, for 250–300 marks, and had it shipped to Dachau (at a cost of about 1000 marks). He built a little shed and installed the steam engine, to take over if the turbine should break down. That process took about two years. Then he said, "Now if the turbine is out and the steam engine doesn't function, we'll need something to back them up." So he went back to Hamburg and got a diesel engine; then went through the same process: it was installed, and everything was fine. Next he said that it was ridiculous to work with such an old, inefficient diesel, he wanted a new turbine— which would cost something like 40,000 marks. There were many sessions about it, and he grew more and more insistent. So finally he bought the new turbine, but decided it would not be economical to run the steam engine or the diesel motor for such a long time while the new turbine was being installed (a process of three or four months); it would be much better to cut into the city power lines, which he did. The factory ran on city power for those three or four months until the turbine was installed. When the bills came in, my grandfather figured out that for what had been spent on the first turbine, the steam engine, the diesel engine, and the new turbine, they could have run the factory on city power for approximately 386 years. Max was furious.

Franzl, 1925

Franzl, Catherine, Mark, 1974

As Rolf remembers, Max's son Franzl was just as mechanically minded as his father: "He [Franzl] could tell different kinds of cars, not by looking at them, but by the sound of their motors. We would test him, and he would turn around and say, 'That was an Opel, that was a Ford...' So Violet [Rolf's wife] wanted to test him—so when the next car came by (it was an Opel), and Franzl said, 'That was an Opel,' Violet said, 'Aha, this time you're wrong, it was a Ford.' Franzl didn't say anything for a while; 'Are you sure?' 'Yes, it was a Ford.' We talked about other things; then, ten minutes later, Franzl said, 'If that was a Ford, then they put an Opel engine in it!'"

Franzl was sent to England with a children's transport when he was fifteen. Today he's a professor of mathematics at the University of Bath, and has three children of his own: Catherine, a doctor; Paul, a medical student; and Mark, aged nine.

Ernst, at far left, guards World War I prisoners of war (probably Russian): Christmas, 1914. He was the seventh of the Wallach siblings. His children, Heinz and Elsbeth, emigrated to South Africa, and in 1938, Ernst and his wife, Clara

Breitbarth, followed. He worked in a tobacco-import house in Johannesburg until he was killed in an auto accident in 1960. In 1975, Ernst's grandson Charles became a rabbi, the first in the family in 350 years.

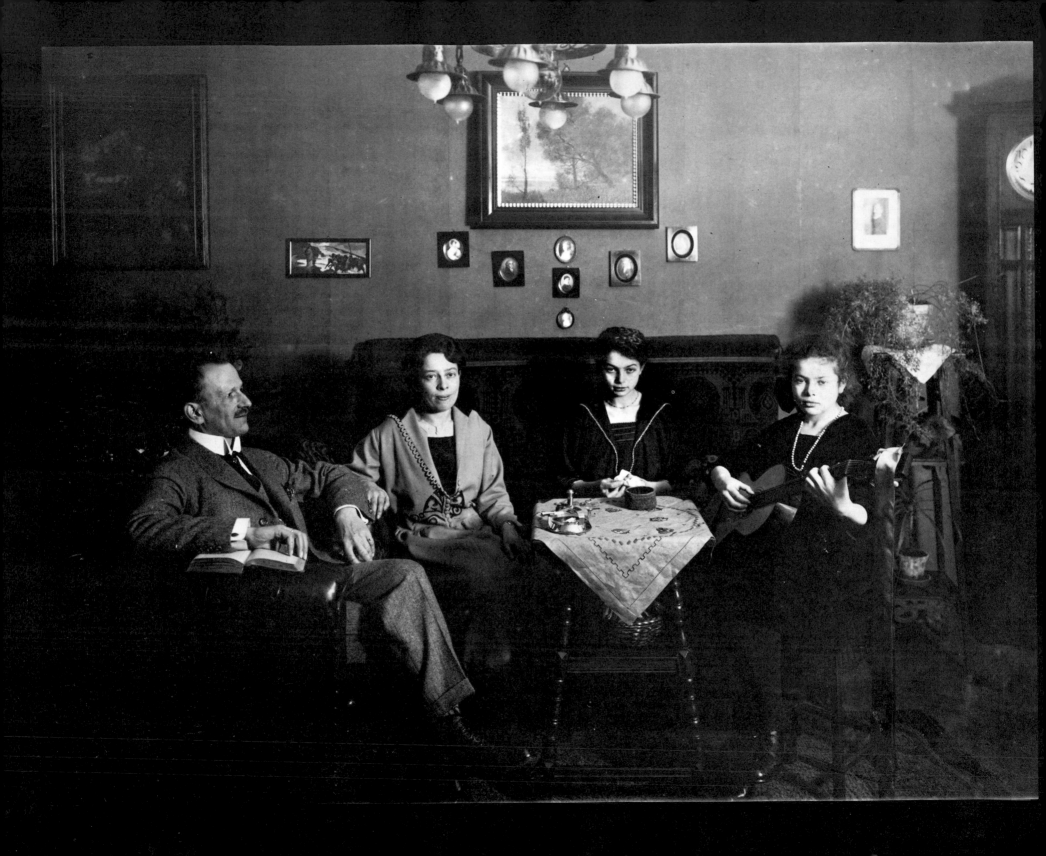

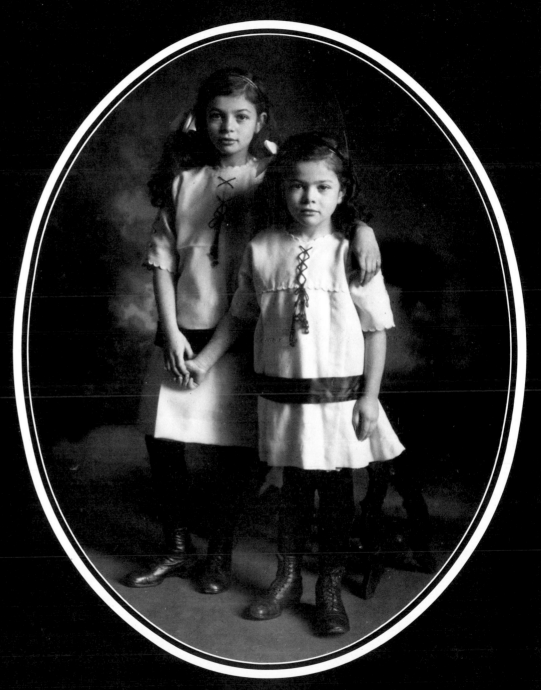

Liesel and Anny, 1914

Betty with her two children, Liesel and Anny, and her second husband, Hugo Epstein. Her first husband, and the father of her children, was Bernhard Rothstein, who died. During the late thirties, Anny was able to get to England, sponsored by an anonymous donor. Liesel came to the United States, but Betty and Hugo never got out of Germany. Liesel did everything humanly possible to save them (see letters on pp. 154-7), but all her efforts were fruitless.

Opposite, from left to right: Hugo Epstein, Betty Wallach Rothstein Epstein, Liesel and Anny Rothstein.

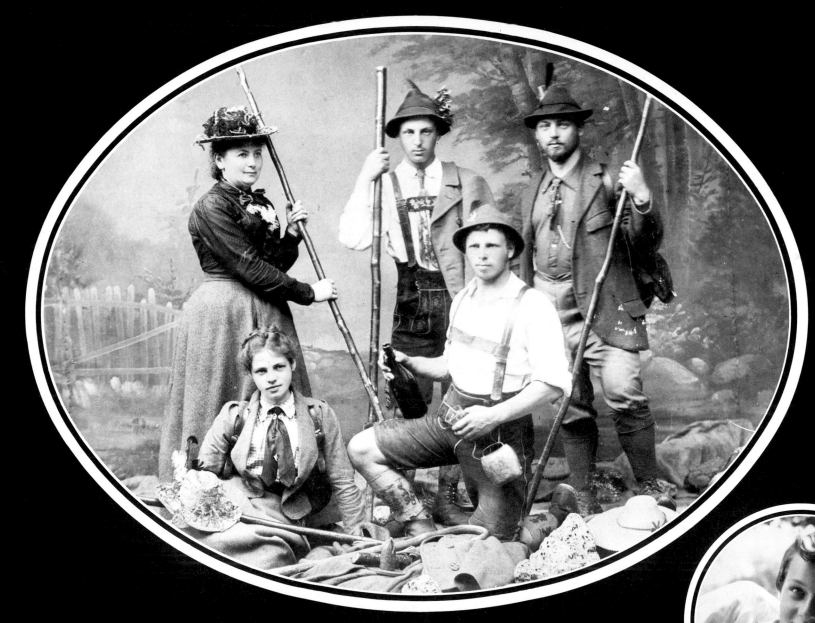

Else and Mutter Julchen,
Moritz, Julius, and Adolf

I include this photograph
of myself, aged sixteen, near that
of Else, for obvious reasons.

In his biography of the Wallachs, Julius describes his sister Else: "My sister Else— Elsken—whom I loved so much: she was always my type. In spite of all the misunderstandings in her marriage, she remained cheerful and patient. Those lovely hours we spent playing dominoes, or sharing a little drop, with white cheese or fresh nuts . . . From our mother she had her love of gardening and flowers. Both artlessly and naturally she wrote almost all his Schlaraffia 'scribblings' for her sweet Willy. [The Schlaraffia is a fraternal and cultural organization, named for a Breughel painting, to which many of the men in the family belonged.] As a young girl in Bielefeld she was always surrounded by admirers, no wonder, she was endowed with so many talents. Elsken died much too young—she was hardly fifty-four— during a visit to our brother Adolf in Amsterdam. She was deeply mourned by all those who knew her."

Near left: Catherine Hanf, 1955.

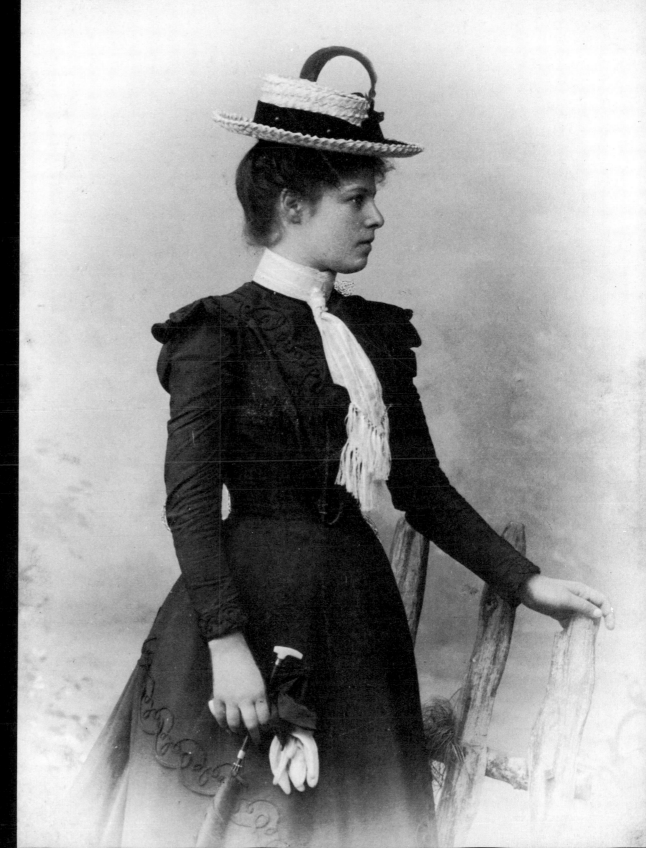

Else as a Young Girl

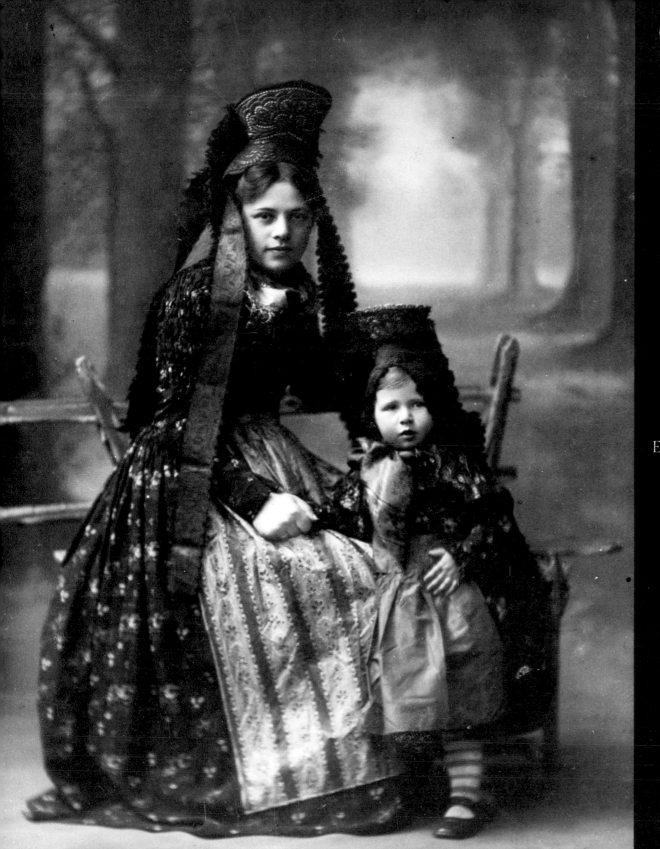

Else and Ruth

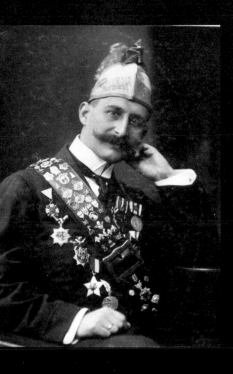

In one way or another everybody in the family was at some time or another involved with Moritz and Julius's enterprise. At the far left, Else and her daughter Ruth model the *tracht* of the Schwarzwald. Ruth is also the baby in the oval, with the message "Aren't I a little brat?" written across the pedestal.

Above, Willy Mannheimer is in his regalia as "Schlaraffe," and at right are Else and Willy's three children, Ruth, Herbert, and Käte Mannheimer, ca. 1918.

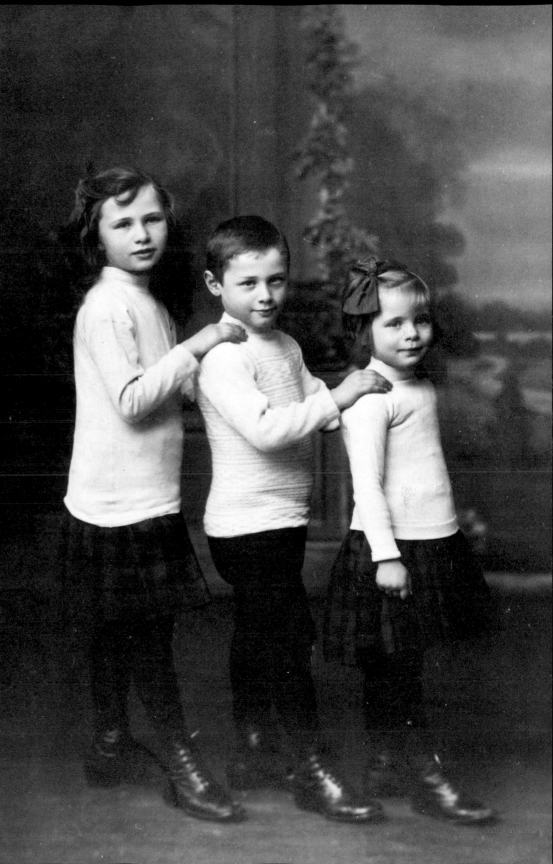

Ruth, Herbert, and Käte

I received this letter from Ruth, one of the many replies I got to my requests for photographs and information.

<div align="right">

Barnsley, Yorks
December 17th. 73

</div>

Dear Catherine,

I was highly pleased to receive your airmail letter and the enclosures yesterday. I did know of your endeavour, the exhibition in New York, and that you attempt to write this wonderful book about [our] families. This summer we spend some time in Germany with friends of my husband, and as it was not far from Wiesbaden, we were several times at aunt Grete [Ohletz, the youngest of my grandfather's nine brothers and sisters, and the only one still living]. She showed me a letter from you and the booklet [catalogue of the exhibit] as well. I told her then, if she liked, she could give you my address as well. By the way aunt is very well, she writes to me almost every week, and her handwriting is incredible, she will be 86 in January. In one of her last letters she said, if she keeps well enough, she might fly over in spring to visit us. You see we only recently moved into this bungalow, and we love it. When I have written to you, I must see whether I find the box with all my photos, and whether there is any I could send. Most of the recent ones are in colour and no good to you. If you have any to spare after you have finished with them, I mean photos you got of your Grandmother, may I have them please? We have lost almost all our possession, coming over here late, it was July 1939, and our luggage and belongings were stored in the Free port of Hamburg, but we never got anything, a little compensation after the war, that was all. I have acquired a few photos, but would love to have some more. Of course I know about you all, as I am very interested in the family and write to almost everybody in their turns — Uncle Julius, you might have known him? [I didn't] He told me once how much you were like my late mother, any recent photo of you? My mother was wonderful, a real good mother and friend, full of interests of all sorts, I wish I had inherited half of it. But then again their life was a more or less normal one, and

we had to work to contribute to the cost of living, having emigrated with no assets. But I am not grumbling. We have managed nicely and feel quite happy in our retirement, since just four years. My mother Ella called Else was born Feb. 9, 1883, and married my father Willy Mannheimer from Worms, born 30.11.1878, on Dec. 6, 1906. My father was a leather merchant, very talented in making occasional poems for different occasions, very witty, belonging to the Schlaraffia, a lodge. I think quite a few of the family belonged to the same lodge. My parents had three children:

<div align="center">

Lotte Ruth Mannheimer born	*5.10.1907*
Herbert Mannheimer	*9 Sept. 1909*
Katharina (Käte) Mannheimer	*25.4.1911*

</div>

Ruth: went 12 years to school, worked as a secretary in a private hospital, got married 10.7.1930 to Eric Goodman (Gutmann from Heppenheim near Worms). He worked at his father's fruit wholesale business, trained as a teacher in physical education, when the Nazis came and the business went down, had a job with the Jewish authorities in Hannover till we both emigrated in July 1939 to England. Of course he was arrested in this terrible November [Crystal Night], and was 4 weeks in Buchenwald. We both worked here first in a big household of a M.P. till May 1940, when we were interned for two years in the Isle of Man. When we were released in summer of 1944 we came to Barnsley, where we still are. Eric worked for the local grammar school as a P.T. master and taught some German, and I worked after a short wartime training at school in the Nursery Class from 1944 to 1970 [?], when we both retired together. We have no children (only a golden hamster in a cage)!

Herbert: was at school till he had "das Einjahrige" [approximately two years' high school], worked for different firms in the accounts dept., then moved to Leipzig and worked for a big store as a buyer; there he met his first wife, Dagmar Lewinsohn, they got married in 1937 when they moved to Munich where my brother worked for another big store as a buyer, and emigrated

Ruth Goodman
24 Hardwick Crescent
Athersley-South
Barnsley, Yorks. S71 3QY

December 17th.73

I was highly pleased to receive your
enclosures yesterday. I did ~~not~~ know
the exhibition in New York, and that
te this wonderful book about the
ncerned with. This summer we spend
any with friends of my husband, and as
m Wiesbaden, we were several times at
owed me a letter from you and the book
l her then, if she liked, she could
ss as well.By the way aunt is very well
er mind, she writes to me almost every
writing is incredible, she will be 86
of her last letters she said, if she
this winter, she might fly over in
s. You see we only recently moved into
this bungalow, and we love it. She would like to see
where we have landed.When I have written to you, I
must see whether I find the box with all my photos, and
whether there is any I could send, because most of
the recent ones are in colour and no good to you.If you
have any to spare after you have finished with them, I
mean photos you got of your Grandmother, may I have
them please? We have lost almost all our possession,
coming over here rather late, it was July 1939, and our
luggage and belonging were stored in the Free port of
Hamburg, but we never got anything, a little compensa-
tion after the war, that was all. I have acquired a
few photos, some of aunt Grete, some of an old friend
in Germany, but would love to have some more.Of course
I know about you all, as I am very interested in the
family and write to almost everbody intheir turns-
Uncle Julius,you might have known him or ?he told me
once how much you were like my late mother, any recent
photo of you?My mother was wonderful, a real good mother
and friend, very arty, full of interets of all sorts, I
wish I had inherited half of it.But then again their life
was a more or less normal one,and we hadto work to con-
tribute to the cost of living, having emigrated with **no**

via Holland to England in 1938, soon after the awful days. He worked for different firms in London, when the war broke out joined the Army, where he stayed till the bitter end, coming back from the Middle East, where he acted as an intelligence officer. Was demobbed as a Captain, called himself then Manning. When he came back to London, Dagmar asked for a

Above: Ruth and her husband, Eric Goodman, Derbyshire, England, 1972.

divorce. They never were very happy. One little girl Eva-Ruth is their daughter (born June 13, 1941); (she is married since to a teacher, she is a teacher too, they have two children—Steven six and Helen two). My brother married two years later a French girl; they have one son, John Michael, born June 9, 1950, lives in London now in some obscurity. This marriage did not last neither and they were divorced in 1966. In 1968 (May) Herbert married for the third time, a Jewish lady of almost forty-five, unfortunately this did not last long as Herbert passed away in November 1968 in London. He worked after the war in London for different firms as an accountant, he was very intelligent.

Käte: went to school till she was sixteen, had several jobs in shops and offices, married in 1938 Paul Nussbaum from Neuwied, where they lived, till Nov. 9th, when they fled to us in Hannover. They stayed behind when we emigrated, and unfor-tunately were both deported, we have no exact dates when they were send away and what happened to them, we can only presume. They had no children.

My mother went to live in Amsterdam in the summer of 1936 with uncle Adolf, brother of your paternal Grandfather, but she died of cancer in Jan. 1937. My father had died in 1930. He never was a healthy man.

I do hope you can make sense of my account of our family, I shall now see what photos I have of any interest to you. May I wish you all the very best for the New Year, and remember me to your parents, I knew your mother very well as a young girl, she was most beautiful, well groomed, refined. I met your father only shortly once, when our grandmother Julchen died in Bielefeld in 1938. I think she was an absolutely wonderful lady. You will [have] heard of her. If ever you come to visit your sister in Oxford and you feel like coming to the cold and dirty North Midlands, we will give you a warm welcome. Once more mine and my husband's very best wishes, yours

Ruth

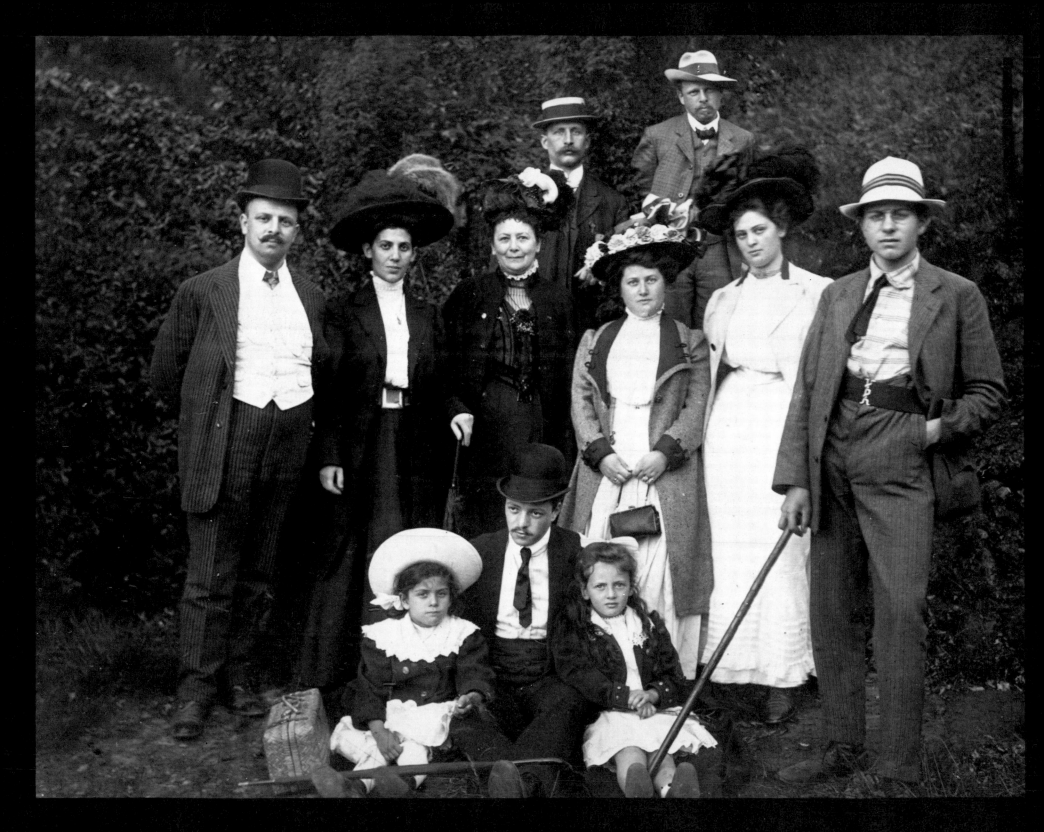

A Family Gathering, 1910…

… and a Family Gathering, 1936

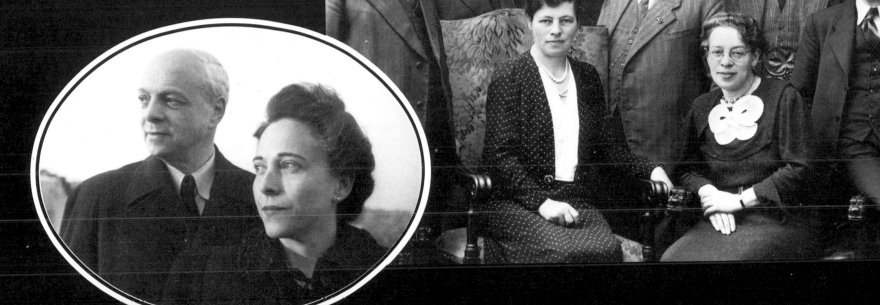

Karl, born on December 29, 1884, was the ninth of the ten Wallach siblings, and the youngest of the seven brothers. Like Moritz, Julius, and Adolf, he also had an interest in textiles, but after his father's death, he moved back to Bielefeld to help operate Heinemann's grain business. There he and his wife, Leni (born Stein), lived with Mutter Julchen. The Karlleni's, as they were always called, had no children, but they did have what appeared to be the happiest of marriages.

How the Karlleni's got out of Germany is quite remarkable; traveling via Berlin, Moscow, and Vladivostok to China, their safe passage was assured by a Nazi diplomat traveling incognito. In the Far East, they met a fellow member of the Schlaraffia, who lent them money to get to this country. In New York, Karl worked first as a butler, later as a guard at the Museum of Modern Art, where I have a vague memory of

meeting him for the first time shortly after we arrived in this country.

Karl died, more or less of old age, in 1968, and Leni's mind and spirit left her almost immediately thereafter. After focusless years in a nursing home, she too died, in 1975.

To me, the family photographs on these two pages reflect not only the difference in the style of their respective times, but also in the mood. The first, despite the serious faces presented for the camera's eye, shows the light-heartedness of pre-World War I; the soberness of the second reflects the family's ever-increasing anxiety.

Opposite, bottom row, left to right: Karl, with Julius's daughter Hilde (left) and Hugo's daughter Ilse. Second row: Ernst, Emma (Julius's wife), Mutter Julchen, Martha (Hugo's wife), Grete, Walther Weinberg (Martha's brother). Top row: Willy Mannheimer and Julius. Above: Adolf, Karl, Else, Julius, Betty, Moritz, and Max. Near left: Karl and Leni, ca. 1948.

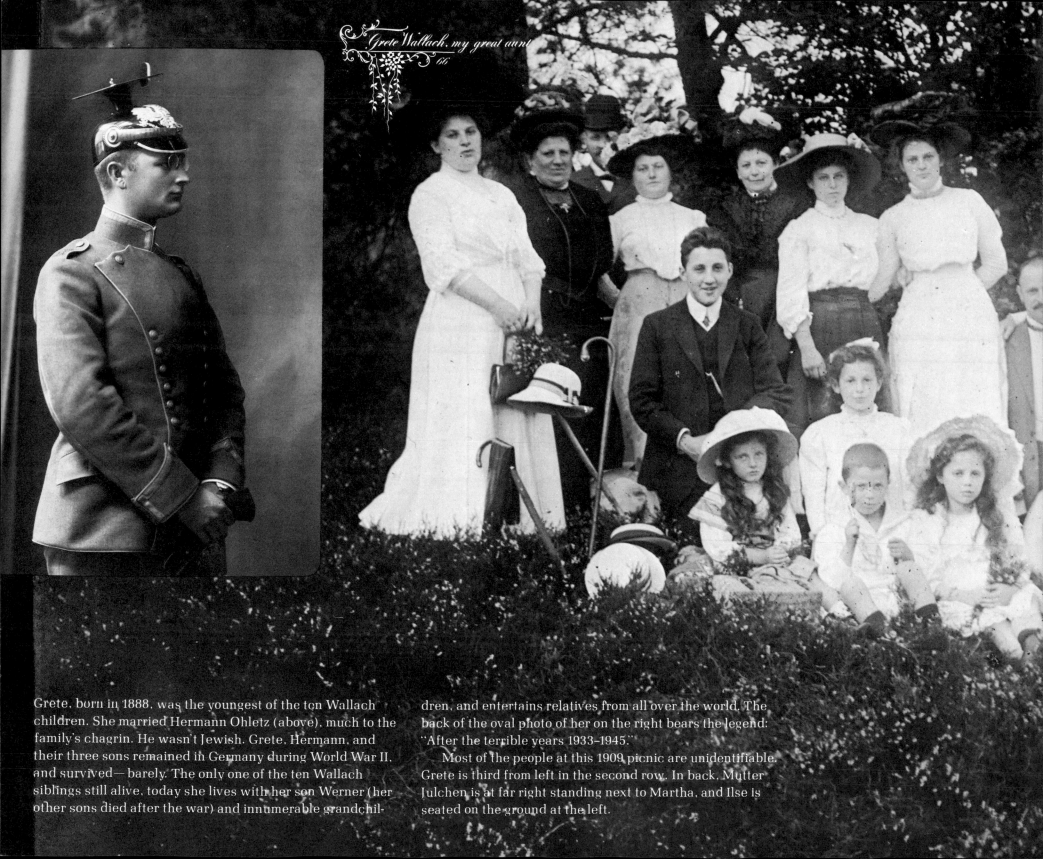

Grete, born in 1888, was the youngest of the ten Wallach children. She married Hermann Ohletz (above), much to the family's chagrin. He wasn't Jewish. Grete, Hermann, and their three sons remained in Germany during World War II, and survived — barely. The only one of the ten Wallach siblings still alive, today she lives with her son Werner (her other sons died after the war) and innumerable grandchil-

dren, and entertains relatives from all over the world. The back of the oval photo of her on the right bears the legend: "After the terrible years 1933–1945."

Most of the people at this 1909 picnic are unidentifiable. Grete is third from left in the second row. In back, Mutter Julchen is at far right standing next to Martha, and Ilse is seated on the ground at the left.

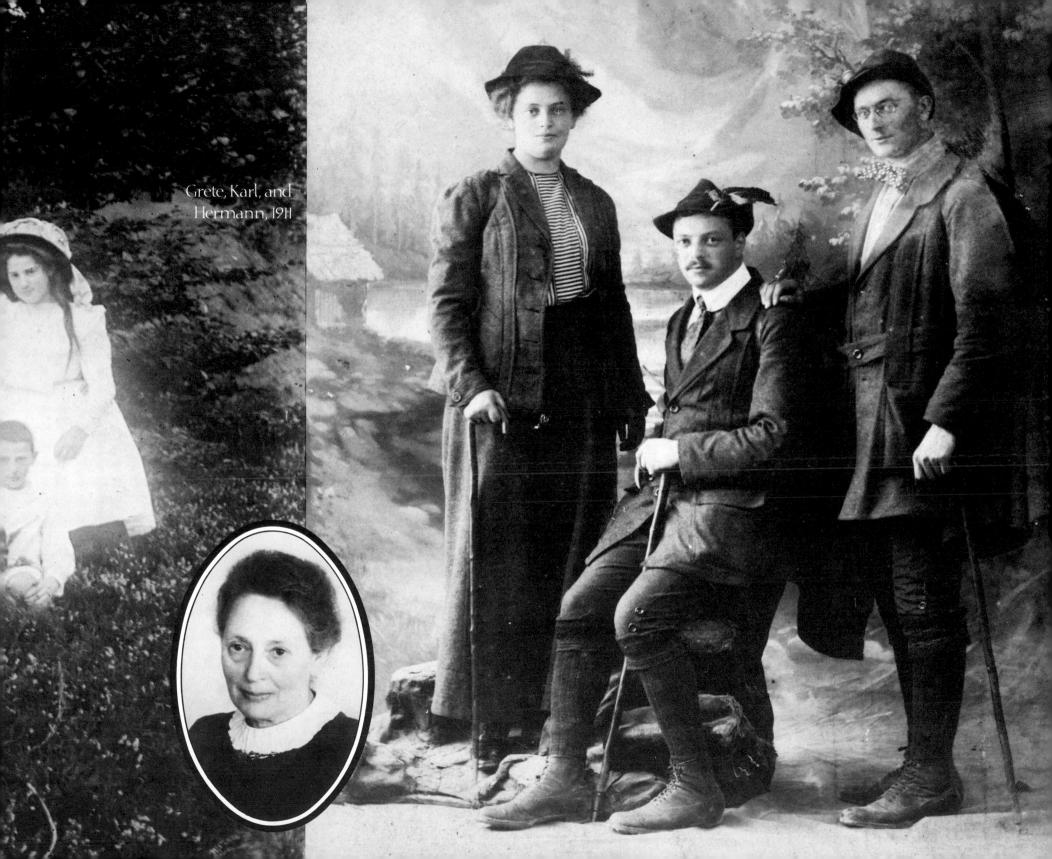

Grete, Karl, and
Hermann, 1911

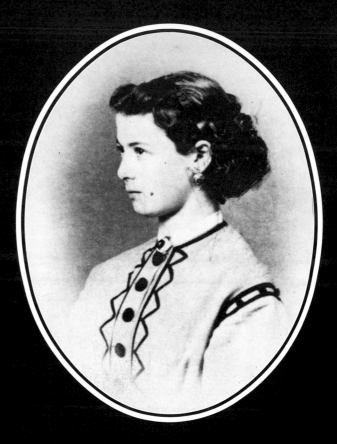

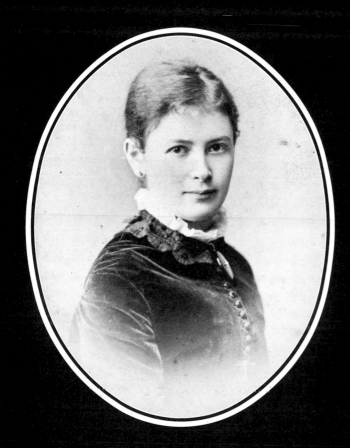

Mutter Julchen had a strong personality and a strong influence on her children, all of whom adored her. She was an elegant presence in both manner and style; and she always had a pot of bouillon on the stove, ready to receive visitors. Many of her communications were written in verse, a trait which she handed on to a number of her children (see poems on pp. 36, 158).

The photo on the right is, I suspect, of a type called cabinet portraiture, in which the subjects were posed in a studio with theatrical props against a painted background. It was particularly popular with actors around the turn of the century.

Opposite: Mutter Julchen. Else. Moritz. Julius. and Adolf.

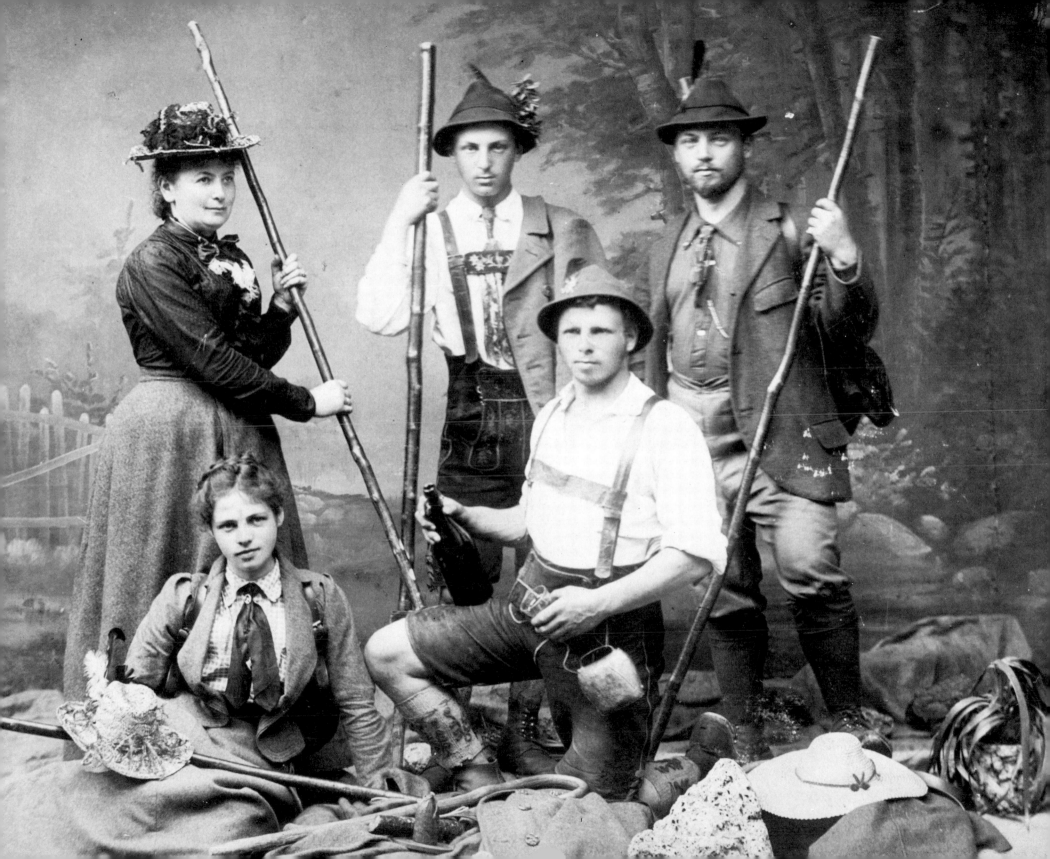

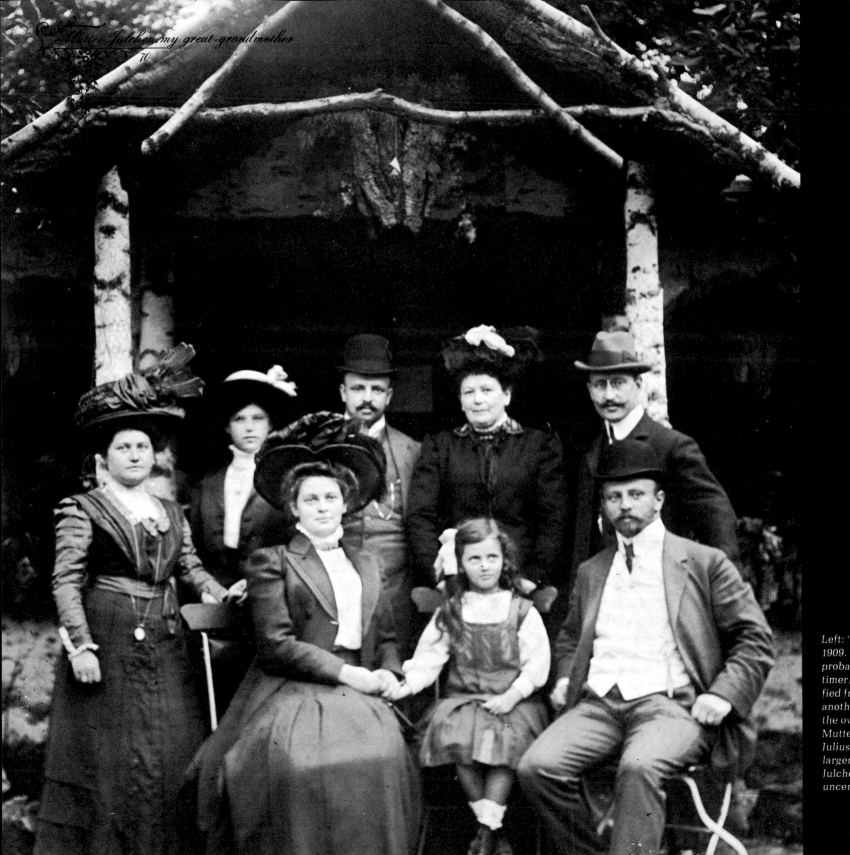

Left: "Im Stillen Frieden." August 22,
1909. Seated: Grete. Ilse. Hugo (who
probably took this picture on a self-
timer). Standing: Martha. an unidenti-
fied friend. Ernst. Mutter Julchen.
another unidentified friend. Right. in
the oval: Ilse in the foreground with
Mutter Julchen over her shoulder. and
Julius full-face in the back. In the
larger photograph: at right. Mutter
Julchen. for once seated
unceremoniously.

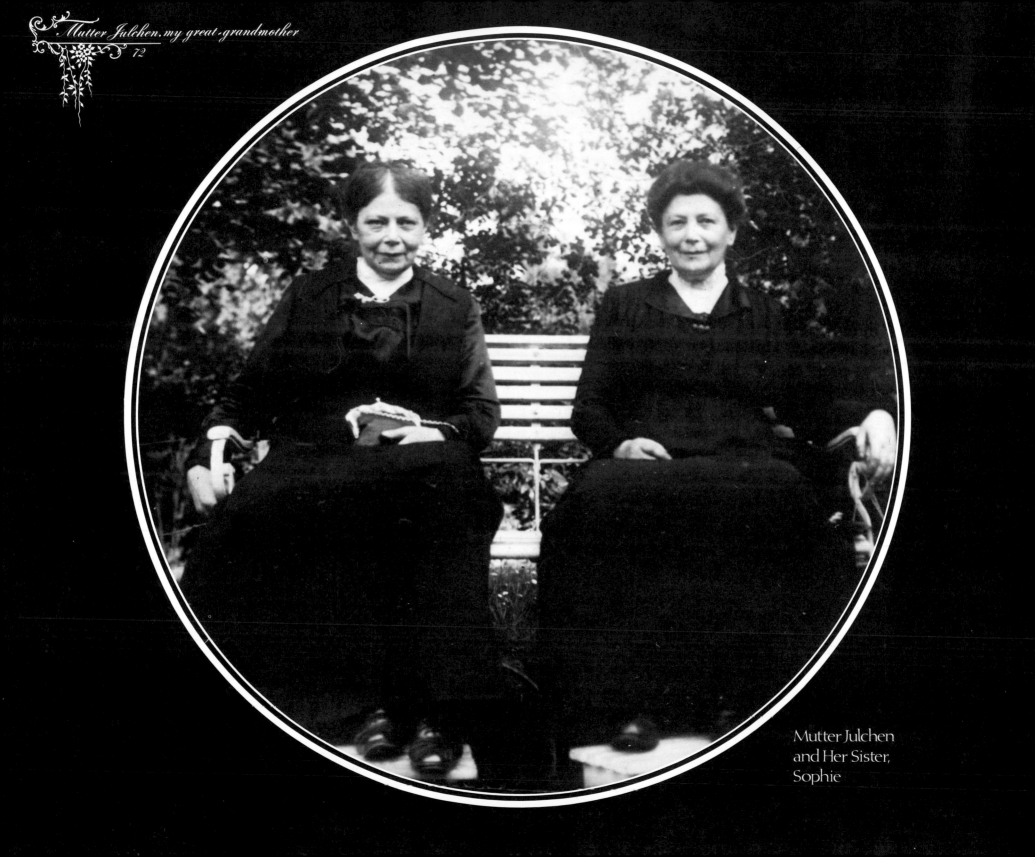

Mutter Julchen
and Her Sister,
Sophie

1922

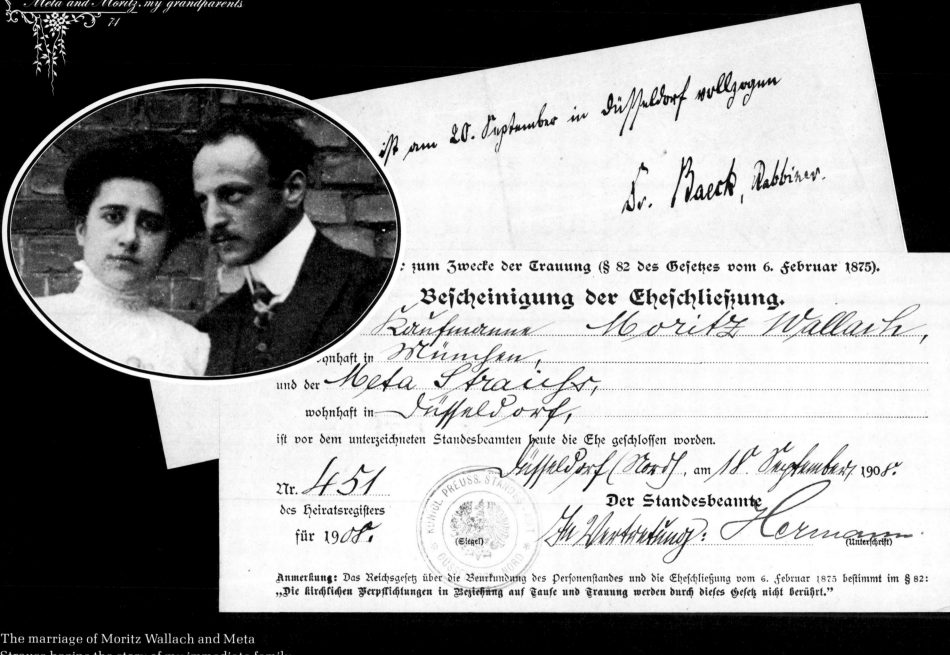

ist am 20. September in Düsseldorf vollzogen

Dr. Baeck, Rabbiner.

zum Zwecke der Trauung (§ 82 des Gesetzes vom 6. Februar 1875).

Bescheinigung der Eheschließung.

Kaufmann *Moritz Wallach,*

wohnhaft in *München,*

und der *Meta Strauss,*

wohnhaft in *Düsseldorf,*

ist vor dem unterzeichneten Standesbeamten heute die Ehe geschlossen worden.

Nr. *451*

des Heiratsregisters

für 19*08.*

Düsseldorf (Nord), am *18* *September* 1908.

Der Standesbeamte

In Vertretung: *Hermann*

(Unterschrift)

(Siegel)

Anmerkung: Das Reichsgesetz über die Beurkundung des Personenstandes und die Eheschließung vom 6. Februar 1875 bestimmt im § 82:
„Die kirchlichen Verpflichtungen in Beziehung auf Taufe und Trauung werden durch dieses Gesetz nicht berührt."

The marriage of Moritz Wallach and Meta Strauss begins the story of my immediate family. Above, the wedding certificate, and opposite, at lower right, the wedding announcement with its query, "Did it actually happen?" written in an anonymous hand.

Opposite, above: the silk-bound menu for the formal

MENU

Caviar on Ice

Oxtail Soup

*Blue Trout with Potatoes
and Buttersauce*

*Partridge with Sauerkraut
in Champagne*

Asparagus. sauce mousseline

*Duckling with
Apple Sauce and Salad*

Wedding ice cream

Fruit. Dessert. Cake. Mocha

Meta Strauß :: Moritz Wallach

20. September 1908.

The union of our children Meta and

Moritz took place on

Sunday. 20 September 1908

Grafenberger Allee 45

Düsseldorf. Bielefeld. September 1908

S. Strauss and wife Frau Julie Wallach
Emilie. born Cahn born Zunsheim

Speisen-Folge.

Caviar auf Eis.

Ochsenschwanz-Suppe.

Forellen, blau, mit Kartoffeln
und Buttersauce.

Rebhuhn mit Sauerkraut in Champagner.

Stangenspargel, Sauce mousseline.

Enten mit Compot und Salat.

Hochzeits-Eis.

Obst, Dessert, Torten, Mocca.

Ist das auch richtig geschehen?

Die Vermählung unserer Kinder Meta und
Moritz findet hierselbst am
Sonntag, den 20. September 1908
Grafenberger Allee 45 statt.

Düsseldorf, Bielefeld, September 1908.

S. Strauß u. Frau Frau Julie Wallach
Emilie geb. Cahn geb. Zunsheim

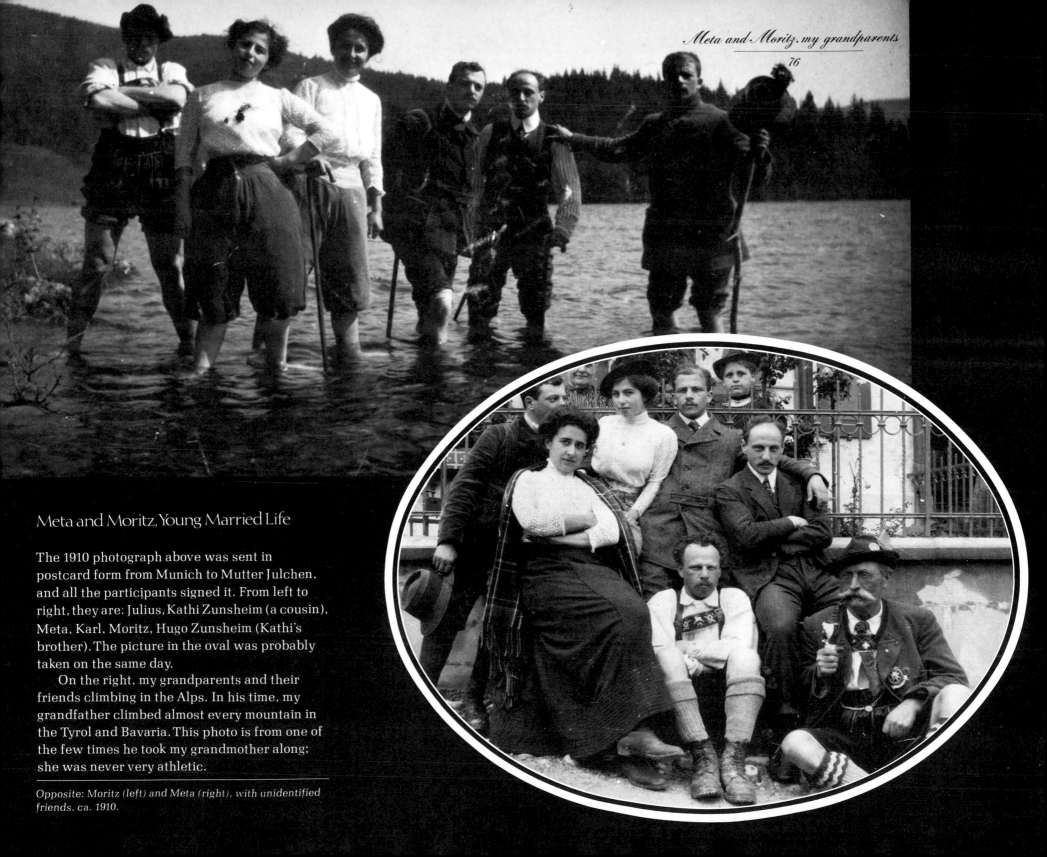

Meta and Moritz, Young Married Life

The 1910 photograph above was sent in
postcard form from Munich to Mutter Julchen,
and all the participants signed it. From left to
right, they are: Julius, Kathi Zunsheim (a cousin),
Meta, Karl, Moritz, Hugo Zunsheim (Kathi's
brother). The picture in the oval was probably
taken on the same day.

On the right, my grandparents and their
friends climbing in the Alps. In his time, my
grandfather climbed almost every mountain in
the Tyrol and Bavaria. This photo is from one of
the few times he took my grandmother along;
she was never very athletic.

*Opposite: Moritz (left) and Meta (right), with unidentified
friends, ca. 1910.*

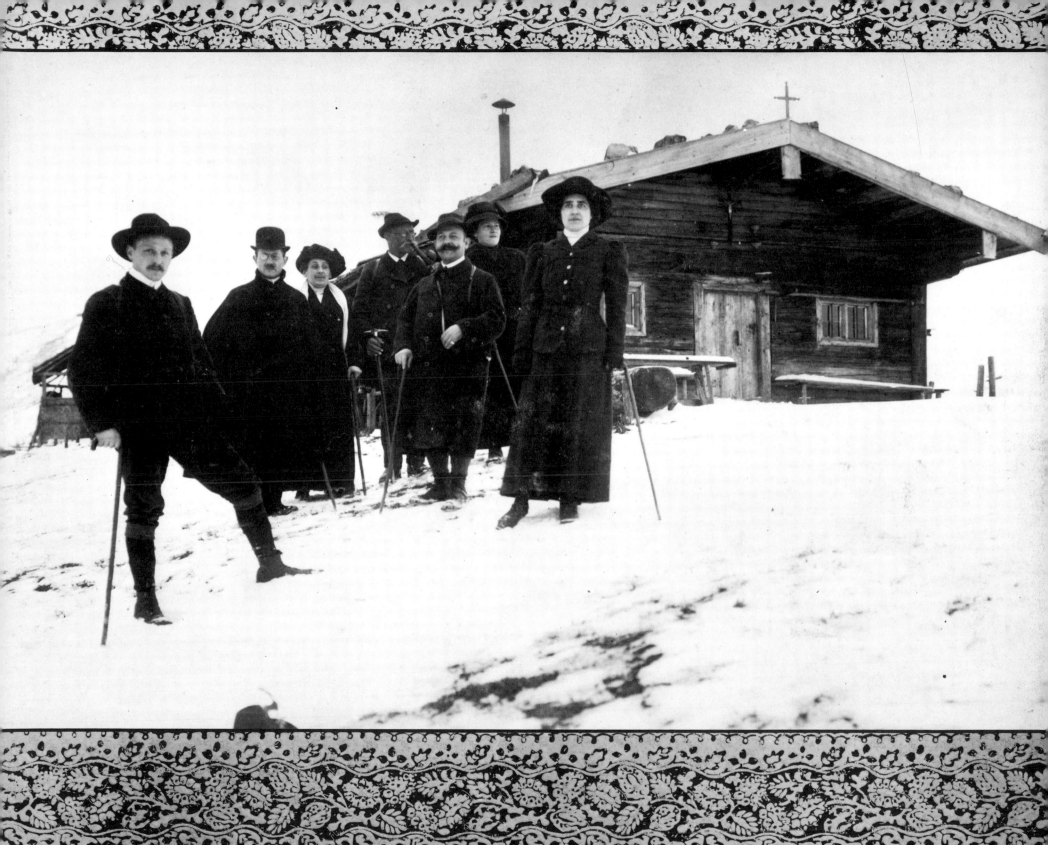

During the summer of 1910, my great-aunt Grete (Strauss) was invited to spend her vacation with Meta and Moritz in Enzenau, in Bavaria. At left, Grete and Meta dry the laundry, and at right, they go walking with my great-uncle Max (hat off) and an unidentified friend.

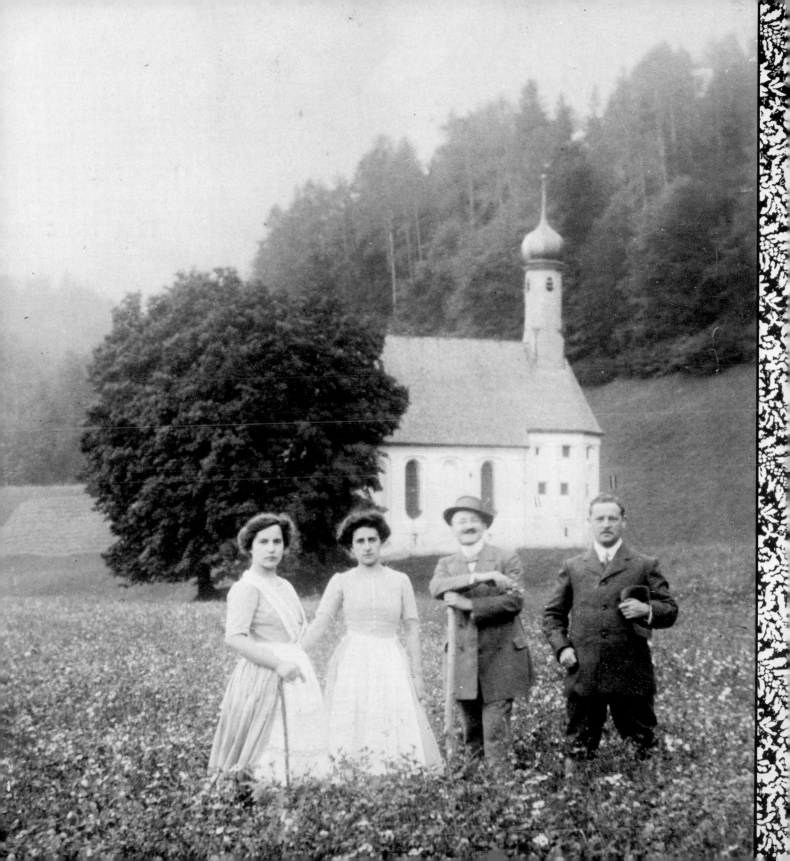

Moritz and Meta's first child, my uncle
Rolf, was born in 1909. Here he is at
four and half months, and, opposite,
on his first day of school.

Rolf

Lotte, my mother, born in 1911, was Moritz and Meta's second child. Below, she is sitting in the center, in white, with Rolf and some of their Wallach cousins. This photograph was taken on the day of the *Schafflertanz*. Once a year, the *Schafflers* (coopers) would drive through Munich in a cart, and stop to perform their dance wherever it was requested (and paid for). This ancient custom had its beginning at the end of one of the plague epidemics when people were afraid to leave their houses. The *Schafflers* danced through the streets to draw them out and prove it was safe. On this occasion (probably 1914), they danced in front of Wallach's, and the whole family was present to watch them. My grandfather lined up all the children and took this photo.

At right, my mother, about six years old, in the family's garden. This garden was a small private park of about one and a half acres, in Föhring, on the outskirts of Munich. It had a cabin with a cookstove and bunks, and a swimming pond. The family spent their weekends and summer evenings there.

Below, left to right: Hilde (Julius's daughter), Rolf, Traudl (Julius's other daughter), Lotte, Anny Rothstein, Helmut (Julius's son), and Liesel Rothstein; 1914.

Traveling to Nussdorf, a Bavarian village where the family spent their summers. Meta is third from left, holding Rolf on her lap, ca. 1910.

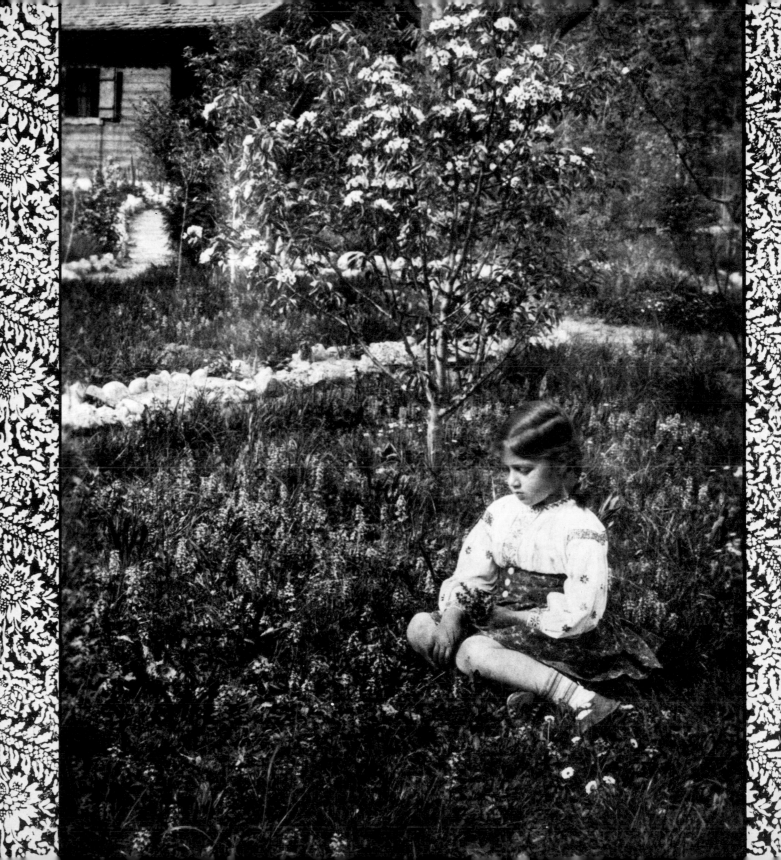

Lotte

THE VOLKSKUNSTHAUS WALLACH *(continued)*

As we had feared, war broke out in August 1914. We were not prepared for it. We had always lived simply, and reinvested all our earnings in our business. Julius was called to the front and sent with the infantry to the Balkans. I was declared eligible only for home duty because of a kidney ailment.

Our outfit was geared to handwork, and so we could not count on war orders. At last we were given an order to make kneesocks for the new ski troops, and the already-cut material was furnished to us. We had to survive. The discount bank had been swallowed up by the German bank, and this new bank canceled our credit. Linen and other materials were rationed. I had to print on raw material, which otherwise I would never have done.

Slowly things eased up. I leased a nearby store, the rental of which brought us some ready cash. I also rented a loft to store furniture and other things for our planned Volkskunsthaus. I bought Bavarian, Swabian, Franconian, North German, and fragments of Bohemian, Hungarian, Russian, and Scandinavian carvings, tiles, light fixtures; in short, all the installations needed for peasant rooms. There wasn't much general interest in such things, and therefore I was able to acquire an interesting collection.

In 1919, we had the opportunity to buy an old paper mill in Dachau, and with the help of our brother Max—who had served in the Merchant Marine and later for a German cable company in Latin America, China, and the Azores—we renovated it for our own use. So at last we were in a position to both weave and print our own fabric without having to rely on the home weavers, as formerly. . . .

. . . Julius, who had meanwhile been in the Balkans, had looked around and found material to complete our collection. He did this with great skill, and meanwhile I was in charge of the furnishings, the samples, and exhibitions.

Because of the difficulty of buying yarns, Julius decided to install spinning wheels. I didn't like the idea, because I knew that when the war ended, we would once again be able to buy yarn. So I laid aside this idea, and concentrated on the printing area of the factory. . . .

. . . The war brought the end of the reign of the Wittelsbachs, those fair and democratic rulers. The government under [Kurt] Eisner ended suddenly when he was shot. Count Arco was a royalist, and while all murder is contemptible, one could well understand this deed. To his prison cell we sent the count a pillow embroidered with the Bavarian royal shield. . . .

. . . Incredible chaos followed the murder. Workers and workers' councils ruled in Munich. The councils formed troops under the leadership of [Ernst] Toller. The city was shut off from the world.

It was March 1919, and time for the fair in Leipzig. A neighboring exhibitor came to see me; he had found a way to pass through the two lines of troops; would I join him? I answered that if other booths from Munich were empty, nobody would look for us there either, therefore everybody would have to go. I asked him to phone his friends and acquaintances and ask them in turn to telephone their acquaintances, and invite everybody to assemble in our store. About 120 people came on Tuesday; the fair was to begin on Sunday. I went to the Wittelsbach Palace, where the members of the workers' government were, and they sent me to the army museum. The then-minister of railroads, Paulukum, asked me whether I was sure there would be a fair in Leipzig. I in turn asked him for a permit to telephone Leipzig. It didn't work. Only when we pretended to be speaking on behalf of the director of the railroads could we get through. We were given permission to go ahead.

Now I had to get in touch with the director of the Munich railroad. Herr Direktor Pöhlmann promised to ready some freight cars in the east station, in which the exhibitors could pack their sample cases, but only under the condition that they would guard the merchandise themselves. Meanwhile

the number of participants rose rapidly. Many had heard that a train was being prepared, and they also wanted the opportunity to get out of the fortress that was Munich. However, it was a condition for every participant that, in addition to my own signature, he had to have that of the workers' council and of the Chamber of Commerce to pass through the lines. On Thursday a mixed train of freight cars and coaches was ready at the main railroad station. Armed soldiers stood by; in cases of doubt, I had to okay the passengers. Herr Paulukum was there, and even Herr Pöhlmann, who said he would travel with us in order to get the train safely through the cordon. However, I thought he would get cold feet; and in Freising he ordered the train to halt and got out.

From Regensburg I cabled Köhler, the director of the fair: "Train with exhibitors from Munich en route." So our places in Leipzig were made available for us. After a twenty-hour trip via Nürnberg-Bamberg-Hof, we arrived at our destination. The fair was an enormous success. Everybody wanted to hear what was going on in Munich, and we received many orders. On Thursday I was visited by a gentleman from the Halle railroad. He said that I had arranged the train to Leipzig so successfully that he wanted me to arrange for the transport back too. I sent a message to all the exhibition halls and asked the Munich people to come to a meeting on Thursday evening in the Astoria Hotel. Since the sales at the fair had been so successful, we agreed to start our return trip the next day.

The train was very crowded, but I was given a special compartment. A salesman from Steiner's Paradise Beds screamed: "Naturally this Jew gets a private compartment!" This was the first time that I had experienced anti-Semitism. The others insisted that the man apologize.

We arrived at the suburb of Pasing; in Munich they were still shooting. Although it was pouring rain, they could only offer us open flatcars for the rest of the trip. Then we were given passes by the Epp Commando. At the Hackerbräu they were still fighting. We had to walk through the whole city,

and were happy and relieved to find our families safe and in good health. One pleasant aspect of this time in Munich was the universal membership in the local militia. The intelligentsia and the workers were together; we were given target practice, drill, changing of the guard, and everybody worked in harmony.

Back in Munich, whose reputation had suffered so badly, I had the idea that all Bavarian arts and crafts workers should have a permanent sales outlet, as in Scandinavia, in order that the scattered workshops, which were often hard to find, could have a centralized outlet for their products. I went to see Herr Esterer of the royal cultural administration; I asked him whether there was a possibility of obtaining space in the Residenz [Royal Palace]. They gave me a beautiful long hall; the city donated the trappings, and the wrought-iron work from Laube, and so we could begin.

In 1920, we were ready to open our living folk art museum. [This folk art museum was the crowning point of Julius's and Moritz's aspirations. It was a forty-two-room house—formerly a girls' school—and each room was decorated with the furniture and in the style of a different region of Europe.] In spite of all the difficulties, we had finally accomplished it. The press, not only in Munich and Augsburg but also from Vienna, Hannover, Cologne, Amsterdam, and Copenhagen, etc., gave us great publicity. We showed, in their proper settings—paneling, furniture, windows and doors—the folk art of various countries of Europe, both work from earlier periods and folk art that still existed; some of the objects were for sale, others only on exhibition.

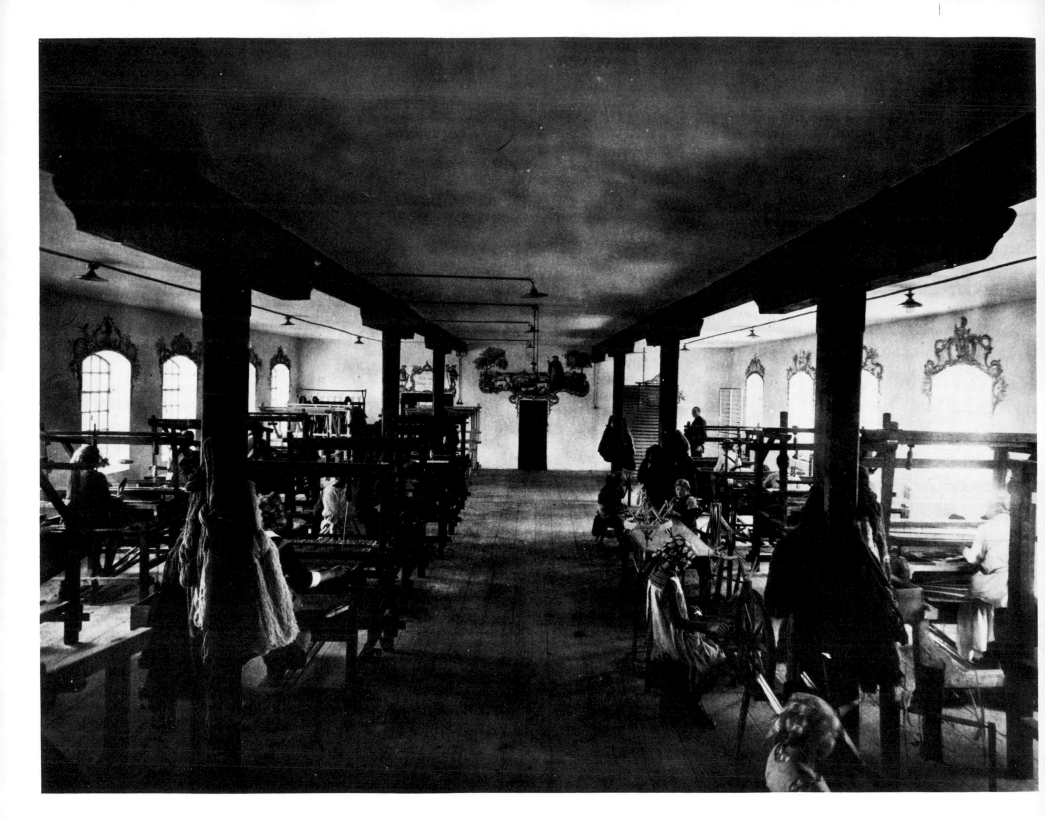

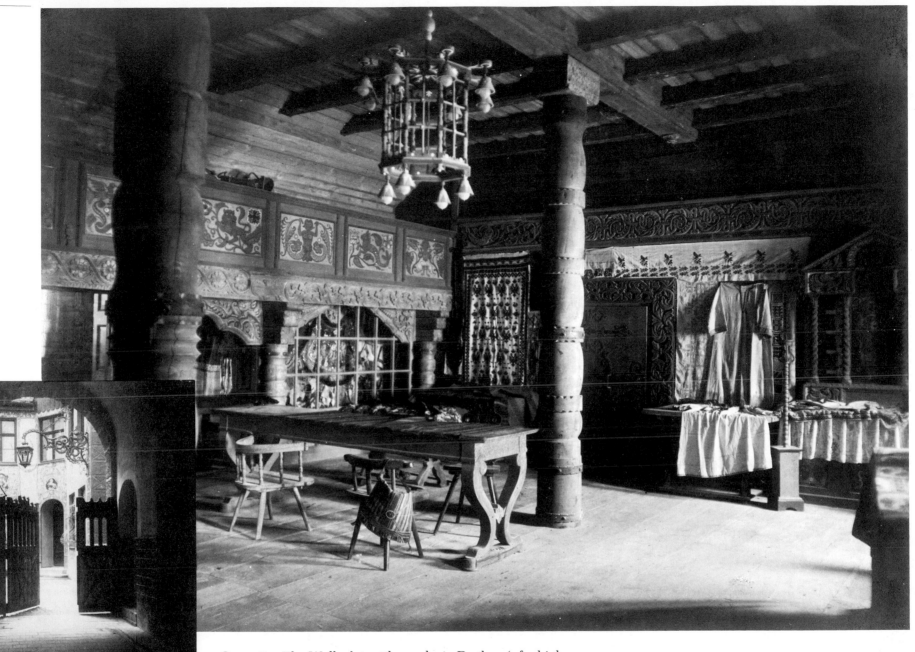

Opposite: The Wallach textile works in Dachau (of which
Max was called home to be the technical director), ca. 1919.
When it first went into operation, this room was used for
weaving, and the rest for block-printing and silk-screening
designs. The hand looms were later discarded and the whole
operation used for printing fabric. Left, and above: Courtyard,
and one of the rooms in the Volkskunsthaus Wallach, 1922.

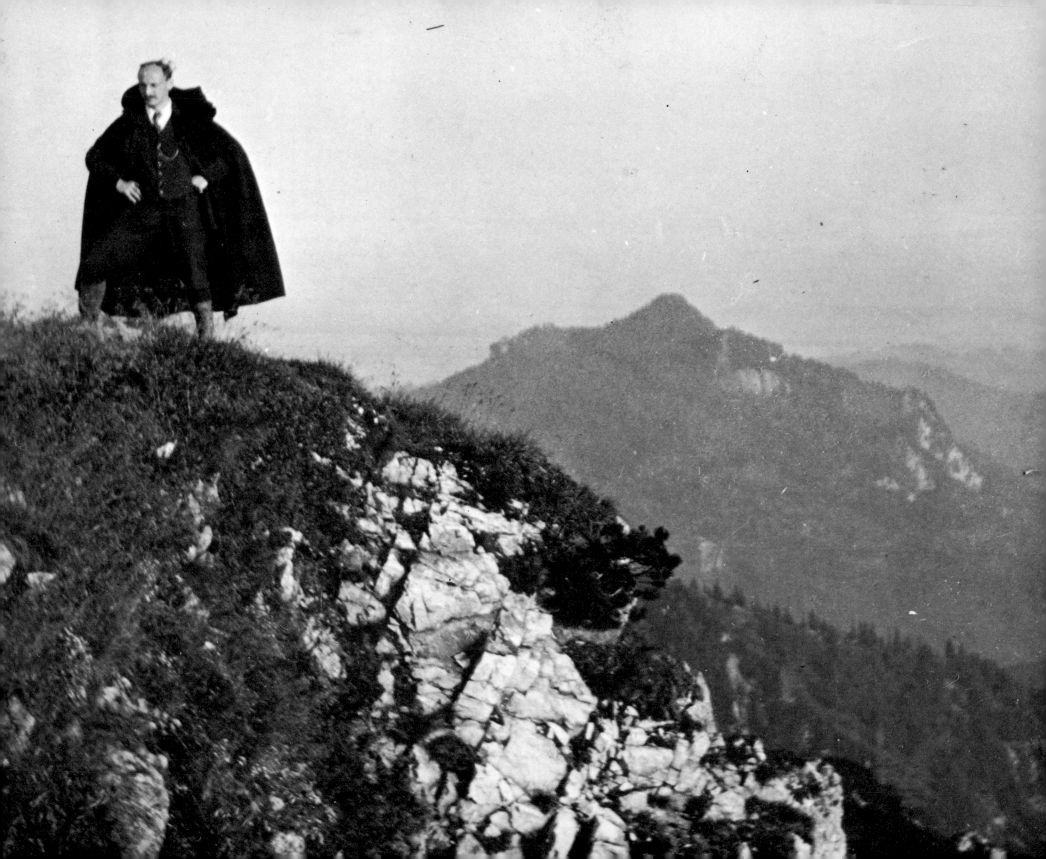

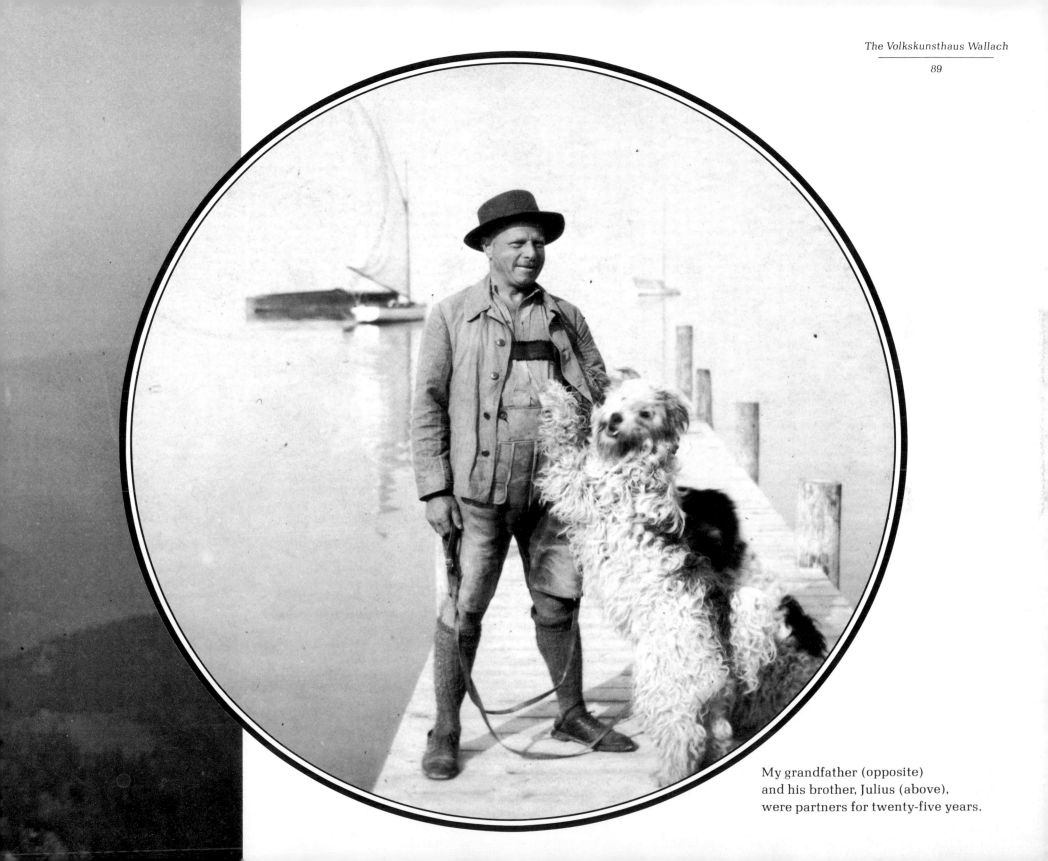

My grandfather (opposite)
and his brother, Julius (above),
were partners for twenty-five years.

Fritz, 1914

Fritz, born in 1914, was probably named
for Meta's brother Fritz, who was later
to disappear so tragically. My mother
was terrifically jealous of her younger
brother: "I accused Mutti (Meta) of
Fritz's being her favorite, and that I was
only adopted. For years I threatened to
run away. There was a girl in my class,
and her pencils were always beautifully
sharpened and everything about her was
neat, and I envied her, and she had only
one sister, and I had these two brothers
that I didn't know what to do with.
And I was going to run away and they
would be only too happy to take me in . . ."

Right: Fritz, in the cabin in Föhring, ca. 1918.

Munich street scene,
February 1917—with Liesel
Rothstein, Meta, Fritz, Betty,
and Lotte. And on the left,
my grandfather walks my
mother and Rolf to school,
ca. 1917.

In front of a home for elderly noblewomen in Munich was a hill where Rolf and Lotte used to go sledding. My mother remembers it chiefly as being very cold there—no wonder. Rolf and Lotte (right), with Helmut (Julius's son) and another cousin, ca. 1917.

Opposite: Königsee in the Bavarian Alps.

Rolf and Moritz in the garden at Föhring, ca. 1914. Rolf caught his pet snakes in Föhring, and learned about botany: one day he found an acorn and asked his father what it was. "It's a seed," said Moritz, "one day it will be an oak tree." So Rolf found a suitable spot, planted the acorn, and sat down to watch it grow into an oak tree. He sat for half an hour; nothing happened. Disgusted, he got up and walked away. When he returned an hour later to check, he found a tiny seedling where he had planted the acorn. He studied it awhile, then left, and returned in another hour or so. The seedling had grown into a little plant.

This procedure continued through the afternoon, and by evening, Rolf's acorn had grown into a small oak tree.

Rolf was five years old when World War I started, and he has clear memories of it. "I remember that morning (that's one of those early memories of mine), when Vati came in—Mutti was in bed, it was early in the morning—and said that the Archduke Franz Ferdinand had been assassinated in Sarajevo, and he was very worried and said he thought that meant war. And I couldn't quite imagine what war was like. For example, if you asked me if we ever missed things or whether we were hungry, I couldn't say; I don't think we were. On the other hand, I do remember Mutti saying, 'There was a time when you could just go into a store and buy milk.' So from that memory I know we didn't have milk. And I remember that once after the war we were in Nussdorf and things were still unobtainable, and the cook at the Schneiderwirt [an inn where they used to go in summer] brought out a bowl of whipped cream, and this was something we had never seen: we had never even seen an orange or a banana. But we didn't miss it, we'd never known it. It was a time of deprivation for grownups but not for children."

Onkel Julius also had a garden of his own in Föhring, where he raised chickens, ducks, and goats. He had a man to take care of the garden and the animals during the week, and Julius went out there on Sundays. But the chickens didn't lay eggs all week, only on Sunday, and the goats didn't give milk all week, only on Sunday, and there were no vegetables, except on Sundays. So one Monday morning, early, Julius went out to Föhring and hid in a tree. At eight o'clock the local citizens started arriving, and this caretaker sold all the produce of the garden to these people. Julius came down out of his tree, the man saw him and started to curse: "You dirty, nasty Jew, you, how dare you spy on me!"

Opposite: Betty Wallach Rothstein, Grete Strauss Loeb, Fritz Strauss, and my grandmother relax in the garden in Föhring, ca. 1917.

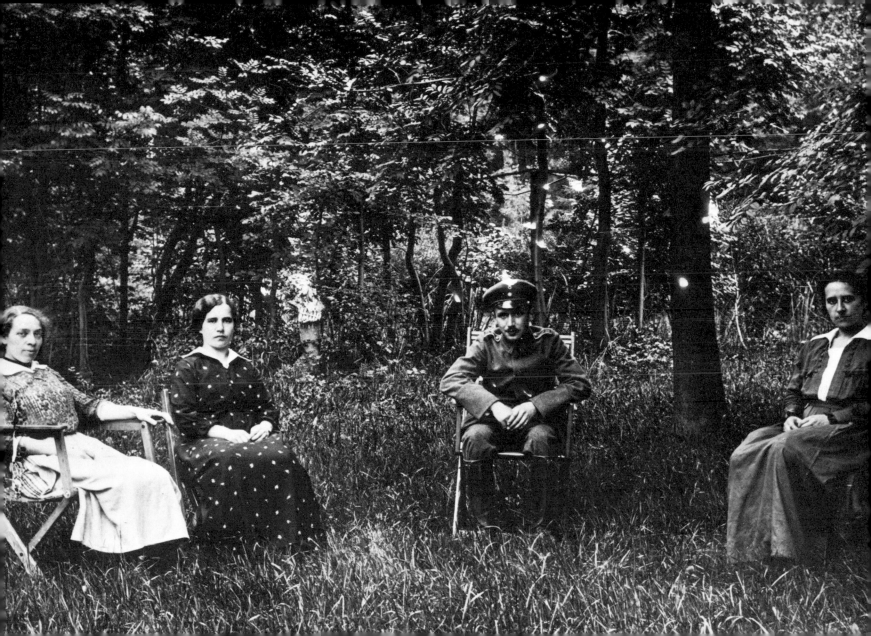

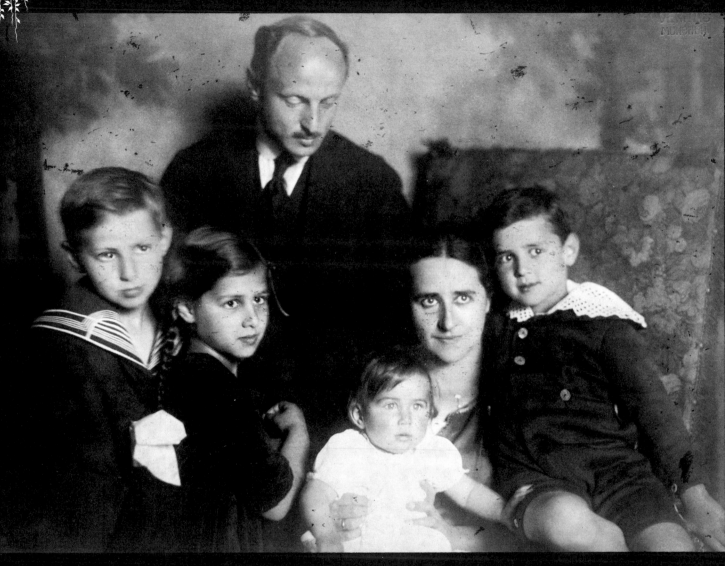

Annelise, born in 1919, was Moritz and Meta's
youngest child. It was a local joke in Munich
that the Wallach children were constantly being carted
off to the photographer's. My grandparents were
exceedingly proud of their four children, as
large families, in reaction to the previous
generation, were unusual by that time.

Rolf, Lotte, Moritz, Annelise on Meta's lap, and Fritz. 1920.

My mother (left) was equally proud of her new ring
(it had turquoises in the center) and her
new sister Annelise (second from left).
So she displayed both, placing the ring
on top of the sister.

Lotte, Annelise, Rolf, and Fritz, 1920.

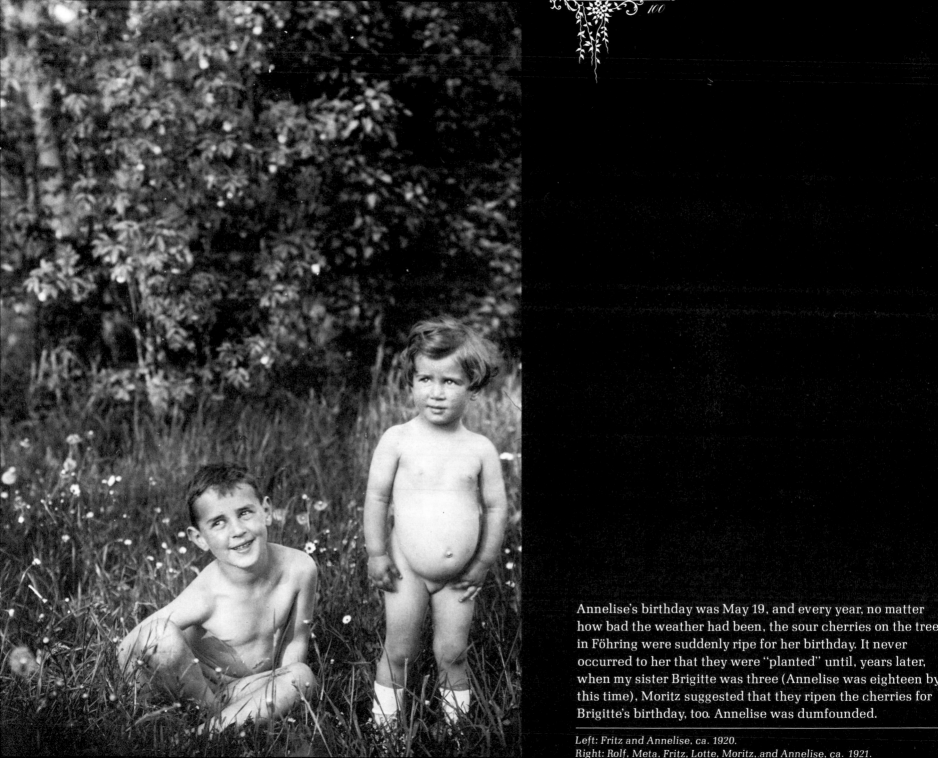

Annelise's birthday was May 19, and every year, no matter
how bad the weather had been, the sour cherries on the tree
in Föhring were suddenly ripe for her birthday. It never
occurred to her that they were "planted" until, years later,
when my sister Brigitte was three (Annelise was eighteen by
this time), Moritz suggested that they ripen the cherries for
Brigitte's birthday, too. Annelise was dumfounded.

Left: Fritz and Annelise, ca. 1920.
Right: Rolf, Meta, Fritz, Lotte, Moritz, and Annelise, ca. 1921.

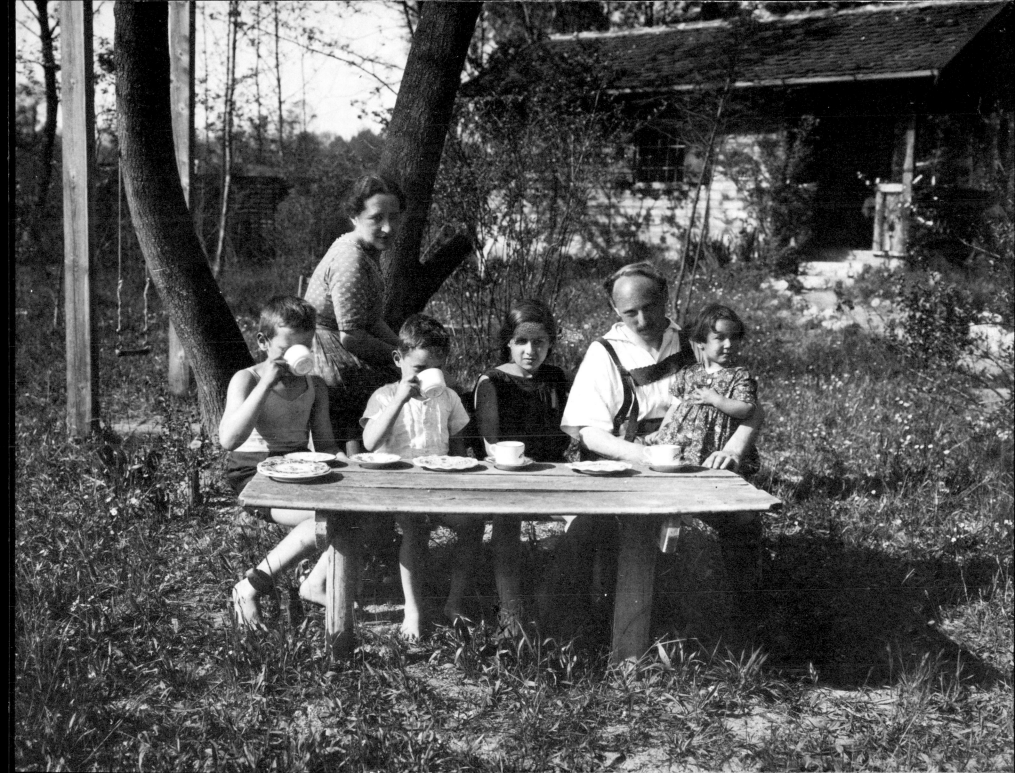

THE VOLKSKUNSTHAUS WALLACH *(continued)*

. . . On November 7, 1923, Hitler had his first putsch in Munich. On November 9, at nine o'clock in the morning, several SS men came to our store. I was standing with my brother; when they asked, "Which of you is Mr. Wallach?", I stepped forward. I was put into a taxi between two of these fellows and taken to the Bürgerbräukeller [a large beer hall in Munich]. In a room on the second floor, there were already about ten men whom I knew. We were to be hostages in case things went wrong. Then they brought in the Socialist Party members of the town council; then came Hitler, Ludendorff, and other "dignitaries." Hands high, then we were frisked. The town council members were taken away, and as we learned later, to the Perlacher Forst, supposedly to be shot if things went wrong. Still later, things began happening in the garden below. A parade formed, Hitler, Göring, Ludendorff, Göbbels, and other Nazi dignitaries at the head, and they started to march. We could see all this clearly from our room upstairs. In the afternoon, about three o'clock, the shooting started; men fled, brownshirts after them. We didn't know what was going on until several policemen burst in and asked us why we were there. When we told them, they told us it was all over and we could go home.

In Frankfurt, the exhibition hall for the German artisans was opened for the fair. As a member of this club, we were invited to exhibit, given a favorably situated room, and enjoyed success. One of the other exhibitors was jealous; her room was less favorably situated, in an upper storey. So I was told that I had samples and objects in my space which did not conform to the general principles of the organization, and that they were sorry to inform us that we could no longer count on our space. More and more we were noticing signs that modern, pragmatic thinking was taking over. A well-known Berlin architect asked me, "When will you finally stop making your ornamental stuff?" I answered: "That stuff was here long before you were, and will still be here long after you're gone."

In 1925, we celebrated our twenty-fifth business jubilee; there were many congratulatory messages. From the artists' community came this: "It is thanks to the tireless activity of the Wallach brothers that a cultural monument has evolved in the artistic city of Munich, which may be preserved through these difficult times for a public that understands arts and crafts. On the occasion of this jubilee, we have reason to thank you for your willingness to sacrifice in a good cause." Signed, "Köhler," and dated "March 12, 1925."

. . . But good wishes didn't help much. The trend toward modernization made it harder and harder to continue our enterprise according to our ideals. So in 1926 we had to give it up. We had offered the museum, which we were prepared to maintain in an honorary capacity, to the city and to the state of Bavaria, if they would give us a small section to use as a sales department. This offer was declined. We had to put the building up for auction, and what we received was most disappointing—we sold it at a comparatively low price to the Bavarian Bank for Agriculture. I had enough money to buy out Julius's share, and still enough left over to start again. My brother had decided to leave the firm. The *Frankfurter Zeitung* wrote: "A longer period of flowering might have been given to the Wallach house if Munich had not denied its liberal and art-loving tradition."

I found a new store at the corner of the Residenzstrasse and Hofgraben, which seemed to be suitable, after renovation and redesigning, to carry on our tradition. In the fall of 1926, I was able to open again. The five large display win-

dows were always surrounded by people, and the company insignia on the upper bay window was visible from far away. The windows of the store displayed headboards from eastern Friesland, beer wagons from Munich and old Munich, prints by the painter Gutensohn, old peasant chests of drawers as counters—the entire first floor gave a pleasant old-fashioned impression.

In a great theater in Berlin (formerly a circus hall), Charell started his play *Im Weissen Rössl* [*White Horse Inn*], with music by Ralph Benatzky. We received the commission to do the costumes. The production ran for more than four-hundred performances, and brought us more orders from other theaters. We did the costumes for productions both in and out of Germany: in London, Denmark, Budapest, Vienna, Geneva, Zurich, Basel, Königsberg, Tilsit, Breslau, Cologne, Düsseldorf, Wurzburg, and above all, Munich. *Im Weissen Rössl* saved us. Our reputation grew.

...March 6, 1934: About our exhibit at the fair, the *Konfektionär Berlin* wrote: "The newest collection from Wallach München: their new designs are peasant scenes in friezes, nuptial marches, old German heraldic motifs in Baroque style, fancy and imaginative little jackets, handwoven silk dirndl dresses, fabrics for furniture which give the impression of patchwork. A specialty of all the Wallach patterns is the country peasant style."

ROLF'S VERSION OF THE BEER HALL PUTSCH

"On November 8, 1923, the Nazis took a Bavarian Minister at gunpoint and made him agree to enter the government with them; they wanted to take over the Bavarian government. At about nine o'clock in the morning, they sent out groups of men to capture about fifty hostages. Some of the hostages were well-known businessmen, some of them were members of the City Council, especially the Socialist members. They knew exactly whom they wanted. I was in school that day, and we were released about eleven o'clock. We were told not to go into the city, but to go straight home. When I got home, a Nazi stormtrooper opened the door for me. He had our maid, the superintendent's wife, and the mailman in the kitchen. Anybody who came to the door was put into the kitchen so they couldn't try to warn my father. They had sent somebody to the apartment and somebody to the business. After about fifteen minutes, a telephone call came, and the stormtrooper took it. He said, 'All right, you can go now.' He had gotten a message from his colleague at the business, that they had captured Vati there. Mutti had been walking along the street and saw people being taken away; she didn't know what to do, so she came home, but they had already captured Vati at the Ludwigstrasse. All the hostages were taken to the Bürgerbräukeller; then the Nazis marched through the Residenzstrasse to the Odeonsplatz, and there they were met by a battalion of the Reichswehr [regular army], who wanted nothing to do with it. The Reichswehr gave orders to halt, but they didn't halt, so they fired one volley into the crowd, and killed seven. Hitler threw himself to the ground and escaped, disappeared. Ludendorff marched right on into the arms of the Reichswehr, who arrested him. (Hitler was found two days later in a cupboard in Hanfstängl's villa. He was arrested—and sentenced to five years in 'gentleman's jail,' of which he served nine months—that's where he wrote *Mein Kampf*.) The Reichswehr went to the Bürgerbräukeller and released the hostages. By five o'clock Vati was home. What would have happened if Hitler had been successful, I don't know, but as it was, the whole thing lasted only half a day."

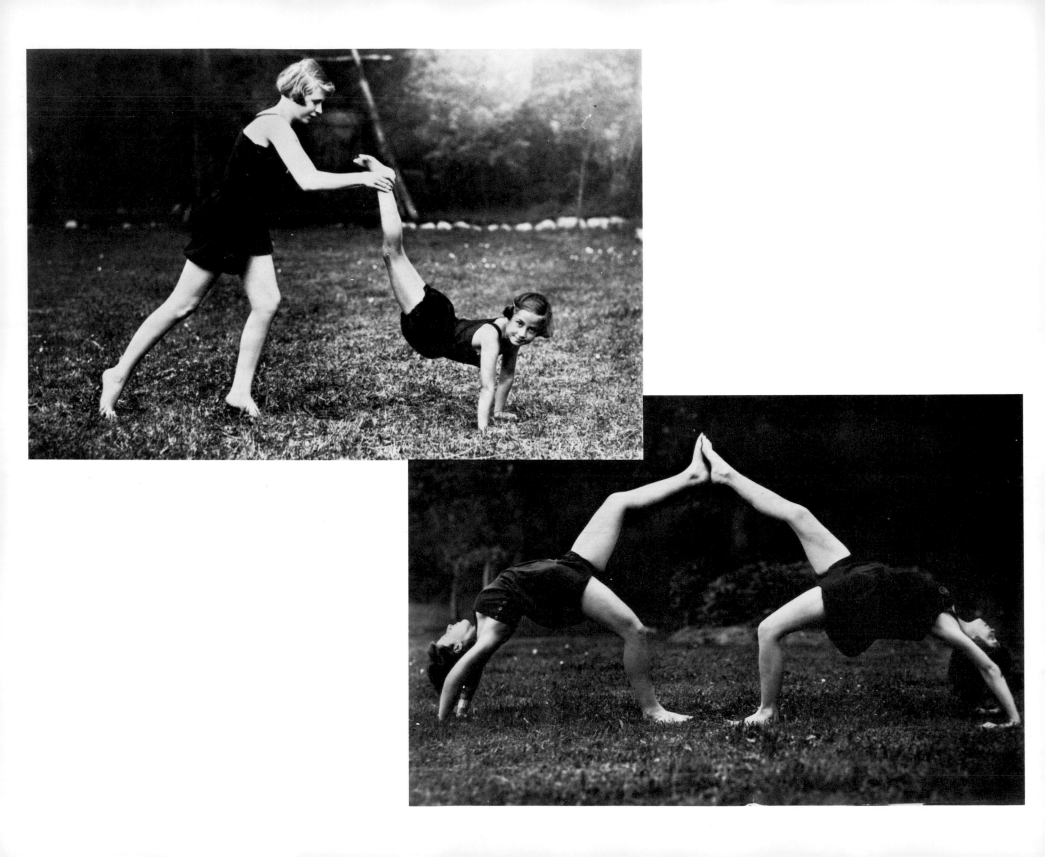

Sissy Moehl was the daughter of a Munich
architect, and a family friend. She taught gym-
nastics, and often conducted her classes in the
garden in Föhring, where Moritz took great
pleasure in photographing them. (This was
sometimes a problem for the performers, as he
used a 5 x 7 field camera, and it required about
twenty minutes to set up each shot. I myself
was never able to understand my mother's
impatience with cameras in general until the
first time I used my grandfather's old camera,
when I at last understood the source of her
irritation.)

*Right: Sissy Moehl, ca. 1924. Opposite, above: Annelise on
her hands. Below: Lotte on the right, with her friend Bams
Weil, ca. 1924.*

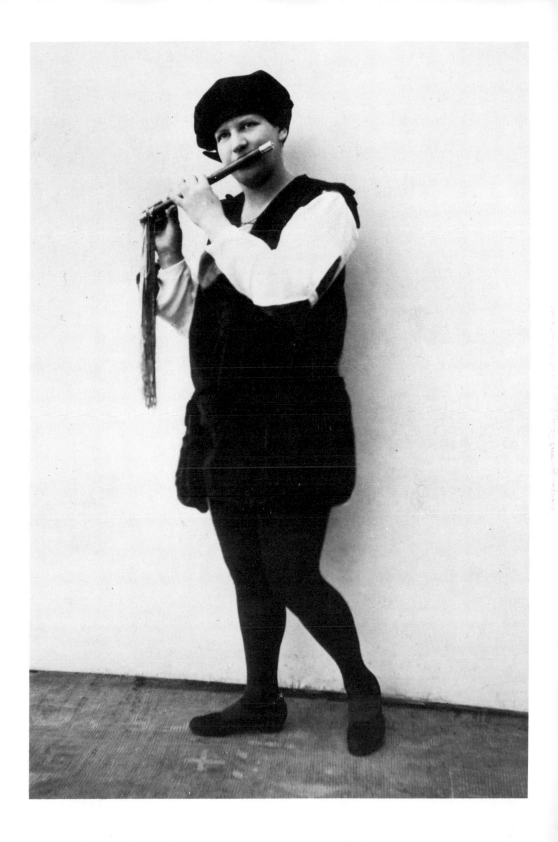

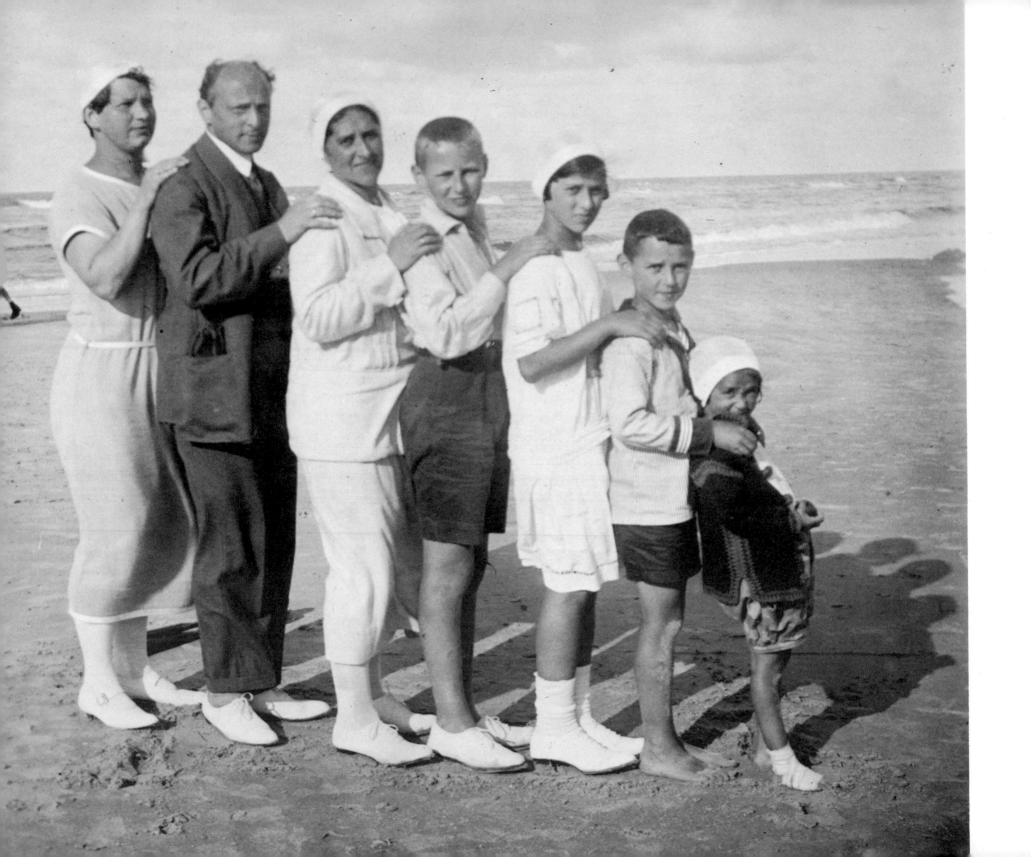

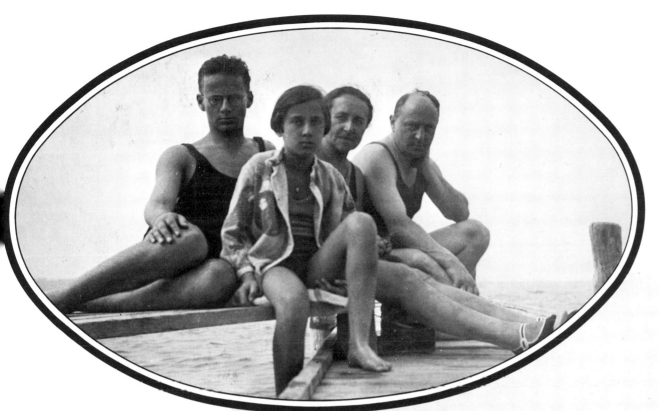

The Summer of 1924

It was an undertaking to transport a family of six and all their luggage from Munich, in Bavaria, to Wangerooge, in the Frisian Islands, and the family usually vacationed in the Bavarian Alps. But my grandparents wanted their children to experience the pleasures of the beach at least once, and so that summer they undertook the two-day journey. Everyone remembers it as a wonderful summer.

Opposite page: Sissy, Moritz, Meta, Rolf, Lotte, Fritz, Annelise. Above: Rolf, Annelise, Meta, Moritz. Right: Fritz, Lotte, Meta, Sissy, Annelise, and Rolf.

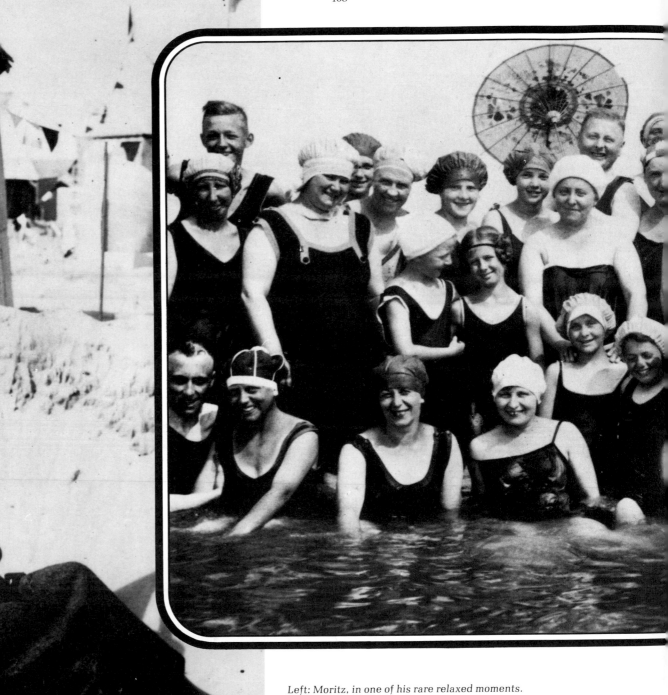

Left: Moritz, in one of his rare relaxed moments.
Above: Fritz is in the first row, third from right;
Lotte and her uncle Karl Wallach in the second
row, fourth and fifth from right; Moritz is in the
last row behind Lotte.

Moritz and Rolf on a seal hunt at Wangerooge. Rolf still remembers how much the experience upset him. He has always been an animal lover (at about that time he was raising snakes in my grandmother's linen closet). The object he is holding is a gull, which he tells me the seal hunters shot simply for sport.

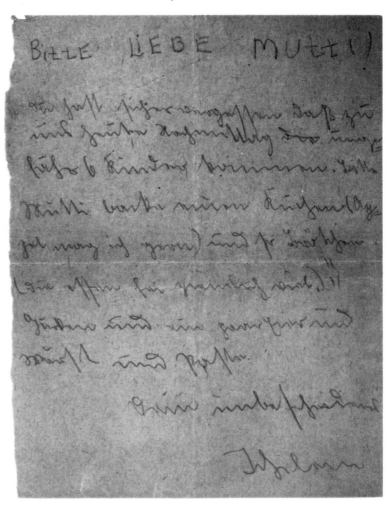

Birthday list

1. a bike
2. a pair of shoes
3. two pairs of socks
4. a bonnet
5. a basket on my bike
6. the blue dress with its matching underslip
7. a deck chair

People to Invite

Illa-la, ~~Nino,~~ Hannelore, ~~Peter,~~ Hannah, ~~Ernst,~~ Margot, ~~Ernst,~~ Suse, Gabrielle, ~~Suse,~~ ~~Kurt,~~ Gertrud, Gerda, Ingeburg, Eliesabet, ~~Margit,~~ ~~Marion,~~ Ursula, ~~Klaus,~~ Lia, Dorle, Ferena, Bams, Auntiefleur

Ichilein, nine years old, 1928

PLEASE DEAREST MUTTI!

I'm sure you have forgotten that there will be about six children this afternoon. Dear Mutti, bake a cake (I like apricot best), and some sandwiches they all eat an awful lot. Cucumbers and some eggs and cold cuts and anchovy paste.

Your greedy
Ichilein

Annelise on her first day of school (opposite) with her friend Hannelore.

When Annelise first learned to talk, she couldn't pronounce her own name, so she called herself "Ichilein." "Ich" means "I," and "-lein" is a diminutive, so I guess you might translate it as "Little me." Today, into her fifties and a grandmother, the name still sticks.

Annelise describes her experiences in school: "As a child, it depended a lot on which school you went to. My principal was very decent, which made a big difference in the attitude of the teachers—except for a gym teacher who was a real Nazi, and who could never forgive my friend and me that we were the best in gym. She would say to the others, 'Don't you have any pride in yourselves, that these two Jew girls are the best in gym here!' I felt more incredulous than angry; personally, we had not really felt any anti-Semitism, so it just seemed incredible."

Hannelore
and Annelise,
1925

My grandmother (right) and her sister Grete, ca. 1927. By this time, Grete had married Theo Loeb and had two sons of her own—Harold and Kurt. Today Harold and Kurt have children of their own, and Grete, a widow, lives in New York.

On the left, Grete goes motoring with a friend of her husband's.

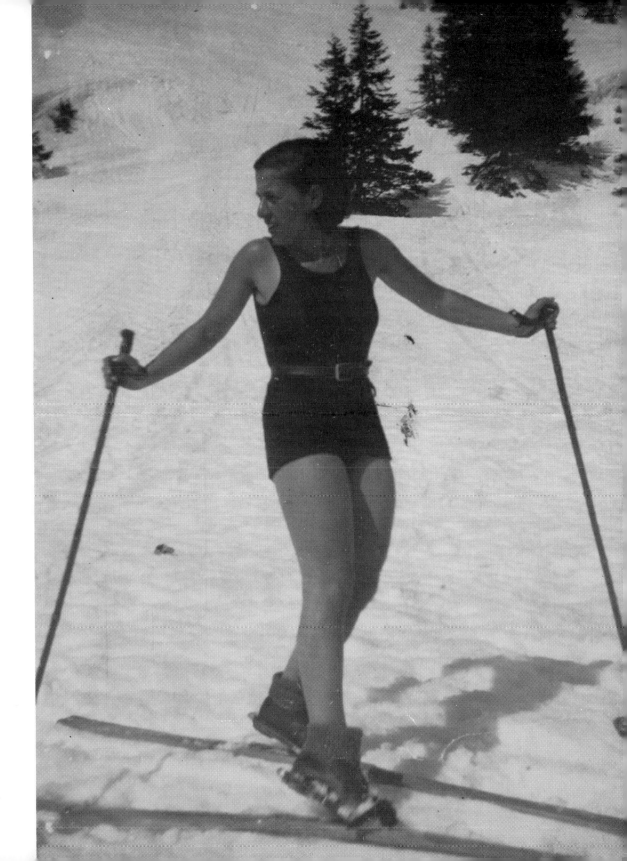

Lotte Grows Up

On this skiing trip, Lotte and Rolf slept in a huge hut on top of the mountain that served as a dormitory. My mother, berthed in a straw-filled upper bunk, suffered agonies between straw and sunburn. The type of bindings my mother is wearing are used today only for cross-country skiing, but at that time they were all-purpose. Nor were there any lifts. With sealskins covering the bottom of their skis, my mother and her friends would take a whole day to climb a mountain, and then spend two or three days skiing at the top, followed by a nice long descent to the bottom.

Right: Lotte, ca. 1928. Left: Lotte and her cousin, Denise Strauss, on the beach at Cabourg in 1929.

The Wallachhaus on the corner of the Residenzstrasse and
Hofgraben, where it still stands today.

At the right, the family in the garden at Föhring, just before
Rolf left for the United States.

The story of how Rolf got to New York may be apocryphal,
as it was told to me not by him but by my grandmother: In
1928, when Rolf turned eighteen, he was invited to sit in on
the Wallach business meetings. At the first meeting, he
opened his mouth to speak, and Moritz told him to be quiet.
Rolf sat silently through the rest of the meeting, then got up,
left the room, went to the American Consulate, and applied
for a visa for the United States.

My mother and her friend Eric Schaal used to play four-hand
piano at his father's house in Munich. On this evening Eric
had invited her to stay for dinner, only to find the pantry
bare. So they set the table with the little food they could find
but with the most elegant appointments in the house, put the
camera on the self-timer, and took this photo.

Lotte and her friend Eric Schaal, ca. 1928. Opposite, from left to right:
Moritz, Lotte, Meta, Annelise, Fritz, and Rolf, ca. 1928.

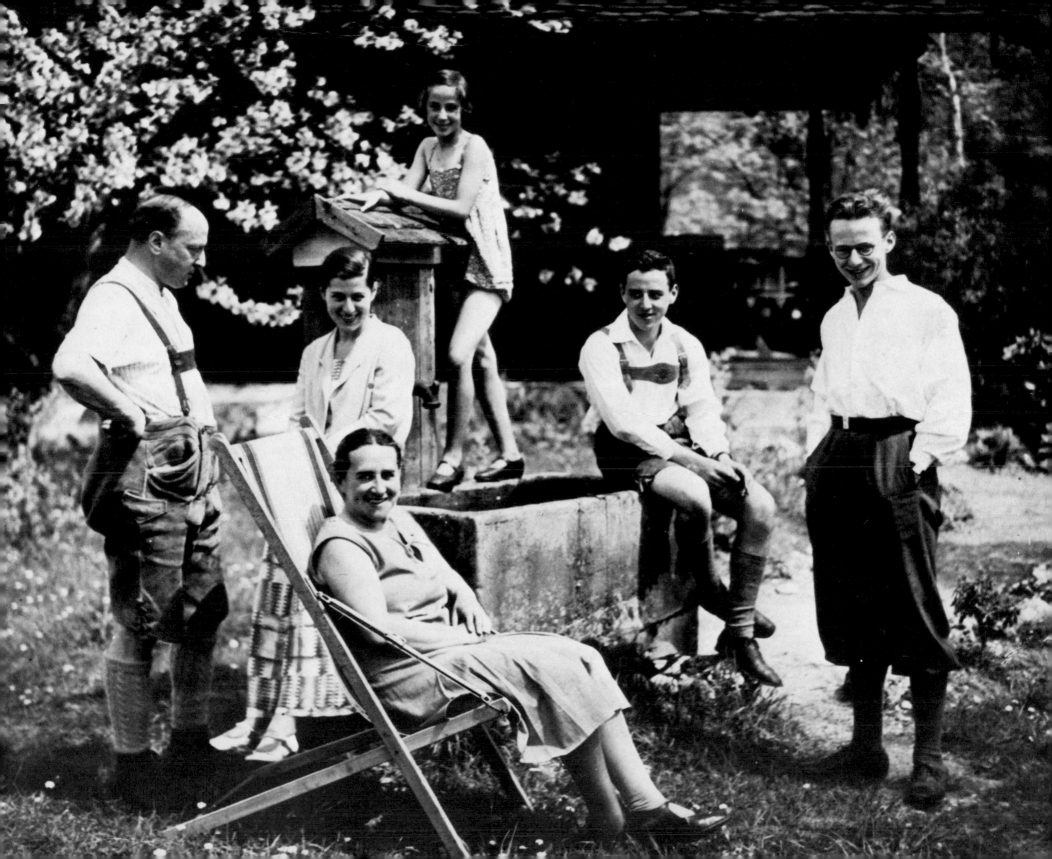

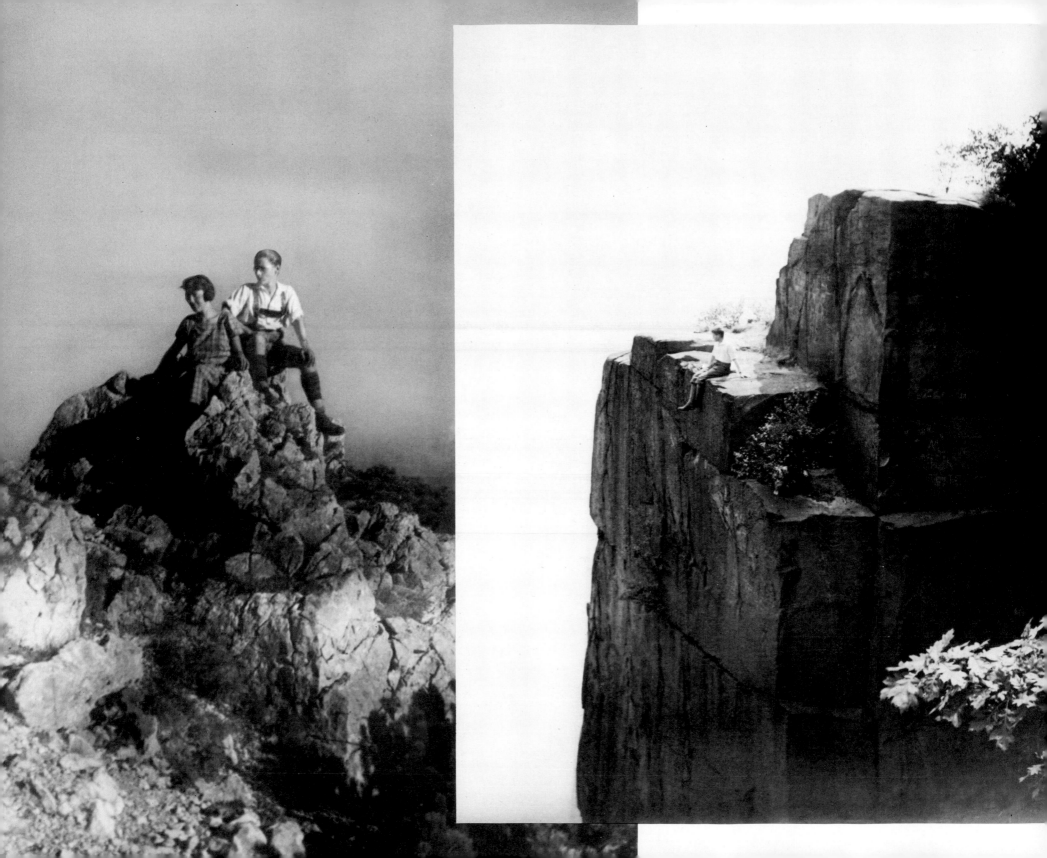

Rolf's falling out with Vati later turned out to be a life-saving event for the family, because by 1936 he was not only a United States citizen, but was well enough established to sign affidavits for ten people, including Meta, Moritz, Fritz, Annelise, and the Karlleni's. As Annelise recently said, "If it hadn't been made easier by Rolf being here, I really think we might have been one of the families stuck over there. I don't think we would have made a big effort. We really didn't believe that it would come to anything like it did...."

Rolf describes his first days in the United States: "At that time—in January 1929—I didn't need an affidavit. I had a letter of credit to the Manufacturers Trust Company for $1,000, and that was sufficient to obtain a visa.

"Eric Schaal [the family's photographer friend from Munich] was here, he called for me at the boat. He had a job in a silk firm, and a room with a family on Haven Avenue, right where the George Washington Bridge comes in now. The house doesn't exist anymore; it was already condemned, and the bridge pillars were already standing. This was up near the 4800-block on Broadway, near 181st Street, and I had credit with the Manufacturers Trust Company at 135 Broadway—so, easy, I thought, I'll just walk down Broadway.

"The next day I started walking at eight o'clock, and by nine o'clock that night I was back: I had walked all the way down to the Battery and back to 181st Street.

"The next day Eric laughed at me, he said, 'You go by subway.' I went with him to 42nd Street (he worked in the 30's), and he said, 'Now remember this entrance. Go where you want to go, but just remember how to get back here, and when you want to go home, go over there, and take the subway to 181st Street.' Easy. Oh, it was—but he didn't tell me that the subway branches at 96th Street; some trains go east, while others go west. That time it only took me *three* and a half hours to walk back to 181st Street!"

Rolf and Eric used to go hiking on the Palisades. They would take a ferry at 181st Street across the river, and then walk along the Palisades (today this is all fenced-off private property), and up the rocks to Alpine, opposite Yonkers. From there they took the Alpine ferry back (neither of these ferries exists any more), then the streetcar from Yonkers to the subway at 241st Street.

Rolf had no intention of staying in the United States permanently, and came back to Munich every year, until, in the mid-thirties, he realized (and I think he was the first member of the family to do so) just how dangerous the situation was, and began to make preparations to get the rest of the family out. Here he is, framed by the lifesaver, on one of his numerous crossings.

Opposite: Rolf and a friend in the Alps; and Rolf on the Palisades, 1929.

Meanwhile, in Munich, Annelise had celebrated her ninth birthday, and this is the report she sent to Rolf in New York.

> Dear Rof how are you. Do you like it there. I'm looking forward to when you come back to us. You forgot my birthday, you didn't have to give me a present, but you could have sent me a postcard I even got a bike I ride it to Führing and ride on the bumpy path by the garden I can get on and off. Now I don't always have to ride with Vati on his bike. And I got a big ball and a football too a hoop, three pairs of socks, a jumprope an alarum clock, two dresses two nightgowns a slate a bathing cap a board game a pair of shoes a book, two coloring books and a lot of chocolates. I am a naughty girl because I haven't ever written to you
>
> A hug and kisses Ichilein

Rolf, in New York, had an earache. He was rooming with Eric Schaal, and when Eric came home and saw Rolf sleeping with his socks around his head, he set up floodlights and took this photograph. Rolf never even woke up.

Annelise, growing up, describes what it was like to live under the shadow of Hitler: "Hitler lived just a half a block away from us, and when I walked home, every so often he and his entourage passed by and honked and everybody stopped and saluted, and of course I wouldn't do that, but it was most uncomfortable..."

Annelise had a non-Jewish boyfriend, and the two of them were constantly uneasy because friendship between Jews and Aryans was illegal: it was called *Rassenschande* (race shame). They were frightened to be seen together; she looked Jewish and he definitely did not. One day she was crossing the square near her home, and a policeman came toward her. She thought, "This is it," that he was going to arrest her. He said, "Don't you know that you have to walk around the square and not across it?" That was all he wanted—but Annelise was ready to faint.

Above: Rolf, 1929. Opposite: Annelise, ca. 1936. Following page 121: My mother, shortly after her marriage to my father, Eric Hanf, in 1933. And opposite, the arbor of the Hanf house in Mönchen-Gladbach.

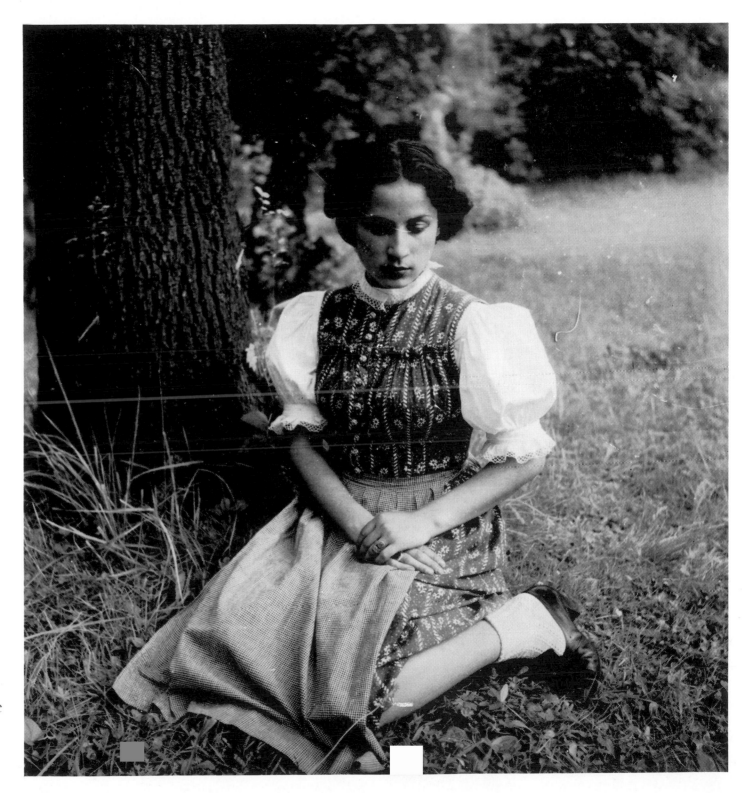

Annelise

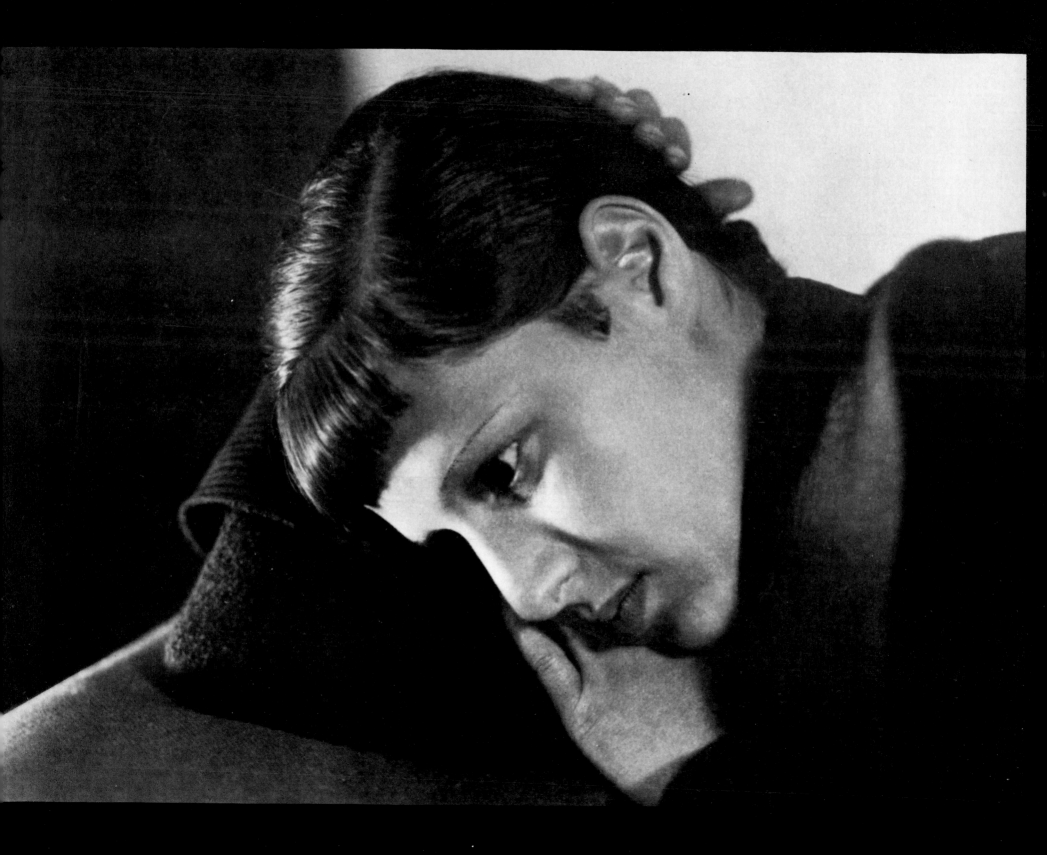

The Hanfs

Marta
and Alfred

My grandparents

Marta Grünfeld, Meta's girlhood friend from Düsseldorf, married Alfred Hanf, a textile manufacturer from Mönchen-Gladbach, in the Rhineland. This is their wedding photograph.

Years later, Meta's oldest daughter Lotte married Marta's oldest son Eric—they are my parents.

Opposite are Marta, Alfred, and their family at Norderney in 1919. From left to right—the nurse, my aunt Lotte, my uncle Rudy, my uncle Günther (in the pram), and Eric, who would become my father. Marta and Alfred are at the far right. The two other adults are Alfred's brother Leopold and his sister Fanny.

There is an apocryphal story about how both my mother and her sister-in-law came to be named Lotte: when Meta and Marta were in school together, they both missed the same exam question about the Liese-Lotte Krieg (a seventeenth-century war concerning the hereditary land rights of Elizabeth, Countess of Orleans), and thus vowed that they would name their first daughters Lotte.

Marta Grünfeld Hanf and Alfred Hanf, November 23, 1906.

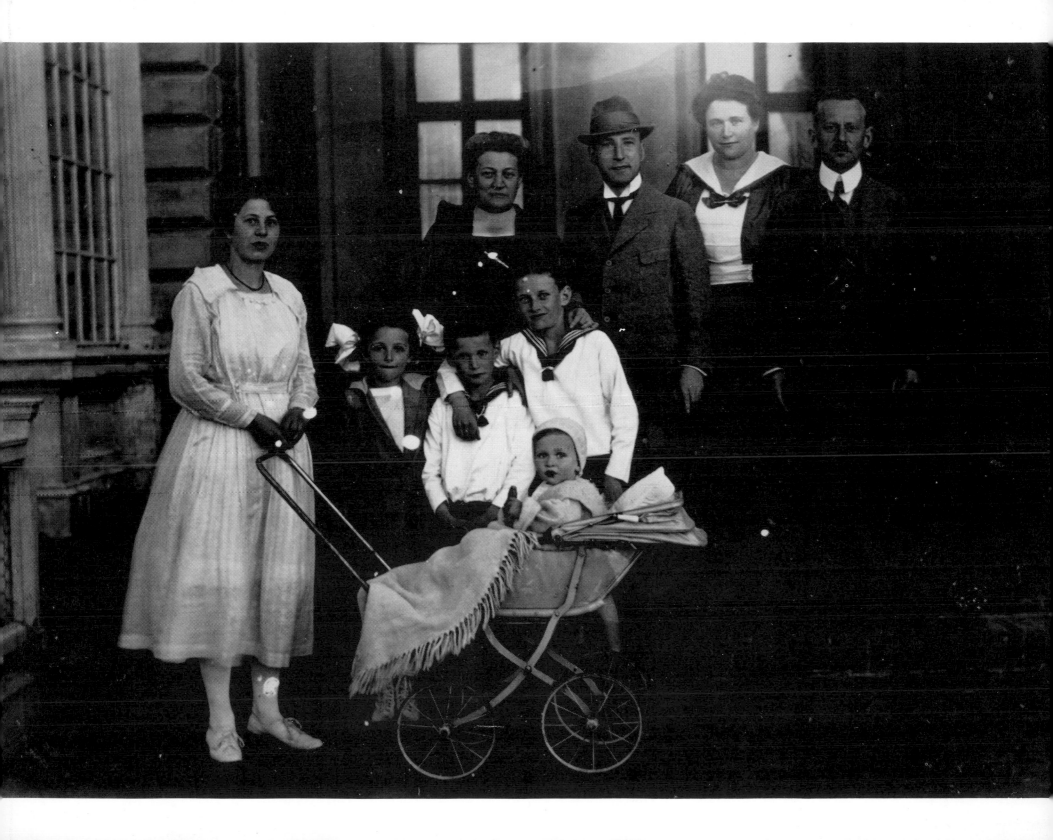

I know almost nothing about my father's immediate family; my paternal grandparents and their siblings, that generation which is the link between the past and the present, have all died. What my father, his sister, and two brothers have been able to tell me is very little, and the Hanfs, unlike the Wallachs and the Strausses, apparently did not have the same interest in documenting themselves visually.

However, there is a good deal of genealogical material available, since one of my Hanf ancestors, an eleventh great-grandfather, was a court Jew and, according to the *Encyclopedia Judaica*, "17th-century head of Prague Jewry." About this man, Jacob Bassevi von Treuenberg, there is considerable literature, including a book privately printed in 1922 by Siegfried Porta, my great-grandmother Henriette Hanf's only brother. This book begins with a missive of Ferdinand II naming Bassevi as court Jew and listing the exemptions and privileges to which he and his family were entitled. It endowed him with a coat of arms, which in itself was of great significance in those times.

Siegfried Porta then goes on to give an extensive description of Bassevi's life and works, and the destinies and destinations of his immediate descendants. At the back of the book is a detailed family tree, of which I have included (see p. 128-9) only the part that is pertinent here—his direct relationship to my immediate family.

Porta writes eloquently, not only of Bassevi and his life, but of the times in which he and his family lived and the difficulties the Jews were forced to endure. The fact that this man, Bassevi, did not renounce his religion and convert to Christianity after he was given a title was no small achievement in itself, as there was tremendous pressure on the Jews to convert.

Jacob Bassevi von Treuenberg (1570–1634), the son of Abraham Basch of Prague, was probably the first European Jew outside Italy to be ennobled. As one of the leading financial geniuses of Bohemia, at that time the center of European politics, Bassevi and his brother Samuel were involved in large-scale trading, and in 1599 obtained a safe conduct from Emperor Rudolph II exempting them from the restrictions imposed upon most Jews. To be made a court Jew as early as 1599 was, according to Porta, rare. In 1611 these privileges were confirmed by Matthias II, and to them was added the right of Bassevi to settle in Vienna.

During the Thirty Years' War, because of the emperor's financial needs, Bassevi formed a consortium with Prince Karl von Liechtenstein and the imperial general Wallenstein, which leased the Prague mint for an enormous sum of money and issued devalued coinage. Bassevi (one supposes because he was the Jew) received the lowest profit per mark within the consortium; nonetheless he provided the financial expertise and bought most of the necessary silver from abroad. In 1622 he was granted a coat of arms by Ferdinand II, which appears in the foreground on page 123 and in the background here. Apparently this still did not give Bassevi unqualified noble rank, for shortly afterward he requested other privileges, and these too were granted.

Bassevi, despite his privileged position in the imperial court, maintained his Jewishness and was considered a "princely Jew" by his fellows. He took an active part in Jewish communal life. When the imperial troops left Prague in 1620, and after the Battle of the White Mountain (1621), he influenced Wallenstein to organize a guard to protect the Jewish quarter from pillage, and subsequently obtained for the Jews of Prague about forty houses bordering on the Jewish quarter. He was largely responsible for apportioning the communal taxes, which as a result made him a controversial figure in the Jewish community. After Prince Liechtenstein's death in 1627, the authorities took steps against the former members of the consortium, and Bassevi's property was confiscated and he arrested. Wallenstein was able to get him released, and he then lived at Wallenstein's residence until 1634, when Wallenstein was murdered. Bassevi died a few weeks later. After his death, all his privileges were declared illegal and were abrogated.

The climate of Jewish life during Bassevi's time can well be illustrated, I think, by enumerating some of the privileges granted this man as court Jew, for most of them were in fact exemptions from the restrictions imposed on other Jews. The main content of the missive of title as given by Ferdinand II in 1622 is as follows:

"Because of his upright way of life and his faithful service, Bassevi of the royal and imperial chamber . . . with his wife, children, and household, is taken as a court Jew into special protection and asylum, which freedoms given to him by the former monarchs Rudolf and Matthias are not only confirmed, but several others added. He, his heirs and descendants, shall be allowed to live anywhere within the imperial crownlands, be it in cities, towns, or villages, whether or not there be Jews living there. Also in Prague, Vienna, or wheresoever he desires. He may buy houses and deal in wholesale or retail businesses. Also, he personally, as well as that which he owns, is exempt from any kind of taxes or duty. So be his possessions when he travels with the royal entourage exempt from all customs charges, and he is permitted to take quarters in the imperial train. Further, he and his descendants shall henceforth and forever be allowed to use in seals, imprints, paintings, gravestones, businesses, and in any other way he desires, a written crest. He will enjoy with this the rights, freedoms, advantages, and honors as all other crest bearers enjoy them in the Holy Roman Empire. Further, he is accepted as imperial servant, to do and perform all that which can be expected of a faithful servant by his master. Also, the above-mentioned title von Treuenberg shall be given him so that he and his descendants shall use the surname in their signatures, titles, and seals; and finally, he shall have the right to be under no other jurisdiction or any other tribunal than the administration of the court. He is also given the right to erect a synagogue in his house in Prague."

Upon his request, further privileges were granted Bassevi by the emperor and seconded by von Liechtenstein:

1 that he receive with his title and crest all the benefits, rights, and advantages as those enjoyed by others, namely, that he be allowed to leave his belongings in a last will and testament;
2 that his houses be free of all city and state taxes and surcharges;
3 that he be allowed to lend money on real estate;
4 that he be allowed to trade with any kind of goods;
5 that he pay the same duty, customs, and surcharges as the Christians;
6 that he be allowed to live in Vienna and buy a house there;
7 that he be allowed to settle in and buy houses in any city in the kingdom of Bohemia, even if no other Jew be living there;
8 that he be allowed to build a school in the Prague ghetto, and that this school should have the same freedoms as the *Meiselschule* (synagogue); and
9 that he and his family should not be answerable to any court of law but that of the king.

Despite the fact that these benefits were granted, not only for him but for all his heirs and descendants, the sun of imperial favor did not shine for long on his family after Bassevi's death. Through a series of controversies, his riches were confiscated and his sons lost one piece of property after another. The dissipation of his riches and the decline of his reputation were followed by the destruction of this titled family; the "glorious epoch of Prague" was over. The descendants of his son Leo are supposedly to be found in Italy; his sons Samuel and Aharon and two of his granddaughters emigrated to Poland. The rest of the family, which had lived partly in Prague and partly in Vienna, were affected by the general expulsion of the Jews from Vienna and Austria decreed in 1669 by the emperor Leopold I.

"Disappeared, lost, and scattered in the upheaval of the world are their traces."

The line between Jacob Bassevi von Treuenberg and the Hanf family, as given by Siegfried Porta, follows.

Generation

I

JACOB BASSEVI VON TREUENBERG
b. 1570
d. 1634, Jungbunslau
m.
1 Kaudel, daughter of Abraham
2 Hendel, daughter of Abraham Geronim
d. 1628
3 ?

II

ARON
b. ?
d. ?, Poland
m.
Channa, daughter of Dr. Salomon (Lublin)
b. ?
d. ?

III

MARCUS JAKOB LEVI
b. ?
emigrated to Poland
d. ?, Doktorbusch
m.
Pesche
b. ?
d. ?

IV

ABRAHAM
b. ?
d. ?, Bruchhausen, 58 years old
m.
Fradchen
b. ?
d. ?

V

ISRAEL
b. ?
d. ?
m.
Esther
b. ?
d. ?

VI

SALOMON LEVI
b. 1728
d. 1781
m.
1 Sara Seligman (no children)
2 Fradel Mansbach (Bielefeld)
b. ?
d. ?

VII

SELIG
b. 1757
d. 1825
m.
1 Jetta Michaelis-Jena
2 Gudula Dahlberg
3 Marianne Herz

VIII

LEVI SELIG PORTA
b. 1779
d. 1858
m.
Rachel Schwerin
b. ?, Mengeringhausen
d. ?

IX

SALOMON PORTA
b. 1802
d. 1890
m.
Johanna Bernstein (Borgentreich)
b. ?
d. ?

X

HENRIETTE PORTA
b. 1843
d. 1896
m. (in Witten)
Elias Hanf
b. ?
d. ?

The Hanf Family Tree

XI

ROSA HANF
b. 1869
d. 1941
m.
Max Reidenberg
b. ?
d. 1932 ?, Vlotho
one son and one daughter*

FANNY HANF
b. 1870
d. 1961, New York City
m.
Samuel Rosenbaum
b. ?
d. ?, Berlin
two daughters (dec.)

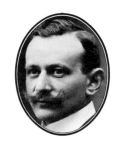

ALFRED HANF m. 1906 MARTA GRÜNFELD
b. 1872, Mönchen-Gladbach b. 1887, Düsseldorf
d. 1944, Friesland (Holland) d. 1967, Lugano

LEOPOLD HANF
b. 1876, Berlin
d. 1939, Freiburg
m.
Liesel Stein
b. ?
d. ?
one daughter*

XII

LOTTE WALLACH m. 1933 ERIC HANF
b. 1911, Munich b. 1907, Mönchen-Gladbach
— Cornwall, Conn. — Cornwall, Conn.

RUDY HANF
b. 1910, Mönchen-Gladbach
— Montreal
m.
1 Ruth ? (div.)
2 Jessie ? (div.)
3 Sylvia Rabinowitz (1973)
b. ?, Russia
— Montreal

LOTTE HANF
b. 1912, Mönchen-Gladbach
— The Hague
m. 1933
Carl Haas
b. 1908
— The Hague
two children

GÜNTHER HANF
b. 1917, Mönchen-Gladbach
— Montreal
m. 1966
Audrey Drisdale
b. 1919
— Montreal

XIII

BRIGITTE HANF m. 1959 JOHN ENOS
b. 1934, Mönchen-Gladbach b. 1924, Hingham, Mass.
— Oxford (England) — Oxford (England)

CATHERINE HANF
b. 1938, Mönchen-Gladbach
— New York City
m. 1963
Andrew Noren (div.)
b. 1941, Santa Fe, N.M.
— New York City

XIV

EVE HANF-ENOS
b. 1971, Oxford (England)

*Died in concentration camps

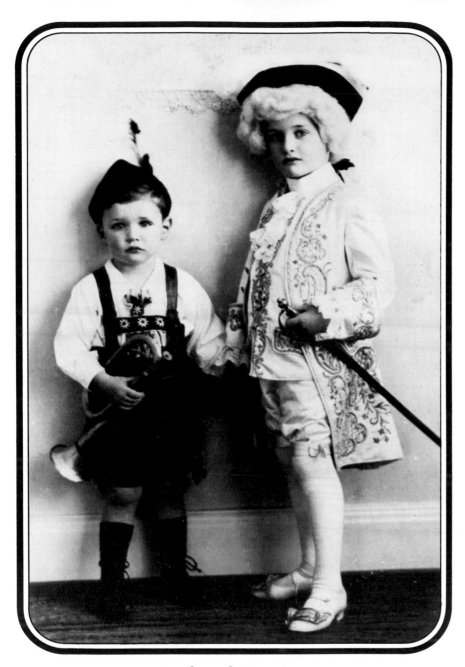

Rudy and Eric

My father was born in 1907. Here he is with his younger brother Rudy, ca. 1915. Again my father (on the right), probably thirteen years old. And opposite, with the rest of the family on the beach at Nordwijk on the Dutch coast. My father is reclining at right, next, his sister Lotte, and Rudy. In back are Marta, Alfred, Günther, and the governess.

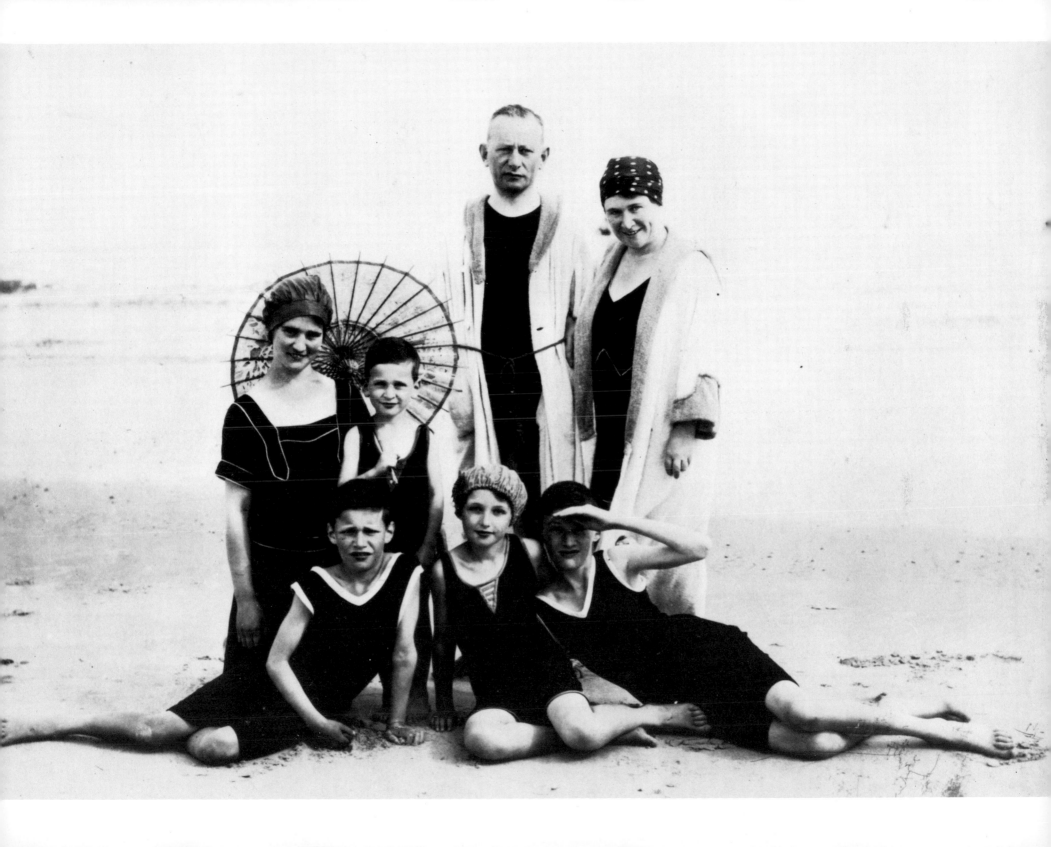

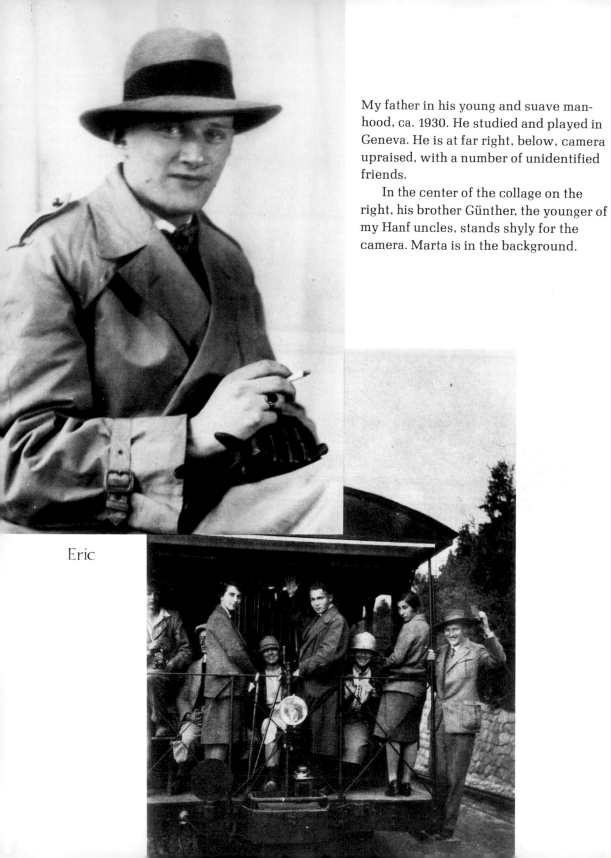

My father in his young and suave man-
hood, ca. 1930. He studied and played in
Geneva. He is at far right, below, camera
upraised, with a number of unidentified
friends.

In the center of the collage on the
right, his brother Günther, the younger of
my Hanf uncles, stands shyly for the
camera. Marta is in the background.

Eric

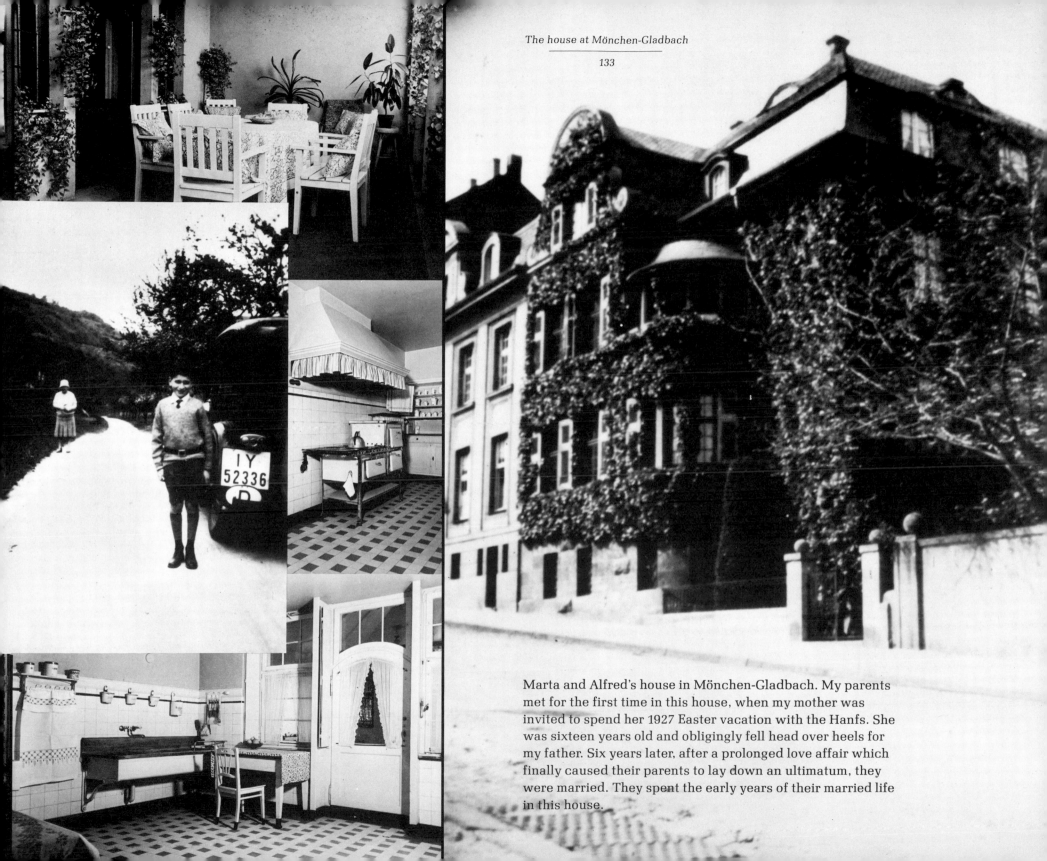

Marta and Alfred's house in Mönchen-Gladbach. My parents
met for the first time in this house, when my mother was
invited to spend her 1927 Easter vacation with the Hanfs. She
was sixteen years old and obligingly fell head over heels for
my father. Six years later, after a prolonged love affair which
finally caused their parents to lay down an ultimatum, they
were married. They spent the early years of their married life
in this house.

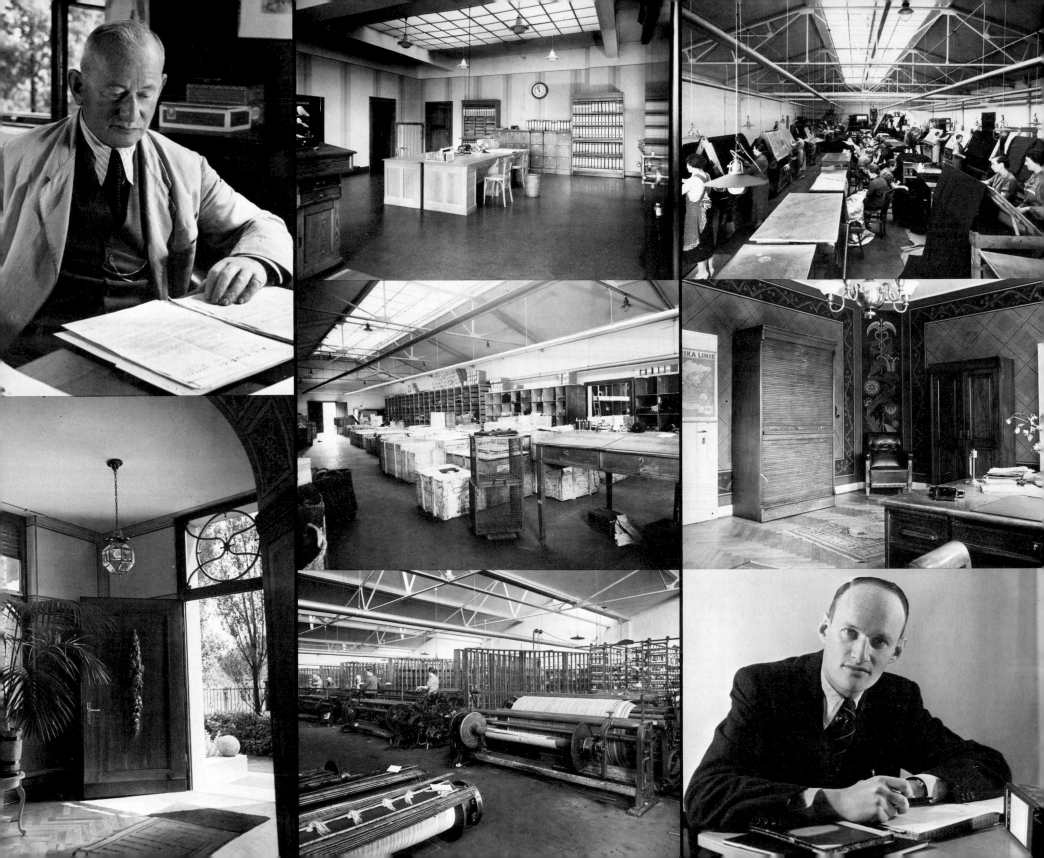

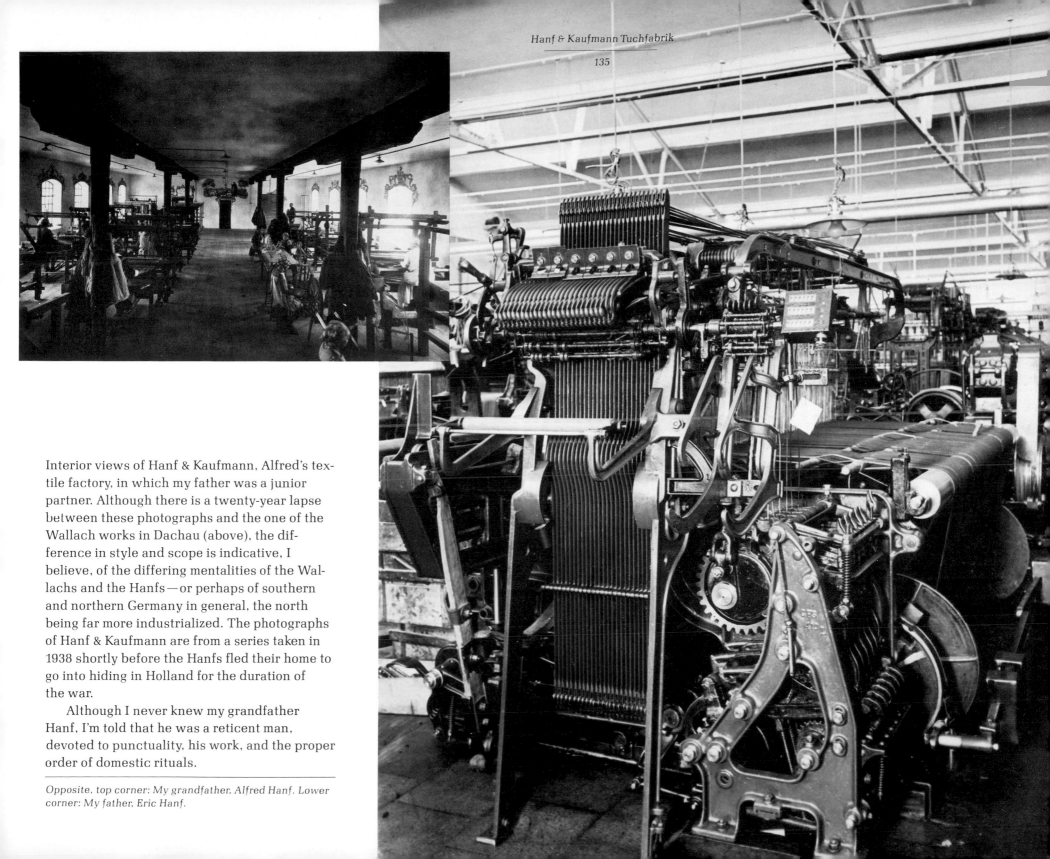

Interior views of Hanf & Kaufmann, Alfred's tex-
tile factory, in which my father was a junior
partner. Although there is a twenty-year lapse
between these photographs and the one of the
Wallach works in Dachau (above), the dif-
ference in style and scope is indicative, I
believe, of the differing mentalities of the Wal-
lachs and the Hanfs—or perhaps of southern
and northern Germany in general, the north
being far more industrialized. The photographs
of Hanf & Kaufmann are from a series taken in
1938 shortly before the Hanfs fled their home to
go into hiding in Holland for the duration of
the war.

Although I never knew my grandfather
Hanf, I'm told that he was a reticent man,
devoted to punctuality, his work, and the proper
order of domestic rituals.

*Opposite, top corner: My grandfather, Alfred Hanf. Lower
corner: My father, Eric Hanf.*

Lotte and Eric's first child, my sister Brigitte, was born in 1934. She talks about her early years in Chapter One of her "autobiography," written for a high-school assignment:

Not to be read in class Brigitte Hanf
 English II-6

The first few months of my life, starting from August 10, 1934, were spent doing what most other babies do, namely, crying, sleeping, eating, and making extensive use of the local diaper service.

Next I learned to smile, sit, stand, crawl, and walk in that succession.

When I was a year old, I was taken to the seaside in Holland where I met a seven year old boy who declared his love for me and before I knew it we were engaged. His older brother, being eleven, considered this a grave injustice and complained bitterly to his mother that he should have first choice of a wife.

A month after this, my father caught the flu and on one of my visits to his bedside, I stuck a thermometer under his arm, waited a minute, pulled it out, and proudly announced "fifteen!"

My grandmother, who was living with us at the time, called me her "sunshine." Once, after looking at a book of "Ten Little Nigger Boys," one of which died of sunstroke, I was asked what my name was. "Sunstroke," I replied.

One morning, I was watching my father shave himself and started idly playing with a razor blade. Suddenly the blade slipped and just about cut my finger off. I calmly announced to my father "Daddy, I bumped myself on the razor comb."

I saw alot of my grandmother in those days, and she frequently told me stories of nature.

One day, my mother was singing to me, a nursery rhyme having to do with bees. "That reminds me," I interrupted,

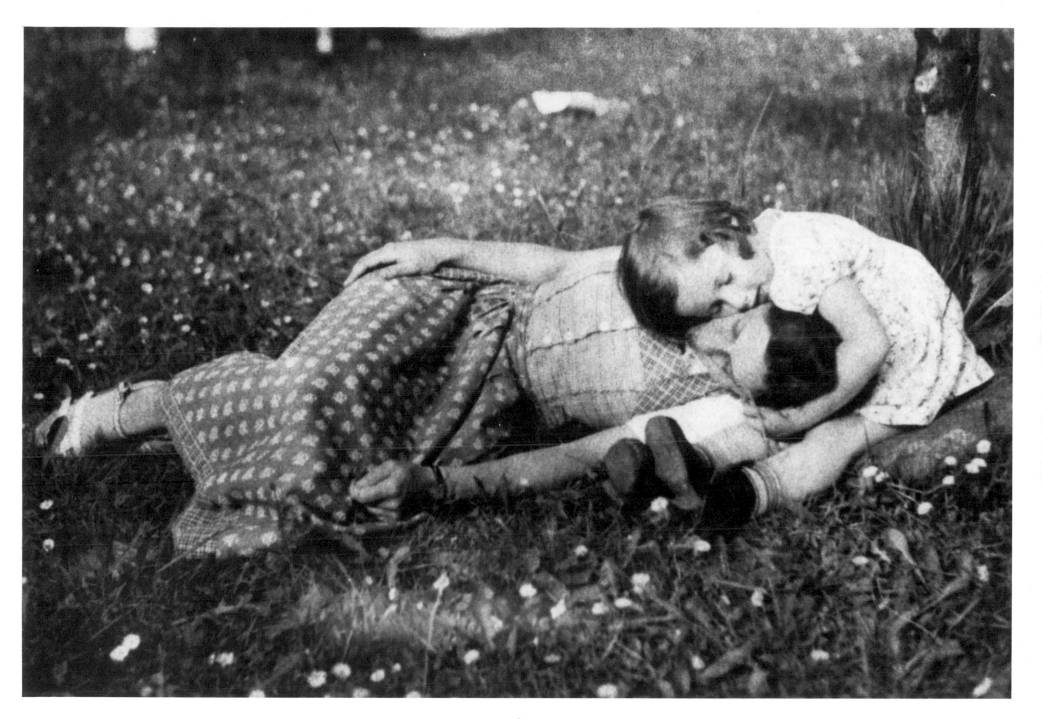

Lotte and Brigitte

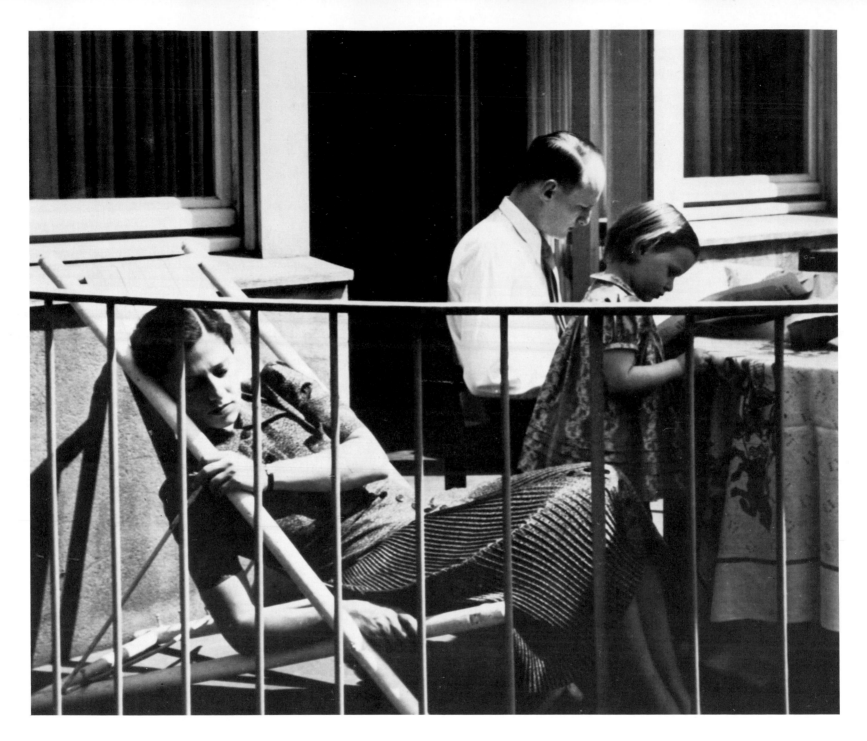

Lotte, Brigitte, and Eric Hanf, in 1937, shortly
after they moved into their own apartment in
Mönchen-Gladbach.

"Granma said that the bees will be coming back soon, and they'll collect some more jam for us."

When I was a few months old, I had a one and one half year old wire haired terrier, "Maxi," given to me, who became my constant companion as I grew older. We had a small wading pool in the back yard, and "Maxi" and I used to play in this for hours at a stretch—splashing each other and diving for stones.

On my third birthday, I was given a little toy candy store which my uncle always kept well stocked. It had a small counter and cash register that sounded a small bell when the button was pressed, and a little bell over the curtained door. There were tiny jars of hard candy on the shelves and red and white striped candy sticks on the walls.

At the age of five and one half I entered first grade, and it was there and then that my social life began.

In the autumn of 1937, my parents took a three-week vacation in Mittelberg in Kleines Walsertal, a small piece of neutral territory between Bavaria and Austria. My mother was pregnant with me, and she, my father, and Brigitte retreated to this peaceful mountain for a brief respite from the increasing Nazi flag-waving and hysteria.

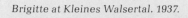

Brigitte at Kleines Walsertal, 1937.

As often happens, I, as a second child, was photographed much less than my older sister Brigitte. Also, I was born in a troubled year—1938. These are two of the few baby pictures taken of me before we left Germany.

By the time I was born my parents had made plans to leave Germany. They had acquired visas for Australia, and were intending to leave in 1939. Because people leaving Germany then were prohibited from taking more than 10 marks (about $2.50) in cash out of the country, my parents bought a number of old and rare books (including a facsimile of the Gutenberg Bible), which they were to send to a dealer in Holland, who had told them which titles he wanted and would pay for. These books were crated by a packer in Düssel-

Brighton, Melbourne, Australia, 1939 and 1941.

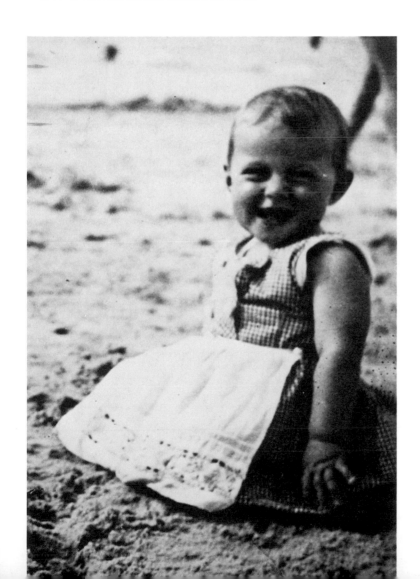

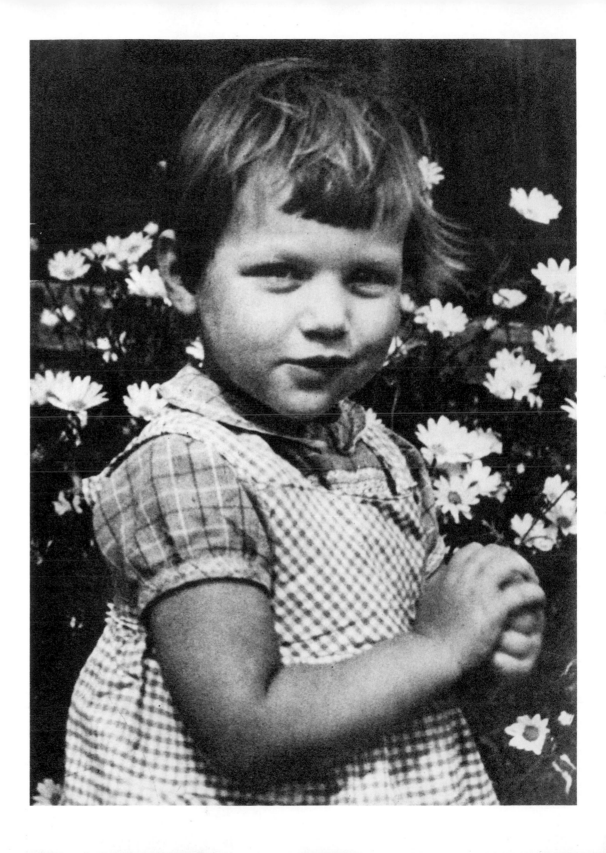

dorf to be sent to Holland, but never reached there. Instead, my parents received a communication from the Nazi customs officials stating that the books had obviously been bought with the express purpose of being sold outside Germany, and therefore were being confiscated. At the time, my parents had a tight-lipped and rather suspect housekeeper, and my mother is convinced, to this day, that she was a Nazi informer.

In any case, their plans to leave the country were realized somewhat earlier than they had foreseen: my father was one of the thousands of Jewish men and boys who were taken during the pogrom that followed Crystal Night (November 9, 1938). When he was thrown into jail, my father happened to have a rather large sum of money on him, and bribing the guard, he was permitted an interview with the Gestapo. After being told that we had visas to leave the country, the Gestapo gave us ten days to get out. Ten days later we were in Holland, waiting for the boat that would take us first to Ceylon, then to Australia. My parents had also bought a complete Leica system, and a very expensive fur coat, which they naïvely believed they could sell just as expensively in Australia—a subtropical country.

The photograph on the left was taken in Moritz and Meta's apartment in the Possartstrasse in Munich. Since my grandfather's life and his work were so involved with German culture, he was a prime target for the Nazis. One day in 1937, they came to the apartment to take all things that were *Kulturgut*—cultural objects. They asked my grandmother whether there was anything she particularly wanted to keep. She pointed to a set of antique pewter cannisters, saying that she was keeping them for her son Rolf. The cannisters were the first things that the Nazis took.

During the war, the Nazis systematically looted Europe—museums, collections, art galleries—and their booty was later found stashed in caves and hiding places all over the continent. The authorities of the Allied Occupation asked my grandfather to itemize everything that he could remember being taken from

him, for, in one of those stashes, they had found a crate with the name "Wallach" still on it. Among other things in that crate were the pewter cannisters. They are now in Rolf's house in upstate Connecticut, where I photographed them in 1974.

Julius and Moritz had many friends among the Bavarian peasants with whom they did business, and they were warned ahead of time about what would happen after Crystal Night; their friends advised them to disappear. Moritz stayed in Munich, but Julius and a cousin took their rucksacks and got lost in the mountains. This is one of Julius's memories about those days:

A SAVING GRACE—NOVEMBER 11, 1938

Glorious autumn days, sun over rust-red forests. It would have been marvelous hiking weather, had Hitler's merry Jew-hunt not been declared.

The hunt had already been under way for three days without having caught the two of us, my cousin and me. We were wearing loden-gray, carrying rucksacks, in hobnailed boots, loden hats—were everywhere and nowhere—with friends in the Alten foothills, with craftsmen and peasants who had been our closest friends for years. But then we had to find an inn; we were hungry and thirsty from our wanderings.

So after cautious inspection of house and courtyard, we stopped at the "Gasthaus zum Kloster-Gebräu." It was a

beautiful area; from below rose the thunderous roar of the Isar, with rafts of lumber lashed together floating down it. The landscape breathed peace and quiet. We two were the only ones who felt uneasy. We had no proof of Aryan grandmother, no visa, no anything. All we had was some gallows humor and the Tyrolean hats on our heads.

A couple of fishermen and lumberjacks sat at the table with us. We talked cautiously, only about the weather and the height of the river, and asked the innkeeper about the possibility of staying overnight. "No, best not," he said. It could be dangerous for him, even though he wasn't a party member. That meant more wandering, despite the nearby cloister, the holy fathers, and the church.

Nowhere did we see a sign: "Jews out" or "Jews forbidden"—until, outside in the courtyard, we went to find the well-known little house with the heart carved into its door: there it hung, quite high and all crumpled up: "Jews are not welcome here."

Leave it there, Herr Innkeeper. There will be a time when such deeds will also be acknowledged.

————————

My grandfather's store in the Residenzstrasse (opposite) when Hitler was having a parade. All the store windows in town had to be draped, in order not to detract from the spectacle that was Hitler.

On the day after Crystal Night, Moritz found his store windows sprayed with acid. Wherever there was a clear space, he painted the outline of a house window, and inside, he decorated the interior as a peasant farmhouse, with a young girl preparing for bed. The sidewalk in front was soon crowded with amazed and admiring spectators (see his biography of the Volkskunsthaus Wallach, p. 149).

Above: Hitler relaxes in his Berchtesgaden eyrie amid Wallach curtains. The legend reads: "Our contented Leader." The curtain fabric is the same design that today covers the couch of my New York City apartment. Below: Julius, ca. 1938.

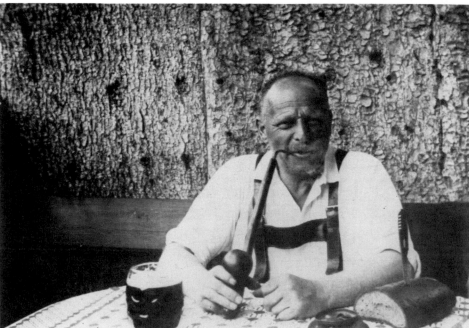

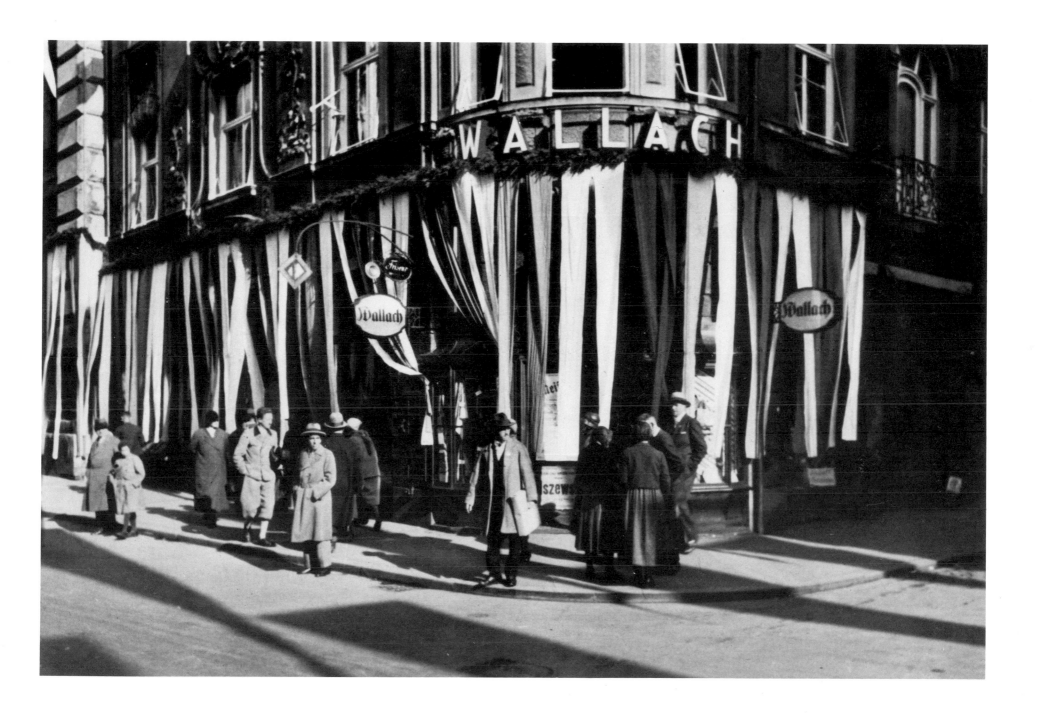

In 1933, Rolf married Violet Hirschfeld, an American girl of
German extraction. They first lived in Jackson Heights, Long
Island, where, after a series of manual jobs, he set himself up
in the import business. Later they moved to upstate New
York and, still later, to rural Connecticut.

Violet Hirschfeld Wallach and Rolf Wallach in 1935 and in 1958.

In the early thirties, when my uncle Fritz had finished high school in Munich and was deciding what to do next, Moritz, with a good deal of foresight, said that he didn't mind what Fritz chose to study as long as it was a trade that he could use anywhere. So Fritz learned cabinet making.

He describes his decision to leave Germany: "The thing that made me decide to get out was when we got a commission to design a big restaurant in Coblenz—do the entire interior and make all the furniture. My friend Jan Ballett was an art director and an artist, and he was to do the murals. We had the whole thing worked out, we had the commission, we did the estimates, made all the designs. One day I got a phone call from the owner of the restaurant; he told me: 'I'm terribly sorry, but I've been threatened if a Jewish firm does the restaurant; we can't go through with it. I hope times are going to change, but for the time being it's too dangerous.' And that's when I decided to leave. But Jan (who wasn't Jewish) did do the murals (somebody else did the restaurant)—and the most fantastic thing was when I came with the American army in a half-track through Coblenz, that building was entirely destroyed, except for that one whole wall with Jan's murals!"

Annelise got here by lucky accident. Everyone who applied for an American visa got a number, and the number she got (she applied late, in 1938) was a high one. At that time the family didn't know how urgent the situation was and she was told it might take three years or so. Then, a month after she'd gotten the number, she had a letter from the American consul at Stuttgart to appear for her visa hearing. She got her visa and left. She knew it was a mistake, because after she'd left letters kept arriving for her saying that she'd have her hearing in due course. Had she waited, she would never have gotten out.

The eligible men in the family either enlisted or were drafted into the American military when they reached this country (those still classified as enemy aliens were not allowed to enlist, but they were drafted); and many, because they spoke German, were put into intelligence units and/or wound up back in Germany. One cousin told me of his experience.

He was one of the Jews rounded up on Crystal Night and thrown into the camp at Dachau. During the five weeks that he was incarcerated (most of the prisoners taken at that time were subsequently released; this roundup was a grisly warning by the Nazis), he and his fellows were forced to watch more than three hundred men murdered by ingenious Nazi methods. On Christmas Day there was a Christmas tree, and under it, one of the prisoners was beaten to death.

My cousin knew there was only one way to keep his sanity, and that was to fight the Nazis; do personal battle, shed his own blood to shed theirs. He swore that one day he would stand in the reception room of the President's palace, where, on New Year's Day 1933, Hindenburg had handed Germany to Hitler.

When my cousin reached the United States, he enlisted in the army and fought in all the major European battles, including the liberation of Paris, the Battle of the Bulge and the invasion of Normandy. And in June 1945, he fulfilled his promise to himself; he stood in that room in Berlin and urinated against its crumbling walls.

The day after Crystal Night, Rolf went to Washington to get visas for my grandparents. Although later on the United States government became much less cooperative about helping Jews to emigrate, that day they were all stunned by the news. Rolf went first to the Department of Justice, from there was sent to the Department of the Treasury, and then from one place to another—there was much telephoning back and forth; but by nightfall he had their visa numbers. He went back home and telegraphed the numbers to the American Consulate in Stuttgart, and Moritz and Meta went there and got their visas.

However, my grandfather was not prepared to give up so easily: he had been fighting the Nazis' demand for his business for almost two years, and he had no intention of surrendering without a struggle.

THE VOLKSKUNSTHAUS WALLACH *(continued)*

After the assassination of the Paris Embassy employee (November 8, 1938) came bad times. Many Jews were taken to concentration camps and horribly brutalized. The windows of Jewish stores were destroyed with acids. We too had this unpleasant experience. Very simply, I decided to have one front window represented as a peasant's house in the form of a painting, and wherever the window was clear and not touched by the acid, we painted a little window. Inside, I decorated a peasant's bedroom with real antique furniture and a scene representing a young girl going to bed. Never has there been an exhibit with such an attendance. Crowds walked up and down in front of that window, adults lifted children onto their shoulders so they could see too. Everyone talked about it.

I tried to sell the company. Everybody refused to buy; they said it was too personal a business, and they would not know how to continue it in the same tradition.

Witte, the manager of the Bavarian branch of the Reichskulturkammer [Nazi Board of Culture, one of many organizations devoted to the Aryanization of Jewish businesses], demanded that I show him the business in Munich and the factory in Dachau. On leaving the factory, he said: "In the pie that is to be divided, your company is the raisin which I want for myself." I knew that he was a bankrupt book dealer, and asked him if he had the necessary funds. He said he was going to look for silent partners. He got help from Dr. Fischer of the Chamber of Commerce, who told me many times that I would have to agree to Witte's terms.

Before this, we had an unpleasant experience. Our Vertrauensrätin [Nazi representative] had taken part in the Hitler uprisings and was therefore permitted any "subordination," and antagonized the other employees against me. She always did exactly the opposite of what I asked her to do, and constantly arranged meetings during office hours; it was impossible to conduct an orderly business. I discussed this with my lawyer, Mr. Heins, who told me to give her notice; even though she was an early member of the Nazi Party, he would back me up. This affair was brought before the labor counsel, Dr. Frey. Everybody lied, screamed, and raged, and then Dr. Frey asked me to tell my side of the story. I told them the facts, and said that this was the first time in my thirty-seven years of business experience that I had had such complicated differences with my employees, and that here I was, facing the board, as the accused. Dr. Frey replied that although he knew our firm had always had a good reputation, he could not condone my giving notice to this employee, but he would demote this Miss Malinowski. The woman could say nothing; she left, which was exactly what Dr. Frey had intended her to do.

With regard to selling my business, I turned, naïvely, to Witte's superiors in Berlin, and received the following letter from the president of the Reichskammer der Bildenden Künste [Reichs Board of Art]:

THE PRESIDENT	*Berlin W 35,*
	Blumeshof 6
Reichskammer der bildenden Künste	*Telephone: 21 92 71*

December 11, 1937

Herrn
Moritz Wallach
MÜNCHEN
Mauerkircherstr. 13/I

After thoroughly assessing your personal qualities and qualifications, you do not possess the necessary status and reliability to participate in the furtherance of German culture in a responsible position. Therefore you do not fulfill the conditions of membership in the Reichskulturkammer of Art, or for an exemption according to paragraph Nine of Bylaw Number One, of the 1st of November 1933, concerning execution of the laws of this agency. In accordance with Paragraph Ten of this bylaw, I decline your admission to the Reichskammer of Art as well as your exemption according to Paragraph Nine of the same, and forbid you to participate in the distribution

or sale of cultural objects. . . . I recommend that you give to an auctioneer or art dealer who is a member of this Board whatever art treasures are still in your possession.

For this reorganization or dissolution of your business, I allow you two months.

You may file a petition of objection against this notice with the President of the Reichskulturkammer. Any such petition is to be addressed to me. At the same time, I request that you undertake to change the name of your firm so that the word "Art" no longer appears.

By order of
Hoffmann

Signed:

My answer to the Reichskammer was that I did indeed have the qualifications to handle objects of culture, and that Herr Witte definitely did not. Therefore I asked them to call a spade a spade: I didn't have the proper baptismal certificate and therefore was being forbidden to pursue my business.

Again I asked Witte if he had the money to buy me out, and again he answered that he would find silent partners, and that I could count on being adequately paid under the present conditions. He brought me a Mr. Hunnius, whom I knew as a partner in the firm of Cord in Berlin, and therefore could assume was serious. The contract was made out to Witte and Hunnius, and endorsed by the authorities. However, as I learned later, Hunnius did not become a silent partner; he withdrew. Meanwhile, together with Witte and the employees, we had taken inventory. The estimate, minus designs, printing blocks, and furniture, turned out to be 220,000 Reichsmarks. The factory was evaluated at around 175,000 marks; fittings and so forth another 25,000; altogether there was a sum of 400,000 marks [about $100,000] involved. Witte was not willing to pay, and asked a Nazi colleague to do

yet another inventory. The result was still too high for Witte's taste. So he had the factory appraised once more, and came up with an estimate of 125,000 marks. The contract was no longer valid anyway. I was told that the businesses in Dachau and Munich had to be handed over one after the other against cash.

On August 1, 1937, at seven o'clock in the morning, Witte came and demanded the keys. He had deposited 100,000 Reichsmarks at the Bank of Pfalz to be paid as a first installment when the deed was signed. I let myself be duped. . . . The affair of the 100,000 marks was a lie just like thousands of others that were made to honest people.

An unsettling time followed. Discussions with the government, the finance division, and other authorities, and negative results from all of them. Finally, on March 1, 1939, 110,000 marks were paid, which immediately disappeared for taxes, then more, special taxes to be paid by Jews and by those who wanted to leave the country. We needed what I still had in the bank to get out of the country. Then came a letter from Witte and his lawyer, Seuffert: "If you do not sign over everything within forty-eight hours, we will hand you to the Gestapo." I answered: "I prefer to be handed to the Gestapo as long as you are not prepared to act according to your government's instructions."

The office for foreign currency demanded that all outstanding debts in foreign currency would have to be collected before they would give me the affidavit which was necessary for the issuance of our passports. So I had to cable my son Rolf in New York to please pay the $300 he owed me. Now I was told there would be no more obstacles to our leaving.

But meanwhile, the Nazi officials still did nothing, until I finally said I would report them to their superiors, and then they threw our papers at my feet.

On March 22, after all sorts of difficulties, my wife and I could at last board the steamer *Manhattan*. At the last minute I turned over the affair with Witte and company to my younger brother Karl, who had been in the business for the last

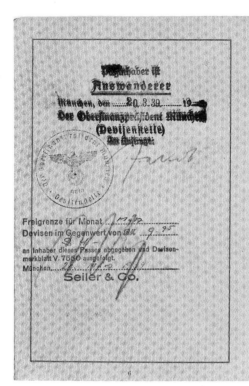
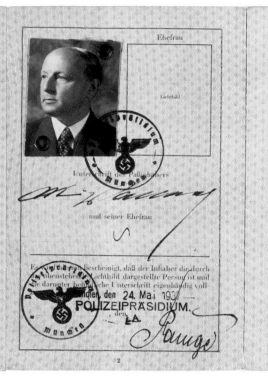
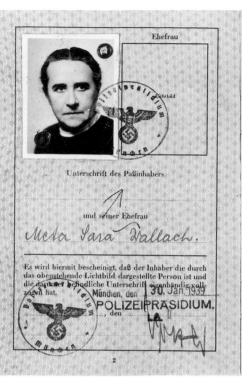

two years (after he could no longer pursue his own business in Westphalia). Later Karl and his wife were able to come to New York, via Russia, Manchuria, Japan, the Dominican Republic, and Panama.

———————

Other members of the family were not so fortunate. Rolf had sponsored ten members of the family, and he was not permitted to vouch for more. My grandparents arrived in New York in 1939 with $10 worth of marks in their pockets. In order to get out of Germany one had to have money; in order to get into this country one had to have connections—preferably relatives.

During the years 1939–1942 there was endless correspondence between the Wallachs in the United States and those left in Germany; for those left in Germany, these letters were their last link with hope. They were written almost daily—hundreds of them, single-spaced, on silk-thin stationery. First they were full of hope and travel arrangements, later they became tokens of love and despair. Herewith two letters from Max and Melly. The first was written fairly early on; the second is the last letter I found from them. They were among hundreds of letters kept in a suitcase by Liesel Rothstein, one of my mother's cousins:

Paderborn
March 13, 1940

My dear ones,

We have heard here that as of the 18th of this month, the clipper will no longer fly to Bermuda, so that we can only hope that these lines will still reach you. We had stopped writing

directly as of the 14th of February, as there was no hope of anything reaching you. The last we heard were a few lines from Fritz [Wallach], with the extensions of the affidavits that we obtained on January 16. You've already heard our news—that again these documents will not be sufficient for the consulate. At least that's what I understood from your wire via Karl [a Wallach brother]. According to that telegram, you had already, on the 25th of last month, sent new documents directly to Stuttgart, or at least were preparing to send them within a few days. As of now, I have no knowledge of how you managed it, nor have we heard anything from Stuttgart about their arrival. In other words, if this mail was sent via the Bermuda clipper, we'll have to consider it lost, or at the most expect to receive it in several months. Karl consoled us with the assurance that you were up to date as to how to expedite this. In this case, the documents would have been directed to the U.S. Consulate in Washington, D.C., as diplomatic mail. Another possibility would have been to send them via air mail through Adolf [in Amsterdam]; in other words, via neutral foreign territory. That is how friends of ours have managed to maintain continuous connection with the U.S. You have probably heard from Mr. Lewin about our troubles here, and I hope that in the event that the papers have not been expedited by one of the above ways, you will send duplicates upon receiving this letter. The duplicates should then most probably reach us. Practically speaking, we are still at the same point as we were three months ago. I am sorry to have caused you these endless troubles and expenses, but I'm sure that you understand our desperate situation. If, and we do hope so, Stuttgart is finally satisfied with these new papers and gives us visas, we will still have to face the difficulty of obtaining foreign money for the journey: we cannot count on the "Hilfsverein" [aid organization], and our efforts through Adolf and Edmund in this matter were in vain. Even though the Fuldas have contacted our benefactor for some help, it is at most doubtful that, under these circumstances, even the good will of this gentleman can overcome these obstacles. One could really envy all those people for whom this miserable question of money was relatively easily solved, thanks to well-off friends or relatives in a foreign country. As I write this, I think especially of the Loebs [Meta's sister and brother-in-law] who will soon be able to leave, and I think of Edmund's sister and brother-in-law (Kabaker–Stuttgart) who, thanks to a rich brother-in-law in Buenos Aires, are in the same happy position. Also Else (Stuttgart) [a cousin] will soon be able to depart since she, as the grandmother of a little American, will get her visa without difficulty.

And now, a few lines about something other than our wanderings-tangle: we happily overcame the cold winter and are fine, and I do hope the same for all of you and yours. I hope also that you have been able to realize the business prospects you mentioned. I presume also that you have heard directly from Betty [another Wallach sister], Karllenis [Karl and his wife Leni], and Grete [Ohletz—another Wallach sister], and I just want to tell you that healthwise everyone is fine, even though they too most desperately look forward to their emigration. By now, Grete has already had good news from her three boys. And, a pleasant duty I still have to discharge is to congratulate you, dearest Meta, on your birthday. Perhaps the coming year will fulfill that which this one did not, and will also bring good health and better finances. And this is how I want to finish this detailed letter—I look forward to hearing from you soon.

Always,
Your Max

P.S. Even though it's actually a little early yet to mention it, there is still the question of how to move our goods. We will have to forget about a lift [crate] as we initially planned, because of the new situation. We intend to pack the travel luggage in three to four trunks, each approximately 3 cubic meters, and take only the most necessary things. One of these

should travel with us for our most immediate needs. We would be very thankful for your immediate opinion.

Again, our most loving thoughts—

Max

Paderborn
June 6, 1941

Dear all of you together,

The last days have brought us all great worries and disappointments, and you I suppose the same. All at once everything again looks gray on gray, and every hope for an early reunion with you is pushed back far into the future.

We hope that these lines find you in good health, and that you, dear Karllenis, have in the meantime found suitable work. If only we don't lose contact with you, that would be the bitterest. Yesterday we received a detailed letter from Betty, they are in the same mood. . . . The weather is so radiantly beautiful and does not at all fit the grip on our souls. Besides our own worries, we are also so concerned whether the Lowenbergs will reach their ship on the 27th of the month. They have already been in Berlin for some days but they had a terrific upset, in that there were Portuguese visas for only three people. For the youngest daughter that may present no problem, since children under fourteen can travel on their mother's pass. But now it looks as though poor Ate must remain here alone. That would be awful.

Not much new has happened, we are so preoccupied that we can hardly think of anything else.

Please, dear ones, do as much as you can for our Franzl, and don't forget him. That is still the saddest for us.

I hope we will hear from you soon, this is only a short token of love. Max has just gone out, and I send you his love.

Be well, be all of you warmly embraced by your

Melly

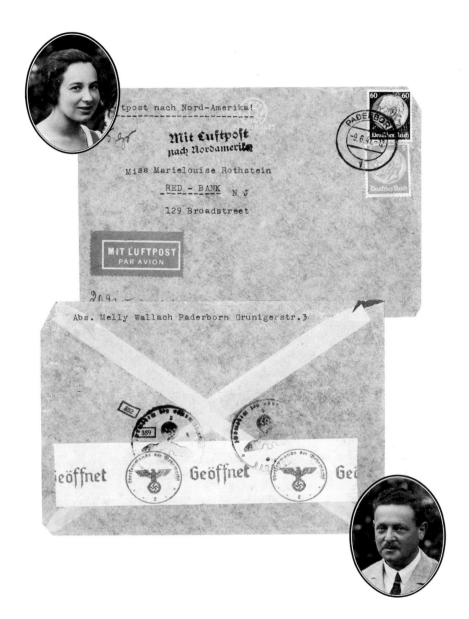

Max and Melly died in Theresienstadt, a "model" camp in Czechoslovakia, no one knows quite when. Their son Franzl, sent to England with a children's transport, is today a professor of mathematics at the University of Bath. He has three children of his own (see photographs on p. 54).

Liesel (Marie Louise) Rothstein, who had been brought to this country by my uncle Rolf (her sister Anny found a sponsor in England), moved heaven and earth to get her mother and stepfather out of Germany.

TELEPHONE 2581-J

MARIE LOUISE
THE SEWING ROOM
129 Broad Street
Red Bank, N. J.

Enclosures with affidavits for

__Mr. and Mrs. Hugo Epstein__

Affidavit of Support Marie Louise Rothstein
Affidavit of Support Rita Feilman

Letter from The Second National Bank Red Bank N.J. notarized
Letter from Union Dime Savings Bank New York "
Letter " Law Offices Florence Forgotson "
Letter " The Dress Shop (Irma Groell) "
Letter " Lysbeth Geran "
Letter " Straus Co. "
Letter " Mr. Rolf Wallach "

Proof of payment of incometax as well
financial statement to follow as soon

According to advise I received I also
papers to the Department of State in
to be forwarded to your address.

I have completed and sent to Washington
proof of my legal immigration.

W. WARREN BARBOUR
NEW JERSEY

COMMITTEES:
COMMERCE
MANUFACTURES
NAVAL AFFAIRS
PUBLIC BUILDINGS AND GROUNDS
RULES

United States Senate
WASHINGTON, D.C.

February 27, 1941

Dear Sir :

I am very glad to write you in behalf of
Miss Louise Rothstein, of Red Bank, New Jersey, who is desirous
of bringing her parents, Hugo and Betty Epstein, who are now
residing in Munich, to this country.

I have known Miss Rothstein since she came
to live in my home community of Red Bank and know her to be honest,
industrious and successfully in engaged in her own business which
would make her well able to provide also for her parents.

I am sure that she has no political affiliations
of any sort and that she subscribes to American principles and precepts
solely.

Any consideration you may be able to grant the
application of her parents for a visa will be appreciated.

With kind regards

Sincerely yours,

W. Warren Barbour

American Consul
Munich
Germany

WWB
11

ROLF WALLACH
LOCUST, NEW JERSEY
TEL. ATLANTIC HIGHLANDS 118

To the American Consul General February 11th
 1 9 4 1
Stuttgart, Germany

Dear Sir:-

I, Rolf Wallach, am a citizen of the United States.

My cousin, Marie Louise Rothstein, who is now endeavoring
to bring her parents to this country, came here herself
over two years ago, under my sponsorship.

I am happy to say that my cousin unbelievably quickly
has understood to assimilate herself. After the first few
weeks, during which she stayed with my wife and myself,
she started her present business, together with her friend
and former partner, of making to order and altering fine
lingerie and dresses.

My cousin is very conscientious and industrious and I am
certain that she will be perfectly able to make a home
here for her parents.

Thanking you for your courtesies, I am,

Very truly yours,

Rolf Wallach
ROLF WALLACH

Subscribed and sworn to
before me this 13th day
of February, 1941.

Melinda Marassi

NOTARY PUBLIC OF NEW JERSEY
My Commission expires 1/30/42

THE DRESS SHOP
161 BROAD STREET
RED BANK, NEW JERSEY

February, 1941

To The American Consul General,

Stuttgart, Germany,

Dear Sir,

This letter is written at the request of
Mrs. Marie Louise Rothstein, and will convey
to you, that I have known her and
her partner, Miss Rita Feilman for the past
two years.

They have established a business "The
Sewing Room", which is going well, and
they are also well thought of in this
community.

In all my dealings with them, I have found
them most reliable, their obligations are
met promptly and I do not hesitate
to recommend them highly.

If they are fortunate enough to bring
Mrs. Rothstein's parents to this country,
I know they will never become a burden
to anyone.

Very Truly yours

Irma M. Groell

IN REPLY REFER TO
FILE No. 811.11 EPSTEIN, Hugo
JCJ/MLB

THE FOREIGN SERVICE
OF THE
UNITED STATES OF AMERICA

DEPARTMENT OF STATE

AMERICAN CONSULATE

Stuttgart, Germany, March 31, 1941.

My dear Senator Barbour:

I have your letter of February 27, 1941, concern-
ing your interest in the immigration cases of Hugo
Epstein and his wife, Betty Epstein, residing at Ger-
maniastrasse 36, Munich, Germany, the parents of Mrs.
Louise Rothstein, a resident of Red Bank, New Jersey.

As the quota to which the aliens are chargeable
is approximately current for qualified applicants who
can travel, consideration may be given to the cases of
Mrs. Rothstein's parents as soon as they can show that
their support in the United States is assured and that
they are able to proceed to the United States, provided
quota numbers then are available for their use.

A thorough search of the visa files fails to reveal
any record of the receipt at this office of evidence of
support in behalf of the aliens who registered as non-
preference applicants on the German quota immigration
list on September 23, 1938, and were assigned waiting
number 27525. If the aliens will be dependent to any
degree for support upon relatives or other persons in
the United States, such persons should send to them for
presentation at this office evidence to show their fi-
nancial ability and willingness to contribute to the
aliens' support, having regard for their obligations
toward the members of their own families or other
persons.

Each

The Honorable
W. Warren Barbour,
United States Senate,
Washington, D. C.

- 2 -

Each person assuming responsibility for the sup-
port of the applicants should furnish an affidavit
setting forth his income, resources, obligations and
expenses in order to show the margin of income which
will be available for the aliens' support. Furthermore,
in order that this office may be in a better position
to evaluate the probative force of the evidence sub-
mitted, the affiant should set forth his relationship
to them and furnish corroborating evidence in accord-
ance with the suggestions contained in paragraphs (3)
and (4) of the enclosed mimeographed circular to which
attention is invited.

You are assured that upon the receipt of such evi-
dence as the interested persons may care to submit, the
cases of these applicants will receive careful and sym-
pathetic consideration under the immigration laws and
regulations.

I am, my dear Senator Barbour,

Sincerely yours,

Samuel W. Honaker
American Consul General

Enclosure:
Mimeographed circular.

Home Life Insurance Company
of New York

HARRY JACOBY AGENCY, INC.
GENERAL AGENT
1440 BROADWAY, NEW YORK, N. Y.
LONGACRE 5-5055-6-7-8-9 AND 5060

HARRY JACOBY, PRES.
LEONARD L. ROTHSTEIN, VICE PRES.

NATHAN B. COHEN, C. L. U., EDUCATIONAL DIRECTOR
HENRY LEVINE, SUPERVISOR
ALVIN WOLFF, SUPERVISOR

April 29, 1941.

Miss Marie Louise Rothstein
129 Broad Street
Red Bank, N. J.

Dear Madam:

On my return from a vacation, I found your letter of March 26th.

I would like to help you but regret very much that I will be unable to do so, due to the fact that I have just signed several affidavits and do not feel that I would like to sign another at the present time.

I hope you will be successful in obtaining an affidavit from another source.

Very truly yours

Leonard L. Rothstein.

LLR:SH

THE WHITE HOUSE
OFFICIAL BUSINESS

PENALTY FOR PRIVATE USE TO AVOID
PAYMENT OF POSTAGE, $300

Miss Marie Louise Rothstein

129 Broad Street

Red Bank

New Jersey

BUY
DEFENSE SAVINGS
BONDS AND STAMPS

WASHINGTON D.C. JULY 17 3-PM 1941

THE WHITE HOUSE
WASHINGTON

July 16, 1941

My dear Miss Rothstein:

In the absence of Mrs. Roosevelt and her Secretary, I am writing to acknowledge your letter of July 3. Mrs. Roosevelt regrets that all she can do in matters of an official nature is to refer them to the proper authorities. I, therefore, am sending your letter to the State Department for further consideration.

Very sincerely yours,

Ralph W. Magee

Administrative Officer
Social Correspondence

Miss Marie Louise Rothstein
129 Broad Street
Red Bank
New Jersey

W. WARREN BARBOUR
NEW JERSEY

COMMITTEES:
COMMERCE
MANUFACTURES
NAVAL AFFAIRS
PUBLIC BUILDINGS AND GROUNDS
RULES

United States Senate
WASHINGTON, D.C.

July 14, 1941

Dear Miss Rothstein :

I hope by this time you have received the forms from the State Department as I called them as soon as I got your letter and asked to have them sent to you. I hope that this may be helpful and in any event I feel, with you, that it is best to try everything.

If you will send the forms to me when you have filled them out I will be glad to send them to the State Department with a letter asking to have everything done for your parents.

With kind regards and best wishes

Sincerely,

Miss M. Louise Rothstein
129 Broad Street
Red Bank, N.J.

LL

EMIGRE SERVICE BUREAU

OF NEW JERSEY

682 HIGH STREET
NEWARK, N. J.
MARKET 3-5237

August 26, 1941

OFFICERS
Chairman
Joseph Steiner
Vice-Chairmen
Leo M. Abrahams
Abner W. Feinberg
Sidney M. Goldmann
Corresponding Secretary
Julius R. Flink
Recording Secretary
Mrs. Bernard Friedman
Treasurer
Howard Mack

EXECUTIVE BOARD

Asbury Park
Charles Frankel
Bayonne
Nathan Suskind
Max Rosenthal
Elizabeth
Harry Lebau
Freehold
Bernard H. Weiner
Hackensack
Benjamin M. Gordon
Hoboken
I. H. Brand
Mrs. L. S. Greenberg
Jersey City
Mrs. Samuel H. Milberg
William Hirshberg
Lakewood
Morton C. Steinberg
Linden
Benjamin Rosen
Dr. H. M. Glasscon
Long Branch
Jules Golden
Joseph Finkel
Morristown
Morris Epstein
Newark
Dr. Rita Finkler
Mrs. Gustav F. Heller
George Luxner
Samuel B. Lesser
Charles Mandel
Mrs. Jack F. Meyers
Leopold Rich
Daniel Shiman
Michael A. Stavitsky
Mrs. Arthur L. Stern
New Brunswick
Philip M. Brenner
Passaic
Mrs. Barney Goldstein
Paterson
Meadon Merrill
Perth Amboy
Alburt Lucs
David I. Stepacoff
Plainfield
Henry M. Dreier
Henry Lords
South River
Dr. A. A. Pansy
Trenton
Sol Walcoff
Union City
Hon. Isadore Haber
New Jersey Conference
*National Council of
Jewish Women*
Mrs. Leo M. Abrahams
State Chairman
New Jersey Federation
of Y. M. H. A's
George Surosky, Pres.
National Refugee Service, Inc.
Edgar S. Bamberger
N. J. Representative
Other names to be added.

Director
A. L. Harris

Miss M. Louise Rothstein
129 Broad Street
Red Bank, N. J.

Dear Miss Rothstein:

Your letter of August 24th addressed to Mrs. Stein
of the Council of Jewish Women has been referred
to us for reply.

We are enclosing Form A, which gives instructions
as to the new procedure in connection with visa
applications of aliens desiring to proceed to the
United States. You will note the requirement
for a Biographical Statement on form "B" and
affidavits of support and sponsorship on for...

The affidavit on form C must be prepared by...
citizens or by aliens lawfully admitted into...
States for permanent residence. This also...
form B unless there are no such persons in...
to offer the requisite information or spons...

Please read the instructions carefully so th...
papers will be in order when sent to the Vis...
Department of State, Washington, D. C.

Please be assured of our desire to cooperate...
possible and do not hesitate to call upon us...
is any further information you desire.

Sincerely yours,

A. L. Harris
Director

ALH:FJ

Affiliated with NATIONAL REFUGEE SERVICE, INC.

AMERICAN EXPORT LINES · INC ·

TELEPHONE
WHITEHALL 4-6500

25 BROADWAY
NEW YORK

July 26th, 1941

Paul Tausig & Son, Inc.,
29 West 46th Street,
New York, N. Y.

Re: Prepaid Order No. N-4019
_ _ Hugo_Epstein_couple _ _

Gentlemen:

We are now in receipt of a cable from
our Lisbon office reading as follows:

"P4019 EPSTEIN NO VISA OBTAINED CANCELLED
PASSAGE YOU REFUND"

In this connection kindly communicate
with the purchaser, requesting her to return to us
the original Prepaid Passage Order No. N-4019 and our
check in refund will be sent in due course.

Very truly yours,

AMERICAN EXPORT LINES, INC.

W. T. Schaefer
W. T. Schaefer
Asst. Passenger Traffic Manager

hk

Miss Maria L. Rothstein
129 Broad St
Red Bank, N.J.

Cable Address: CONGRESS, NEW YORK

GERMAN JEWISH REPRESENTATIVE COMMITTEE

Affiliated with the

WORLD JEWISH CONGRESS

Dear *Miss Rothstein* 330 West 42nd Street ● New York 18, N. Y. *Oct. 19, 43*
Tel. LOngacre 5-2600

In answer to your inquiry, may we inform you that we have found in our
Theresienstadt lists:

Betti Epstein, München

Please be advised that

1— Our Theresienstadt lists are far from complete but are in the process of
being supplemented; the fact that a name is not recorded in the lists in our
possession, is not necessarily an indication that the person in question is
not in Theresienstadt.

2— Parcels have been dispatched to all the persons named in our lists.

3— Should you have any information through official documents or Red Cross let-
ters that the persons you are looking for have been deported to Theresienstadt,
please communicate with us furnishing the following data regarding those persons:
full name, age, relationship, last known address, date of deportation and date
and contents of Red Cross (or other) letters on the basis of which you furnish
the data. Upon receipt of this information from you we shall do everything
possible to have parcels sent to them. We are not authorized to accept payments
for these parcels. They are paid for out of general funds.

4— Should you wish to contact persons in Theresienstadt, you might try to do so
through your local Red Cross Chapter, addressing your communication:

An das Juedische Hilfskommittee fur Theresienstadt
Prag V, Philip de Montygasse 18
An die Postnachsendestelle Theresienstadt
Fuer (Name, details, etc.)

5— Please be assured that any names submitted by you, but so far not found re-
corded on our lists, will be filed for future reference. All new lists, as they
arrive, will be checked for those names. In the event that we have further in-
formation to give you, you will immediately be informed.

We ask you to pardon the form-letter. The overwhelming burden of inquiries
necessitates this. May we, therefore, ask you to please confine all inquiries
to the absolute minimum.

Very truly yours,

DR. HUGO MARX
Honorary Secretary, German J.R.C.

HM:dn
#253-1000

In Liesel's suitcase of correspondence, I found a poem that
someone in the family had written—a grim nonsense poem
about the incredible and murderous red tape that was a
necessity in the effort to emigrate.

Memories of childhood's play
Can never hold their former sway
In our predicament today.
Affidavits, visas, consulates,
Bolivia, Haiti, the Australian States,
Rhodesia, Palestine, Shanghai,
Alexandria, Cuba, Uruguay,
But first and last, the USA.
That's where you really want to be,
That's where you would be really free.
But no family there, how can you swing it?
No family at all? "But think for a minute,"
Says your wife, "Think very hard.
Right! The oldest of your dead mother's brothers—
Remember? How different he was from the others?
The family was beside itself,
That gossip! They tried to hide it on the shelf.
Then finally Uncle Salmon did what's right
And took him to the ship that night.
He sailed from Hamburg to the USA
And that's where he must be today!
With his grown-up children, and they're sure to be healthy,
And in America everyone's wealthy!
Sit down and write to him right away,
Tell him how things are here today.
Is his wife alive, and how is she feeling?
And about these troubles that have us all reeling."
So you write, and then, one day "Hurray!"
Shouts your wife. "The affidavits came today!"
But now the trouble starts in earnest,
Affidavit but no number, you ask when your turn is.

You go to Berlin to show your credential,
And the authorities there are most deferential,
But they mumble and don't dare to look in your face,
They shrug and say "Try the assistance place."
And those people say sadly it'll be five years wait—
They know—and you know—that that seals your fate.
Back home at nightfall, full of defeat,
With nothing but more questionnaires to complete.
Affidavits or no, you're still stuck in the house,
How on earth are you ever going to get out?
Five years you must wait, and it's utterly clear
That if you are careful you might last a year!
Well, let's start again from a quite different angle
To try to unravel our wanderings-tangle.
Where shall we try? How about Argentine?
Shall we sail with a Dutch or American line?
Can we get to New York, to L.A., or to Florida?
To Colombia, Chile, or Nicaragua?
Should we sit here and wait, does it make any sense
To await the results of the Evian Conference?
Or should you sneak secretly over the line,
And sit there in Holland, a-biding your time?
But you'll be abroad, and your family at home
Won't even be able to take out a loan.
You're all feeling crazy, like a demon's possessions,
You run to Herr Roberts to take English lessons.
You're perfectly honest, there's no need to lie,
Learning English is hardly like pie in the sky.
Your wife admits frankly she's no good at learning,
She spends her time packing and dreaming and yearning;
The beds are too big, the sideboard's too tall,
We'll never get it out of that room down the hall,
We won't need the wardrobe, we'll chop it up small,
In the States all the wardrobes are built into the wall.
Then a letter arrives with some startling advice:
"Leave all of the furniture, what we've got will suffice."
So everything's put up for sale though your heart breaks,

The buyers stampeding right through your heartaches,
200 marks for the whole dining room set?
But you're desperate, you sell it, that's all you can get.
Everything's finally gone when you get a new letter;
To bring it all with you would actually be better!`
That's how it continues, each day brings more gloom,
But you and your family, you still have one room,
And in it, the object of all admiration
Is a couch, the symbol of a century's duration.
A couch and your loved ones—your children, your wife,
Are all that remain of your riches in life.
And together you sleep on the couch with your wife,

It's the deepest and happiest sleep of your life.
You dream of your friends; you're aware of their plight,
You're sorry for them, but your luck's at its height.
Then mornings you wake and again starts the yammer,
Your heart's in your mouth, the old fears start to clamor;
But things *will* be better; things will be all right,
You race 'round from morning till late in the night,
But it's always beside you, the worry and woe,
What's that, and when is it, and with what, and why so?
Your life will never be happy again—
But please, dearest friends, won't you please comprehend
How I want it, I want it, I want this to end!!

Erinnerung aus Kindheitstagen
Kann uns heut nicht viel mehr sagen.
das vorgestern—was wird morgen?
Heute haben wir andre Sorgen.
Visum, Affidavit, Consulat,
Brasilien, Cuba, Dominikanscher Staat
Bolivien, Haiti, Paraguay
Alexandrette, Palästina oder Shanghai
Rhodesien, Australien, Südafrika
Und die letzte Rettung U.S.A.
Da möcht man gern sein, da könnt man lachen
Und doch keine Familie drüben, wie solls mans da machen?
Keine Familie drüben? sagt Deine Frau,
Ueberlegs Dir mal, aber ganz genau.
Richtig—von Deiner Mutter selig, der aelteste Bruder
Der musste doch damals, wie war das noch da,
Wegen ner dummen Geschichte nach U.S.A.
Der Onkel Wolf—stimmt. da erinnere ich mich
Die ganze Familie war ausser sich
Und der Onkel Salmon hat ihn damals bei Nacht
Heimlich nach Hamburg aufs Schiff gebracht.
Und der hat doch erwachsene Söhne und die sind reich,
Nun setz Dich hier hin und schreibst ihnen gleich.
Wie es uns hier geht und wir hätten sonst keine Verwandte,
Und ob die Mutter noch lebe, die alte Tante?
Und eines Morgens—da schreist Du hurra,

Frau komm mal rein, das Affidavit ist da.
Aber, jetzt gehts erst los, jetzt kommt erst der Kummer.
Ein Affidavit ist da, aber—Du hast keine Nummer!
Du fährst nach Berlin und zeigst Deinen Schein,
Und landest doch schliesslich beim Hilfsverein.
5 Jahre sollst Du warten, es ist keine Uebertreibung
Was sich da tut, spottet jeder Beschreibung.
Kommst zerschlagen retour und was brinst Du mit?
Nen Fragebogen, was tust Du damit?
Nun hast du's Affidavit und sitzt doch zu Haus,
Hast nur einen Gedanken, wie kommst Du raus?
5 Jahre sollst Du warten, es wird Dir ganz klar,
Wenn sparsam Du lebst, reichst Du grad noch ein Jahr.
Dan fängst Du wieder von vorn an mit Argentinien
Buchst ein Deutsches Schiff oder amerikansche Linien?
Gehsts nach New York, San Franzisco oder Florida
Nach Columbien, Chile oder Nicaragua?
Gehst legal oder illegal über die Grenz
oder wartest Du auf die Evian—Konferenz?
Gehst in ein Zwischenland, wer hat Devisen dafür?
Du sitzt in Holland und die Familie sitzt hier.
Man wird ganz verrückt, rennt herum wie besessen
Und geht zu Herrn Roberts und nimmt english lesson.
Du bist doch ganz ehrlich und brauchst nicht zu lügen:
Englisch lernen ist doch kein Vergnügen!
Jetzt meint Deine Frau, jetzt wird mirs zu dumm

Members of the family who died at the hands of the Nazis:

 Adolf Wallach

 Richard Strauss

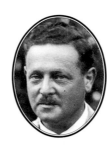 Max Wallach and his wife, Melly (Hollander)

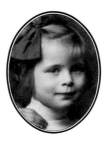 Käte Mannheimer (Else Wallach's daughter) and her husband, Paul Nussbaum

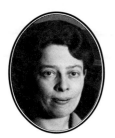 Betty Wallach Epstein

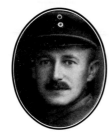 Oskar Strauss and his wife, Agnes (Zunsheim)

 Emma (Koschland), Julius Wallach's first wife

 Trude Gotthelf (Hede Strauss's daughter); her husband, Jack Cohen; and one of her two children

Ich stell meinen Haushalt auf Auswandrung um.
Das Buffet ist viel zu gross, die Betten müssen niedriger sein,
Sonst gehn sie drüben nicht ins Zimmer hinein.
Nen Schrank brauchen wir nicht, der wird mit der Axt zerhaut,
In Amerika sind alle Schränke eingebaut,
Dann schreibt Jemand von drüben, Du kannst es kaum fassen
Die Möbel, die könnt Ihr dorten lassen.
Schön, dann inserierst Du, Du willst alles verkaufen,
es kommen ne Ummenge Leute gelaufen
Für Dein Speisezimmer ganze zweihundert Mark.
Und hast Du endlich verkauft Deinen Kitt,
Dann schreibt man von drüben, bring die Möbel ja mit!!
Und so geht das nun weiter, täglich wirds schlimmer
Für Dich und die Deinen hast Du noch ein Zimmer
Und in diesem Zimmer von allen bewundert,
Steht eine Couch, Symbol des Jahrhundert.
Deine Frau, eine Couch und die Kinder, die lieben

ist Alles, was von dem Reichtum geblieben.
Und schläfst Du mit Deiner Frau, auf der Couch zu Zwett
Dan schläfst Du noch besser als einstens im Bett
Und Du bist zufrieden und denkst voller Lust
Mich können ne mal alle, so von hinten durch die Brust!
Und dann schläfst Du ein und bist zu beneiden
Und träumst glückselig von bessren Zeiten
aber—morgens—wenn Du aufstehst—das ein Jammer
dann bist Du wieder der alte Chammer.
Es wird immer schöner—es wird immer bunter
Du rennst hin und her—rennst rauf und rennst runter
Morgens—mittags und spät in der Nacht
Es ist immer dasselbe, was Sorge Dir macht—
Warum, weshalb, weswegen, wieso?
Du wirst Deines Lebens überhaupt nicht mehr froh.
Ihr wisst meine Freunde und könnt mich verstehen
Den Zoff, den Zoff, den Zoff möcht ich sehen!!

One member of the family, who was in a concentration camp during the war, wrote a diary during the days immediately following his liberation but while he was still in the camp. The author of this diary was half Jewish, as his mother had been born a Wallach. However, he had a Christian upbringing, and was taken as a political prisoner, rather than as a Jew.

Mauthausen, May 10, 1945

Political prisoner
Born: July 2, 1918
Concentration number Auschwitz 187446
Concentration number Mauthausen 119137

1 My Life Until the Arrest

I was born on July 2, 1918, in Bielefeld, Westphalia, where I spent a tranquil childhood. When I was five, I was enrolled in the elementary school, where I stayed for four years. After passing my exams, I went on to the middle school, where my two brothers had also gone.

In 1933, my parents moved to Berlin. My father had obtained a job as manager of a Jewish firm. I enrolled in the city school, Schönberg, where I stayed for four years until I graduated.

My political experience until this time was negligible. My upbringing was completely German national. I knew nothing about national socialism, only that it was radical and anti-Semitic. These two attitudes were enough to arouse in me a strong aversion to the régime. So, from the beginning, I was very skeptical about all regulations and new laws laid down by the Nazis.

I did my apprenticeship with the well-known Jewish company, Albert Stahl, cereal and grains. Because of the pogroms and the growing anti-Semitism, this company received fewer and fewer orders, and less and less income, until they were finally forced to sell, and the owner and his family forced to emigrate. The new Aryan owners took me on.

In December 1937, when the general draft was begun, I enlisted voluntarily. On April 4, 1938, I got my orders to join the Reichsarbeitsdienst [organization created by the government to employ the millions of jobless people to work in the fields, build roads, etc.] on a bee farm. Our main duty there was to dig ditches. On April 26, 1938, I was transferred to the Nürnberg division 6/92. In the same year I was obliged to participate as arbeitsman [member of the Arbeitsdienst—literally, "work service"] in the Nazi rally in Nürnberg. Even, when I had to assist in the biggest festivities of the National Socialists, I would not become a partisan.

Already at that time there were many rumors, partly in jest, and in whispers, that the "heavenly" and "divine" sacredness of the party leaders was not so absolute. There were jokes about Hitler and Cosima Wagner, about Göring's love of luxury, Göbbels's perversity, Heyes's love of liquor, Larres's irresponsibility, etc. Naturally nobody ever dared to say these jokes or rumors above a whisper.

The formation of the Reichsarbeitsdienst when they were presented for Hitler's review was a real event—a great number of young men; healthy, strong young human beings with shinily clean spades and impeccable posture and stance; they made a beautiful picture. Hitler's speech, which lasted altogether seven minutes, disappointed us all, at least those who felt the same way as I did—and they were not so few. On October 30, 1938, I was released.

I was, despite my service with the Reichsarbeitsdienst, filled with pleasant memories of this time of my life, and despite the education of the Nazis, I was still no Nazi; it was clear to me that I would never become one.

On November 15, 1938, I had to report to the 4th artillery regiment 68 in Belgard. Thus began my military life, and one could see from the beginning how surely and securely this leadership functioned. The only reason I joined this division was because my brother was there. But just a few days before I arrived, he was transferred! So what should have been the best time of a man's life began with a disappointment.

This was the beginning of a difficult training period, which was typically Prussian. The trainers were mostly from the 100,000-man army [the 100,000-man army was what was allowed to remain of the German military, according to the terms of the Treaty of Versailles] and the pressure they put on us was as might be expected. And the training was pure national-socialistic. Anything that anybody had ever told me about a soldier's life, I now experienced myself. Nonetheless, it was a carefree and enjoyable time.

Political developments clearly indicated that a confrontation with Poland was on the horizon. The German propaganda ran full speed. After we had already been four weeks in the boot camp in Pomerania, and were counting the days until our release, it was suddenly canceled and the entire garrison was moved back into the boot camp. We knew what was coming. Our release was out of the question, and that meant war. This threatening word, which had hung in capital letters over our heads, now became an actuality.

Army paybooks were distributed, and we received dog tags, as well as real ammunition for guns, and bigger weapons. Reconnaissance men had already been moved to the Polish border to find positions for the weapons and cannons. Naturally this was supposed to be a secret, but everybody knew about it. On August 30, 1939, the mood of enthusiasm reached its peak. But many had anxious faces and ugly premonitions.

The very same day, we started moving toward the east. On August 31, 1939, at 11:48 p.m., we stationed ourselves 1.5 kilometers from the Polish border. Zero hour was a secret, but it was given for approximately 3:30 in the morning.

On September 1, 1939, at 3:30 in the morning, the entire front opened fire on the Polish border, as well as on the villages near the border. There was no sight of the Polish military. Our 10.5 cannons shot to 3 miles behind the Polish border, and also served as illumination. At 8:43 I crossed the border as signal man. The panzer divisions pushed toward the open flat country, and we accompanied them as artillery.

There was no enemy in sight. We saw our first battle at the Brahe, which immediately brought us great losses.

The events of the Polish campaign are known, and I experienced them just as others did. The high points of my participation were Tucheler Heide, Tuchel, Brest-Litowsk, Praga, Warschau-Modlin. The moment when we met the Russian troops was unforgettable. [The meeting of the Russian and German troops was celebrated with champagne and great jubilation as the first actual manifestation of the Hitler-Stalin pact.]

At the end of the Polish campaign, we returned to the garrison, where I got a sinus infection and wound up in the military hospital. While I was sick, the garrison was moved toward the west. On January 3, 1940, I was released from the hospital, and joined a second military division, 3/258 in Prenslau, as senior artillery man. On the same day I was promoted to lance corporal, and in December of that year, to sergeant. Shortly afterward, however, I was released, as my services were needed at home.

Political developments had reached the point where the Jewish firm which my father ran was liquidated. After the liquidation, my father took over as manager of a branch of the Guhrau Millworks. My father had been a friend of long standing with the owner of the mill. The owner's daughter married, and her husband took over the management of the factory, Director K—— bought a mill in Upper Silesia, at Dambrau, not far from Oppeln. . . .

. . . After my discharge from the military, I got a job with this company as a bookkeeper and traveling salesman, with a basic salary of 250 marks [approximately $65 at that time] a month, plus board; I was "man Friday" there. There were seventeen workers in the mill, four of them Polish. In the office there was one girl apprentice, one stenotypist, one bookkeeper, and me. The foreman was a truck driver by the name of K——, who, as I will explain later, did not behave in the most decent manner.

The village of Dambrau had about 1300 inhabitants. Most

of them were either functionaries employed by the railroad, or were on the town payroll. Then came the farmers, and the minority of the residents were the workers. The prominent people of the little village were party members: district manager and honorary party member A——, married. Because of his lack of education and his rather weak character, he should not have been placed in a position of leadership. He was an intriguer, and one of the most passionate party meeting-goers. The next most important man in town was the mayor, W——. Without prejudice, I must say that this man was never influenced by my presence in his restaurant at the railway station, at which I had lunch every day. This man, as well as his wife and daughter, even though they were members of the party, always behaved in the most correct and just way, which, in the mixed population of this tiny village and in those difficult circumstances, was not a simple matter. Then came the civic employee by the name of S——, former Social Democrat. He too had made the famous "change of attitude" from Social Democrat to Social Nationalist just in time to be recognized as a member of the party. I was friendly for some time with the daughter of this man, as well as with his overly ambitious wife, who was a teacher, until the point when I refused their request to become engaged to their daughter. . . . From that moment on I had made two enemies, soon to be followed by another. This man was an inspector of the Upper Silesian agricultural association by the name of H——. He was a Ukrainian, and a party member of the highest order. His insincerity and falseness were combined with a great desire to better himself by denouncing others. The other party members of this village were all more or less forced to become members of the N.S.D.A.P. [National Socialist German Workers' Party], but were, in themselves, normal, harmless, and peaceful villagers. At this point I should like particularly to name some of the inhabitants of this little village, who, even though they wore the emblem of the party, behaved very decently [a list of names follows].

My work continued on a regular schedule, whereas my private life was subject to constant vacillations. In the area of sports, I played quite an important role, and for that reason I had the youth of Dambrau behind me. Almost every evening, members of the Hitler Youth came to visit me. We had political and military discussions and we listened regularly to the German and English radio. The leaders of the Hitler Youth were always present. All those brave little boys kept their mouths shut, and never spoke about it. I'd like particularly to say a good word for H—— and H—— V——, as well as E—— K——.

The district leader's dissatisfaction with me began with my refusal to participate in the pre-military education of the Hitler Youth. I refused on the grounds that because of my work and the sports I was too busy, and also, that I was not a member of the party!

The second explosion came after my refusal to become a party member, and also my refusal to take on any kind of work within the party. However, I could not escape the obligation to participate in the Deutschen Arbeitsfront [German Workers' Party]. The fact that I was a member was evidenced only by the monthly contributions I had to make, as well as to the Winterhilfe [Winter Help], which was automatically deducted from my salary.

The economy worked full speed. If something went wrong in the factory, one first had to conduct endless correspondence or make numerous telephone calls to innumerable government offices, and finally all assistance was refused on account of the war effort. Requests for production increases multiplied, but requests for servicing the factory or for technical assistance were for the most part ignored. The most important things were the taxes that had to be paid, greater production, fewer losses, and much work. The mill owner, a man of over seventy, was not a party member, and had to grapple every day with the constant changes in rules and regulations made by party members who were not at the front and had to find some way to justify their existence.

Through my business trips in the area of Oppeln and

Gross Strehlitz, I came into contact with people of all kinds and occupations, and I learned that most of them were against the leadership, and dared to empty their hearts—talk—about their inner fury with the war and its progress. I am thinking particularly of Frau Bäckermeister I—— M——, the salesman F—— K——, P—— K——; all from the area of Strehlitz. Nor did I fail to state my own opinion, particularly where I still found disillusionment about national socialism and the outcome of this war. . . .

. . . Because of the lack of gas, I had to travel to my clients by bicycle. This was not particularly pleasant, especially in wintertime. They had hired a new bookkeeper in the office, as the other had left to join the military. This "new one" was an old party member with a suspect past; he was a newcomer to this kind of work, and everything he learned, he learned from me. And he compensated by doing everything he could to get me thrown out of the mill. It was only thanks to director K—— and his lack of prejudice that I was able to stay so long in the mill, much longer than the others might have thought. Because my colleague lived with his wife and three children in Oppeln, I did everything I could to bring in as much business [grain] as possible, and was successful, because of my relationships with the peasants in the area. My colleague, who was not particularly truthful, and was by nature a mean person, had had a bad attack of polio, and as a result, one of his legs was shorter than the other. This man, A—— W——, was openly jealous of my good relationships with one of the girls I worked with, and to whom I later became engaged. In appearance, he showed a sincere camaraderie and an apparent friendliness. But as soon as I left the mill, he would start gossiping with the manager and the workers. My fiancée did not fail to tell me about this immediately. Other than this "new one," there was another man I have not mentioned until now: the chief miller, R—— P——: party member of the best sort, stupid, and 100 per cent convinced of his divine task.

———

2 The Deed

On December 13, 1943, in below-zero cold, I started out at 6 a.m. on my bicycle over the icy roads to Krappitz and Gogolin. I rode 32 kilometers that day, and returned to the mill at 4:38 in the afternoon, hungry and frozen. I don't know how it was that my fate, which had been written on the wall for such a long time, should have been sealed on this particular day, but it has remained indelibly in my mind.

I entered the office to find a great gathering around the warm oven. Present were: my "colleague" W——, my fiancée Fräulein D——, Inspector H——, the miller R—— (SS man!), the worker J—— K——, the girl apprentice (very friendly with my "colleague," and a leader of the Bund Deutscher Maedel [girls' version of the Hitler Youth]) . . . and also the wife of the head miller, R—— P——. And I barged into the middle of this gathering. All of them party members, with the exception of my fiancée, warming themselves during working hours, and during working hours in a time of war And they were visibly angry that I had barged in on this idyll.

I began to speak: "Good evening, ladies and gentlemen, I do hope I'm not disturbing you," and went over to my place and started rubbing my frozen hands.

At that moment Inspector H—— recovered from his astonishment at my early unexpected return, and said: "Heil Hitler, you act as though it were cold outside, my friend!"

How it all happened after that, I no longer really know. My entire suppressed rage and hatred for the Nazis of the town and for Nazis everywhere burst out of me, in spite of the warning look from my fiancée—to whom I give my special thanks for that. Exactly what I said I no longer know, but it went something like this: "Why talk to me? Do you think I have time to stand by the oven all day and warm myself like the bigwigs? Do you think that there would be a car available for such a lowly employee? If I were a party member, that would be a different story; those gentlemen need a five-ton truck to travel six kilometers.

"Why are we fighting against bolshevism? I thought that in the National Socialist Germany the rights of individual property would be respected. But no, the district leader comes along and simply confiscates, for his own use, an entire truck, no matter that it might be needed for more important things, or for the war itself. Why do we have an administrator responsible for local traffic if his orders are not followed?

"What is national socialism, then? Are we worth nothing as individuals because we are not party members? What are the soldiers at the front fighting for when things like this are happening at home? And why don't you go to the front? Why don't you show your love for Germany not with your mouth for once but with your life? You're nothing but pathetic cowards who'll do anything to avoid danger; and not only you, but the entire apparatus of functionaries. But above all, you won't go to the front because you all know that the war is already lost; it's no longer possible for us to win!"

With that I walked out of the office, leaving a flabbergasted bunch behind me.

That evening, my fiancée asked me to come to her place for a drink. After Inspector H——, who was with her, had left, I went to her room, and she told me what had happened in the office after I left. I was warned. But it was already too late.

According to her, the colleagues W—— and K——, the miller R——, and Inspector H—— had sent the girl apprentice directly to district leader A—— to denounce me. He, happy about this and grateful to the others who had finally gotten me, sent, that very evening and without a word to me, a full report to the county chief executive of the N.S.D.A.P. . . . And he, who had been simultaneously informed about me by the other party members, immediately denounced me to the secret police.

3 My Arrest

On December 22, 1943, at 10:27 a.m., an Opel Olympia drew up to the mill. Its license number was POL23443. Two men in civilian clothes got out; the first was about twenty-four, the other about thirty. I met them in front of the mill, stood before them, and said I was the person they wanted. They refused to take my word for it, went with me to the manager, presented my arrest papers, and then drove me to my apartment in order to search it. I opened the door, and like two wild beasts they flung themselves on my valuable radio, apparently on the principle that the first one to find it could keep it. The search after that was quite superficial, because aside from forbidden books, which they did not notice, there was nothing to be found. I had burned my notes and diary.

After the search, they took me to the local jail. There I stayed, in the freezing cold, for four hours. In the meantime, in the village, the Gestapo gentlemen had continued their investigation of my character. . . .

. . . Then they sent me to the regional administrator, in whose eyes I could read his pleasure at my arrest, and who was stupid enough to say so openly, and in whose presence they had to file the police reports concerning my behavior, stating that I had never had any kind of criminal record. After that, they took me to Oppeln, to the court prison.

4 My Detention

They registered me at the prison, and while they were doing this, one of the Gestapo employees said: "Well, I guess you won't be playing much football any more." The so-called superintendent took all my valuables, and then I was led into my cell, no. 82, in the second cell block. I stepped inside, and stood with my face toward the wall. Behind me I could hear the rattle of keys, and an icy shock went through me. I turned around; the cell was locked. Strangely enough, I felt safe in there. I looked around my new home. The cell was 7.10 meters long, 3.50 meters high, and 2.20 wide. High up in the cell was a window. I was absolutely forbidden to look out, but that didn't stop the prisoners from clambering onto their bedposts to look out at the snowy town of Oppeln.

In the beginning I was completely silent, and because of

my inner turmoil and worry about my relatives, I was unable to eat. . . . The head guard of my section was a good solid East Prussian, but a big Nazi.

On December 24 a Mass was held. Men and women in prison clothes separated by a wall. I wore civilian clothes during my entire stay in that prison. During this cold and loveless service, looking at the simple Christmas tree, I realized fully, for the first time, exactly what my situation was.

It was 2:30 when I was led back to my cell. For dinner there were six boiled potatoes and 80 grams of bread, and that's the way I celebrated Christmas. My thoughts were with my loved ones in Berlin who still, that night, did not know of my capture.

On January 13, 1944, I had my second interrogation. The first one had been on December 23, 1943. The last hearing was conducted on January 18, 1944, in front of the commissar of the Oppeln Gestapo. This hearing lasted, like the others, from 7:30 in the morning until 8:00 at night. This commission twisted all my words around, even though everything I said was very clear and understandable.

That very evening, simply to get away from the commissar and back into my lonely cell, I signed [a confession].

A few days later my father came to visit me. In the visiting room there was a barrier with a space of 2 meters in between. On one side stood my father, on the other myself, and between us the guard. My father and I could only talk of generalities.

The monotony of my single cell was interrupted by a Mass in which the women were also allowed to take part. The matron who guarded the women knew me, because I had been friendly with her husband, who was an enthusiastic athlete. This woman came to my cell almost every day, brought me something to eat and drink, as well as newspapers, which were strictly forbidden. This woman, Frau L——, was completely selfless and helped me out of sheer friendship.

On March 26 they stopped feeding me the busy work of

making thread and slicing feathers, but they kept me busy with writing jobs. Three days later I was taken into the office. By this time, I was again able to eat.

On April 2, they took my fingerprints and photographed me and I was taken to the Gestapo. But the prison administration kept me until May 5, and only after repeated requests from the Gestapo did they put me on the transport. I had already heard a lot about the concentration camps. But now I was to learn just how little the German civilian population knew the truth of what was happening in these "murder stations."

5 Concentration Camp Auschwitz

On May 6, at 10:15 in the morning, the little transport of thirty-six men stood in front of the gate.

Next I will give a map of Auschwitz [see page 166].

May 12, 1945

The thirty-six prisoners in the transport were Jews from Breslau and Berlin—the only one who was not Jewish was I.

After we had stood for three hours in the glowing May sun, the Kapportführer [acting commander] of the camp, SS Oberscharführer C———, searched us, and immediately set me to one side and led me through the door with the legend "Arbeit Macht Frei" [Freedom Through Work], and into the camp. Next to the Effektenkammer [where personal belongings were confiscated]. There I had to give up my valuables, which were listed exactly. Then I had to undress, my personal possessions were put into a sack, and finally I was bathed. The hair on my entire body as well as that on my head was shaved off. Then I was given a number—187446.

At 6:15 I was taken to Block 8, the so-called quarantine, and into Room 3. At that time there were eight hundred prisoners in Block 8. In Block 8A, that is, on the first storey, were the prisoners of the new SS Special Regiments, the "Dirlewanger," named for their commandant. These prisoners were all professional criminals and security measures were taken accordingly.

That same evening I received my clothing: a blue-and-white-striped zebra suit. Shortly before the bell, that is, at about 8:30, I had to sew on my number. One number on the left breast, the other on the right trouser leg.

They made strict differentiations between the different kinds of prisoners, and next I will explain these:

Those who were in the camp for the second time had to wear, above their insignia, a horizontal red bar. Those who were not German also had to wear the initial letter of their nationality. The Russians were generally designated as "asocials," in other words, with black triangles, and were further divided into SLL—prisoners of war—and R—that is, Russian civilians. There were also a few political Russians in Auschwitz, about 40, very few compared to the total number, about 4000. The entire population of the camp at that time numbered about 19,500 prisoners. The total number of pris-

Red	Political prisoner for duration of war
Red, gold	Political prisoner for security reasons (only Jews)
Pink	§175 (homosexuals—named for the number of the law)
Black	Asocial elements (pimps, etc.)
Purple	Biblical scholars
Green	Criminals
Green	Trustees

Red	Would-be escapees
I.L.	Camp employees

oners in the administrative domain of the central Camp Auschwitz was 135,000.

The camp had its own bakery, its own butcher, its own dairy and enormous agricultural facilities, a printing press, forges, a warehouse, wood and coal ovens, a building yard, a repair shop, tailor, shoemaker, the SS hostel, etc. It was a huge organization, and probably very profitable because of the cheap labor. That part of it which concerned the war effort was called the Union. The Union worked day and night in two shifts of 550 prisoners each. The D.A.W. [German weapons factory] employed 800–900 prisoners. The Strafcommando [gas chamber official] of the camp called himself "foul gas"—this commandant who had cost thousands of brave men their lives.

In the quarantine in Block 8 everything was very clean. The food was good and there was enough. After four days the entire block was transferred to Block 2, where shortly afterward I became the room monitor.

On July 2, I was made bookkeeper in the Arbeitsdienst [work service]. The Arbeitsdienst . . . was a huge bureaucratic organization. There were two of these services, employing one prisoner for the bookkeeping, six typists, and eighteen women prisoners for the filing. Mostly Jews. The prominent people of the camp were for the most part Poles, with only a few German nationals. The different duties of the workers were defined by armbands. These people made up a sort of intelligentsia, as the most specialized workers. Before someone received this armband, he had to pass special exams to show his knowledge.

May 13, 1945

As a typist . . . I had a very clear view of the several camps. . . . My employers were the . . . three Arbeitsdienst managers. The first one was SS Oberscharführer E——, who will be mentioned again later in this report. The Obereinsatzführer, another of my employers, was SS Obersturmführer N—— S——, who was famous in Auschwitz because of his perverse "tests" with the women prisoners, and was already on the well-known London lists of the BBC. Our officers were in the officers' barracks, outside the gate of the camp.

I had spent about three weeks at this work when a comrade by the name of W—— K—— was released and sent to the front. This Breslau comrade was in the camp because he and his Jewish wife had escorted a Jewish couple to the railway station to emigrate. His wife had already been gassed two years before, immediately after the arrest.

My friend's job was taken over by a man by the name of J—— S——, a Pole. After he had had this job for eight days, seventy-six prominent prisoners were one evening transferred to the bunker in Block 2. There were some spies among us from the political division, who worked under the command of Oberscharführer R——. Every morning, these prisoners had to make their reports to the "secret service." It was clear that after a certain time, these spies would wind up being gassed themselves, because they had become too well known, and could no longer gather any information as no one would have anything to do with them.

They had to find the phoniest reasons to arrest those who were to be gassed, because they had been so prominent in the beginning but were now no longer of any use. Among those who were delivered to the bunker and whose armbands were immediately removed was my colleague, the Pole. Upon the order of the Oberscharführer, I got the job in the Arbeitsdienst, and from that moment on I was one of the prominent ones. I was happy about this, however, because it gave me the opportunity to help many of those who were suffering. The Arbeitsdienst had the authority to issue orders without having to consult the Arbeitsdienstführer. This was done via the following work slips:

My main duties had to do with transports, the checking of work distribution, and its billing, and also the control of all kinds of tasks. After eight days I had already taken away the jobs of several trustees of various nationalities because they had beaten people, and, according to the gravity of their behavior, I had even sent them for either four or eight weeks into a kind of punishment task known as "foul gas" ["foul gas" was most probably clean-up detail]. Thanks to my new authority, I was able to help some prisoners who were very weak not to wind up in the "foul gas," and to get them easier jobs.

I continued to do this the entire time I worked in that office, and because of this, I acquired more and more enemies among the prominent ones, who were unhappy because the other prisoners liked me. Every evening, after reveille, I organized meetings in the office, where everyone who had a complaint about his work could voice his objection, or if there was someone who was too weak to continue with the work he had been assigned. That way, some of those poor weak prisoners could be saved from a certain death because, at the last moment, they were given different and easier tasks, where they could get some rest. (It's understood that this was done without the knowledge of SS Obersturmführer S———.)

One evening, about eight o'clock, there were about eighty prisoners in front of the typist's room when the SS Obersturmführer suddenly barged in. By training he was a tailor; I have nothing against that honorable vocation, but this person was about the meanest creature imaginable. When he saw what was going on, he started beating the prisoners with a riding crop. . . . I immediately ran out of the office and called the camp leader Obersturmführer H——— for help. He came at once, and in the presence of the beaten prisoners, told this madman exactly what he thought of him. After I had explained to the camp leader what I was doing with these people, he told me that he appreciated my work, and asked me to continue, as he was not in a position to oversee all that was hap-

pening. (This, however, did not prevent Herr S———, the next morning, from forbidding me to continue. Because of this order, I was forced to listen to the complaints of my comrades in my room, although this was on a much smaller scale.) This was the only way I could reassure them that I would help. Finally one day the bully asked for the work slips, and found out that I was the person who arranged the work distribution—in other words, who gave easier tasks, that is, ones inside the camp—rather than the hard ones outside the camp. There followed a terrible explosion; this so-called officer called me the most unbelievable names, but he did not dare to beat me. I said nothing until the camp leader appeared, having heard the noise. Then I let loose, I, prisoner 187446. The outcome of this scene was that I was directed to report directly to the camp führer, and S——— was no longer permitted to give me orders. With the help of the camp führer, I could now continue my activities without interruption, to help many people, and to punish those who betrayed their comrades. I am sure that, particularly among the Jews, I had many friends, thanks to my authority to intervene in an event that I shall describe later. I saw that my main obligation was to help these people who had done nothing other than belong to a different race, and who for that reason had to cope with years in terror of death, and with torture and beatings if they didn't have the *luck* to be killed.

There's not much more to say about my activities; for that reason I shall now go on to describe some of the other aspects of the camp.

The camp had an orchestra of about seventy prisoners, most of them Poles, and a few of them German nationals. The conductor of the orchestra was my best friend, the Pole A——— K———, formerly the conductor of the Cracow Opera. When the prisoners marched out of or into the camp, the orchestra played march music. . . .

. . . On Sundays there was a football game, in which I regularly participated. This was a welcome diversion; furthermore, on Sundays we had boxing matches and concerts.

These concerts were of serious music, no jazz. The camp had a cabaret, in which famous artists who were prisoners, for example, S—— S——, played. A famous Hungarian piano virtuoso, P—— K——, gave classical piano evenings, which, on account of his brilliance, were always played to a packed hall. The small swimming pool, with its diving board, was a popular diversion. On Sundays the orchestra, wearing white suits with red borders, played by the edge of this pool.

The camp also had a brothel, but as I never visited it, I cannot report on it. I only know that there were twenty-six women, German and Polish. An active promoter of these activities for the prisoners was the camp führer K——, who himself took part in many of them. The women's camp that he installed later on was also his creation. All the women had beds, bedding, and decent clothes.

Now, however, I come to a description of events which I saw with my own eyes and which were so shocking in their brutality that much of it will seem unbelievable. I cannot remember all the details, but the fact that this camp, Auschwitz, became so infamous was because of such cruelties, which remain in my mind as if they had happened yesterday. I wish to emphasize that the worst cruelties were committed before the beginning of the war against Germans who were political prisoners, as well as against the Jews. But now I shall report only what I have seen with my own eyes, and also experienced myself. The world must know what monsters and assassins were hidden in the uniform of the SS, murderers with not one but hundreds and thousands of people on their consciences. Monsters who, in as many cases, have stolen the property of their victims.

When I think of it today, that amongst those party members there should have been any idealists, I cannot imagine that this idealism could have been without egotism. Because the party members must at least have been informed about what was going on, when you consider the enormity of the crimes. Certainly among the prisoners there must have been some highly criminal elements, but character-wise, they could not begin to compare with those in uniform. The biggest proportion were those who were political enemies of the party. There was not one asocial, criminal, or recidivist who had belonged to the party, but there were political prisoners who at one time had been party members; some of them were the so-called old veterans, soldiers who at one time had been at the front, like me—those who, after a time, had begun to understand the real meaning of this kind of régime, and who, because of that, had made no secret of their feelings about Hitler and his companions. In the camp were [a list of names follows, of various professions and degrees of fame].

In the middle of May 1944, an enormous transport of Jews from Hungary arrived. Each transport was composed of 75 wagons, each wagon carrying 150 people. For seven and a half days, these 14,250 Jews had been locked in these wagons without water or food or the opportunity to relieve themselves. The train arrived at the Birkenau ramp. I knew exactly what that meant. The people had been told that they were being taken to Germany to work and that they would receive lodgings. And that they should bring all their valuables and clothes with them.

The doors of the wagons were opened. An unbelievable stench spread through the air. Dead people fell onto the platform, were trampled on by the others in their desperate search for fresh air. Over 3,700 dead bodies were to be undressed by the "clean-up" detail, and thrown in a heap on a pyre, without even registering their names. The rest had to undress, and completely naked, were sent to be bathed. Clothing and valuables lay in heaps upon the platform.

While the Hungarians were being bathed and shaved, the SS went about robbing them. They fought over each piece, they all wanted everything. A ghastly scene, to see these people in uniform like vultures at their quarry. The knapsacks, suitcases, and attaché cases were filled, and while the Jews were led from the baths to the gas chambers, the SS was busy swapping their loot with each other.

The gas chambers were hermetically sealed, with a thick

iron door, and a wide glass window offered the opportunity to watch those poor people in their ten-minutes-long death throes. I myself stood about 6 meters away from this window and saw nothing, because the SS was so eager to watch this infamous scene. I heard and saw only one thing: how the the commandant SS Stürmbannführer B——— stood in front of the window and said: "Isn't it fabulous, the way those people are dying?" In their death throes they bit each other's noses and ears off. National socialistic culture! The German language is certainly not lacking in vocabulary, but there are simply no words to describe such a scene. I myself would call such a report a lie, if I hadn't been actual witness to this and other horrors.

At the end of May a French transport of [illegible] . . . and Jews arrived. These people were to be numbered; in other words, they were to be registered in the files. The Jews and the . . . [illegible] were separated. Amongst the Jews was a woman of about twenty-four, who had been taken prisoner while she was performing on stage. She was still wearing her ballet dress and toe shoes.

The leader of this action was the Arbeitsdienstführer SS Oberscharführer E———. The woman knew what was about to happen. In her despair she did something which immediately caused about 3000 people, and later, another 5,500 people their deaths. I was standing about 25 meters away and could see the woman clearly. In an instant, she took off her ballet shoes and started hitting the Oberscharführer with them. In the shock and confusion that followed, she succeeded in getting his pistol, and fired two shots, one into his thigh and the other into his hip. Now the guards woke up. I barely had time to get to safety in the bathroom. There followed an unbelievable bloodbath, in which about 3000 people were shot or beaten to death. It was a single, screaming bloody and swarming heap. The machine guns and submachine guns shot uninterruptedly into the mass. The rest, after being completely robbed, were immediately gassed, and there was no one left alive.

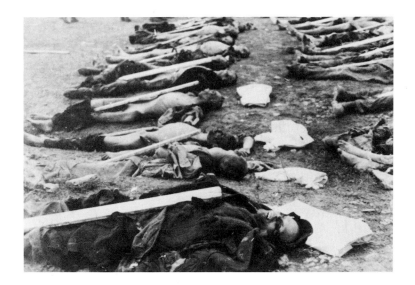

In June I attended the first execution in my life. It was a Hungarian Jew who had tried twice to escape and had twice been captured. After reveille, the delinquent was brought to the gallows that stood in front of the kitchen. The spy of Block 11, J———, was the one to perform the execution. With no show of emotion, the Jew climbed the steps. The SS people surrounded him. They would never miss such a spectacle: B———, S———, B———, K———, S———. They did not hesitate with their sadistic remarks, but no one paid any attention. The noose was put around the neck, the stool was pushed away. The rope tautened, then broke. The victim fell against the gallows. They brought a new rope, and with no observance of the humane rules, they repeated the procedure. Again the same thing happened; the second rope broke. Now it was even too much for the SS. They led the prisoner into the bunker. Two minutes later there was a shot; the fate of the man was securely sealed. On the same evening, the commandant sent the following telegram to Berlin: "Strangulation accomplished, death after eight minutes without complications." The spy, who was certainly not responsible for the rope breaking, was

forced nevertheless to spend the next two months in the bunker, and then was allowed to resume his duties.

Between May '44 and January '45, there were about thirty-six of these strangulations. At the end of the report on Auschwitz, I shall describe another one of these.

In September 1944 a telegram arrived from the Reichssicherheitshauptamt [Reichs security head office] in Berlin: "Special action against the undernourished and physically weak is desired. The number of people chosen, and those responsible for the special action against them, must be reported." Thus Berlin refused the responsibility for the action, as it was not an order, merely a "request." To find someone to undertake the responsibility for this action, in light of the current military circumstances, was not easy. And as I later learned myself, all the "officers" refused it.

That afternoon there was a great celebration amongst the officers and führers of the SS in the officers' club. This had never happened before. That evening, all the inhabitants of the cell blocks had to gather together in the Birkenallee. In the old laundry, sitting on chairs placed on the table and reigning over us all, were the SS officers. All completely drunk, with clubs in their hands. Each prisoner had to pass beneath these "sovereigns" (as such they felt themselves to be). Now they started sorting prisoners, with no apparent criteria. All the weak ones were put to one side, as well as the ones whom any of the "sovereigns" particularly disliked. The 1236 who were chosen were of all nationalities, and the majority of them were Jews. These people were lodged, totally isolated, in Block 10. Because of my position, I had the opportunity to go to Block 10 the next morning. . . . The camp leader gave me permission to sort out the Aryan-related (or half Jews), also Dutch Jews who were diamond cutters, as well as some other professionals. . . . The "transport list" looked very strange, as it contained only the prisoners' numbers. The other transport lists appeared as follows: running number, name, first name, profession, place of birth, kind of arrest, date of imprisonment.

At 11:05 the 776 remaining prisoners, who knew exactly what was in store for them, were loaded on heavily guarded trucks, and under the supervision of Unterscharführer K——, were transported to Birkenau. At 2:10 the trucks, carrying the clothing of the murdered ones, returned. Himmler's desire had once more been fulfilled!

Auschwitz will most surely be described by my comrades, therefore I will not go into further detail about the daily atrocities and the constant cost of human lives. It is sufficient to tell you that, according to the rules of this camp, any animal, any creature at all, had more right to existence than did the prisoners. This was evident daily in innumerable instances. A not-completely shaved head, a hard-to-read number, a missing button, a wrong word, even a wrong step marching in or out could mean death, or severe physical wounds and lesions that could take weeks to heal. The infirmary and its leader, SS Obersturmführer K——, saved the lives of many people, and all the prisoners were particularly thankful to him. But naturally the institution was powerless against Berlin. Thus in November 1944 the very sick ones were thrown into trucks and driven to the gas chambers. This under protest by the head of the infirmary, who as a result lost his job, and was replaced by another by the name of F——.

I will now describe an incident, typical of Auschwitz, that cost seven of my comrades their lives. They were two German nationals, three Viennese, and two Poles. One of the Viennese, who had fought with the Communists during the Spanish Civil War, got married in the camp to a Spanish woman. These comrades, between twenty-five and thirty-five years old, tried to escape. Two of them were in the trucking task force, and therefore had contacts with the SS drivers. After months of preparation with one of the SS drivers, they had planned their escape for May 26, 1944. The prisoners worked in the following areas: two in the trucking task force, two in the SS hospital, one in the building office, two in the

officers' lodgings. They had prepared one of the trucks especially for this project—the escape. The other person informed about this projected attempt was the SS block leader F——, who was more of a comrade than an SS man.

On May 26, 1944, everything was ready, and the truck started to move. It drove safely past the guards, and then, shortly thereafter, was "received" by an army of twenty-five SS men! The truck was searched, and of course the stowaways were discovered. Seven prisoners and the SS block leader were put in shackles, but two of the Poles still had the opportunity to take poison; it was strychnine. The driver himself had given them away, and now he was led away with them, but for this heroic deed, he received the service cross, second class. The two who had taken poison died in Block 11, in ghastly agony.

The other five prisoners, as well as the block leader, were chained in the bunker. Everybody was sorry for these men and their fate. We sent quantities of food and cigarettes into the dark cell.

On December 29, 1944, the death penalty for the five prisoners was forwarded from Berlin. They were to be executed on the 30th. At the request of the camp commander,

the execution was delayed, because he was afraid that it would cause trouble in the camp. But on December 31, 1944, the order came from Berlin to hang them.

A large gallows was erected. The German nationals were to be present, also the assembled block leaders. The five prisoners behaved like heroes on their last walk to the gallows. With the cries: "Down with Hitler, down with fascism, long live bolshevism!" they put their necks in the nooses and pushed the stools away themselves. SS Unterscharführer K—— continued to beat at their bodies even long after they were dead. We Germans honored the memory of those comrades. . . . The SS man who had also been condemned to death was freed in the general confusion of the evacuation.

6 The Evacuation and Transport

a The Evacuation May 15, 1945

Those of us in the camp who were officially allowed to read the papers knew that the Russians had begun a great offensive drive with the beginning of the year (1945). What that meant for us was clear, because the possibility of defense was now out of the question. The mood among the SS was in no way depressed (they still thought they were winning the war), and that's why it was that on January 17, 1945, K——, commander of Auschwitz at the time, could energetically deny the rumor that the Russians were just outside Kattowitz, not far from the camp. Nevertheless, we knew quite well that this rumor was the truth!

On the evening of that same day, at 10:30 p.m., I was called suddenly into the office where there was a frenzy of confusion. Among others present was the new Arbeitsdienstführer SS Oberscharführer S——. (The old one had been arrested on December 17, 1944, because he had sold gold illegally, and had also raped the wife of one of his comrades.)

I was instructed to assemble a transport of 1500 "not-so-important" prisoners immediately. This transport left the next afternoon. On the morning of January 18, 1945, only a

few work forces were dispatched. There was general confusion. All the Polish files were burned, as well as the other files in the office which contained the registry of the total number of deaths in the camp.

There was great excitement; the camp appeared to be dissolving. I no longer went to work, but packed my rucksack, and, together with some friends, just sat there waiting for things to happen. It was clear to us that an evacuation would be terrible, for we were *only* prisoners, and it was winter! We had terrible premonitions about what was to come. But the most skeptical of us could never have foreseen just how bad it was actually going to be. This chapter will describe the transport, and the thousands of men and women to whom it brought death—through cold, hunger, or, for the most part, the bullets of the SS escort.

The last hours in the camp were total confusion. All the secret stores which had been kept locked away, like clothing, food, etc., were lying in heaps on the floor in the midst of the camp. No one paid any attention to the margarine and other precious provisions that were in the storehouses. Each of us thought only of what was to happen, where we were going, would we ever get through, ever be free. On the evening of January 18 the camp was attacked by Russian dive bombers. The SS fled inside the camp. The perimeters of the camp were illuminated by "Stalinkerzen" [phosphorous bombs], and all around it the bombs fell and the machine guns of the Russians fired into the trucks of the SS. All of us, who had not been allowed to leave the blocks during the alarm, stood on the street and watched the attack. It lasted almost two hours, and immediately afterward the evacuation of the main camp Auschwitz, plus Birkenau, was begun.

b The Transport

The women of Auschwitz, about 5000 prisoners, were already on their way. The female manager of the camp . . . who held the rank of Unterstürmführer, and whose husband had been the Third Arbeitsdienstführer, had already left Auschwitz.

Our marching column numbered about 6000 prisoners. I marched at the head of the column, stood at the entrance barrier, and was at the head of the economics task force. [Apparently they were grouped according to the work they had done.] The end of the column was at the door of the camp. There were guards everywhere, posted every 2 meters.

At 1:30 a.m., this train started moving; nobody could guess what awaited us over the first 26 kilometers. We marched in the direction of Pless, across the nursery gardens of the Rajsko fields, which belonged to the camp. I walked on the right side of the road and counted, in the time between 1:30 and 11:45, on the edge of the road to Pless, the dead bodies of 378 women! Most, I would say almost all, had been shot behind the ears. It was ghastly to see these bodies lying on the road or in the ditch, with wide, terror-filled eyes or folded, pleading hands, already stiff. But these 378 bodies were by no means the most awful things we were to see—those who had left their lives in this short distance of 26 kilometers. My comrades told me that the other side of the road was also strewn with women's bodies. Behind me I heard the continuous sound of shots, and according to what I was seeing, I knew exactly what that meant. Many of the prisoners were old and sick, but if they so much as stopped to rest for a minute, they were killed immediately.

In the villages through which this miserable train passed, the inhabitants stood shoulder to shoulder, and many of them tried to help us to escape. But many were caught while trying to escape and were immediately shot. The SS Unterscharführer K—— was particularly adept at this murderous activity! He even boasted about inviting the old and weak ones to stop a minute and rest, and then he shot them.

In the town of Pless the brave inhabitants stood right and left, and I don't think I exaggerate when I say that these good people were able to help over two hundred prisoners to escape.

We were not used to this kind of march, we were tired, and were very happy when suddenly they announced a halt.

It was clear to us that so many people could not find a roof to put over their heads, but the Nazi brains had already planned how to take advantage of this very situation: We were led into a sports arena, and forced to lie down in 10 centimeters of snow. In the bleachers guards were posted with machine guns, so that no one would dare to try to move toward the bleachers, which afforded a bit of protection against the wind. We had to stay there in the bitter cold for three hours. When we rose to continue our march, this reduction method had succeeded very well, for more than seventy bodies remained, dead, lying in the snow.

The very ill were simply kicked or hit on the head with guns.

Happy to be moving again, because our limbs were almost frozen, the sad train once again set itself in motion. Just after we left the town, I recognized, among the civilians, some prisoners; they were decently dressed, they gave us some food to put in our pockets, and they told us to try to escape. An executive airplane, a Fieseler Storch [a three-seat cabin monoplane, used for communications, staff transport, and sometimes short-range reconnaissance], accompanied the march for a long time. About 600 meters from Pless the airplane landed, 200 meters from the road, at the edge of the forest. There we saw two more of these airplanes. Was this the headquarters?

One kilometer beyond this place was a farm with a big barn. Here we spent the night: that is, 2000 people were under the roof; the rest lay under the open heavens in the snow. At 11:00 p.m. we were awakened by the noise of the airplanes, by the noise of bombs, and by the barking of flak. Through the cracks in the walls of the barn, we watched the headquarters being bombarded. Bright columns of fire rose toward the heavens. It was a panorama. The attack lasted about twenty minutes. The rumors about the proximity of the Russians grew and grew, and so we left the next morning in a great hurry. In the barnyard lay more than one hundred frozen bodies.

The march lasted from 6:00 a.m. to 11:00 p.m. The destination was Bad Königsdorf. There was a farm there, with a barn, and also several small stables. Here too most of the people slept in the open. They told us that we would soon be loaded into railway cars, but that had been delayed because it was so difficult to get any kind of rail transportation.

Throughout the entire march we received not a thing to eat or drink, so that a number of people also starved to death.

At this farm we stayed two days and three nights. When our march continued, we found out that not only had many died or escaped, but also a large number of SS people—twenty-six—had escaped.

From Bad Königsdorf we walked to the next railway station, Loslau. There we were loaded into railway cars, that is, about 150 prisoners in each car. The walls were about 1.10 meters high. We had to sit, which was a problem, considering the number of people in each car. No one could lie down, no one dared to stand up! Whoever stuck his head above the side walls was immediately shot. Obviously under these circumstances many died, either from hunger or cold, or they were shot. The dead were thrown out into the fields in the open stretches.

To get out to relieve yourself. meant endangering your very life, as there was a guard at both the front and back of each wagon. If you asked one of the guards, the other one would shoot; if you asked both, you would be shot by the guard in the next car. To describe in detail this gruesome trip is too ghastly for me; I shall leave that task to others who have survived.

May 16, 1945

The journey lasted altogether six days. First we moved toward Breslau, then were detoured through the Sudetenland, and finally arrived at our destination. The destination was the well-known small city of Mauthausen, which we had named "Murderhausen." On our arrival, there were only 1876 prisoners left. It was early, 7:30 in the morning, when this

starving, thirsty, lousy, miserable group was marched from the station to the camp, about 4 kilometers away. The first stop was at the fully intact city fountain in the middle of the market place. The inhabitants stood there shoulder to shoulder, but nobody was able to fill our cups, which we extended toward them. It was agony for us to see this water not 3 meters away, and not be able to get any; the SS guards were too watchful. And we cannot forget the ugly shouts at us from the people of Mauthausen.

At 1:15 we saw the camp. After we had climbed a steep hill with many curves, we saw the castle on the top. The roar of two cannons tore through the lovely countryside.

We were led through a wide door into the camp, and the monitor of the column, who was supposed to keep the prisoners five across in line, received so many kicks from the SS that he soon broke down. . . .

. . . We had to stand in line and the camp leader SS Hauptstürmführer B—— inspected the remaining 1844 prisoners. The rest had been left lying on the way from the station to the camp!

We stood for review until 9:15. Then we got something to eat. After all that starvation, each got 3/4 of a liter of cold watersoup. Naturally most of the people got diarrhea immediately afterward. Then we stood for the whole night. We stood behind the laundry buildings until 6:30 in the morning, and again and again the SS guards herded us together if we tried to run around a bit in order to warm up.

In the morning we were finally allowed to bathe, and after the hot baths, we stood in shirts and undershorts for half an hour in the ice-cold air. Then, barefoot, they led us to Block 22. This block, built to house 600, was now stuffed with 1200 people. The ones left over were sent to Block 24. (In the laundry, they had taken our receipts for personal property, and in addition, any valuables we had left had been stolen. Our hair was cut off, even though we had all gotten written permission to wear our hair.) We were treated like new arrivals. Again and again, we were beaten and clubbed. We could not de-

fend ourselves, and I was happy when, on March 13, 1945, I was given the role of trustee in the task force for laying cables and poles. But as part of this section, I was only able to leave the camp once, and after that I was held in reserve.

On March 23, 1945, I was sent, as trustee of one hundred prisoners in a group of five hundred, to Linz. We assembled in line at 1:30 in the morning. The camp leader was jovial, and gave each man two cigarettes! We were told that this "voluntary" work we were to do in Linz would last from three to four days. They lied to us. Then we went to Balinstation Gusen. There we were loaded together with 1000 Jewish prisoners onto cattle wagons.

It took us four hours to get to the area of Linz; that is, we could only ride as far as Steyer-Eck, and the rest of the way we went on foot, walking on the rails. At 2:30 in the afternoon, we finally arrived at the Linz junction. At 3:30, the tools were distributed, and we marched up a hill. What a scene confronted us! This was supposed to be four days' work? All the tracks, as far as the eye could see, were derailed and broken and in spirals. The railroad cars, like toys, sprawled across and around each other. Pieces of metal in a wild confusion, and this in a stretch of 4 kilometers long and about 1.5 kilometers wide. On the road from Linz to Klein-München, a small neighboring town, there was not a single house still standing intact, and we saw Hitler Youth, the army, and the marines everywhere, cleaning up.

Now our work started, and the railroad fed us. We worked through the night, and the next noon we experienced something which clearly outlined the ideology of the SS. The commandant was the Mauthausen Arbeitsdienstführer A——T——, SS Oberscharführer and famous for his sadistic murders and torture methods. He had given the order that in case of a bombing alarm, we were to continue working. The SS were to hide in the nearby bunker, and to continue guarding the prisoners.

The bombing alarm was given, and not only that, Linz was attacked. Hundreds of Allied bombs were dropped onto the

railroad area. We prisoners hid ourselves beneath the wagons and also in the bomb craters. The SS sat in the bunkers, their machine guns trained on us. The attack lasted one and a half hours, and it's a miracle that none of the prisoners was lost.

Since the railroad bridge to Gusen was damaged, we had to stay overnight in Linz. There, a very bad time began for all of us. The entire hierarchy of officers [a list of names follows] saw it as their main duty to plunder the 1500 prisoners assigned to this clean-up detail. We were robbed, beaten, and deceived.

We worked from 3:30 in the morning until 7:00 p.m. There was no food in the camp, and when there was any, it was totally insufficient. The work load increased daily. After ten days, the German railroad stopped our provisions. All that remained of the work detail by this time was 970 prisoners. Loss of strength, wounds, and death had reduced the number. We were covered with lice. Because of the continuous rain, most of our shoes were ruined. Most of the prisoners, in any case, ran around in rags, and completely barefoot. The people of Gusen, as well as of the Hermann Göring factories, took no notice. On the contrary, they stared at us and did not hesitate to hurl insults at us. I shall never be able to forget the attitude of those people for whom we worked for such a long time. Four weeks without a bath, no change of clothing, and in any case our clothes were rags, still worse food and treatment, and on top of that, we had to stand for hours after work, in the rain and snow, doing deep knee bends by order of Arbeitsführer K——. This was our punishment if any of the prisoners tried to escape, or if there were too many ill ones.

When we had finished the rails in Linz, they sent us to Unstetten to continue working. There the situation was even worse than in Linz. We stayed two days, then were finally released and sent back to Mauthausen via Gusen. Of the original 500, 216 prisoners remained.

Emotionally and physically ruined by the treatment we

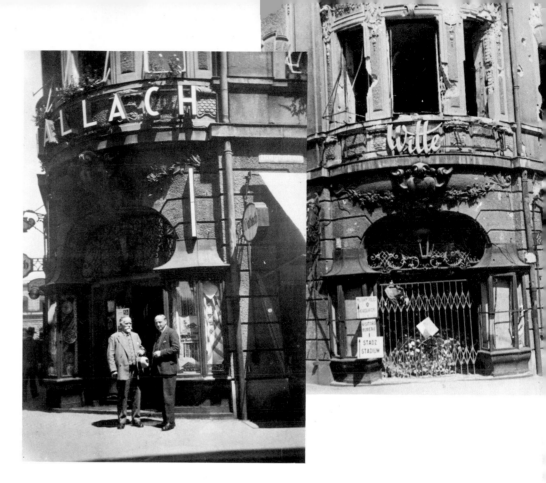

had suffered, we stood once again in front of the laundry. Once again, as if we were new arrivals, they sent us to Block 13. . . .

. . . They composed two SS units of some of the prisoners in the camp. For these units they used the convicts, the worst of their kind. The first unit was sent to the front, and for the most part, died. The second unit had the luck to change their clothes swiftly and, when the end of the SS tyranny was finally accomplished, appear to be prisoners.

On May 4, 1945, the camp was taken over by the Viennese police. Only a few SS men stayed in the camp. There was total chaos. And when, on May 5, at 1:12 p.m., the first American panzer divisions came in sight, the jubilation was indescribable.

Most of the family who were able to leave Germany—and they were the majority—found new homes for themselves all over the world.

Oskar Strauss's son Werner had emigrated to Israel during the early thirties; he had urged his parents and his uncle Richard to follow, but they could not bring themselves to leave Germany. In Israel, Werner changed his name to Binyamin Banai. Here he is ca. 1947, a member of the Haganah, working a heliograph.

The story of Hede Gotthelf (Meta's sister), her husband, and three children is excerpted from the *Leominster Daily Enterprise,* Leominster, Massachusetts, May 10, 1960, and May 17, 1960.

LEOMINSTER MAN TO SEE SISTER AFTER 26 YEARS

From the German community of Remscheid in the Rhineland to the land of the tulip, Holland, to the northern part of Israel, and then to Leominster comes a story of tragedy and joy that spans more than 25 years.

On Friday of this week a brother and sister, separated for 26 years, will meet under the shadow of the Statue of Liberty in New York City. They are the only members left, of a family of five.

Frank Gotthelf, 12 Merritt Street, and owner of the Lunch Box on Water Street last saw his sister Ulla Jahalom, in 1933 [when] she left [Remscheid] for Holland.

In Holland, Ulla was trained by partisans of "the cause for freedom in Palestine." After a year's time she was transported to Palestine and entered a Kibbutz.

The Kibbutz where Ulla met and married her husband, reared her two daughters and two sons is located in the northern section of Israel near Lake Tiberias. It saw the transition of Palestine to the republic of Israel in 1948. It is one of the oldest and most prosperous communities. Ulla was one of the original settlers.

But with the joy of the reunion there will be a portion of sadness for those who could not escape from the Nazi terror in Germany.

Mr. Gotthelf said, "My mother was in Holland when the German forces overran that land. One day they lined all the people up. The soldiers began counting from the front of the line up until number 111 and then they stopped. My mother was number 111. These first 111 persons were exchanged for German war prisoners. Her life was spared. My oldest sister [Trude] was number 112. Then came number 113, her husband, and number 114, her daughter. We have not heard anything of them since."

"My oldest sister had another daughter who is alive in Israel today. She was being transported to a gas chamber when Russian troops stopped the train. She hid in a Red Cross ambulance [which] took her back to Holland. And from there she was able to get to Israel somehow," he said.

"For years I had thought that my mother had died. It was only after the war that I found out that fate had spared her. She died in 1953 in Israel from the effects of the years of imprisonment in the concentration camps."

When the Israeli ship the *Zion* enters New York harbor, Mr. Gotthelf and his wife, Ruth, will be waiting.

ALMANAC
DAYLIGHT SAVING TIME

Leominster Daily Enterprise.

WEATHER
Partly cloudy, showers, cool tonight. Tomorrow, cloudy, showers and cooler.

VOL. LXV NO. 132 LEOMINSTER, MASS. TUESDAY, MAY 10, 1960 EIGHT PAGES SEVEN CENTS

Spy Flight Made by U.S. As Protection

WASHINGTON, May 10 (AP)—The United States has acknowledged sending spy planes inside the Soviet Union occasionally as part of "extensive aerial surveillance" designed to protect the Free World from surprise attack.

Secretary of State Christian A. Herter reported the practice yesterday after briefing congressional leaders on developments since the Soviet claim to have shot down a U. S. plane deep in Soviet territory May 1.

"The United States has not and does not shirk this responsibility," Herter said, leaving the implication — not discouraged by the State Department — that such flights might be continued until Soviet secrecy is relaxed.

Soviet Premier Nikita Khrushchev took note last night of an earlier State Department statement which mentioned Soviet secrecy in explaining the May 1 flight.

Khrushchev called it "a very dangerous explanation" because he said it tries to justify and does not denounce such flights.

Washington awaited an official Soviet response—not propaganda utterances — in its note of last

— SPY FLIGHT —
(Continued on Page 2, Col. 6)

Japan, Korea On Itinerary Of President

WASHINGTON, May 10 (AP)—President Eisenhower will visit Japan and Korea next month as scheduled regardless of whether he cancels plans to go to the Soviet Union, the White House said today.

"That's firm," the associate press secretary, Anne Wheaton said in making public a preliminary schedule of the President's activities in Tokyo June 19-23.

Preparations still are going forward for the Soviet tour, she said in reply to newsmen's questions. She said representatives of the two governments are "constantly in consultation" on details.

The Tokyo schedule includes visits and state dinners with Emperor Hirohito and Empress Nagako, a round of sightseeing and a golf match with Prime Minister Kishi.

The schedule also indicates that Mrs. Eisenhower still is planning to accompany the President to Japan and Korea, as well as to the Soviet Union if that visit remains in the picture.

The White House said, for example that Mr. Eisenhower and his wife will be hosts to the Emperor and Empress at a dinner in

LEOMINSTER MAN AND SISTER SEPARATED 26 YEARS

LEOMINSTER—An emotion-filled reunion occurred on a fog-bound pier in New York City Saturday night. Frank Gotthelf and his sister, Mrs. Ulla Jahalom, described the reunion as "overwhelming."

Gotthelf said he and his wife were standing on the pier fearful they would not recognize his sister. As they waited for the passengers to disembark, they saw a woman waving and shouting from the deck.

Mrs. Jahalom, a dark, attractive woman, said she knew her brother right away because of his resemblance to their parents.

The meeting was the first time the two had seen each other since Ulla left Germany in 1933 [for] Israel.

In the beginning, she said, her Kibbutz consisted of 150 persons from the four corners of the earth, "Poland, Russia, Hungary, Germany, everywhere."

From the outset there was trouble between the Arabs and Jews. All the members of the Kibbutz were armed at all times. The work of defending the community was shared evenly by the men and women. Even today, Mrs. Jahalom explained, the women play an equal part in the defense of their country.

Until 1944, Gotthelf said, he had no idea whether his mother and relatives were alive until he heard from his sister Ulla. She wrote and said their mother had been released from the camp along with other Jews in an exchange for German citizens held in Israel. She then lived in Israel with her daughter until her death 10 years later.

Their sister's daughter, also confined at Bergen Belsen, escaped and managed to get to Israel, where she is living today. The rest of the family perished at the concentration camp at the hands of the Nazis.

Mrs. Jahalom plans to stay in this country for two months, then return to her own family living in Israel.

Planning Board Objects

Legal Question Keystone Drive

A question of legality on itself on members of the Council at last night's meeting. The legal point revolved on a petition to lay out a section of its Keystone drive. Council was not sure whether it had power to vote on it, and what type of majority required. And it was uncertain as to

To Consider

Several Rule

An ordinance streets, to give wastes fed into calendar and paged Council at its

City Councilor

Council Asks A Study of Foot Bridge

The construction of a foot bridge and erection of a four-foot chain-link fence along Manning avenue at Monoosnock Brook, an area where accidental deaths have occurred, met with both approval and disapproval from members of the City Council last night.

Kennedy's Big Test

Nation Watches Primary Today

By THE ASSOCIATED PRESS

The voting of several hundred thousand Democrats in West Virginia overshadows all else today in the national political picture.

Legion Aides List Donation Of Clothing

A meeting of the American Legion Auxiliary was held last night in Veterans Hall with Miss Ann Tulonen, presiding.

Mrs. Mildred Johnson, reporting on community service work, said 158 pounds of clothing had been sent during the past week to the Children's Federation for children in the Kentucky hills, also a box of clothing for the Hillside School at Marlboro.

Chapter Two

Brigitte Hanf
English II-6
November 13

As the second chapter of my life opens, I am four and a half and facing my first day at school. It was an English speaking school because we were now living in Australia. I carried my lunch box containing a thermos of milk and my mother informed me she would be at the school punctualy at three o'clock to take me home. At lunch time, the other children were served milk in bottles to be drunk through straws and my poor teacher who could not understand my clamoring in a strange language for equal priveleges, had to take me home to ask mother what it was that made me so unhappy. However it did not take me more than three weeks to become perfectly at home with the new surroundings and language.

I was very sad when the small school closed a few months later and I had to attend a larger private school in the same vicinity. This school was a girls' school by the name of Cranly. We had to wear uniforms here consisting of a navy blue, pleated, wool tunic; a white blouse with long sleeves, knee length white stockings, brown lace shoes, and a soup bowl hat on which was sewed the school emblem. The only outstanding memories I have of this school was that it was surrounded on all sides by a high corrogated iron fence and that every day for the first week I refused to wear my soup bowl hat. Finally the head mistress (principal) heard of it and told me not to come back the next day without it. I spent two years at this school and then we moved to Brighton which was another suburb farther out and located near the bay. There we lived in a "semi-detached brick villa", one of thousands of its type found around all British cities. It was a low, modern, one story brick or stucco building which housed two families who used seperate entrances and whose front and back yards was divided by a fence or hedge, in this way giving each family complete privacy, disturbed only by occasional children's noises and kitchen smells. We had a nice bunch of kids as playmates and liked Public School number 1542. However, the threat of the Japanese invasion disturbed my parents so, that they decided to evacuate my sister, who was then three and a half, and me to a private boarding school in the country some thirty miles from Melbourne.

The school was the only progressive co-ed institute in Australia at the time and consisted of a number of buildings scattered over a half acre of land, nearby the Yarra River. Believe it or not, but at this school we could call the teachers by their first names and if we didn't feel like going to class, we could go swimming in the river instead!

Life up here was much like camp life. The buildings all had names such as "Girls' cottage", "Boys' cottage", "Primary Cottage", etc. I boarded here for a year and ahalf, and then my parents moved up into the village about two and a half miles from the school. I lived with them then, and had to walk an hour to school in the morning and again back home.

The principle of "Koornong" was mainly to make individuals and personalities out of the scholars and knowledge of regular school lessons rated second. Once a year, tests of school work, given by the state would have to be taken and it was always extremely difficult for pupils to pass in these because we did so little in the way of math, English, etc. I spent three years in this "educational paradise" and then we got word that we could expect to get a passage on a ship to the United States any day. However it turned out that we had to wait another year until there would be room aboard a ship and in the meantime my father managed to get a berth aboard a cargo ship sailing from Melbourne, and he went without us. He thought he could get a job over here and buy a house before we came, so we could get settled right away.

While I was struggling in the strict Public school again and getting spanked with the ruler by my teacher, mom was awaiting word from dad, who, by this time, was in America.

At long last the welcome news came that there was an empty cabin aboard the H.M.S. Rimutaka which was to sail from New Zealand on September 28, 1946.

Right: Lotte, Brigitte, Catherine,
and Eric; Melbourne, Australia, 1940.
Overleaf: Brigitte and Catherine in the
backyard of the house in Brighton, 1941.
(My interest in photographs
started at an early age.)

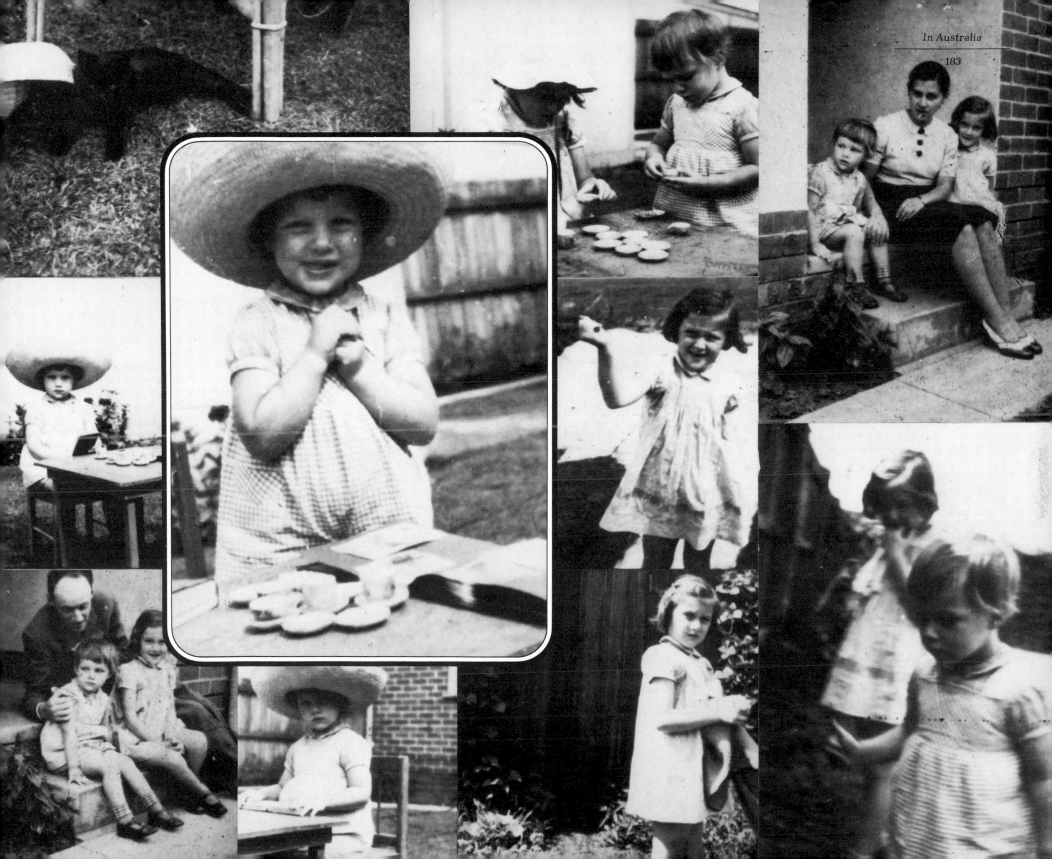

At first Brigitte and I boarded at Koornong, later our parents moved to Warrandyte (above), and my sister and I became day students. We lived in the cottage next to the one on the right (there's no picture of our own house) on a hillside on the far side of town. This house had no plumbing (it did have an outhouse), no heat, and we collected our water in a rain barrel (just visible to the left of the house). One summer I remember there was a bad drought—it didn't rain for almost three months—so in order to bathe I had to learn to swim...in the Yarra River.

This is the way Warrandyte looked in 1942. Today, I am told, it more nearly resembles New Rochelle, in Westchester.

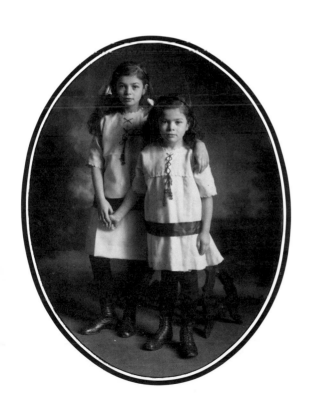

Brigitte
and Catherine

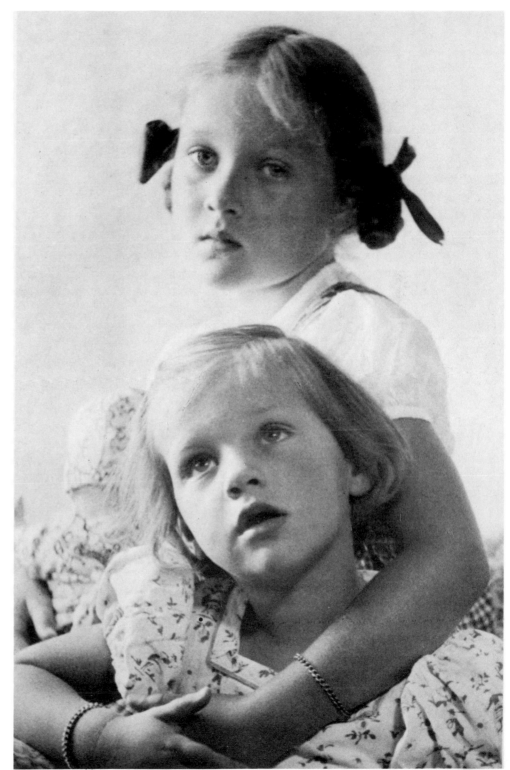

from them and you I shall write in more detail. Unfortunately, I myself have suffered terribly, and it isn't over yet. We, like all Jews who had any connections at all, went underground, namely, here in Friesland on a small, very primitive farm. Alfred fell terribly ill, and was so bad that on the first of June, 1944, the doctor prepared me for his death. He had arteriosclerosis, and then a thrombosis, and on September 20 he died after hopeless weeks in the local hospital. And more grief: Lotte and Carl had fallen into the hands of the Germans and were deported to concentration camp in Germany and my hopes of seeing them again are very dim. Günther, after two and a half years underground, is at last free again, he wrote me today that he saw the name Hede Gotthelf on a list of people who had reached Palestine. I am so glad, and surely you have had news yourselves. Perhaps she knows something about Lotte and Carl. Dear Meta, would you ask her right away? She must have been imprisoned too. As for the rest of it, we have lost everything, and I myself, though healthy, have become an old woman.

Be well, and please write as soon as you possibly can.

Your Marta

This letter was the first news anyone had heard from my father's family since 1939. Sent by Marta to Meta and Moritz in the United States, it was forwarded to us in Australia:

Friesland [Holland]
Toren Street 9
June 5, 1945

Dearest Meta and Mor,

Through lucky chance I am able to get this letter to you, the first after our liberation.

I hope that everything has gone well for you all these years, and that your boys are not having too hard a time if they are in the army, and that Annelise is well. Is she married? The reports are slowly beginning to come through and I can't wait to hear from everybody, especially the children. As soon as I have news

My grandparents Hanf had fled Germany in 1939, and gone to Holland, where Lotte and Carl Haas (my father's sister and her husband) were already living.

Lotte and Carl were captured and interned in Bergen Belsen. Later put on the last train to Auschwitz, which was intercepted by the Russians, they escaped from the train, but somehow lost each other. Carl finally found Lotte in a French army hospital. Today they live again in The Hague.

Günther, my father's youngest brother, spent the war in a Dutch attic. Today he, as well as my father's other brother Rudy (who had emigrated to South Africa during the thirties), live in Montreal.

Hede Gotthelf did in fact reach Palestine (see pages 178–9), where she lived with her daughter Ulla until her death in 1953.

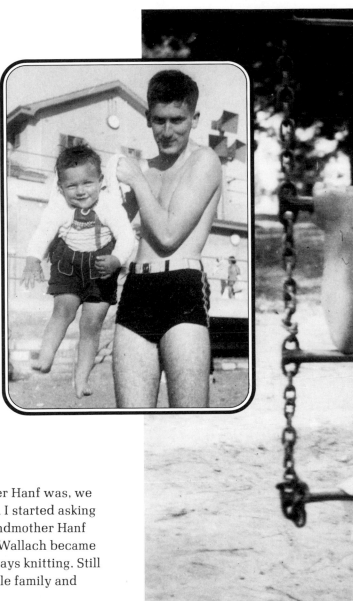

Once we knew where our Grandmother Hanf was, we
were diligent about writing to her, and I started asking
for photographs—even then. Our Grandmother Hanf
was "Oma Martha"; our Grandmother Wallach became
"Oma Pick-Pick," because she was always knitting. Still
later Marta became Mutter to the whole family and
Meta became Mutti.

(The P.S. refers to my father's handwriting, which
was illegible to me at the age of seven, and which I still
have difficulty with today.)

*Above: Catherine at the beach with our friend Allan Kenneally,
in 1940. Right: Catherine, age seven.*

Brigitte Hanf
English II-6
December 18

Shortly after my twelfth birthday, we began packing for our voyage. Those days were the shortest, busiest, and most exciting of my life as far as I can remember. When I came home from school at four in the afternoon, I would find my mother washing, ironing, mending, sorting and packing with the house upside down. Moving vans came and went carrying the pieces of furniture which we were not taking with us, to the auction house in Melbourne. The telephone was ringing constantly, and our weekends were spent shopping and cramming as many articles as we could into the small wooden crates. My mother had some beautiful sets of china and crockery which she sent to a packing company to pack for the rough journey. The company wrapped them in a few sheets of newspaper and let it go at that, but when we arrived in the U.S. there was scarcely one whole dish left. Of course we were quite upset over that but there was nothing much we could do about it. My mother recieved packets of letters with instructions from my father in America, and spent hours studying them. The night before we were to leave I was so excited I couldn't sleep. After waiting for over four years we were coming to the U.S.!! It was hard to believe. At last the big day arrived. We were to leave at (two) four in the afternoon so I spent the morning visiting and saying goodbye to my friends. One thing I still regret is missing my best friend Lorraine. She wasn't home when I went over so I raced all over town trying to find her—but with no luck. I found out later that she misunderstood the time and had gone shopping. At four o'clock a friend of my father's came to take us and our baggage to Flinders Street station. After hasty farewells we boarded the "Spirit of Progress" which was the fastest train in Australia and were off!

It was the first time I had been in a train overnight and I was tremendously excited. My sister Catherine and I spent the first hour roaming all over the train and inspecting every thing. After a while we had supper and settled down for the night. We did not get a berth so we had to spend the night on the hard seats. Very early in the morning we had to change trains and continued in an old rickety railway coach. The reason for this change was that the width of the railway lines changed from state to state so the trains have to change also.

We pulled into Sydney late that morning where we were met by friends who were to lodge us for a week. We spent that week looking at the sights of Sydney from the top of "double decker" busses. One of the most beautiful sights is the famous harbor bridge at night when it is all lighted up with strings of electric lights.

A week later we took off from Rose Bay in a sea plane. It's a strange sensation to feel the plane rumble and rock beneath you and to look out the window and see nothing but foamy water spraying over it.

A minute later we were in the air and high over the city, and after awhile I looked out and saw small fluffy clouds through which the ocean could be seen. An hour later the stewardess brought us a light lunch on trays. Suddenly I began to feel dizzy. My ears rang and even the chewing gum which the stewardess offered didn't help. I got up in a hurry and stayed in the women's room most of the way to New Zealand.

When we landed at Auckland a bus was waiting to take the passengers to their various hotels. We had known nothing about the hotels here and so had made reservations at the first one we looked up, with the result that we landed at a small, dingy, out-of-the-way place. As soon as we entered it I felt home sick. I thought Auckland was a dreary, old fashioned place and didn't change my opinion after we got stuck there for a week longer than we intended.

The hotel "Atlantic" was old fashioned and the only good thing about it was the food which was excellent. We spent our prolonged stay here roaming around the streets and doing window shopping. One evening we attended a very good presentation of "A Midsummer('s) Nights' Dream" put on by one

of the high schools. When notice at last came that we could leave on the H.M.S. Rimutaka in two days, we were very thankful.

The next day we packed and stored our luggage aboard and asked a steward if we could look around. "Jeff" as we later came to call him was very nice and showed us all over the ship including our cabin. There seemed to be so many corridors, doors and stairways that I was sure I would never find my way around and was quite surprised when we had been aboard a few days to find our cabin very easily.

When we wanted baths we would have to make reservations from the steward first. He would heat buckets of salt water and pour it into the tub. We washed ourselves in salt water and rinsed ourselves with cold fresh water. It was a strange experience and I wasn't so sure that I liked it.

On the day we left the people all stood on the dock and threw us colored streamers. Then at five o'clock we pulled up the anchor & set sail. As we looked ahead of us, we saw three weeks of life on the ocean and we prepared to make the most of them. A few minutes later the gong sounded for supper and we all filed into the dining room. I might mention that the Rimutaka was really a cargo ship but it took about 300 extra passengers.

As the days went by, I made many new friends among the stewards, sailors, passengers and captain, and strangely enough I wasn't seasick at all. Captain Clarke was something of a magician and one day he invited all the children on board to a party in his cabin. We were served soda, cookies and candy while he showed us his tricks and souvenirs that he had collected all over the world. Then he took us to the engine room and the room where the steering wheel was. Here he let us each take a turn at steeering the ship and looking through a telescope.

As we neared the equator it began to get steadily and unbearably hotter, and a swimming pool was erected. This consisted of a huge, wooden, boxlike affair with a canvas cloth strung across it and filled with salt water. You got into it by means of a ladder running up each side. Unfortunately, I was only allowed in it a couple of times because I had just been vaccinated by the ship's doctor and wasn't feeling too well.

One day when I was looking out to sea, I noticed something that looked like a cloud on the horizon. After we had watched it getting slowly nearer for a couple of hours it turned out to be Pitcairn Island. We dropped anchor a half mile out for a few hours while the natives swarmed aboard laden with shells, beads, necklaces, fruit, grass skirts, baskets and flowers. We traded anything we happened to have with us, but what they craved most was candy for their children. That evening when we set sail again I discovered that I was heaped down with ten shell necklaces, three baskets, a grass skirt and a cocoanut.

When we reached the equator, the captain called me up to the bridge and handed me a telescope. I looked through it and saw a black line. "That's the equator," he said. For a minute I believed him and then looked at the deck. The black line was still there.

That day the people who had not crossed the equator before had buckets of cold water thrown over them.

The days till we reached the Panama canal were filled with parties, deck games, swimming, movies, dances and sun bathing. I remember in particular a passenger by the name of "Red" Stevens. He was from Texas and we always teased him because of his drawl. He in turn would tease us because of our English accent.

Then one memorable evening we dropped anchor at Balboa, Panama.

That night we toured the town from 7 to 3 in the morning. I'll never forget that night. We took in everything including a night club where they even let my sister and me in, although I was only 12 and my sister 8.

The next morning it was so hot that I almost passed out. I kept seeing red and black spots in front of my eyes.

We spent a few days at the best and only hotel in town

where they served the most wonderful food I have ever tasted.

Then on the 18th of October we boarded a plane for Miami, Florida. This time I wasn't sick and after a night of flying we landed in Miami.

There we took sight seeing tours all over the countryside. We even saw an alligator farm. I wouldn't want to see that again. A man came right into the pen with about 40 alligators and poked them with a stick. He would dodge quickly as they snapped at him.

At the modern hotel "America" we were taking showers continually. All this heat was new to me and I didn't like it too well.

One day we decided to go swimming at one of the famous beaches we had heard so much about. We were in for a big disapointment. After riding in a hot, crowded bus for over an hour we arrived at a small, dirty beach, surrounded by large, white, modern hotels with beautiful private beaches. No matter where we looked, the hotels owned all the nice beaches. However the city itself was beautiful and we enjoyed our stay there.

On the first of November we again boarded a plane this time bound for New York. It was a wonderful flight—especially the landing at Newark, New Jersey. (The destination was changed.) My mother and sister were sick this time and so missed the picturesque scene. It was just about dusk and the sun was almost down. All the lights of the city were on and it looked very beautiful, as they got nearer and nearer.

As soon as the plane touched the ground, my mother was racing toward my father and grandmother who were waiting for us. I had not seen my grandmother since I was three.

After the first wild greetings were over and our passports, etc. attended to, we piled into a taxicab and went to my grandmother's house in Woodside. There a minature party awaited us.

After we had been living with my grandmother a few days, we found a one room basement in Jackson Heights, but

my sister and I continued to attend the school in Woodside. Every day we would board an overcrowded bus to school and often be carried way past our stop before we could fight our way off the bus. I thought P.S. 152 was wonderful compared to the Australian schools. It seemed that we could do almost anything we pleased there.

We sweated through an awful summer in that basement and then my grandparents moved their home and their business to Lime Rock. We followed suit and moved to Cornwall where we have lived ever since.

Meanwhile my sister and I started attending the grammar school in Cornwall. I was put in 8th grade and my sister in 4th from where she soon skipped to 6th. I felt kind of out of place and unsettled at first but later got used to it. I joined various clubs in Cornwall and later graduated and started attending high school.

Believe it or not but I can remember very little about my Freshman year. That year seemed to go by in one big rush of homework, dances, club activities, and so forth. I started keeping a scrap book of my freshman year and when summer vacations started, it was pretty well full. This has been the 3rd and last chapter of my life.

Eric sails for the United States. The citation I later received for "crossing the line" is in the far right corner. I was very proud of it.

Lotte, Eric, Allan and Lois Kenneally (friends), Brigitte, and Catherine, 1946.

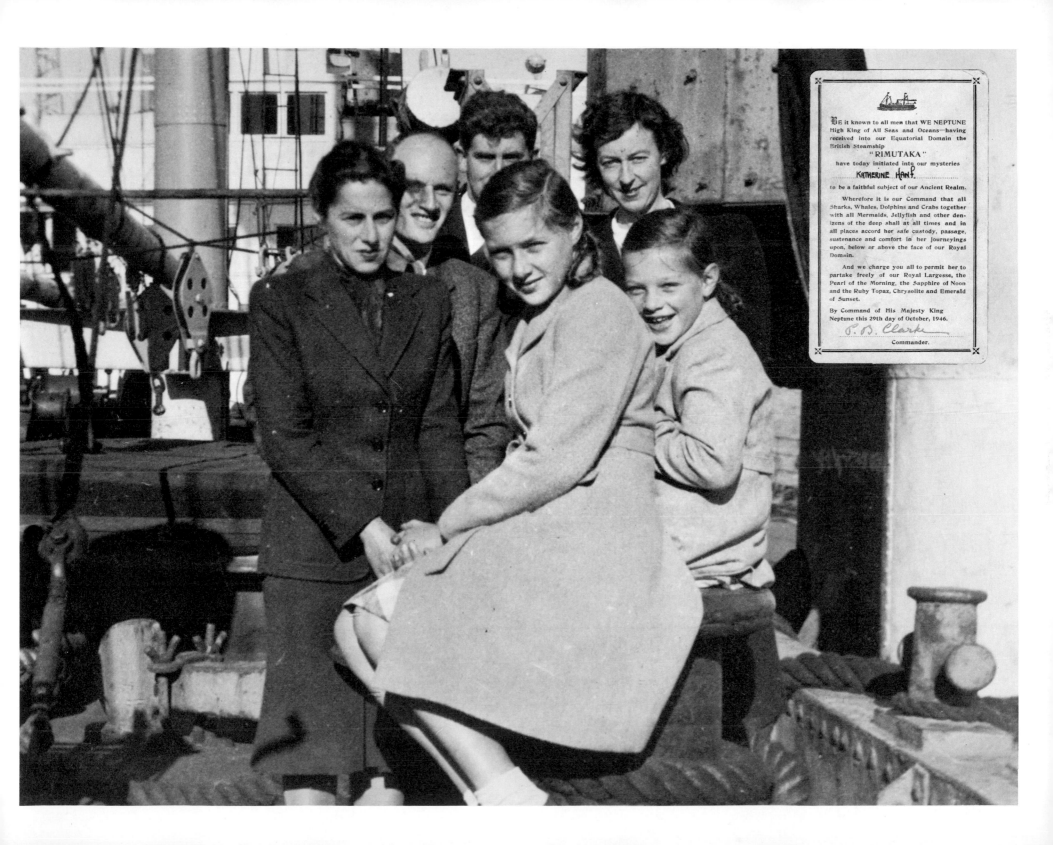

BE it known to all men that WE NEPTUNE
High King of All Seas and Oceans—having
received into our Equatorial Domain the
British Steamship
"RIMUTAKA"
have today initiated into our mysteries
KATHERINE HANF
to be a faithful subject of our Ancient Realm.

Wherefore it is our Command that all
Sharks, Whales, Dolphins and Crabs together
with all Mermaids, Jellyfish and other den-
izens of the deep shall at all times and in
all places accord her safe custody, passage,
sustenance and comfort in her journeyings
upon, below or above the face of our Royal
Domain.

And we charge you all to permit her to
partake freely of our Royal Largesse, the
Pearl of the Morning, the Sapphire of Noon
and the Ruby Topaz, Chrysolite and Emerald
of Sunset.

By Command of His Majesty King
Neptune this 29th day of October, 1946.

P. B. Clarke

Commander.

THE VOLKSKUNSTHAUS WALLACH *(continued)*

After we arrived in the United States, we had neither opportunity nor means to get money across. We arrived at the pier in New York with $10 each of worthless German marks. My children Rolf, Fritz, and Annelise [who were already in the United States] earned a little, but barely enough for themselves.

In spite of my sixty years, I had not lost my capacity to work, or my will. In the [New York] suburb of Woodside, we rented a small apartment on the fourth floor of a clean-looking house, and for the first time learned how decent and helpful people were in the United States. Our landlady told us that we should pay our rent after we had gotten over the worst. "Right now you need what you have," she said.

I went to the city every day, looked at stores, made myself acquainted with the local taste, and tried to find European craftsmen, smiths, carvers, and bookbinders, and above all a carpenter. I had light fixtures made from my designs, candlesticks and paper baskets. The best luck I had was with a three-piece candlestick, which represented horses facing each other. I sold these to a firm; the people there asked me to give them the address of my carver, as they were going to have some furniture made for which they needed carvings. I gave them the address on the condition that they would buy the candlesticks only through me. When I returned to this firm after several weeks, I found two dozen of my candlesticks standing around, and was richer by a nasty experience.

Through coincidence, I learned that a printing place downtown was not fully occupied. I arranged with the owners, a Spaniard and a Russian, to rent their printing table and dye kitchen for $10 a day.

From one of the refugee committees I asked for a loan of $500, and received it. When I told them who I was, they said, "Oh, Wallachs in Munich. You won't get very far with such a small loan; we will lend you $2,000." I said that I did not want to risk their money, and that I would come back after I had had some success.

That fall, there was an exhibit at the Empire State Building, where refugees were to show what new things they had brought to the United States. We were invited to exhibit, and had the great good luck to be introduced to Mrs. Roosevelt, who ordered several tablecloths. Mrs. Vanderbilt encouraged me, saying she was sure that I would be successful, and invited me to come visit her home on Park Avenue to help advise her. Several society women had opened a store on Madison Avenue, and here hand-crafted products made by new immigrants were exhibited; it was a juried exhibition. What I had printed and my wife had sewn was well received. That was our first connection. I went to see several houses, for instance, McGreary (associated with Lord and Taylor), and was given a small order. When I learned that the president was the former head buyer at Macy's, I wrote to tell him how pleased I had been to be given my first order by his house. There was a telephone call to say that that particular order was canceled, and would I please come and call once more. The head of the department told me that his boss was dissatisfied with the size of the order, and wanted to buy more. Therefore I went to see the gentlemen at the organization for help to refugees and asked for a larger loan. They regretfully declined, explaining that they could only give loans to people who did not intend to stay in New York. Whereupon I saw a linen importer who was most accommodating, and thus was able to go on working without the loan. I printed several tablecloths for the head of this firm. The war had already started, and he anticipated more and more difficulty in importing merchandise, but if at all possible he would put me first for delivery. I went to see Lord and Taylor's and several arts and crafts stores, sold through my son Fritz once in a while, and sold some furniture which had been released by the German Kulturkammer. Meanwhile, our son Fritz, together with his friend Liebhold, had established their own business. They didn't have an easy time, either. From various houses I received letters of encouragement and praise.

One day, toward the end of 1939, when I wanted to start

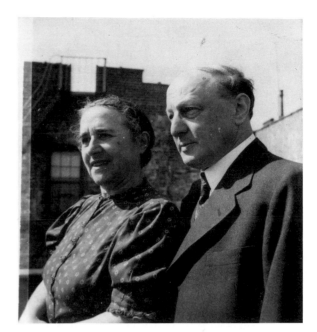

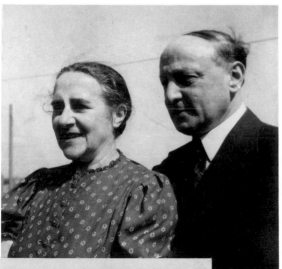
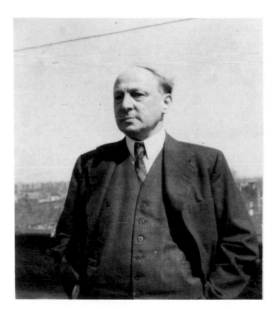
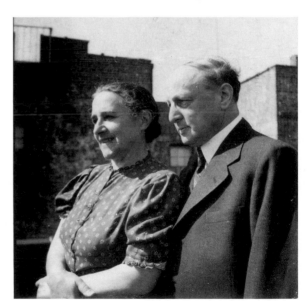

My grandparents arrived safely in Woodside, Queens,
where they moved into a fourth-floor walk-up.

Moritz and Meta, 1939.

printing, the gentlemen told me they were sorry but they had orders to fill and I could not use their printing equipment. I couldn't disappoint my hard-come-by customers, and asked these men, who after all had had an extra income through my rental payments, to help me establish my own workshop. They agreed, and I found my own workroom in one of the many empty, long, narrow shops on 39th Avenue in Woodside. A German carpenter (who is still, in 1961, working for my son) made me a long printing table, and there was a kitchen in the building.

With the continuation of the war, it became harder and harder for specialty stores to import Scandinavian, Italian, and Persian merchandise. The buyers were sent to me; also, there were several committees or organizations for help to refugees, with whom I was in touch. From Yugoslavia came some pictures, with the request for me to print similar things or to make printing blocks from these designs. As I had studied the subject earlier, I already had several blocks in that particular style, and then I had more blocks cut. Norwegian, Swedish, and other orders came in; I worked from early until late and my wife sewed incessantly. [My grandmother later said that this was one of the happiest times of her life; it was the first time she had ever helped earn her own livelihood.]

One day my linen supplier told me that he could no longer supply me, but if I could find another firm that would sell me linen, he would loan me the money without interest. I was delighted by this trust, but who, under these conditions, would sell large quantities to a new customer? So I was left with only small stores in various parts of the city. All over the city, to the farthest suburbs, I went to look for companies that could possibly provide merchandise. So I found new addresses, sometimes third-hand, and managed to scrounge together some material. Even with less profit I could at least supply my customers.

By 1940, I had a salesman for the New England states. It was easier during the war years to sell than to buy. In the Western states we also had a representative who sent in orders. Unfortunately, he had represented larger houses and was thinking of going back to them after the war.

After 1941, I engaged a gentleman from Hamburg to help with the business and keep the books and take care of correspondence for me. In 1946, my son-in-law Eric Hanf, from Mönchen-Gladbach, came to live in the United States. He had gone to Australia with his wife and two children and had not liked it there. I had asked for an affidavit for him, and had to go to Washington to answer various questions before a military and civil tribunal. The gentlemen were very kind and told me that they couldn't promise anything, but that I could go home without worrying. Within a few days I had their okay.

Eric helped me until he started to build up his own business.

My grandfather in front of his business in Munich, 1936—and, opposite, in Woodside, Queens, 1944.

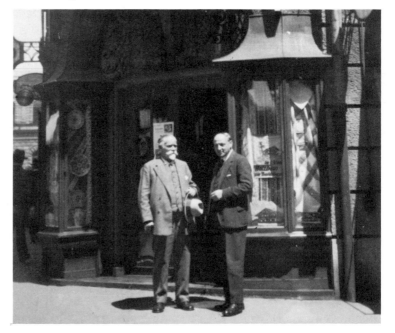

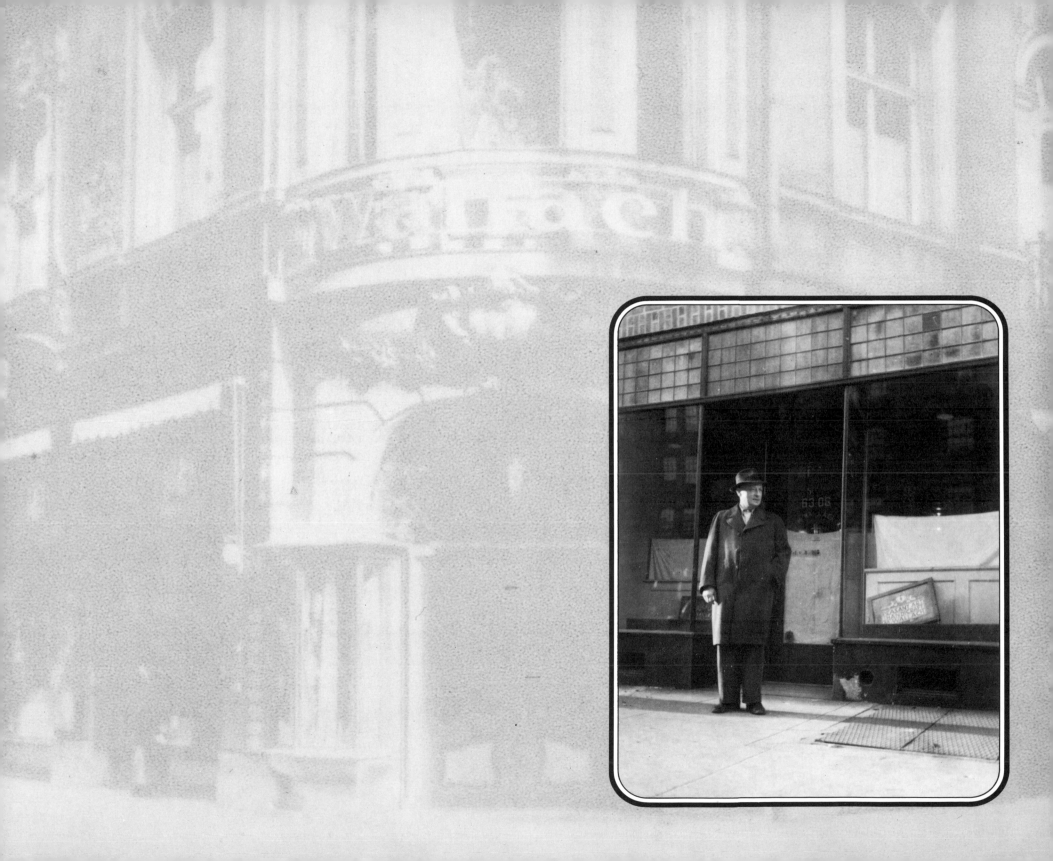

A letter from Adolf's son, Hendrik, from Holland.

*Zolscheweg A 449
Raalte [Holland]
July 6, 1945*

Dear Uncle Mor and dear Aunt Meta,

What a great joy it was to receive your precious lines of June 18! I had not even known that you were safe, and to learn that you and your children are well is such a comfort to me!

I have already written to Anny Rothstein in Bristol, and asked her to send me as much information as possible about all the Wallachs. It's been so many years that I've had no word of anyone in the family, and I look forward to re-establishing contact. The way our family has been strewn all over the earth! Australia, South Africa, the United States, Canada, England, and God knows where else. I hope our ties are strong enough to hold in spite of this; that was something our dearest grandmother Julchen understood so well.

And now, to start with your generation: Uncle Julius and Uncle Ernst are also safe; how sorry I am to hear that poor Uncle Hugo is so badly off. Please send me their addresses soon, so that I can write to them. But you say nothing about the Karllenis: how are they, and where do they live?

You certainly know that poor Aunt Else died in Amsterdam while she was keeping house for Father; this happened just before the outbreak of the war.

We know nothing about Aunt Betty, I fear the worst. I had stopped hearing from the Ohletzes even years before the war broke out. Aunt Grete seems to have more or less forgotten us. It's sad, because she was such a dear, wonderful woman. And now, in the first place, I no longer know their address, and secondly, it's not possible to send letters to Germany, so I could only get information through the Red Cross. But you can also do that from over there.

And about my generation, I know almost as little. I do have Liesel's address, and I expect that I will hear something from her soon, now that it's once again possible to write. And I also have Anny's address. But I know nothing about the rest, except for what you have written me. To begin with:

Ilse: I do know that she lives in Buenos Aires, but I have no address. When she was with us in Amsterdam, she had one daughter, is that still the same? What does her husband Robert do?

Gretel: She was in Paris when the war broke out. What has happened to her?

Traudl: As far as I know she was married in Denmark, but where and to whom, I do not know. . . .

. . . And now to answer your many questions. You can probably picture for yourself what it means to live under the Huns. You yourselves lived through the beginning, and since then, the Master Race has continued to perfect their Art of Living. That is: to make their own lives as comfortable as possible at the expense of everyone else. I knew exactly what it meant for our country in general and for Father and me in particular, when, on May 10, 1940, our country was overrun, despite what Hitler and his entourage had said—that we had nothing to be afraid of.

It was perfectly clear to me that the plan outlined with such German precision in *Mein Kampf* would be followed just as precisely, so long as the Huns held the power in their hands, or thought they did.

There was no doubt in my mind, what I had to do. From the very beginning, I realized that it would be sheer craziness to try to cooperate with them in any way, to stick my neck in the noose, and thank God, it went well for me. But of course there were many narrow escapes. How many lies I lied, I really no longer know: how many false signatures I wrote, that too I no longer remember. But the chief thing was that I never wore the Star of David, and remained untouched by events, inasmuch as my burden was no heavier than that of any other Dutch person, and that was more than enough. Shortly after the occupation began, I joined the resistance.

Hendrik's first wife, Nan, died during the war,
and Henk later married Gerda Goedhart, who had kept house
for him and Peter. Here they are on their wedding day,
December 4, 1945. Hendrik is now in his seventies;
he and Gerda have three sons and two grandchildren. When
the war was over, Henk and Gerda returned to his original
home in The Hague, where they still live.

Thanks to the fact that I speak the German language quite well and that during the time I spent in Berlin in 1926 and 1929 I learned to speak with the "Berlin snout" and to open it wide when necessary, [I could help] many of those who wanted to "dive under" obtain papers and provisions who would otherwise either have starved or fallen into the hands of the S.D. [Sicherheitsdienst—German Security Service].

Perhaps you can imagine how difficult it is for me to write this hateful language, which in the last five years we were so often obliged to read only in order to learn about the newest attacks against our people. I can't help it, but I'm simply unable to think of the members of our family as being German; you all have too many good and dear qualities. The type of Huns that we have had to observe here—you can have them. I had always known, but never fully realized, that romanticism and sadism were divided by such a fine line. I can think of one incident which I will give you as an example.

The Dutch islands in southern Holland and Zeeland were blockaded. No one could get in or out without an official permit, and almost no one could get a permit unless he was a quisling or a member of the German Reich. But we had to get in, in order to steal rationing cards and to help some people go underground. A factory that made bakery machines requested safe-conduct passes for traveling engineers, as the machines needed servicing. No answer. They asked me to do something about it, and one morning I walked into the lion's mouth: the headquarters of the Sicherheitsdienst. The guard asked me: "What do you want?" but I looked straight through him, and marched past him into the office of the head man (naturally, we had discovered which room this was beforehand). I was hardly inside before I just started to scream and yell: I turned red in the face, banged my fists on the table. The officer looked at me absolutely flabbergasted, snapped at the air a couple of times, tried to drown me out—but without success—and finally said, "Calm yourself, dear man, please sit down and let us talk this over quietly. Would you like a cigarette?"

I pointed out to him that delivery of the entire bread provision to these islands was endangered if those machines, which had not been serviced now for three years, were not overhauled (actually, such a machine can operate for ten years and longer without overhauling, but he didn't know that). No bread for the German soldiers! He recognized this danger immediately, and when I threatened to inform Berlin at once if I didn't get the necessary permits within the next ten minutes, I got the papers without any conditions. The man escorted me to the door, apologized again and again that I had had to wait so long, and let me go without even asking to see my identification! A few weeks later this same friendly officer was eliminated because, during the interrogation of some Dutch, he had stomped on their faces until they were one bloody mass, and then calmly watched as the men screamed in agony and finally died.

Enough of these memories: German and Culture no longer go together, and a new generation must be educated before we can once more sit together at the same table. Such re-education is going to be anything but easy. This stupid nationalism must make way for less arrogance and self-glorification, so that other people may live in peace without continuously having to keep one hand on the hilt of the sword.

On September 24, 1942, my poor father was "called for." Apparently he had reported himself, and promptly took his place on the "extermination list." I did everything I could to prevent him, but it didn't help. He was still counting on the "nobility" and "integrity" of the Germans, who, after all, would not consider an old gentleman of seventy-one to be dangerous, and would treat him decently. Even after it had already happened, I tried everything to get him back: but he was already on the way to Auschwitz within forty-eight hours of his arrest. Of the 125,000 Jews we had here in Holland before the war, they say that there are about 5,000 still alive; I think it unnecessary to say more.

Shortly after father was gone, Nan became depressive; too many friends had lost either their lives or their freedom.

For the next year, until November 9, 1943, she was in the hospital, then she ended her life.

I have very difficult years behind me. The constant danger that the S.D. might smell something, the loneliness; it was hard to bear, and had I not had Peter, I don't know whether I would have had the courage to continue fighting.

All my savings, as well as Father's money, are of course gone. Confiscated, stolen, whatever you want to call it, but it doesn't matter, I am still young enough to begin again. At the outbreak of the war, I was export manager at Phillips. Then, when there was nothing left to export (except to Germany! Our "friends" exported to Germany, for a mere 10 billion guilder, payable in Berlin after the war), I joined an office for scientific, commercial and economic organization. This office worked as consultant for many companies in Holland. In the meantime I had studied economics and psychology, so that my knowledge stood me in good stead. In 1942 my boss was captured and died of weakness (that is, he starved to death) in concentration camp. We continued working until, in September 1944, the railroads went on strike, and there was no longer any traffic in Holland. After that, I needed my time too badly anyway, in order to find food. No gas, no electricity, and after a short while no more heat. Thus passed the winter of '44–'45. By the beginning of 1945 not even our wits could help us. We lived on one slice of dry bread a day, and a half-liter of flower-bulb soup (one no longer even had the choice of tulip, hyacinth, or narcissus). We fled to the land, where we have lived since then. Travel was dangerous, for the S.D. and Todt Organization [Nazi organization for construction and road building] had traps all over, not to mention the quislings. But I had good false papers, and the quislings fell for them. Nevertheless, there was one time when it almost went wrong. My bicycle broke down just when the Todt Organization was starting to round up people again about 50 meters away—papers or not, it made no difference.

Here on the land we have regained our strength. In a few days, gas and electricity will be restored in The Hague, and then, as soon as we can find a car, we will go home. . . . Slowly I will be able to start work again, but only in the vicinity of The Hague, as the railroads are still not running.

Whether or not I will stay in Holland is a question. I can see the handwriting on the wall, that sometime in the not-too-distant future I too may make that trip across the ocean. The reason for this premonition? Anti-Semitism has grown so strong that life here is hardly a pleasure any more. Even though many of my friends and colleagues don't know my origins, it is a very unpleasant feeling to know that Jews will no longer get a fair chance.

If I knew of a country where it is otherwise, and where only effort and human qualities are what count, I would not hesitate long.

Since Nan's illness, I have had a very nice young woman as housekeeper, who is also with us here in Raalte. Peter, who is now almost twelve, has become very friendly with her, and thanks to her, we've had a very warm atmosphere even under the worst circumstances.

Before I forget, please tell Uncle Julius that I have some small boxes of miniatures that belong to him, according to Father, and that I've saved them for him. Please ask him what I should do with them.

And now I shall close for this time. I hope to hear from you very soon, and will write immediately if I have something to report about the family Hanf and/or Haas.

My warmest thoughts for both of you, and for everyone whom you can reach.

<div style="text-align: right">

With love, your
Hendrik

</div>

A letter from Grete Loeb's son Kurt, who was stationed with the Allied occupation forces in Berlin.

B - 115890 Cpl. LOEB, K. Berlin. Germany
A and S H of G 15 Jul 45
CDN ARMY OVERSEAS

Hello New York:

Received a birthday letter from Harold this morning which reminded me of the fact that today IS my birthday. Well, things like that don't seem to be of particular importance any more, and the thought that this is my 2nd birthday overseas doesn't make me particularly happy, either....

When I sent my last letter to you I hadn't seen much of the city of Berlin as yet, a state of affairs which has been corrected since then. I have taken some of the boys—a company to be exact—on sightseeing tours and thus saw a lot of things myself. The company commander figured that since I speak German I must of course know Berlin and I was elected. Well, with the aid of a map I did find what used to be the centre of Berlin and after that could talk to the boys about the various piles of debris they were watching. The centre of Berlin is absolutely kaput, finished, gone once and for all. All that remains is the Siegessaeule, pathetically overlooking gutted and bombed buildings as well as the remains of the Tiergarten, and the Brandenburger Tor, which is somewhat worse for the wear. Everything else—theatres, cafes, museums, schools, chateaux and government buildings—are reduced to rubble. In the Reichstag—a horrible mess—we met a Russian colonel, who was writing his name on the wall with a piece of chalk. That seems to be a favorite Russian past-time, every inch of space is covered that way. He was perched atop a cupboard, but leapt to the ground, saluted us (the highest rank in our party was a lieutenant but the colonel saluted on general principle), inquired our names and added them to his list of Russian names on the wall. Their democracy within their army is amazing by American or Canadian standards. The Reichskanzlei was the spot where we got some delightful souvenirs—despite the fact that the building is so badly torn apart that what few walls and floors are left will have to be torn down. Found dozens of German medals, which I sent home already. My prize souvenir catch was discovered in an office, where I noticed two volumes of correspondence, with the edges partially burnt. Evidently the owner had unsuccessfully tried to do away with them. My curiosity aroused, I looked at them and discovered them to be two files of personal correspondence of Reichsminister Dr. Meissner, Sec'y of the Interior. They were dated 1939 and 1941. They contained letters from bigshots such as the Nazi ambassador to Moscow—Graf von Schulenberg and from Field Marshal von Brauchitsch, also letters from assorted SS leaders, from various mayors and Gauleiters, from small-fry who wanted favours done and from political prisoners who wanted to be let out of jail. Also two from half-Jews who wanted to join the glorious Wehrmacht!!! The sons of bitches. It truly is a fascinating document and one that should increase in value and interest as time passes. Also sent home a street-sign from "Unter den Linden," which has been damaged by some bullet holes and shrapnel holes. Very rare souvenir, I guess, there probably aren't more than 10 of these signs, representing the street that was always associated with German militarism and Nazi imperialism. As you can see we are all slightly souvenir-mad, but that's half the fun while staying in Berlin.

Had a good look at the Reichssportsfeld, or Olympic Stadium. Only 2 or 3 of its buildings are destroyed, the balance is OK and the main stadium has been left intact except for one or two bomb-craters. We held our sports day there the other day and had a baseball game vs the American 2nd Armoured Division team yesterday. A good time was had by all. It is strange when one considers how the mighty have fallen. Everywhere in the stadium are marble placques, commemorating the Olympic games and everywhere we saw the name of Dr. Diem, who was sort of an executive director for the whole sports field. Went to see Diem a couple of days ago. Burst into his office without knocking—we never knock here in Germany, since we are always hoping to catch one of the Jerries doing something

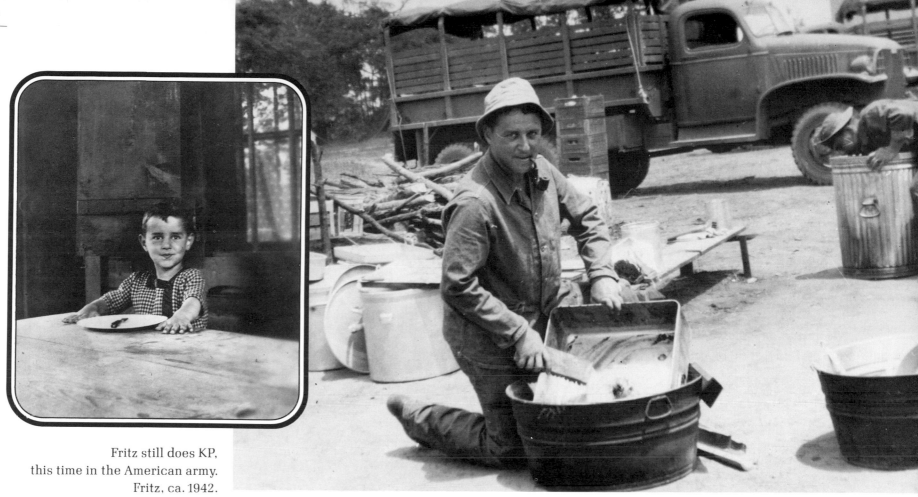

Fritz still does KP,
this time in the American army.
Fritz, ca. 1942.

wrong—interrupted a conference he was having with a woman, and told him to get cracking and get the grass cut in the main stadium since we required the field for a baseball game. He was very respectful, standing almost at attention—and needless to say he DID get the grass cut. In a more relaxed mood, later on, he informed us that the only other baseball game there had been held in 1936 with 100,000 spectators looking on. So I guess the Canadian Berlin Battalion and American 2nd Armoured Division teams more or less made history over again in their game....

I have been writing letters since 6 o'clock and it is now shortly after midnight. Tomorrow I have to get up at 6 a.m. (!!!) to go back to Braunschweig and buy some fresh vegetables etc for our kitchen....

My remaining plans for tonight are to write to Zelda and then to find a gas-heater someplace, make some hot chocolate and get the hell into bed. I hate to think of sleeping only a few hours, especially since I have such a delightfully soft mattress. Well, even that is better than sleeping a few hours on the floor.

Until next week, everyone,

Love to all,
as always yours

Kurt

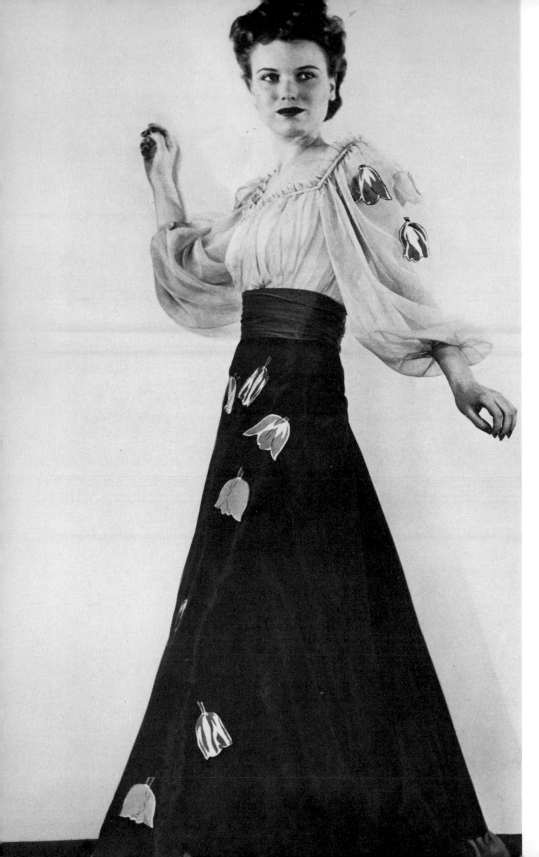

When Fritz met Lucille Carey, she was working as a model in New York. Their relationship was initially one of mutual dislike, primarily because she was always elegantly dressed, and he was rather a bohemian. They overcame that problem, however, via a mutual interest in trotting horses, and in 1943 they were married.

By the late forties, Fritz and Lucille had become the parents of two boys, Michael and Robert, and had also reached a satisfactory compromise in the matter of dress.

Left: Lucille Carey, ca. 1942. Opposite: Fritz and Lucille, ca. 1949.

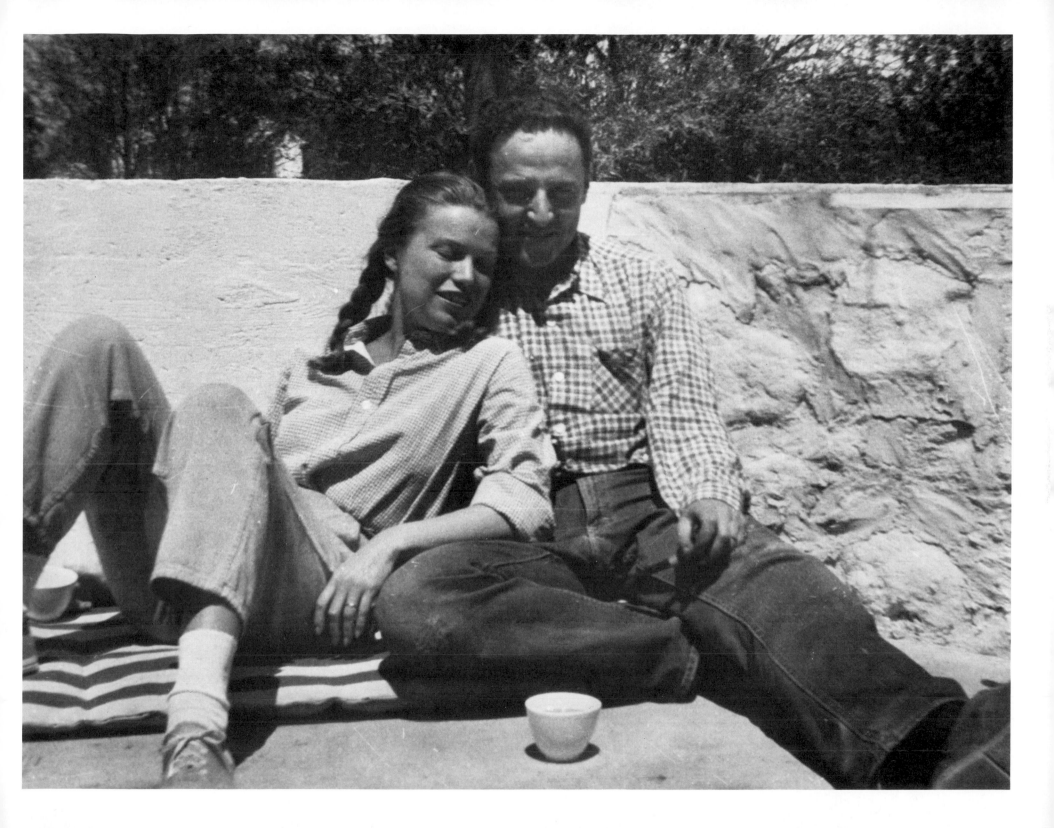

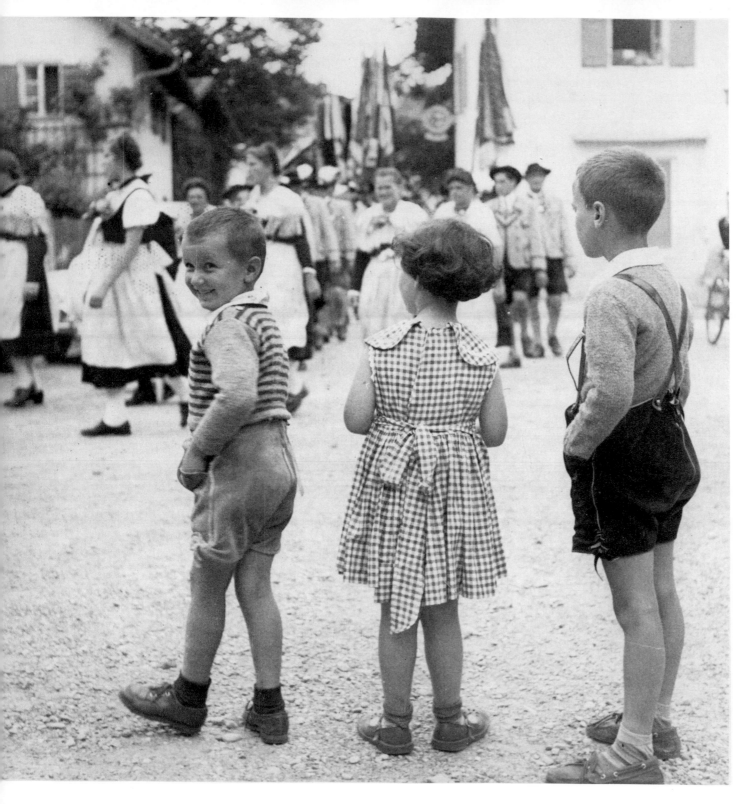

Fritz and Lucille's sons, Robert and Michael, with Franzl's daughter Catherine in the center (see p. 54), on a visit to Europe, ca. 1952.

Robert studied architecture at the Rhode Island School of Design, but gave it up in favor of transcendental meditation, which he and his wife, Lucinda, both teach. Opposite, an article about them. (Fritz had Americanized his family name when he came to this country.)

BUCKS COUNTY GAZETTE Thursday, March 30, 1972 10

ROB AND LUCINDA WALLACE

Wallaces offer peace with meditation

Rob and Lucinda Wallace, of New Hope, have just returned from Mallorca, an island off the coast of Spain, where they were studying with Maharishi Mahesh Yogi. Three months of study has enabled them to bring back to Bucks County the message of the Science of Creative Intelligence: each man has the ability to use more of his potential; Transcendental Meditation is the technique to develop full potential in life, to enrich all aspects of practical life.

The Wallaces, as teachers of transcendental meditation, will be giving lectures in the area and also courses of personal instruction for those who wish to learn how to practice the technique.

Lucinda reports that at the lectures people often ask, "Can anyone do it?" "Do I have the ability to contact the creative intelligence within that you are talking about?" The answer is always the same, she says. "Yes. Anyone can learn... because it's natural and simple no special abilities are needed."

Rob Wallace is one of 1,000 new teachers trained this year by Maharishi; Lucinda has been teach-

ing for a year already. Her experience has been that though the appeal of this technique is great among students, many business people and housewives have started "TM" (transcendental meditation) and are enthusiastic about the results: immediate relaxation and increased ability to deal with problems. One new meditating parent said simply, "I'm more pleasant."

The Students' International Meditation Society (S.I.M.S.) and the International Meditation Society (I.M.S.) the non-profit educational organizations which teach TM are growing fast this year. SIMS reports 100,000 students have taken the course in the past few years. Rob says, "This growth we attribute first of all to the joy reflected in the lives of those meditating and, secondly, to the increasing scientific acceptance of the technique."

Findings of scientific research published recently in "Scientific American, Feb. '72; Science Mar. '70 and Time Oct. '71 indicate that the deep rest gained during TM is unique and has benefits in relieving tension and anxiety to bring about better health.

One career girl from Doylestown said after meditating a few months, "I'm wide awake, have energy, things don't bother me as much and I don't get headaches any more. I'm more tolerant and more cheerful." Others feel "I'm more alert, more energetic" and "I'm happier".

Two free lectures, offering background and discussion concerning transcendental meditation will be given on Tuesday, April 4 and Friday, April 7, 8 p.m., at the St. Phillips Chapel, River and Chapel Rds., in New Hope.

Michael (much to his parents' chagrin) dropped out of school in the early sixties and in 1964 went to Mississippi to register voters. Later he moved to Berkeley and taught himself to make jewelry. Today he's the father of a seven-year-old daughter, and is also a first-rate goldsmith.

On the left, one of Michael's creations: "The waterpipe is hand wrought, not cast. It is approximately a foot high, and of sterling silver. The lion and the vine are 14 carat gold; the pipe in the lion's hands is carved of lapis lazuli. The mouthpiece and base are Brazilian rosewood."

Above: Michael (right), ca. 1973.

STEIN WALLACH PHOTO STUDIO
704 EASTERN PARKWAY • BROOKLYN, NEW YORK • SLOCUM 6-6166
• DISTINCTIVE PORTRAITS FOR EVERY OCCASION •

Annelise studied photography in Germany, and bought a Leica and a complete set of lenses before she left. When she arrived here, of course she had no money—but also had no idea of what things cost; she had never had to worry about money before. One day she made a date to visit Eric Schaal in Jackson Heights. Just the day before, somebody had approached her in the street and asked for a nickel. Annelise gave the woman a quarter, thinking nobody should be on her last nickel. Then, when she wanted to take the subway to visit Eric, she found that she herself didn't have a nickel! She walked over to Fritz's apartment to get some money, but he wasn't home. And she couldn't even call. It was getting late and she was getting frantic, then she thought of the woman who'd asked her—and decided, "Well, I'll ask someone too, I'm sure someone will give me a nickel." The first girl she asked said, "I'm sorry, but I'm looking for a boyfriend myself," so that was that. Then she asked a well-dressed woman, who just gave Annelise a nasty glance from top to toe and walked past her. By this time Annelise was crying; she really felt lost, had nobody to turn to. Finally she realized she had a stamp in her purse (overseas, 5 cents), and a drugstore gave her a nickel for the stamp.

Annelise tried to find work doing photography, but it was difficult, and she had to sell the lenses; first the wide-angle lens went, then the telephoto, slowly all the rest, and finally the camera itself.

She kept a Rolleiflex, however (she still uses it today), and she and a friend soon set themselves up in business on the ski slopes at Woodstock, Vermont. They would photograph skiers in the morning, then hitchhike into town where they had borrowed a darkroom. They would develop the film, make prints, and be back on the slopes by afternoon to sell them.

Later, with another friend, she set up a photographic studio in Brooklyn, and at last they became quite successful.

Above: Annelise poses for members of her photography class, ca. 1938.
Opposite: Annelise at work, ca. 1940.

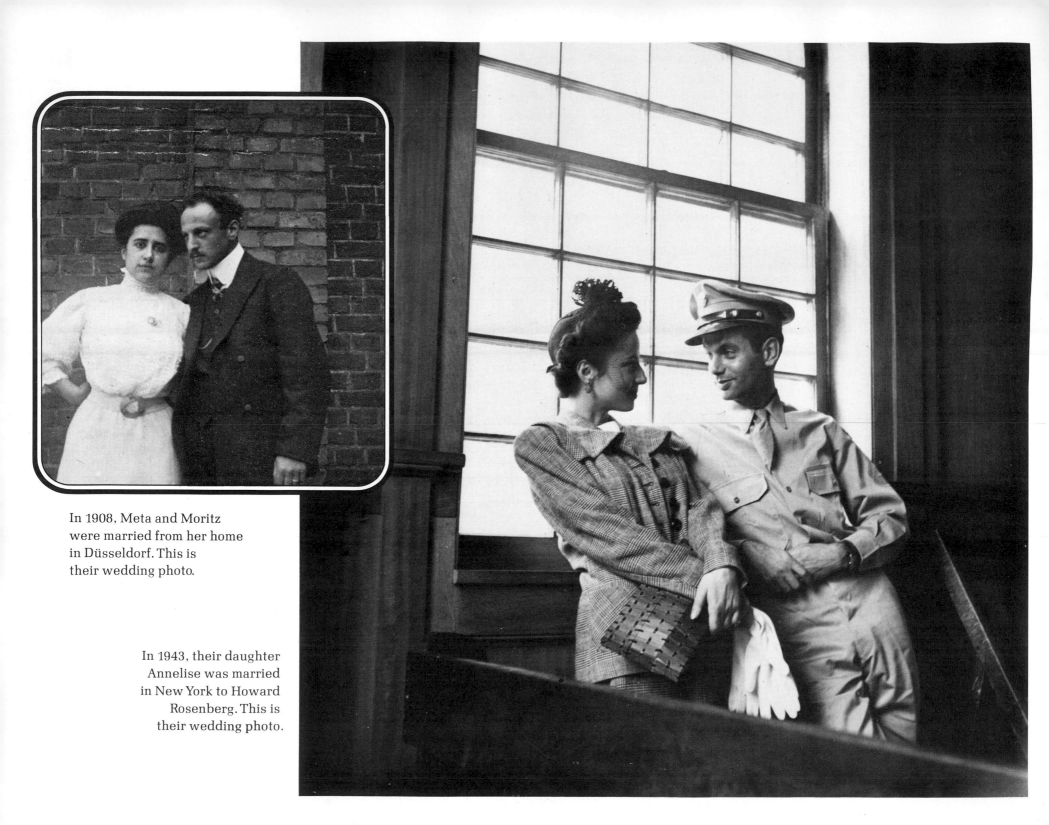

In 1908, Meta and Moritz
were married from her home
in Düsseldorf. This is
their wedding photo.

In 1943, their daughter
Annelise was married
in New York to Howard
Rosenberg. This is
their wedding photo.

In 1970, Howard and
Annelise's daughter, Yvonne,
was married on Long Island
to Mitch Relin. This is
their wedding photo.

Mitch and Yvonne's daughter, Mahri, was born in August 1973. Annelise took this picture of her in 1975 with her new 35 mm camera, which she finally bought to replace the Leica she had had to sell when she first came to this country.

Annelise and Howard's son, Steven (second from left), relives the fifties at a camp follies in 1969.

THE VOLKSKUNSTHAUS WALLACH *(conclusion)*

Neither my wife nor I liked the climate in New York, and after having established ourselves, we decided we could take the risk of moving to the country, to a place where we could both work and live. Through an ad in the *Times* our attention was drawn to the place where we are living now—Lime Rock, a small town in the area where the states of Massachusetts, New York, and Connecticut meet.... My wife and I came to Lime Rock on a foggy, rainy March day. We saw nothing of the beautiful surroundings, knew none of the inhabitants, but we accepted the offer of a building which had once been a casino for the workers of the now-defunct Lime Rock Mill. It had a large hall on the second floor, and beautiful rooms downstairs—in short, made for us. Adjacent, a lovely piece of ground with old trees and a wishing well.

We had saved about $8,000; the down payment was $5,000, the mortgage $4,000. Many trees had to be cut, the yard and entrance paved, the roof shingled, and many other things put in order. I inquired at the bank after the appropriate artisans and tradesmen. Every weekend I went up to Lime Rock, giving each of them his task for the week. At the end of the week, he gave me his bill which I would pay, and then he was given a new job. It all worked out very well.

In 1948, I went to Germany for a restitution hearing. After I was able to show threatening letters in front of Dr. Auerbach [the head of the Committee on Restitution], Witte was forced to return the factory and store, though in miserably bad condition. He had the nerve to ask me, through his lawyer, for an interview. I asked him what he wanted, and he said, "I was wondering whether there wouldn't be a possibility, after all, to go on working with you." He apparently hadn't stolen enough yet. I answered him, "If at the time you took my business away you had paid me according to your Nazi instructions, I could have saved my family. As it was, I was penniless in the United States. I consider you their murderer."

When I got back to the States, I knew that my German business was in good hands. After the so-called *Treuhende* [trustees] had pocketed money from both businesses, the employees had been able to do as they pleased. A few old and faithful ones had asked for an interview with the town government in Dachau, who had gotten in touch with the military government to ask for help. Upon which, a Mr. Max Sedelmayer was put in charge. We could not have found anybody better. He soon had everything straightened out and running well. [Today, Mr. Sedelmayer is still managing Wallach's.]

... I can look back with satisfaction on my successful and, although sometimes disappointing, rich life. I am particularly proud of the fact that I have been lucky enough, with neither knowledge of the language nor independent means, to rebuild an independent existence.

Now I am eighty-two years old, am up at six o'clock every morning, and work, because it pleases me, until evening.

THE HAND-BLOCKED FABRICS OF MORITZ WALLACH
By Joan Hess Michel

On a lovely blue-and-gold day last summer, I made an expedition into the rolling foothills of the Berkshire Mountains to the charming little town of Lime Rock, Connecticut. The fields were dusted with daisies, farmers were taking in their first hay, and butterflies fluttered through the air in lazy patterns. A state highway forms the main and only street of this Connecticut village. Large frame houses sit back comfortably surveying the passing scene. At high noon there is no sound except the buzzing of the bees in the back-garden rose bushes, and the occasional swish of a passing automobile. On a small hill near the road is a neat sign reading, "Wallach Studios," which the unknowing motorist or hiker could easily pass by. The Wallach Studios are housed in a barn-red house, shaded by immense pine trees and bordered by cheery red geraniums. This gingerbread structure, with its jig-saw moldings and ornate doors, was once the recreation hall for the workers from the Lime Rock locomotive-wheel factory in a heyday of industry which has long since passed by this quiet village.

Entering from the side door, one steps into another world. Moritz Wallach's shop is crammed with attractive things to buy. Any woman would be able to spend hours browsing among the objects collected by Mr. Wallach during his yearly trips to Europe. From the ceiling hang handmade wrought-iron chandeliers; the walls are covered with old copper cooking utensils and hand-carved woodblocks; shelves contain old beer steins made of china, pottery, pewter, and wood. Dowry chests, painted with authentic peasant motifs and mysterious storage boxes, decorated by hand, are set on the floor. Tables overflow with pottery pitchers, plates and mugs, while tea pots, carved animals, and sections of stained-glass windows from European churches share the remaining space. Off into the adjoining room, one finds floor-to-ceiling shelves filled with bolts of beautiful hand-printed linens and cottons, all designed and printed by Moritz Wallach. Customers may buy the hand-printed fabrics by the yard to make curtains or dresses, slip covers or pillow shams, bound only by their own imagination and sewing skills. On one side of the room, carved wooden angels and cherubs from European cathedrals stand guard over the heavy Gothic doors which lead to the Wallachs' living quarters in the rear and the workshop upstairs.

Moritz Wallach, a pink-cheeked, lively gaited man, looks twenty years younger than his eighty years. He leads the way upstairs to his workshop, bounding ahead past massive hand-carved armoires from all parts of Europe, and his fine collection of pewter plates and mugs, bits of old wood carving and iron work, to the second floor. Here in a tremendous, light room—the former auditorium which the railroad employees used for entertainments—most of the work of the Wallach Studios is carried out, from design conception to final fabric printing. Hundreds of wood blocks for printing fabrics, all carefully numbered and catalogued, stand around the room on shelves. Some blocks are very old, carved by peasants in the deep forests of Austria and Bavaria; some blocks are new, designed and executed by Mr. Wallach; some are metal, most are wood. All are used to hand-print colorful and unusual designs on bolts of specially imported linens and cottons.

At a long trestle table works Mr. Ulrich, Moritz Wallach's only assistant, who came to the United States especially to work for the Wallach Studios because there was no craftsman of comparable skill to be found in this country. Mr. Ulrich does *all* the fabric printing. It seems humanly impossible that he alone has printed the yards and yards of fabrics that will eventually become countless tablecloths, napkins, dresser scarves, skirts and blouses. Mrs. Ulrich works nearby, presiding over a group of sewing machines, stitching up skirts, blouses, and dresses, and hemming napkins and tablecloths to be sold in the shop downstairs. Explaining the tremendous amount of work that is accomplished, Mr. Wallach says: "The winter is long and quiet; we work hard printing."

My grandfather
at work in his studio
in Lime Rock, 1956.

THE SOCIETY OF ARTS AND CRAFTS
145 NEWBURY STREET, BOSTON 16, MASSACHUSETTS
TELEPHONE COMMONWEALTH 6-1810

November 30, 1956

Dear Mr. Wallach:

It gives me the greatest satisfaction to write you of your election as a Master block printer in the Society.

This was announced at our recent Annual Meeting. It represents approval by the Jury, the Craftsman Advisory Board, and the Council of your elevation.

I do hope that you will take real satisfaction in this recognition of your ability. Believe me.

Sincerely yours,

Humphrey J. Emery
Director

Mr. Moritz Wallach
Lime Rock
Connecticut

HJE:JB

Handcraft **W**allach

Lime Rock, Connecticut

NEW YORK
Von Nessen
225 5th Ave.

LOS A
LLO
B

#1 West 12 Street

New York City

The w

Dear Lady
Last Saturday You gave us by Telefon an order

-sices but forgot to give us your Name Wi

it so that We are able to fill your kind ord

With best regards yours

From

M. WALLACH

LIME ROCK, CONNECTICUT

Tis Letter will be to whom it will belong

31 West 12 Street
New York City

My grandfather established his reputation in the United States (see letter above). Although he never mastered the English language, this never inhibited him—an example of his business correspondence is at right.

Opposite, above: Moritz carves a woodblock, ca. 1948.

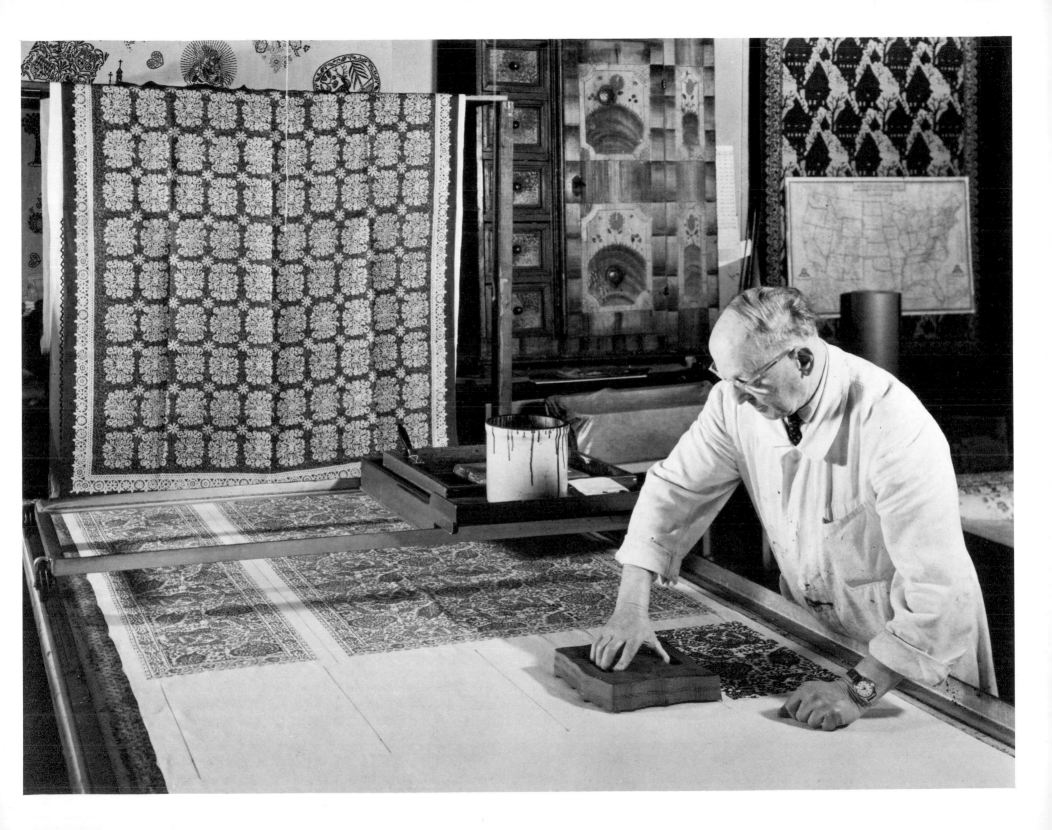

Special orders are packed and standing on the floor ready for shipment. "We have many good customers in the West — in Arizona — and Neiman-Marcus in Texas, and also California," he explained.

Against one wall of the workshop stands an old Danish chest with many small doors which houses a priceless collection of peasant hand-weaving samples. Mr. Wallach, on his many trips through Europe, has collected the bits of beautifully colored silks, mohairs, cut velvets, and wools. He can identify at sight each example of intricate and delicate peasant hand-weaving. "That ribbon is from Provence," he said, "and see, this cut velvet is from the Black Forest area. Each town, each section of the countryside can be recognized by its colors and its unique designs which the peasants weave into these fabrics for their vests and ribbons, skirts and blouses.

"The Museum of Costume Art wants these books," Mr. Wallach said with a twinkle in his eyes. "But I won't give them away. I smuggled these books out of Europe when we were forced to leave in 1938, by hiding them inside my furniture, which they allowed me to take." These books of samples of peasant hand-woven fabrics now serve as invaluable source material for designing blocks for the present-day Wallach prints. The authentic folk motifs are collated by Mr. Wallach, skillfully transferred to wood blocks, cut by hand, and ultimately printed in color on linen or cotton fabrics. As we toured the workshop, Moritz Wallach told me about himself.

"I was born in Westphalia, Germany, in 1879; there were ten children in our family. My father was a grain merchant. My mother was very much interested in the peasant crafts, although she had not had any art training or ability. On weekends our whole family would travel over the countryside visiting the peasants in their homes and watching them work. Thus we learned about their crafts, which had been handed down from father to son," As a hobby, young Moritz began to buy old hand-cut wood blocks from which the peasants printed traditional designs on fabrics for their clothing. He tried to adapt their methods in using the blocks himself. Through some friends who owned a small printing shop, Moritz began to print on fabrics with these old blocks. His brother and he became members of an organization which was devoted to the preservation of the peasant crafts. Unfortunately, in the 1890's, the general public was too interested in filling their homes with Victorian bric-a-brac to reflect enthusiasm for the simple beauties of the peasant crafts. Therefore, handcrafts were inexpensive.

After working for six years as a window decorator, he went into partnership with his brother and opened a modest shop called Wallach's — dedicated to the sale of peasant handcrafts: textiles, ribbons, costumes, etc. Twice a year the brothers journeyed to Leipzig to show their wares at exhibitions. Soon their shop's reputation grew, and peasants were bringing their work to the Wallach brothers to sell. Eventually the Wallachs had their own corps of craftsmen working at home as they had done for hundreds of years — except that now there was a profitable outlet for the products of their "cottage industry."

As his fame grew, Moritz Wallach was called upon to design and execute authentic peasant costumes for the Hof theater in Berlin and for such operatic productions as *The Flying Dutchman* and *The Marriage of Figaro*, as well as for theater productions in Austria and Switzerland. By the middle twenties, the Wallachs' shop of handcrafts had earned acclaim, and was exporting to such well-known American stores as Macy's and Lord & Taylor in New York. In 1926, Mr. Wallach purchased his brother's share of the business and continued the shop alone.

In the thirties when the long shadow of Hitler fell on Germany, the Wallachs, like so many other people, were forced to flee to the United States. They were not permitted to take any money out of the country, nor was Mr. Wallach allowed to take his *own* hand-cut wood blocks, because as reflections of German culture they belonged to the state! However,

Wallach did manage to smuggle some of his wood blocks to other members of his family who kept them safe from seizure. Eventually the Wallachs and their four children arrived in New York—without funds. They were able to find a place to live in Woodside, just outside of New York. Mr. Wallach immediately began to cut some new wood blocks, and with the help of a printer, was able to make some sample prints which he took to the representatives of several New York department stores.

Among those who were most helpful to him at this difficult time was a store on Madison Avenue known as The Window Shop, which invited Wallach to display his work in their windows and subsequently placed a large order with him. About this time there was also a show held in the Empire State Building, sponsored by New York businessmen, and Wallach was among the exhibitors. (Mrs. Eleanor Roosevelt was among those who saw his work there, purchased some, and wrote him encouragingly!) Through this foothold, Mr. Wallach was able to renew his work and, with borrowed funds, he rented a small store in Woodside, New York. Using it as a workroom, he began to work, all alone, designing and executing wood blocks, and printing them by hand on lengths of material.

Mrs. Wallach recalls those days as "nice to look back on, but not to relive." She sewed the hand-printed fabrics into dresses, skirts, and blouses—often every piece of furniture in the house was covered with the results of her busy needle. Although the Wallachs were Woodside residents for eight years, the damp climate had an ill effect on Mr. Wallach's health, and on the doctor's advice, they began to look for a new place to live. Quite by accident, they learned about Lime Rock, Connecticut, from a classified ad in *The New York Times*, and when they visited the village, they knew at once that it was the perfect place for them to live.

"Now I do not cut so many blocks any more," says Moritz Wallach, with a sigh. "My hand is not so steady. I cannot do all the work myself so I sent for Mr. and Mrs. Ulrich to come and visit. They liked it here so much that they asked me if they could stay." So now the Ulrichs too are Lime Rock residents, and they work long hours to produce the beautiful printed fabrics.

Mr. Wallach still creates the designs for the fabrics. By collating motifs from the antique wood blocks in his collection and from the peasant hand-woven fabric samples, and adding his own imaginative touch, he creates interesting new patterns. He draws his sketches in pencil or charcoal and transfers them by the use of carbon paper to blocks of pear or juniper wood (his favorite surfaces). "I do not often use linoleum," he says, "it is too gummy. Only if I have a special order for a short run of fabric, then I can cut a linoleum block in an hour or two. I prefer to use the wood or some of the old metal plates in printing."

The blocks are carefully cut along the lines of the design. Mr. Wallach does not have a favorite tool; he uses the usual assortment of wood-cutting tools. When the cutting has been completed, the blocks are reinforced on the back by wooden crosspieces. The design surface is smoothed, cleaned, and felted. This last operation is important, for the felt helps the color dyes to adhere to the surface of the block. This is accomplished by sizing the surface of the block with glue and using bits of finely shredded felt (wastes from the factories in that Connecticut hat-producing town, Danbury). Naturally the felt wears off during printing, and must be renewed from time to time.

If the fabric design is to be printed in several different colors, a separate wood block must be designed and cut for each color. That, of course, means a separate printing operation and careful register for each successive color. However, interesting "dream-like" effects can be created by overprinting several colors a little out of register. "The customers seem to like it," says Mr. Wallach.

Wallach Studios mix their own colors in large stone crocks. The pigment (indigosol colors) is imported from Switzerland and mixed with other chemicals. Some colors, like

black, must be made fresh every day, while others keep well. Each color is mixed from a different formula which Mr. Wallach did not divulge. Naturally, separate bolts of fabric printed from separate dye lots cannot be guaranteed to be exactly the same. But then, this is the charm of the hand-printed fabric—the slight variation which makes each piece unique. Color samples are always printed on small swatches of fabric before a large-scale printing on yards of fabric is begun. I watched Mr. Ulrich hand-printing a design in what appeared to be a deep red-black. Mr. Wallach explained that the color would oxidize when the fabric was steamed. After a fabric is printed in one color, it is allowed to dry on a large rack. Obviously it is necessary to work with only one color at a time, and each color must dry before the next one is applied. It is difficult to detect the "joinings" of the individual block prints on the completed lengths of fabric, so skillfully has the design been printed. Indeed, the average person's eye, accustomed to machine-printed fabrics, cannot really appreciate the loving labor that goes into the Wallach fabrics.

After the lengths of fabric have been printed and dried, they are sent out to be dry-steamed. The timing of this operation is very important, for it is then that the oxidation of colors takes place. The fabric is then washed and pressed, but not stretched. Back at the Wallach Studios, the fabric is cut and hemmed, or stored in bolts, ready to be sold.

There is love in Moritz Wallach's eyes as he guides you through his Lime Rock shop and workroom. He is proud of the craftsmanship displayed in his fabrics. He drapes linens from bolts on to the table tops, or eagerly tells you to feel the silky textures of the beautifully patterned cottons. He has dedicated his life to the crafts of the European peasants. He has studied their traditions and methods, and incorporated their designs and color combinations and transmuted them into handsome designs through his own gifts of skill and imagination. His hand-printed designs have been carefully, patiently, and painstakingly produced with the care and the will to perfection that seem to have disappeared from our over-mechanized, over-pressurized, hurly-burly world. There are only a few groups of dedicated craftsmen here in the United States, working in the old ways, preserving the joy of fine craftsmanship, and helping the public to appreciate more fully the artistry which such skills require. We so-called modern men want quick answers and immediate results; we want to surround ourselves with mass-produced items that are currently in style; we want what everyone else has. It is time we reawakened our spirits and began to appreciate the honest labor of the human hand, which contains that intangible that makes every handmade item superior to the machine-made—the element of human heart and spirit, a little of the creator in it.

Moritz and Meta's house in Lime Rock, Connecticut, where my grandmother still lives.

In 1947, the same year that Meta and Moritz moved from Queens to Lime Rock, Connecticut, we moved to West Cornwall, Connecticut (eight miles away), where we first rented, then later bought, one of the houses of a large estate.

For the first few years, my father worked for Moritz. Later my parents started their own business: both manufacturing and importing sports clothes. When they first started, my mother (who was their sole employee) didn't know how to put a zipper into a dress—but, then, when she had married my father some seventeen years earlier, she hadn't known how to boil water. She learned both. Lotte, above, ca. 1949.

Lotte and Eric vacation in Maine, 1952.

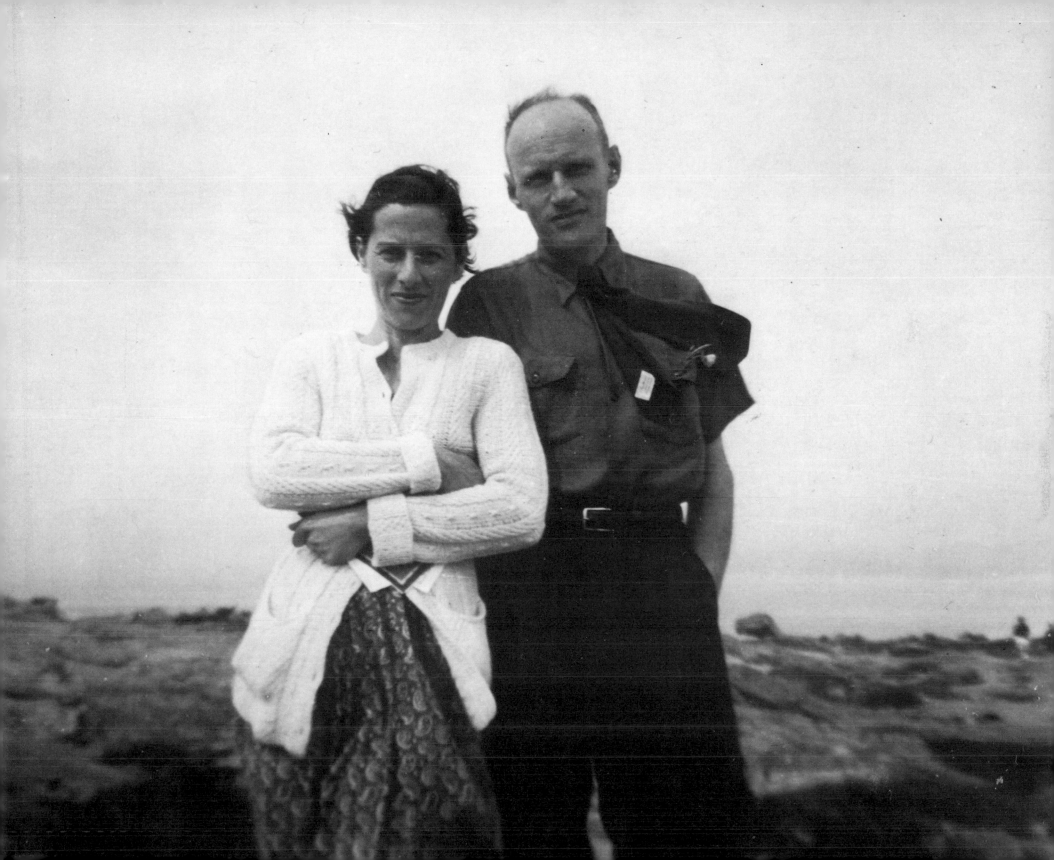

Brigitte and Catherine, 1949.

Eric Hanf Tel. Cornwall 75-13

West Cornwall, Conn.

August 3rd 1949.

Dear Catherine,

 Received your letter while alone here in the house,
garden and closer neighborhood; Mami is in Wingdale and I shall for-
ward your letter to her to morrow morning. Thanks for writing and
such a lot too, I do not think I have ever seen such a long letter
of yours. - I am glad that you have an enjoyable stay there at the
camp and hope it will continue that way right to the end.

 Enclosed is a slip, which came by same mail from
your camp leaders; I put my signature to it and you may return it
to whomever it concerns.

 There is not so much to tell from home. The hens
seem to start to lay in all seriousness; I collected seven eggs when
I got home to-night. Henrietta as usual. The cat is having another
litter inside her; she is quite round already. Henry is a pest pet;
as he had gotten into the habit of spending his nights on tables in-
stead of under and was fond of chewing the rug in the hall, I built
him a dog house after work yesterday and left him out when I went to
bed; however, as yet he does not like it and preferred to stay out
of it. Half the night I could hear him jumping up and down the roof
underneath my bedroom window, laying down on the shingles with a bump
and after a few minutes getting up again and down again and running around
and continuing this vicious circle for hours. That way I got an awful
lot of sleeping done myself - curse him. - But he stays at home by him-
self and not tied; to-day was the third day that he was alone all day.

 It is no good to write you Brigitta's address, as she
leaves there on Saturday or Sunday and surely your mail will not reach
her; I had a postcard from her, just after her arrival, but it did not
say too much. Well - this will bring this letter to an end. Write again
to here, Mami will be back on Saturday, and continue to be good.

 Cordially

 Dad Eric

Above: Girl Scout Camp.
Left: Henry, the pest-pet.

My grandmother Hanf came to this country in 1947, and she lived with us in West Cornwall for two years. She then worked in New York as companion to an elderly woman. After her employer died, my grandmother immigrated to Montreal, where she was joined by her two sons Rudy and Günther. She died suddenly in 1967 on one of her yearly trips to Europe to visit her daughter Lotte.

I took this photo of her and Mutti in the garden in West Cornwall in 1966.

Petition No. 6765

FEB 28 1962

Personal description of holder as of date of naturalization: Date of birth April 5 1938 sex female;
complexion fair color of eyes blue color of hair brown height 5 feet 4 inches;
weight 125 pounds; visible distinctive marks none
Marital status single
I certify that the description...

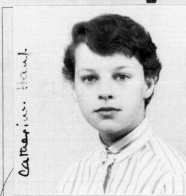

Catherine Hauf

Seal

Housatonic Valley Regional High School

This is to Certify that **Catherine Hauf** has satisfactorily completed the curriculum in Classical Studies as prescribed by the Regional High School Board and is entitled to this

Diploma

In testimony whereof, the Regional High School Board has caused the following to affix their signatures at Falls Village, Connecticut, this 17th day of June, A.D. 1955

G. Edward Byers
Chairman of the Regional High School Board

Paul W. Stoddard
Principal

Martha Brown Briscoe
Secretary of the Regional High School Board

Wilmer L. Shultz
Superintendent of Schools

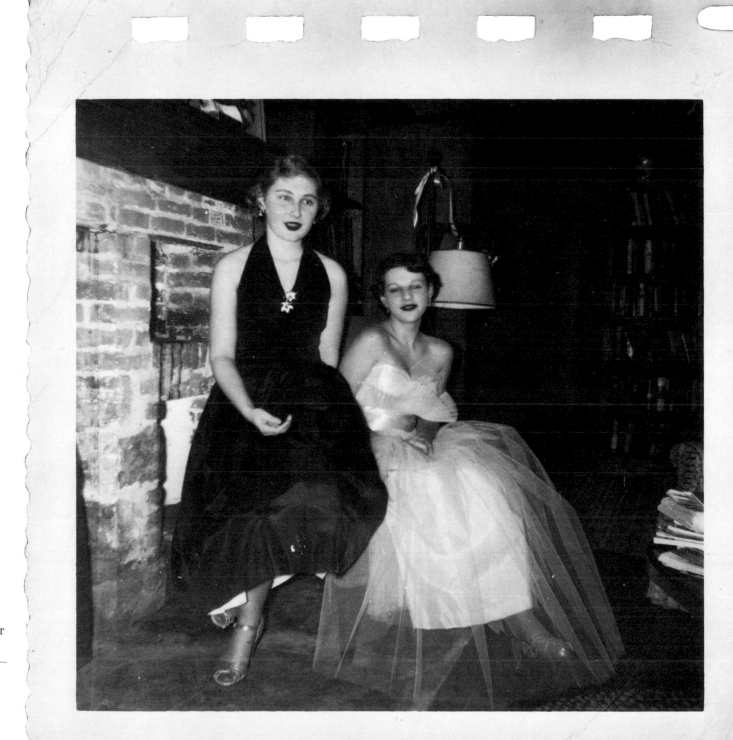

Growing up in the fifties: my friend
Molly Moore and I wait for our dates for
the Senior Prom.

Molly Moore and Catherine Hanf, 1955.

News Items of The Cornwalls

MRS. CLARENCE BLAKE, Reporter. News, Classified Ads, Public Notices and Subscriptions should be given to Mrs. Blake by 10 a.m. Mondays. Phone ORleans 2-6632

Fenn in Cornwall for several weeks.

Mrs. Charles Hardy of St. Petersburg, Florida is visiting at the home of Mr. and Mrs. Edwin Whitcomb.

Mr. and Mrs. George Lorch and sons have returned to their home in Roanoke, Virginia after visiting Mr. Lorch's parents, Mr. and Mrs. Jacob Lorch.

Mrs. John Lyman and children have returned to their home in Pennsylvania after visiting her parents, Mr. and Mrs. James Beeny.

Miss Hanf Weds In Athens, Greece

Mr. and Mrs. Eric Hanf of West Cornwall have announced the marriage of their daughter, Bridgitte Monica, to Dr. John Lawrence Enos, son of Mrs. Norman J. Elmes of Lakeville. His maternal grandmother is Mrs. Clinton R. Foutz Jr. of St. Petersburg, Fla. The bride's maternal grandparents are Mr. and Mrs. Moritz Wallach of Munich and Lime Rock.

The wedding took place on July 13 at the American Presbyterian Church of St. Andrews in Athens, Greece, where Mrs. Enos was visiting friends.

Dr. Enos, who received his early education at Harron (England) and Phillips Academy, Andover, Mass., was graduated from the Massachusetts Institute of Technology where he was a member of Sigma Chi and Tau Beta Pi. Recently he received a Doctorate of Philosophy from this same institution where he is presently Assistant Professor of Economics in the school of Industrial Management.

During the war he served as a Lieutenant in the Air Force and was in the OSS.

Mrs. Enos was educated at "Koornong" Warrandyte, Victoria, Australia; at the Housatonic Valley Regional High School in Falls Village and in the Rhode Island School of Design in Providence, R. I. She was graduated from the latter with a BFA degree in 1956. Until recently she was employed by Little Brown and Co., publishers, in Boston where she was designer in charge of children's books and texebooks in medicine.

After their return from Europe in August, Dr. and Mrs. Enos will live in Boston.

WED IN GREECE . . . Mrs. John Lawrence Enos whose marriage took place in Athens, Greece, on July 13 at the American Presbyterian Church of St. Andrew's. Mrs. Enos is the former Miss Brigitte Hanf of Cornwall.

First Church News

The Young People will present two one act plays; "Return Journey" by Dylan Thomas, and "Riders to the Sea" by J. M. Synge on Friday nightg at 8:15 at the Cornwall Consolidated

481 Beacon Street
Boston, Mass.
May 25, 1959

Dear Mrs Hanf,

With only two arduous weeks before I sail I am very grateful to have had such a restful weekend with my parents and an enjoyable visit with Mr. Hanf and yourself. You were very kind to invite me to dinner and to give me of your company. My only qualification is that, after the beauty of Cornwall, the city of Boston now looks very drab and unappealing.

As might be expected in my condition, I liked particularly to speak of Brigitte and to anticipate our forthcoming reunion. Although I did not confess it, you are aware of my devotion, and also of my aspirations, which I hope this summer to see fulfilled. It is for this that I so look forward to Europe.

Affectionately, John

In the spring of 1959, my sister decided to go to Europe. John Enos, an MIT instructor who was courting her, decided to follow. The letter, above, he wrote to my parents shortly before he left.

Above, left: From the Lakeville Journal, *Lakeville, Connecticut, July 30, 1959.*
Opposite: John Enos (left) and Brigitte Hanf Enos.

❋ Volkskunst ❋ Peasant Art ❋

Alte Bauernmöbel, bä...
Kunstgewerbe, Belcu...
Bauern-Fleckertepp...
Kupfer, Zinn, Keram...

Vor einem halben Jahrhundert wurde das ❋ WALLACH ❋ Haus für Volkskunst u. Tracht von den Brüdern Wallach gegründet. Durch ihre Initiative begann sich das Publikum und die Geschäftswelt nach einigem Zögern für Volkskunst und Trachten zu interessieren. Durch das Wirken der Brüder Wallach wurde das Kunsthandwerk wesentlich angeregt und schuf im Sinne alter Tradition neue Volkskunst. Sein Grundsatz, nur gediegenste Qualität zu führen und das Beste an europäischer Volkskunst zu pflegen und auszuwerten, trugen in hohem Masse dazu bei das Wallach-Haus während des halben Jahrhunderts seines Bestehens weit über Deutschlands, ja selbst über Europas Grenzen hinaus bekannt und geachtet zu machen.

50 Jahre

1900 — Wallach — 1950

Wallach

HAUS FÜR VOLKSKUNST U. TRACHT
MÜNCHEN·1·RESIDENZSTR.·3

About half a century ago the ✠ WALLACH ✠ House for peasant art, crafts and costumes was founded by the Wallach brothers. Thanks to their untiring efforts, they gradually succeded in capturing the interest of the public which at first had been very reluctant and hesitant to buy such unusual merchandise. The brothers also knew to inspire the old craftsmen who had already given up hope for a renewed recognition of their traditional crafts which in this way were gradually brought to new life. By merchandising only goods of high quality and executed according to highest standards the Wallach House became known and well reputed not only nationally but everywhere in Europe and also to a large section of the American public interested in old European traditions.

Moritz Wallach, 83, Printed Fabrics With Wood Blocks

LIME ROCK, Conn., April 17 (AP)—Moritz Wallach, a German-born craftsman who revived the folk art of printing fabrics with wood blocks, died yesterday. He was 83 years old.

As a young man in Munich, Mr. Wallach became interested in peasant and folk art, including designs on fabrics with handcarved wood blocks. With his brother, Julius, he founded a small factory in Munich in 1900. The company specialized in printing linen and other cloths with antique blocks. The Wallachs fled Germany in 1939 and were forced by the Nazis to leave behind their assets.

After the war, Mr. Wallach regained control of the company, and it still operates in Munich. In 1947, he founded the Lime Rock Hand Block Industry, which imported some products from Munich and also did work here.

Am 16. April 1963 ist mein lieber Mann, unser guter Vater und Bruder

MORITZ WALLACH
(früher München)

im Alter von 83 Jahren nach kurzer Krankheit verschieden.

Im Namen der Hinterbliebenen:

META WALLACH, geb. Strauss

Lime Rock, Connecticut

On April 16, 1963, my beloved husband, our good father and brother

MORITZ WALLACH
(formerly of Munich)

died, at the age of eighty-three, after a short illness.

In the name of those he leaves behind:

META WALLACH, born Strauss

Lime Rock, Connecticut.

Although my grandparents never had any desire to go back to Munich permanently, they did return there once a year to visit and to buy for Vati's business in Lime Rock. In 1950, Wallach's in Munich celebrated its fiftieth anniversary. Opposite is their anniversary card.

Every year the employees of Wallach's in Munich sent my grandfather an imaginative and charming birthday card. It was usually in the shape of a horse, as the German word *Wallach* means "gelding" and a horse has always been the family "crest."

The last birthday card my grandfather received is at right. On April 12, 1963, the family gathered at our house in West Cornwall to celebrate Mutti's eightieth birthday. Toward the end of the evening, Vati complained of a headache. They went home to bed, and my grandfather never awakened. He died four days later.

*Zum Geburtstag 1962 wünschen
wir Münchner und Dachauer Mitarbeiter
unserem lieben Chef
Herrn Moritz Wallach
viel Glück, Segen und Gesundheit.
München, den 5. Juli 1962
Im Namen aller Mitarbeiter:*

Above, left: The New York Times, April 18, 1963. Right: Aufbau, April 26, 1963.

November 28, 1963

Dear (Cathy,)

Congratulations on your engagement. Trite as it sounds, I hope fervently that you will be happy, and your parents resigned. I don't know whether your particular combination (love and marriage) of sensibility and sense is the best of all and guaranteed to bring success, but without being terribly cynical can't think of any better for both of the two.

C. A. N. sounds very interesting and I am awfully sorry that I will not be able to meet him, for a year at least. How does he work on three films simultaneously? Is it like writing three books at the same time or like eating meat, potatoes and a vegetable? (Or rather a bony fish, rice and artichoke, all in reverse?)

Keenedy's assasination (a Spanish word) has stupified everyone here. The Chilians had a personal attachmmet to him that they have had for no other American president, and can hardly imagine the United States without him. While all the papers receive news from the same agencies, and carried the main story similiarly, each, depending on its ploitical leanings, has come up with a different interpretation. El Siglo (communist) says the Birchers are responsible; El Mercurio (independent, dull) refuses to associate anyone with guilt; La Nacion (conservative) implies that it is a conspiracy directed by the Cubans; and the tabloids accuse the Mafia. In best gangster fashion, Oswald was bumped offbecause he "sabia demasiado". The most horrible, though, is the lurid full-page drawings not of what actually happened but of what the magazine editors think people would like to have happened. Just like Proust and Durrell and Mariedbad, only nasty too.

I hope that you will write me once in a while. Often it seems as if the letters I most enjoy come the most seldom.

Love,

John

In 1963, my brother-in-law John, an economist, was in Santiago (Chile), where he was doing research. Above, a letter I received from him at the time of my engagement.

I include my marriage license for purposes of comparison only (see the wedding contract of my great-great-grandparents, Sibilla Gottschalk and Salomon Cahn, pp. 1-4).

Right: From the Lakeville Journal, *Lakeville, Connecticut, January 2, 1964.*

LEGAL FEE $1.00 **CONNECTICUT STATE DEPARTMENT OF HEALTH** **CERTIFIED**
Public Health Statistics Section — Hartford, Connecticut, U. S. A. **COPY**

Marriage License: Town of Cornwall

1. GROOM'S NAME Cecil Andrew Noren	11. BRIDE'S NAME Catherine Hanf
2. (a) DATE OF BIRTH Sept. 15, 1941 (b) AGE 22 3. RACE White	12. (a) DATE OF BIRTH April 5, 1938 (b) AGE 25 Wh...
4. OCCUPATION Film Editor	14. OCCUPATION Teacher
5. BIRTHPLACE: (TOWN) Santa Fe, New Mexico (STATE OR COUNTRY)	15. BIRTHPLACE: (TOWN) Munchen Gladbach, German...
6. RESIDENCE New York, N.Y.	16. RESIDENCE Cornwall, Conn.
7. (a) PREVIOUS MARITAL STATUS Never Married LAST MARRIAGE ENDED BY: Death Divorce Annulment (b) NUMBER OF THIS MARRIAGE 1st	17. (a) PREVIOUS MARITAL STATUS Never Married LAST MARRIAGE ENDED BY: Death Divorce Annulment
8. FATHER'S NAME Cecil A. Noren	18. FATHER'S NAME Eric Hanf
9. MOTHER'S MAIDEN NAME Genivieve Lee McCurdy	19. MOTHER'S MAIDEN NAME Lotte Wallach
10. SUPERVISION OR CONTROL OF GUARDIAN OR CONSERVATOR no	20. SUPERVISION OR CONTROL OF GUARDIAN OR CONSERVATOR n...

We Cecil Andrew Noren AND Catherine Hanf NAMED IN THIS MARRIAGE LICENSE, DO SOLEMNLY SWEAR THAT THE STATEMENTS THEREIN MADE ARE TRUE.

SWORN TO BEFORE ME THIS 21 SIGNED Cecil A. Noren

DAY OF Dec. 19 63 SIGNED Delphine F. Fenn

SWORN TO BEFORE ME THIS 27 SIGNED Catherine Hanf

DAY OF Dec. 19 63 SIGNED Delphine F. Fenn

THIS CERTIFIES THAT THE ABOVE-NAMED PARTIES HAVE COMPLIED WITH THE LAWS OF CONNECTICUT RELATING TO A MARRIAGE LICENSE, AND ANY PERSON AUTHORIZED TO CELEBRATE MARRIAGE MAY JOIN THE ABOVE-NAMED IN MARRIAGE WITHIN THE TOWN OF Cornwall

THIS LICENSE MUST BE USED ON OR BEFORE February 25 19 64 NOT GOOD AFTER

DATE ISSUED Dec. 27 19 63 ATTEST Delphine F. Fenn

MARRIAGE CERTIFICATE

I HEREBY CERTIFY THAT Mr. Cecil Andrew Noren AND

Miss Catherine Hanf THE ABOVE NAMED PARTIES, WERE

LEGALLY JOINED IN MARRIAGE BY ME AT Cornwall THIS 27th

DAY OF December 19 63 s...

ADDRESS West Cornwall

THIS CERTIFICATE RECEIVED FOR RECORD ON December 31, 19...

I certify that this is a true transcript of the informa...

Attest:

Dated January 5th, 1968

Form V.S. 14B (2-61) 15M NOT GOOD WITHO...

Mr. and Mrs. Eric Hanf

announce the marriage of their daughter

Catherine

to

Mr. Cecil Anderson Noren

on Friday, December twenty-seventh

Nineteen hundred and sixty-three

West Cornwall, Connecticut

News Items of Cornwalls

MISS HANF IS WED DURING THE HOLIDAY

Miss Catherine Hanf, daughter of Mr. and Mrs. Eric Hanf of West Cornwall, was married on Friday, Dec. 27, at the home of her parents, to Cecil Anderson Noren, son of Mrs. C. Anderson Noren of Redlands, Calif., and the late Mr. Noren. Mrs. Scott Walker, Justice of the Peace, performed the ceremony.

Given in marriage by her father, the bride wore a street-length gown of white cotton brocade, and there were no bridal attendants. Following the ceremony there was a reception at the home of the bride's parents.

After a wedding trip to an unannounced destination, the couple will live at 511 Third Ave., New York City.

Mrs. Noren was educated at the Koornong School in Warrandyte, Australia; the Cornwall Consolidated School; and is a graduate of the Housatonic Valley Regional High School in Falls Village and of Bennington College, Bennington, Vt. Prior to her wedding she was the director of dramatics at the Beverly, Mass., High School.

Her husband attended schools in San Francisco and Redlands, Calif.; the University of California at Los Angeles; the University of London, England; and the British Institute of Film Technique at Brixton, England. He is an assistant film editor for the American Broadcasting Company in New York City, and is also a producer of independent films.

Following a wedding trip to the Caribbean Islands, Mr. and Mrs. Noren are now at home.

CUTTING THE CAKE . . . Mr. and Mrs. Cecil Anderson Noren who were married in Cornwall during the holidays. Mrs. Noren is the former Catherine Hanf.

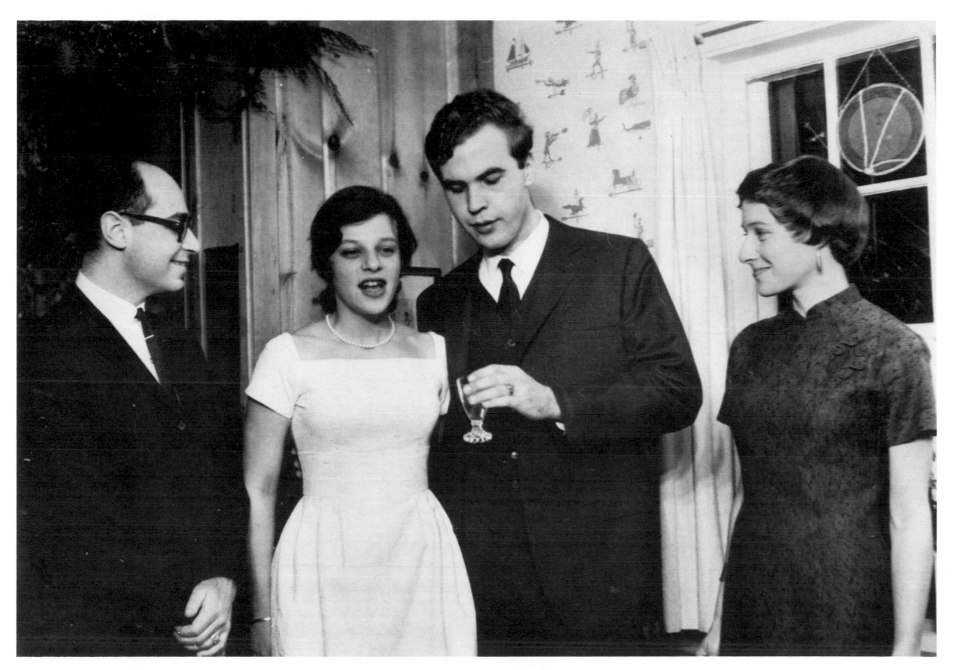

Andrew's and my wedding photograph. Although the photograph lasted, the marriage did not. We were divorced in 1970.

Jerry Zindler (Andrew's best man), Catherine and Andrew Noren, and Brigitte Enos

John and Brigitte have lived in Oxford, England, where John teaches. since 1968. Here they are on a visit to Cornwall in 1970. These photographs are quite an accurate portrait of their individual personalities: John is an eager and enthusiastic adventurer. Brigitte considerably more cautious—even reticent.

Brigitte is a printmaker by profession, and the influence of my grandfather's work is sometimes apparent in her own.

1972: Meta with her great-granddaughter, Eve Hanf-Enos (born September 8, 1971), wearing a Wallach dirndl.

1973: My mother, Lotte Wallach Hanf, with her granddaughter Eve, and a coffee cup.

The four Wallach siblings revisited, June 1970. Left to right: Rolf, Lotte, Fritz, and Annelise.

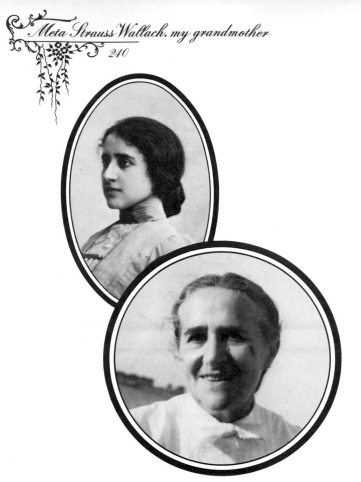

On April 12, 1976,
my grandmother, Meta Strauss Wallach,
became ninety-three years old.

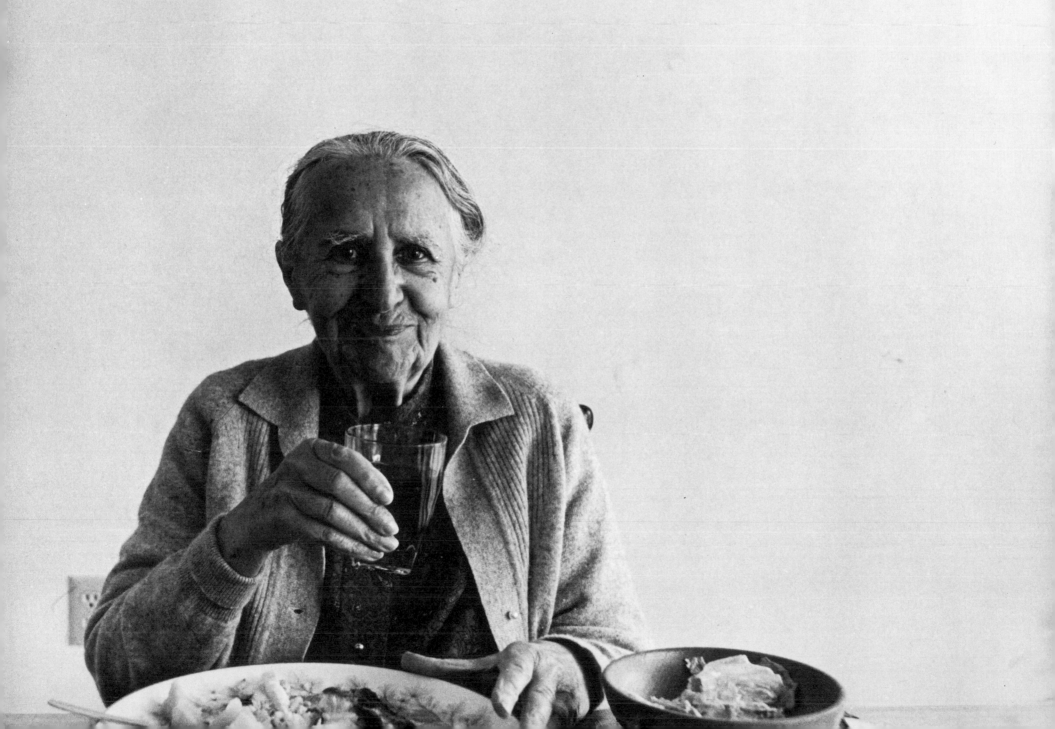

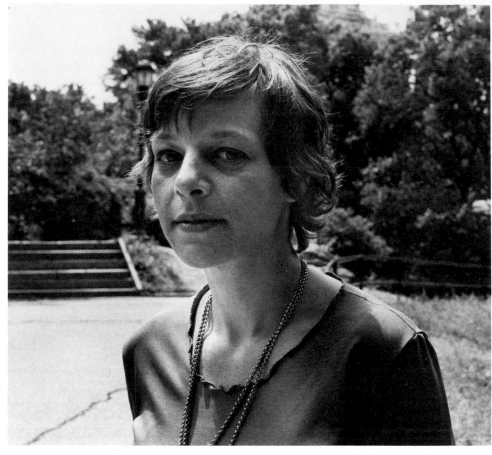

Catherine Hanf Noren, 1976.

ABOUT THE PHOTOGRAPHS

Most of the photographs in this book have been reproduced in the condition in which I originally found them. That is, no attempt has been made to alter the damage caused by time, wear, bad fixing, frequent exposure and handling. Some of them show defects that were not originally apparent in the prints, because although time has faded the images themselves, it has not affected the original retouchers' marks.

Photographers, where known, are given below.

Carl Backofen, Darmstadt: p. 68, left

Elizabeth Bloch: p. 208, right

Blumberg and Herrmann Studio (?), Cologne: p. 45, left

H. Borschel Studio (?), Dortmund: p. 5, left

A. Duval Studio (?), Tours: p. 5, right

Bruce Elkus: p. 147

Kathleen Foster: p. 242

Fritz Gaertner Studio, Norderney, pp. 10–11

Joern Gertz: p. 206

Lisel Haas: p. 122; p. 123, and inset, upper left; p. 124, far left; pp. 132–3 (interior and exterior of Hanf house); p. 134, all; p. 135, right; p. 138; p. 140, both

Haeyn-Wilms Studio, Bielefeld: p. 59

Lotte Wallach Hanf: p. 136, right center and bottom; p. 187, both

J. Herf Studio, Worms: p. 60, left

W. Höffert Studio, Düsseldorf: p. 75

Allan Kenneally: p. 191

P. Krenleitner Studio (?): p. 81

La Trobe Collection, State Library of Victoria, Australia: p. 184, left

Courtesy Dr. Alfred E. Laurence: p. 29

Frans van Leeuwen Studio: p. 197

Ernst Lohöfener Studio, Bielefeld: p. 37

Megaloconomou Brothers (Greek Photo News), Athens: p. 231

A NOTE ON THE TYPE

The text of this book was film set in Melior, a typeface designed by Hermann Zapf and issued in 1952. Born in Nürnberg, Germany, in 1918, Zapf has been a strong influence in printing since 1939. Melior, like Times Roman, another popular twentieth-century typeface, was created specifically for use in a newspaper. With this functional end in mind, Zapf nonetheless chose to base the proportions of its letterforms on those of the Golden Section. The result is a typeface of unusual strength and surpassing subtlety.

The book was designed by Betty Anderson and composed by Superior Printing, Champaign, Illinois, and by TypoGraphic Innovations, Inc., New York, New York. It was printed by Halliday Lithograph Corp., West Hanover, Massachusetts, and bound by Economy Bookbinding Corp., Kearny, New Jersey.